THE FORGER'S SPELL

Also by Edward Dolnick

THE RESCUE ARTIST

MADNESS ON THE COUCH

DOWN THE GREAT UNKNOWN

THE FORGER'S SPELL

A True Story of Vermeer,

Nazis, and the Greatest Art Hoax

of the Twentieth Century

———————

EDWARD DOLNICK

HARPER

An Imprint of HarperCollins*Publishers*
www.harpercollins.com

HarperCollins books may be purchased for educational, business, or sales promotional use. For information, please write: Special Markets Department, HarperCollins Publishers, 10 East 53rd Street, New York, NY 10022.

FIRST EDITION
Designed by Level C

Library of Congress Cataloging-in-Publication Data
is available upon request.

ISBN: 978-0-06-082541-6

08 09 10 11 12 WBC/RRD 10 9 8 7 6 5 4 3 2 1

For Lynn

It is in the ability to deceive oneself that the greatest talent is shown.
—*Anatole France*

We have here a—I am inclined to say *the*—masterpiece of Johannes Vermeer.
—*Abraham Bredius*

CONTENTS

Preface *xiii*

Part One
OCCUPIED HOLLAND

1 A Knock on the Door 3

2 Looted Art 6

3 The Outbreak of War 9

4 Quasimodo 14

5 The End of Forgery? 18

6 Forgery 101 22

7 Occupied Holland 26

8 The War Against the Jews 30

9 The Forger's Challenge 33

10 Bargaining with Vultures 40

11 Van Meegeren's Tears 44

Part Two
HERMANN GOERING AND JOHANNES VERMEER

12 Hermann Goering 51

13 Adolf Hitler 55

14 Chasing Vermeer 57

15 Goering's Art Collection 62

16 Insights from a Forger 66

17 The Amiable Psychopath 77

18 Goering's Prize 82

19 Vermeer 85

20 Johannes Vermeer, Superstar 88

21 A Ghost's Fingerprints 93

Part Three

THE SELLING OF *CHRIST AT EMMAUS*

22 Two Forged Vermeers 105

23 The Expert's Eye 109

24 A Forger's Lessons 115

25 Bredius 121

26 "Without Any Doubt!" 127

27 The Uncanny Valley 132

28 Betting the Farm 137

29 *Lady and Gentleman at the Harpsichord* 139

30 Dirk Hannema 145

31 The Choice 150

32 The Caravaggio Connection 163

33 In the Forger's Studio 167

34 *Christ at Emmaus* 170

35 Underground Tremors 173

36 The Summer of 1937 179

37 The Lamb at the Bank 186

38 "Every Inch a Vermeer" 192

39 Two Weeks and Counting 198

40 Too Late! 201

41 The Last Hurdle 203

42 The Unveiling 207

Part Four

ANATOMY OF A HOAX

43 Scandal in the Archives 213

44 All in the Timing 218

45 Believing Is Seeing 223

46 The Men Who Knew Too Much 227

47 Blue Monday 234

48 He Who Hesitates 239

49 The Great Changeover 243

Part Five

THE CHASE

50 The Secret in the Salt Mine 249

51 The Dentist's Tale 252

52 Goering on the Run 256

53 The Nest Egg 260

54 Trapped! 262

55 "I Painted It Myself!" 265

56 Command Performance 272

57 The Evidence Piles Up 276

58 The Trial 280

59 The Players Make Their Exits 288

 Epilogue 291

 Notes 295

 Bibliography 325

 Acknowledgments 331

 Index 333

PREFACE

A NOTE TO THE READER

This is the true story of a colossal hoax. The con man was the most successful art forger of the twentieth century, his most prominent victim the second most powerful man in Nazi Germany. The time was World War II. The place, occupied Holland.

Everything about the case was larger than life. The sums that changed hands soared into the millions; the artist who inspired that frenzy of buying was one of the best-loved painters who ever lived, Johannes Vermeer; the collectors vying for masterpieces included both Adolf Hitler and Hermann Goering.

But the outsize scale and the extravagant color were only the beginning. The story differs in key ways from most true tales of crime. Usually we are presented with a crime, and we set out to find the criminal. Here, no one even knew that a crime had been committed.

Where there was no crime, it stood to reason there was no criminal. For a villain who craved recognition, that made for a vicious dilemma. Keep his crime secret, and he would live rich and safe but unknown. Confess what he had done, on the other hand, and though he would find himself condemned to a prison cell, his genius would be proclaimed worldwide.

A second, even stranger feature made this case of art fraud different from any other. What made the fraud succeed was the very thing that should instantly have revealed it.

In this mystery, then, the usual questions do not apply. For us, the central question is not *whodunit* but, instead, *howdunit?*

Part One

———•◆•———

Occupied Holland

1

A KNOCK ON THE DOOR

Amsterdam
May 1945

Until almost the very end, Han van Meegeren thought he had committed the perfect crime. He had pocketed more than $3 million—the equivalent of about $30 million today—and scarcely a trace of scandal clung to his name. Why should it, when his dupes never even knew that someone had played them for fools and taken them for a fortune?

Even now, with two uniformed strangers at his door saying something about an investigation, he thought he might get away with it. The two men seemed polite, not belligerent. No doubt they had been impressed by the grandeur of 321 Keizersgracht.* Maybe they really did have only a few routine questions to sort out. Van Meegeren decided to keep his secrets to himself.

Van Meegeren was a small, dapper man of fifty-five with a tidy mustache and gray hair swept back from his forehead. His house was one of the most luxurious in Amsterdam, on one of the city's poshest streets, a neighborhood of bankers and merchant kings. Imposing but not showy, in keeping with the Dutch style, the house rose four stories high and looked out on a postcard canal. Most impressive of all in space-starved Amsterdam, where every staircase rises as steeply as a ladder, the house was nearly as wide as it was tall. The front

* Throughout this book I have given addresses in the American style, with the house number first. The Dutch put the number last.

hall was tiled in marble, and envious rumors had it—falsely—that the hall was so big that guests at Van Meegeren's parties raced their bicycles around it. On the other hand, the rumors about indoor skating were true. Van Meegeren *had* found a way to convert his basement to an ice rink so that jaded partygoers could skate in style.

Joop Piller, the lead investigator on this spring day, would not have been a guest at those parties. A Jew in Holland—and Holland lost a greater proportion of Jews in World War II than any other Western European nation—Piller had fought in the Dutch resistance from 1940 to 1945. In years to come, many would embellish their wartime credentials, but Piller was the real thing. His last mission had been to set up a network to rescue Allied pilots after the Battle of Arnhem and smuggle them to safety.

Piller had only begun to learn about Van Meegeren. Holland in 1945 was short of everything but rumors, and Piller had picked up some of the gossip swirling around Amsterdam. Van Meegeren had friends in all the worst—which was to say, pro-German—circles; he was a painter and an art collector; he was a connoisseur of old masters and young women; he had lived in France and had won that country's national lottery.

Skeptical by nature, Piller was inclined to wave all the talk aside. Still, it was easy to see why the rumors flew. What kind of artist lived like this? Rembrandt, perhaps, but Van Meegeren was no Rembrandt. He was, according to all that Piller had heard, a middling painter of old-fashioned taste and no special distinction. He was apparently an art dealer as well, but he seemed to have made no more of a splash as a dealer than as a painter. He supposedly had a taste for hookers and high living and a reputation as a host who never let a glass stay unfilled. Other tales hinted at a kind of self-indulgent posturing. He had brought his guitar to a friend's funeral because "it might get boring."

The bare facts of the artist's biography, as Piller would begin to assemble them over the next few days, only deepened the mystery. Van Meegeren was a Dutchman born in the provincial town of Deventer. He had studied art and architecture in Delft, the hometown of the great Johannes Vermeer. He had won prizes for his art, but he was as out of tune with the current age as his favorite teacher, who had taught Van Meegeren to prepare his own paints like his predecessors of three centuries before.

Despite the occasional triumph, Van Meegeren hardly seemed marked for greatness. In college he got his girlfriend pregnant, married her at twenty-two,

and settled down uneasily near Delft. There he tried, without much success, to support his family with his art.

Van Meegeren spent the 1920s in The Hague, where life improved. He gained a reputation as a playboy and a portrait painter whose skill was perfectly adequate but whose client list was positively dazzling. In 1932 (by this time, with a new wife), he left Holland for the French Riviera. In the small town of Roquebrune, he moved into a spacious and isolated villa perched high on a cliff above the sun-dappled Mediterranean. As the Great Depression strengthened its grip, Van Meegeren somehow continued to thrive. In 1937, after five years in Roquebrune, he moved to even more imposing quarters, purchasing a mansion with a dozen bedrooms and a vineyard in Nice.

But at his first meeting with the little man in the big house, Piller knew only that Van Meegeren's name had turned up in the paperwork of a dodgy art dealer. And so, when Piller took out his notebook and posed the question that would set the whole complicated story in motion, he had suspicions but not much more. Tell me, Mr. Van Meegeren, he asked, how did you come to be involved in selling a Vermeer?

2

LOOTED ART

Piller's knock on Van Meegeren's door came only three weeks after VE-Day, which marked the Allied victory over the Nazis and the official end of World War II in Europe. Holland had suffered bitterly through the war years, its citizens bombed and starved and dragged into slave labor and sent off to extermination camps. For the Germans occupying Holland, on the other hand, life had retained its civilized pleasures. While the Dutch had choked down "roof rabbit"—dog or cat—Nazi officials had dined off fine china in bustling restaurants. When peace finally came, the Dutch erupted in anger. Jubilant crowds jeered and screamed, "Traitor!" as members of the Dutch Nazi Party were paraded through the streets. Indignant mobs grabbed Dutch girls who had taken German boyfriends—"Kraut girls," the Dutch called them—and shaved their heads as punishment.

Rebuilding the country would take years. Piller had been made a captain in the Militair Gezag, the provisional government, but he had not the slightest interest in formal authority or chains of command. A freelancer and a rebel by temperament, Piller had lived by his wits for the last five years. Now, with the war finally over but few government structures yet in place, he had a free hand. He set up, essentially on his own authority, a group charged with investigating collaborators and crooked businessmen who had sold out the Dutch to the Nazis.

A hunt for looted property led inevitably to a hunt for stolen art. Holland had lost countless art treasures to the Nazis. Both Adolf Hitler and Hermann Goering, the two highest-ranked figures in the Nazi pecking order, fancied themselves art connoisseurs and collectors. Europe's art, Hitler and Goering believed, belonged in German hands. With the Fuehrer and the Reich Mar-

shal showing the way, the Nazis had ransacked Europe's museums and private collections and grabbed whatever caught their eyes.

Goering, a six-star general and the highest-ranking military official in Germany, was self-obsessed to an almost unfathomable degree. What he wanted, he deserved. What he wanted, after power, was art. "I love art for art's sake," he told an interviewer at the Nuremberg trials, where he was charged with war crimes, "and, as I said, my personality demanded that I be surrounded with the best specimens of the world's art."

With the help of art dealers scouring Europe on his behalf, Goering accumulated masterpieces literally by the trainload. "I intend to plunder, and to do it thoroughly," he had declared early on, and for once he kept his word. From Holland, France, Belgium, Poland, and Italy, trucks full of confiscated art drove in convoy to Goering's private trains, for delivery to Germany. There the Reich Marshal's newest masterpieces took their place among his other trophies, Rembrandts and Van Dycks and Halses and Goyas hanging on the walls in tiers three and four paintings high.

Goering reveled in taking visitors on tours of his new possessions: old masters, statues, tapestries, antique furniture, suits of armor, golden candlesticks, bronze lions, all in endless profusion. Some of it little more than ornate clutter, much of it priceless, all of it unmistakable testimony that Europe's new rulers could do as they pleased.

Goering had wasted no time. By the time the war was a year old, his collection had grown to a spectacular size. "At the current moment," he wrote in a letter in November 1940, "thanks to acquisitions and exchanges I possess perhaps the most important private collection in Germany, if not all of Europe."

Amid such splendors, no single work could jump out, but Goering prized some of his paintings above the others. One special favorite was a previously unknown Vermeer called *Christ with the Woman Taken in Adultery*. This was the most valuable of all his possessions, and Goering displayed it in a place of honor at Carin Hall, his grandiose country estate.

For the Nazis and all other art collectors, a Vermeer was a prize almost without peer. The beauty of the work was part of the appeal, but its scarcity counted for even more. In all the world there are only three dozen Vermeers. Even a conqueror with Europe at his feet could do nothing to alter that brute fact.

THE WAR HAD shattered countless lives. In the "hunger winter" of 1944–1945 alone, twenty thousand Dutch citizens had died of starvation. Joop Piller had

suffered, and seen his friends suffer. Van Meegeren had floated through the war in style. Now his name had turned up in the worst possible company, with Hermann Goering's, on the sales records for *Christ with the Woman Taken in Adultery*. Piller, who before the war had managed a factory that made raincoats, had no special interest in art or in Vermeer. He did, however, have a special interest in the Nazis and in those of his countrymen who had done business with them.

3

—◆—

THE OUTBREAK
OF WAR

On the evening of May 9, 1940, Hermann Goering swept into Berlin's State Theater resplendent in his white uniform. The play was half over. Goering's entrance was hard to miss, just as he preferred.

Elsewhere in Berlin on the same evening, two old friends met for a tense dinner. Major G. J. Sas was the Dutch military attaché; Hans Oster was a German officer, a colonel in the German High Command, and a committed opponent of Adolf Hitler. They had first met in 1932 and had stayed in touch afterward. In September 1939, when Germany invaded Poland and triggered the Second World War, Oster began secretly passing his Dutch colleague detailed information about Hitler's plans to attack the West.

After their dinner, the two men took a cab to German headquarters. Sas waited in the car; Oster disappeared inside. When he returned, he delivered his news in an urgent whisper: "This is the end. No counteroffers. The Swine has gone to the western front. It's all over now. Let's hope we see each other after the war."*

Sas raced off to phone the War Department in The Hague. He was put on hold. Twenty minutes passed. Finally, Sas had the chance to pass along his coded message and its urgent conclusion: "Tomorrow at dawn. Hold tight." The Dutch chief of foreign intelligence, not quite sure whether to believe Sas,

* It was not to be. Oster was hanged in Flossenbürg concentration camp on April 9, 1945, along with several colleagues, for attempting to assassinate Hitler. Sas died on October 21, 1948, when his KLM flight crashed in the fog near Prestwick, Scotland.

phoned him back. "We have heard the bad news of Mrs. Sas's illness. Have all doctors been consulted?"

"Why bother me again?" Sas snapped. "You know it now. She has to have an operation tomorrow morning." He hung up.

IN THE YEARS to come, everyone in Holland would remember the unsettling beauty of the spring days just before the invasion. As the news from elsewhere in Europe grew ever worse and people's moods ever darker, the weather in Holland had turned uncharacteristically, almost mockingly, mild and bright. The tulips bloomed on into May. In the early morning hours of May 10, German bombers cut their way through cloudless skies. At first, no one who was woken by the humming in the air knew where the sound came from. But when the planes dipped lower, the hum turned to a roar, and soon everyone in Holland knew that the long-feared invasion had come at last.

German parachutists began dropping from the sky at precisely 4:00 A.M. At the same moment, hundreds of thousands of German soldiers and more than a thousand tanks began pouring across the border. The paratroopers' task was to secure Holland's bridges before the Dutch could blow them up, so that the invading army could thrust into its tiny neighbor unimpeded.

Holland had been braced for an attack for months. (In a sense, Sas's problem was that his source was *too* well connected. In the months before the actual Nazi attack, Hitler repeatedly canceled his invasion plans at the last second—*eighteen* times in all—and Sas had passed along too many false alarms.)

In the Nazis' eyes, France and England were the biggest prizes in Europe, and Holland more a means to an end than a goal in itself. (In World War I, Germany had swept into France by way of Belgium, sparing Holland.) In the end, the decision to take Holland fell largely to Goering, who was commander in chief of the Luftwaffe, the German air force. Goering wanted to use Holland's airfields as launching sites for attacks on Britain.

But even while plotting battle tactics, Goering scarcely wavered from his focus on plunder. For the Reich Marshal, Holland meant airstrips, but it meant old masters, too, and it was by no means clear which struck him as the higher priority.

EVEN IF MAJOR Sas's warning had gone through immediately, Holland stood no chance against the Nazis. With the exception of a brief battle with

the Belgians in 1830, the Dutch army had not gone to war since Napoleon's day. Now, in 1940, it stood in the path of its belligerent next-door neighbor unprepared, outnumbered, and out-equipped.

Like the Belgians, Norwegians, and Danes, the Dutch had opted for neutrality in the forlorn hope that if they kept their heads down, trouble might pass them by. It was less a strategy than a prayer. "They hoped," in the words of the Dutch historian Walter Maass, "to avoid provoking the monster that had already clawed at their doors."

In Rotterdam, the monster stepped into the open. On the afternoon of May 14, 1940, while the Dutch tried to negotiate surrender terms, one hundred Luftwaffe bombers took to the sky over the city. "The planes are searching systematically for their targets," a German observer noted approvingly. "Soon the center of Rotterdam is burning at many places. Within a few minutes the center is enveloped in dense black and sulfur-yellow clouds. The bombers are flying quite low over the city. A splendid picture of invincible strength."

Nine hundred Dutch citizens died, and seventy-eight thousand were left homeless. The next day, the Germans announced, it would be Utrecht's turn. The Dutch had fought bravely against unthinkable odds, but the loss of a second city would be a futile sacrifice. On May 15, five days after the Nazi invasion, Holland surrendered.

For the rest of his life, Hermann Goering would exult in recounting the triumphs of his Luftwaffe in the war's early days. As the fighting moved on to France over the next few weeks, he grew ever more boisterous. He sent his planes aloft to bomb the airfields around Paris with the command, "Let my air force darken the skies!"

In the midst of battle, Goering dreamed of pilfered art. Almost as soon as Holland fell into German hands, he dispatched Walter Hofer, his primary art scout, to start "shopping" on his behalf. An art dealer of no great reputation before the war, Hofer now carried a business card that declared him "Curator of the Reich Marshal's Art Collection."

FOR THE NAZIS, the spring of 1940 brought triumph after triumph. Winston Churchill had taken over as British prime minister on May 10, the same day the Nazis invaded Holland and France. "Behind us," Churchill told his countrymen, ". . . gather a group of shattered states and bludgeoned races: the Czechs, the Poles, the Danes, the Norwegians, the Dutch, upon all of whom a

long night of barbarism will descend, unbroken even by a star of hope, unless we conquer, as conquer we must, as conquer we shall."

Delighted with Germany's run of good fortune, Goering flew to Holland on May 24 to survey the wreckage of Rotterdam. In high spirits, he continued on to Amsterdam to see what art and jewelry he might find. One of Goering's scouts purchased 368,000 guilders' worth of diamonds on his behalf, about $2.7 million in today's dollars.

Two days after Goering's visit to Holland, the Allies achieved their lone "victory" in this early fighting. The victory was in fact a retreat, at Dunkirk, where a makeshift fleet of fishing boats and ferries and lifeboats and yachts managed to rescue hundreds of thousands of soldiers trapped in northern France. British and French soldiers fought their way across the beach and into the water, and then searched frantically for a boat they could clamber into. German machine gun fire swept across the beaches; Luftwaffe bombers swooped down over the water. Somehow the improvised flotilla—"English fathers, sailing to rescue England's exhausted, bleeding sons," in the historian William Manchester's phrase—carried 338,000 souls to safety.

Two weeks later, in early June 1940, Goering was back in Amsterdam. Jubilant in his quarters at the Amstel Hotel, he took out a pen and a sheet of hotel stationery and set down a heading: "List of Pictures Delivered to Carin Hall on June 10, 1940." The tally included more than two dozen works, paintings by Brueghel, Rubens, and Rembrandt among them.

On June 27, Goering returned to Amsterdam yet again. This time the lure was the immense art collection of the renowned Jacques Goudstikker. One of Europe's best-known and wealthiest art dealers (and a Jew), Goudstikker and his wife and baby had tried to escape Holland as the Nazis swept in. As he joined the desperate crowds rushing to the coast in search of a boat or ship, Goudstikker carried with him a small black notebook with handwritten entries on the 1,113 paintings he had left behind. The list was extraordinary. Under *R*, for example, the entries included Rembrandt, Rubens, and Raphael; under *T*, Titian and Tintoretto.

Goudstikker managed to snare three precious places on the SS *Bodengraven*, bound for South America by way of Dover. As the refugees neared the English coast, Nazi dive bombers attacked. On the night of May 16, with the ship blacked out in case of further attacks, Goudstikker lost his way in the dark, fell through an open hatch in the deck, and died.

In Holland, eager buyers immediately began circling around Goudstikker's

firm. One of them represented Hermann Goering. Exactly what deals were struck for Goudstikker's various holdings, and on what terms, no one has ever learned. At his Nuremberg trial, Goering would reveal that he had paid 2 million Dutch florins (roughly $13 million in today's dollars) for some six hundred paintings, including nine by Rubens. (The Nazis were criminals who went out of their way to profess respect for the law; rather than steal outright, they often preferred to make coerced purchases. Goering's outlays, needless to say, did not come from his own pocket.)

However complex the negotiations, the outcome was brutally straightforward. "A few months after Goudstikker's death, on a very hot day in July," wrote the Dutch historian Jacob Presser, "a corpulent figure wearing a white uniform and clutching a baton appeared at his gallery in the Herengracht. Reich Marshal Goering was paying a visit. An eyewitness has described what happened a few days later: 'Huge lorries and barges drew up outside, and were soon filled to overflowing with valuable paintings and antiques. Goudstikker's was left empty. Everything went to Germany.'"

4

QUASIMODO

Han van Meegeren fervently believed he was a great painter. He was not. His own work was no better than that of countless others, and the worst of it was dreadful. Van Meegeren was versatile—he painted society portraits and Bible scenes and nightclub dancers—but his work was marred by a taste for the cloyingly sweet or the creepily erotic. His best-known picture, once so familiar that nearly every Dutch home had a reproduction, was a sentimental drawing of a huge-eyed doe. The marketing of the drawing, rather than the picture itself, set it apart: sales took off after Van Meegeren declared that the deer was no ordinary animal but belonged to Holland's beloved Princess Juliana.

As a young man, Van Meegeren had won some recognition for his painting, but his taste was old-fashioned and out of favor. (He painted his doe around 1917, a decade after such Cubist masterpieces as Picasso's *Demoiselles d'Avignon*.) By 1920, Piet Mondrian, Van Meegeren's best-known Dutch contemporary, had already begun working on the geometric grids and colored squares that are now known around the world. Deeply contemptuous of all such nonrepresentational art, Van Meegeren continued to churn out landscapes and madonnas.

In 1922, he organized an exhibition of his biblical pictures. One of Van Meegeren's paintings, scarcely noticed at the time, was a New Testament scene called *Christ at Emmaus*. Years later, in 1937, one of the best-known authorities on Dutch art would announce a startling discovery. He had found a new Vermeer, the greatest masterpiece that Vermeer had ever painted. It, too, was called *Christ at Emmaus*.

The show of religious paintings was a financial success: Van Meegeren sold

all his paintings, and the exhibition led to a number of portrait commissions and a cushy gig teaching young ladies from The Hague's tonier neighborhoods how to draw. But the critics had been less charmed.

Some reviewers hailed Van Meegeren's technical flair, but most damned his work as more akin to magazine illustration than proper painting. "Here and there one finds something to praise," observed a writer from the magazine *De Groene Amsterdammer*, before going on to complain that "there is too much frivolity, too little depth, too little psychology, too little respect, and no sense of religious feeling." In similar fashion, the writer from *Het Vaderland* offered a bit of perfunctory praise—Van Meegeren had "a unique, fluent way of painting"—and then a hearty slap: Van Meegeren's paintings of Christ were "often insipid and sweet, sometimes miserably forsaken, always weak and powerless."

Even a placid soul might have snarled at such treatment. Van Meegeren had nothing placid about him. Jumpy, vain, and prickly, he treasured his grievances. Each critical snub provided further proof that he had fallen victim to a smug and narrow-minded clique. First in coffeehouse diatribes and then in angry essays in a tiny magazine he helped start up, Van Meegeren fought back. Modern art was a scam, and the critics who endorsed it were ignoramuses and crooks. Painters of real talent met with sneers and sarcasm, if they managed to win any attention at all. The critics reserved their praise for "art Bolsheviks," fashionable frauds whose abstract paintings were nothing but smears on canvas. These so-called artists were a "slimy bunch" of "drunken madmen."

Sometime after that fateful 1922 show, Van Meegeren set to work on his first forgeries. If he could not win the critics' applause, it would be nearly as satisfactory to make fools of them. A good hater, Van Meegeren did not mellow as the years passed. A scribbled note turned up in his papers after his death. "Revenge keeps its color," it read. "Who waits, wins."

FEW PEOPLE TODAY recall Van Meegeren. Outside the art world, even those in educated circles respond to a mention of his name with blank stares. (*Inside* the art world he remains notorious, so much so that insiders refuse to believe that his story is not every bit as familiar in the world at large as that of, say, Benedict Arnold.)

To ask a historian or an authority on Dutch art about Van Meegeren's forgeries feels rude, like asking the owner of a three-star restaurant about the time the health inspectors shut him down. Why not ask about great paintings

instead? And, indeed, Van Meegeren's fakes are as clumsy and lifeless as the experts maintain. Ask scholars for specifics and they scarcely know what to criticize first. How about the "heavy-lidded eyes with raccoon-like shadowing"? Or the "overly fleshy lips and noses" or "the bag-like garments" or "the faker's lack of ability in achieving correct anatomical structure and volume"?

That badness is undeniable, but it is precisely Van Meegeren's badness that gives his story its sting. Van Meegeren was a tireless experimenter, a savvy tactician and deal-maker, and a brilliant psychologist. What he was not especially good at was painting. He found a way to make that not matter.

Van Meegeren's tale has been told often. Nearly always it is told wrong. Van Meegeren was a genius, we read, a master forger, the greatest forger who ever lived, and so on. This is to get the story almost exactly backward. Van Meegeren did fool the world and he did earn a fortune for it, but his true distinction was this: he is perhaps the only forger whose most famous works a layman would immediately identify as fake.

The story of virtually every forger follows familiar lines: a talented but unscrupulous artist turns out paintings so like their famous counterparts that no one can tell worthless sham from priceless masterpiece. Van Meegeren's story doesn't fit that frame. To try to jam it in is to misrepresent the tale and to rob it of its strangeness.

Today no one who happened unaware upon a Van Meegeren forgery would admire it. A Van Meegeren "Vermeer" next to an actual Vermeer is like a Madame Tussaud waxwork next to a living person. But when Van Meegeren turned from his own work to forging old masters, the critics who had damned him as shallow and insipid hailed his forgeries as superlative, among the greatest paintings in the entire Dutch pantheon. Even in comparison with other works by Vermeer, these newfound paintings stood out as "especially beautiful," "serene," and "exalted." The greatest Vermeer expert of the day singled out one Van Meegeren forgery where "Vermeer" had outdone himself and asked plaintively, "Why was there never again a canvas where he expressed so deeply the stirrings of his soul?"

Today the very works that the greatest connoisseurs of the 1930s and '40s praised as superior to those of Rembrandt and Vermeer languish in museum storerooms and remote hallways. They seem not beautiful but stiff and clumsy. "After Van Meegeren's exposure," one scholar wrote, "it became apparent that his forgeries were grotesquely ugly and unpleasant paintings,

altogether dissimilar to Vermeer's. His success is, retrospectively, literally incredible."

That turnabout is the great mystery at the heart of the Van Meegeren story, and it is what makes his tale worth telling. Van Meegeren's best fakes should never have fooled a soul. Instead, they fooled the world.

The real question with Van Meegeren is this: How did the experts get it so wrong? How did they hail as Vermeer's greatest achievement—supposedly superior to the stunning *Girl with a Pearl Earring* and *The Milkmaid* and all the other masterpieces—paintings that were "grotesquely ugly" and "altogether dissimilar" to the real thing?

It would be one thing if Van Meegeren had produced fakes that nearly replicated authentic works by Vermeer. He might have painted a woman in a quiet room, for instance, but moved a chair this way or that or shifted a map on the wall. We might fall for that sort of tiny variation on a well-worn theme. Here, we would say, is proof of Vermeer's obsession with achieving a perfectly balanced and harmonious composition.

If art lovers mistook such a painting for the real thing, who could blame them? Anyone might be fooled, just as anyone might mistake one twin for another. But Van Meegeren's fakes were intentionally different from all known Vermeers, and still they won swooning admiration. When expert after expert, and then enraptured museumgoer after museumgoer, gazes at twisted and misshapen Quasimodo and sees Adonis, *then* we have a mystery to explore.

5

THE END
OF FORGERY?

Forgery is a strange crime. Buy a fake Rolex on the street for ten dollars and a week later it stops running and the hands fall off. Buy a fake Picasso and the fake does its job—delights the eye—precisely as well as the real thing. At least it does so until the owner learns of his folly. Then yesterday's joy becomes today's reproach, and the masterpiece that once reigned above the fireplace ends up relegated to a guest bathroom.

But forgers themselves are seldom compelling figures. They tend to be bitter and self-centered—it is bad for the soul when the world shrugs its shoulders at your own work but falls at your feet if you pass yourself off as someone else.

Most accounts of forgers portray them as romantic and misunderstood. With a tiny handful of exceptions, this is a myth, akin to the myth that art thieves look like Thomas Crown. Real-life art thieves are not tuxedo-wearing art lovers but thugs who have never ventured into a museum except to rob it. And forgers are not unrecognized geniuses but craftsmen who have a considerable skill for imitation. It is the difference between having something profound to say and having an ear for languages.

Despite their sour outlooks, forgers can be good company, like many rogues. Even their cheating is easy to forgive. No one winks at the con man who takes an old couple's life savings in exchange for a phony insurance policy. But who would fight down a grin if he heard that an investment banking hotshot had blown his million-dollar bonus on a fake painting cranked out in a basement?

Not that forgers are as good-hearted as Robin Hood. On the contrary. They have about the degree of sympathy for their victims that lions have for antelopes. The dupe's role in the universe, his reason for being, is to *be* a dupe. In the words of one con man, "If you gave one of them an even break, it would spoil his evening."

FORGERY IS A craft as much as an art, a battle of wits between the con man on one side and connoisseurs and scientists on the other. Technique is crucial, but it is only part of the story—in every successful forgery, psychology plays a role every bit as important as art.

That is why forgers continue to thrive today, even though science has grown so sophisticated that no one should be able to pass off a new work as an old one. "With old master paintings, it's just about over," says Marco Grassi, a well-known specialist in art conservation. "Forgery is much more difficult because we have so many tools to discover them."

But Grassi is too optimistic. The problem is that, even in the case of paintings that cost millions or tens of millions, science seldom comes into play. The best tools don't help if no one uses them. "Nobody bothers to take the time or spend the money to go to the scientists," says Thomas Hoving, former director of the Metropolitan Museum of Art and an expert on fakes. Crazy as that sounds, Hoving insists that it makes perfect sense. The deeper problem with scientific tests, beyond their expense, is that they can seldom deliver the clear-cut answers they seem to promise. We turn to science to free ourselves from the fallible judgments of human experts, and we find that the scientific tests themselves require human interpretation.

Consider the experience of the team of scholars known collectively as the Rembrandt Research Project. For years they have labored to separate Rembrandtian wheat from school-of-Rembrandt chaff. They have taken countless pains. Art historians by training, they have enlisted the help of experts in half a dozen arcane specialties. With the aid of specialists in dendrochronology, for instance, the Rembrandt team can look at a painting on a wooden panel and tell the exact year that someone felled the tree that became the panel.

But tree experts know about trees and not about Rembrandt. On one occasion the Rembrandt committee examined two paintings, both of them attributed to Rembrandt and both on wooden panels. The scientific tests proved not only that both panels were the same age, but that *both came from the same tree.* But in the end even that information proved irrelevant. On the basis

of stylistic differences between the two works, the committee concluded that one painting was by Rembrandt and the other was not.

"Unless you find something egregiously stupid," says Hoving, "science can't resolve anything on its own. Not unless you have a sculpture that's supposed to be paleolithic but it's really made out of Silly Putty."

When it comes to art, scientific tests have another shortcoming. In theory, a single failed test—a Silly Putty sculpture or a "Rembrandt" painted on a panel from a tree chopped down in 1950—can unmask a painting. But a questionable painting could *pass* a dozen scientific tests—paint from the right era, panel and frame of the appropriate wood,* X-ray and ultraviolet and infrared and autoradiography findings as they should be—and still it might stay stuck in limbo. Scientists can demote a painting, but only connoisseurs can promote one.

In the case of the Olympics or the Tour de France, every would-be champion has to run a gantlet of scientific tests. But when a painting with a giant price comes up for sale, there is no clamor for testing. During his years as director of the Met, Hoving says, there was never a time, no matter how big the purchase under debate, when the museum's trustees insisted that they would raise the money to buy a painting only after it had been thoroughly tested scientifically. "Never!" Hoving cries out indignantly. "Nor should they. They're a fucking bunch of lawyers. What the hell do they know?"

Hoving spits out the name of one trustee, a prominent investment banker, and makes a face like he has swallowed spoiled milk. "I want to ask [the banker] how to tell if a picture is right? Give me a break. If those guys want to make a fifty-million-dollar purchase, they hire people like me."

They hire, in other words, connoisseurs with deep stores of experience, intuition, and savvy. So it has always been, in the world of art. When an exciting painting comes along, who would be the advocates for playing down the connoisseurs' role and beefing up the scientists'? Not the dealers—if a dealer has a buyer lined up, to test it is to ask for trouble. Not the art experts who vouched for the painting—they have reputations to uphold, faith in the "eye" they have spent years training, and, quite likely, no patience or interest in esoteric technical findings.

* British author Anthony Bailey tells the story of an art collector who learned that his prized (and costly) Rembrandt could not be genuine because it was painted on a mahogany panel, which was not used in Rembrandt's day. The collector burned the painting. It now turns out that seventeenth-century painters *did* use mahogany.

And not the buyer. One might think that a buyer would take every precaution before spending a fortune, but it rarely happens. The buyer has fallen in love. He *wants* his painting to be authentic. Disillusioned spouses hire detectives to snoop on their partners only after their marriages have gone bad. No smitten young lover hires a spy in the early days, when life is still champagne and candlelight.

THE FORGER, THEN, is out to fool a person, not a machine. He does so by making the buyer see what he wants him to see.* A forgery is a performance, and a forger is in many ways a magician.

By the time a magician announces that he is ready to perform his next trick, the trick is already over. "Please give my beautiful assistant a round of applause," he tells the audience. "And, Nancy, before you climb inside the box on this table, would you please touch the edge of this saw with your finger, and tell us if that blade is sharp enough to cut through a body."

But this is all window dressing. No one is going to be sawed in half. The real trick took place weeks before, in a carpentry shop, where craftsmen fashioned a box that would give a contortionist like Nancy room to pull her legs up close to her body, safely out of the saw's path.

Half a dozen years before Hermann Goering ever set eyes on *Christ with the Woman Taken in Adultery*, Han van Meegeren had already crafted the illusion that would one day befuddle the Reich Marshal. Van Meegeren had designed it without any thought of Goering, but he had spent years of his life pondering his illusion, and its presentation, in every detail.

* The list of famous forgers is long and virtually entirely male. Throughout this book I refer to forgers as "he."

6

FORGERY 101

A forger can hope that no scientists will examine his fakes, but he cannot take that for granted. For a forger who specializes in old masters, the first technical challenge is to simulate age. How can he give something that is in fact three months old the look and feel of a work made three centuries ago?

Start with drawings, which present many of the challenges posed by paintings but in a less daunting form. A forger might test his skills on drawings before he turns to oils, as a thief might hold up gas stations before tackling banks. First you need paper. You have to get it right because someone *could* call in the scientists, who can date anything made from a source that was once alive (such as a tree).

This part is easy. Christopher Wright, a distinguished Vermeer scholar and a man no one has ever accused of larceny, leaps up to demonstrate. Rummaging around the bookshelves in his London flat, which sag beneath thousands of tomes on art, he quickly settles on John Smith's nine-volume *A Catalogue Raisonné of the Works of the Most Eminent Dutch, Flemish, and French Painters*. Wright plucks down volume one and flips to the publication date. "Ah, 1829. Perfect." He turns a few pages. Handsome old books like this one always included a blank page or two at the front and back, which a forger could certainly cut out and use. Here's one. Wright holds the book open to the empty page and considers for a moment. He affects the unctuous manner of a dealer with a deep-pocketed client. "Perhaps I can interest you in this fine Constable? *Salisbury Cathedral*, you know. Isn't it lovely?"

As in Wright's spoof, most forgers in real life work backward—they start with materials, not with an artist, and then choose the artist to fit. Their

motto is, "Let the paper choose the master." Usually that paper comes from books. Tom Keating, a sloppy but nonetheless successful English forger who thrived in the 1960s and '70s, once found a supply of vintage paper at a venerable art shop that had gone out of business. But such finds are rare. Books are far easier to locate than any other source of blank centuries-old paper, and like John Smith's tome, they carry precise dates.

So forgers haunt secondhand-book shops in search of forgotten, dusty books, preferably ones with large pages. Elmyr de Hory, a famous Hungarian-born forger, favored such titles as *Chateaux of the Loire* and *Battles of the Great War.* He claimed he once sold a "Modigliani" on a page torn from a book he'd bought for a dollar.

So far, so good. Next come wormholes. Forgers are not the only bookworms with a consuming interest in *Chateaux of the Loire.* Wormholes are tiny tunnels burrowed into old books or other pieces of ancient paper. (The culprits are not worms but beetles and other bugs, especially silverfish.) The forger is glad to see wormholes, since they testify to age, but the holes pose a subtle problem.

In an authentic drawing made centuries ago, the sides of a wormhole would not show any sign of ink, because the ink would have dried long before the bugs began their tunneling. But if a modern-day forger ignores the holes and starts drawing, ink from his pen might seep into the wormhole and give away the game. What is the forger to do?

Forgers tend to clutch their secrets jealously—again like magicians—but the late, showy Eric Hebborn broke the union rules. His *Art Forger's Handbook* is a how-to guide. Thomas Hoving says that the book abounds in insights "virtually on the level of $e = mc^2$."

Hebborn was a liar by trade, and many of his stories are hard to credit. Could it really be true, as Hebborn claims, that as a teenager he worked for a kindhearted madman whose eccentricities included sleeping with his leg out the window with a string hanging from the big toe? Attached to the string was a note instructing visitors to pull only in case of emergency.

But everything about Hebborn was different and strange (including his death, on a street in Rome in January 1996, when someone bashed in his skull with a hammer). He had sold upward of five hundred fake old masters, he boasted, and he claimed that some of them hang even now in such temples of art as the Met in New York and the National Gallery in Washington. Whatever the truth of these stories, Hebborn was undeniably a skilled draftsman. (Hoving

refers to his "frightening talent.") And his fellow forgers concede—sometimes with irritation—that the technical information in his handbook is solid.

Hebborn's solution to the wormhole riddle called for little more than cunning and spit. How to keep ink out of a wormhole? The trick is first to plug the wormhole and only then to start drawing. Chew a bit of paper until it is perfectly soft. Unfold this patch and lay it over the wormhole. Tap it gently into place with a wooden mallet. When the patch has dried completely, trim away any protruding bits with a razor. Proceed with your drawing. Then, when the ink has dried, remove the plug.

Fox marks pose a similar problem. These are the rusty-looking spots found on old paper, and forgers have learned a variety of homey ways to fake them. Tom Keating favored powdered coffee. First he would make his drawing. "When the ink was dry," he recalled, "I would wet the paper with water and flick a spoonful of Nescafe into the air. As the powder descended, fox-marks appeared as if by magic."

For those who forge works closer to their own day, life is simpler still. Since the paper only has to appear years or decades old, rather than centuries, rough-and-ready treatments will do. Giorgio Vasari, author of the sixteenth-century *Lives of the Artists*, claimed that Michelangelo made good use of a smoky fire. "He also copied drawings of the old masters so perfectly that his copies could not be distinguished from the originals, since he smoked and tinted the paper to give it an appearance of age," wrote Vasari. "He was often able to keep the originals and return his copies in their stead."

If holding a sheet of paper above a fire is too much trouble, the forger might opt for dipping it briefly in tea or coffee instead. The forger David Stein, who specialized in such modern masters as Picasso and Chagall until his arrest in 1969, spoke as enthusiastically about the virtues of tea as any connoisseur. At one point he broke down the costs of a "Chagall" watercolor that he would knock off in an hour or two and sell for $5,000: "Tea, two cents; paper, $3; colors, $8; framing, $30."

On to ink. Here the forger's strategy is akin to the sharpshooter's trick of first firing his pistol at the wall and then drawing a bull's-eye around the bullet hole. As ink ages, it fades. To produce a drawing that looks old, Hebborn explains gleefully, you *start* with watered-down ink.

The ink itself, of course, must be made to ancient specifications, to pass any chemical tests. The ink favored by the old masters, Hebborn writes, had one of three main sources: soot from a chimney where willow logs had been

burned; or cuttlefish ink; or the tree growths called oak galls. Like the formulas for an apothecary's remedies, the old inkmakers' recipes spell out a sequence of involved steps. Mix the raw materials with a dash of rainwater, one recipe begins. Add a few flakes of rust and a drop or two of vinegar, and then heat the concoction until it reaches the proper consistency.

Few forgers are scientifically inclined; their tactics smack more of the kitchen than the laboratory. Hebborn, especially, continually resorts to cooking analogies. A drawing "may be baked, not burnt, in a moderate oven," he instructs, in a discussion of how to make ink cut its way into the surface of the page, as it eventually does in old drawings. "It is rather like frying garlic, a moment too long and it is spoiled, so keep a close watch over it."

HAVING SEEN SOME of the obstacles facing a would-be forger of drawings, let us turn to oil paintings. Later we will look in detail at how forgers go about making "old" paintings, but for now the point to emphasize is a general one—forging paintings is difficult, and forging old paintings is terribly difficult. Forgers themselves blanch at the challenge. "The likelihood of catching a forger of oil paintings is a thousandfold greater than catching one who fakes in the other media," warned the French forger David Stein. "Oil paintings constitute an artist's major works and are almost always catalogued worldwide. Thus, when a counterfeiter tries to sell a fake oil and the gallery owner or art dealer fails to find it listed in the book, he knows immediately that something is fishy. Moreover, a major oil painting, like a Chagall, cannot be peddled to just any gallery. How many galleries have sixty thousand dollars to shell out for such a work, which is what an oil by Chagall usually goes for?"

Stein was a small-timer in comparison with Hebborn. Cocky as Hebborn was, though, he echoed Stein's warning. Stick with drawings, he advised would-be forgers. Stay away from oil paintings. And then Hebborn added a further warning. Even if the forger has had the sense to steer clear of oils, he still must concentrate on "accessible artists." Big names, like Brueghel and Holbein and Rembrandt will not do. These titans posed a double danger—they were so skilled that the faker's imitation wouldn't measure up, and their works were so valuable that any forgery would be sure to draw skeptical, expert scrutiny. For once, Hebborn set aside his jester's cap and spoke sternly. "These great artists," he insists, "are quite unsuitable for the faker's purpose."

So spoke Eric Hebborn, an artist of formidable vanity. Han van Meegeren, on the other hand, decided to pass himself off as Johannes Vermeer.

7

OCCUPIED HOLLAND

Fat, swaggering, casually cruel Hermann Goering was the best-known of Van Meegeren's victims. The forger's scams ensnarled countless others as well, many of them supremely confident connoisseurs of art who could raise a work from obscurity to glory by whispering an enthusiastic word into an eager ear. But the stage for this drama played as important a role as the actors themselves. The chaos of occupied Holland was crucial to everything that followed. Only in those unsettled times could such grasping buyers and such frantic sellers have found one another. And only in a country and an era where no rules applied could a man like Han van Meegeren have pulled off one multimillion-dollar scam after another.

When the Nazis first took over Holland, the Dutch seemed almost dazed, not quite able to grasp that the world had changed forever in five frenzied days. "The man on the street was grieved and startled, but not desperate," the Dutch historian Walter Maass wrote, based partly on his firsthand observation. "Many people seemed to live in a strange state of euphoria, hoping for speedy liberation, though no real cause for such optimism existed."

Desperation would come soon enough, but for a time the Nazis did not tip their hand. All the eyewitness accounts of the first days of occupation highlight the conquerors' discipline. The Dutch watched warily, Maass continued, but despite all they had heard of Nazi atrocities, they saw no looting, no celebrating, and certainly no killing and raping.

This brief era of forebearance reflected a miscalculation on the part of the Germans—they believed, at first, that the Dutch were fellow "Nordics" so

closely tied to Germany by culture, language, and "blood" that Holland could smoothly be annexed into greater Germany.

That belief did not last long. In February 1942, Joseph Goebbels, the Nazi propaganda minister, confided his impatience to his diary: "The Dutchman's character is in many respects quite strange to us," he groused. "...His pig-headedness can't be beaten." By September 1943, Goebbels offered his complaints without preamble, as if Dutch contrariness was so familiar that there was no need to give examples. "As everybody knows," Goebbels wrote, "the Dutch are the most insolent and obstreperous people in the entire west."

The Germans had brought in a dangerous but seemingly bland official, an Austrian lawyer named Arthur Seyss-Inquart, to rule Holland for them. Seyss-Inquart was a music lover and an intelligent man (the Allies administered IQ tests at Nuremberg, and Goering sulked that Seyss-Inquart and one other Nazi official outscored him). More important, he was a doggedly loyal follower of Adolf Hitler. In Austria, after the Nazi takeover, Seyss-Inquart's diligence on behalf of his new masters had helped him rise from obscurity. He performed so well that when the Nazis put a formal end to Austrian independence, they made Seyss-Inquart chancellor.

When the Nazis went on to conquer Poland, they brought Seyss-Inquart in as deputy governor-general. He distinguished himself again. By the time the Germans took Holland, Seyss-Inquart was a natural choice as Reich Commissar for the Occupied Netherlands Territories. His authority was nearly unbounded. As "guardian of the interests of the Reich" in Holland, Seyss-Inquart answered only to Hitler. His first official act was a reassuring, if insincere, address to his new subjects. Dutch laws would remain in force, Seyss-Inquart promised, "as far as possible."

In Holland, as in his previous assignments, Seyss-Inquart quickly won his superiors' admiration. "I have the impression that the treatment of population in the occupied areas is being handled best in the Netherlands," Goebbels wrote in his diary on September 8, 1943. "Seyss-Inquart is a master in the art of alternating gingerbread with whippings."

FOR THE DUTCH, occupied Holland was a trap, and as the years passed, the trap squeezed tighter. In part, the problem was geographic happenstance, in part Nazi malevolence. "The Netherlands were more isolated than any other country in western Europe," lamented the Dutch historian Louis de Jong, who witnessed the events he wrote about. "If you tried to escape from France,

there was but one frontier you had to cross. From Belgium two. From the Netherlands three."

Occupied France had a neutral neighbor, Spain, next door. Occupied Norway had Sweden, and over the course of the war, eighty thousand Norwegians managed to escape to Sweden. But Holland is squeezed between the sea to the north, Germany to the east, and Belgium to the south. By the spring of 1940, escape through Germany was out of the question, and Belgium (and, beyond it, France) lay in enemy hands.

Escape by sea was no more promising than escape by land. Holland's ports and coastal waters were heavily patrolled. Throughout the entire war, only two hundred Dutchmen escaped to Britain by boat.

So fleeing was extraordinarily difficult. And in tiny Holland, so flat that a rise of three hundred feet merits a name, and so crowded that a single tulip bed might almost constitute a garden, going into hiding was nearly as hazardous. For two groups in particular—the Jews and the Dutch resistance—the lack of hiding places proved devastating.

"Probably no other country in Europe is so unsuited for action against an occupying military power as the Netherlands," noted Walter Maass. Trains and excellent roads connected every part of the country. The Germans could speed their troops anywhere they wanted. No region was remote or inaccessible. Dutch resistance fighters had no mountains or forests to retreat to, no caves or valleys to serve as hideaways that strangers could not penetrate. In France, Norway, Poland, and Czechoslovakia, in contrast anti-Nazi bands could launch hit-and-run raids, and vanish.

Nor could the embattled Dutch resistance hope for much help from the outside world. Once again, geography created much of the problem. Because the route from Britain's airfields to Germany's industrial heartland passed directly over Holland, the Nazis dotted the Dutch countryside with antiaircraft weapons and kept large numbers of fighter planes at the ready at Dutch airbases. So much for any chance of dropping supplies to the resistance fighters or parachuting in secret agents.

HISTORY, TOO, WORKED to undercut any hope of successful resistance to the Nazis. "Every tradition of conspiracy and insurrection was lacking," wrote Maass. Holland had never been occupied, and the well-off Dutch had little of the bitterness or desperation of their counterparts in, say, Greek or Balkan backwaters.

In particular, the famously thorough Dutch bureaucracy stayed in place under Holland's new masters and continued to do its job. No one had thought that it might be better to destroy Holland's official records—which included personal and professional information on every Dutch citizen—than to let them fall into enemy hands. The Nazis pounced with glee on this unexpected gift.

In a radio broadcast from London in 1943, the Dutch government-in-exile issued an agonized condemnation of its own civil servants for refusing to look at the big picture. "They had spent their whole lives accustomed to obey, they were always—and rightly—so proud of the impeccable execution of their tasks and conscientious fulfillment of their duties that they brought the same conscientiousness and the same fulfillment of duty to the scrupulous organization of the plunder of our country, to the advantage of the enemy."

What made matters worse was the personality of the man in charge of the national population registry, Jacob Lentz. As early as 1936, Lentz had been decorated by the Dutch crown for his work to create a system of national ID cards. The idea was that if war came, rationing would soon follow, and ID cards could help smooth the process. But in 1936 the Dutch man in the street had bristled at the suggestion that he carry mandatory identification, as if he were guilty of something, and the project collapsed.

When the Nazis took over, the plan resurfaced. Lentz devised a new card that each Dutch citizen over the age of fifteen had to carry at all times. Failure to produce the card meant arrest on the spot. This was no mere typed form— the specifications included two photographs, two sets of fingerprints, two signatures, the signature and initials of a registry official, and an official stamp. (Everyone also had to carry a ration book in order to obtain food, shoes, coal, and other necessities. In Holland in the 1940s, few people were as vital to the Dutch resistance as skilled forgers.)

By the end of 1941, Lentz's new registration system was in place, and the Germans could immediately check the identity of anyone they encountered. All Jews were ordered to have their identification stamped with a large black *J.*

Astonishingly, Lentz never seemed to understand what he had done. "Although undoubtedly pro-German," according to the Holocaust historian Bob Moore, ". . . he did not join the [Dutch Nazi Party] or any other anti-Semitic group, either before or during the occupation." Instead, writes Moore, Lentz was "that strange animal, the bureaucrat who was always anxious to please his masters and for whom perfect organization was everything. . . . The arrival of the Germans gave him the chance to carry out his dream."

8

THE WAR AGAINST THE JEWS

Holland's Jews were no better prepared to recognize their predicament than were the rest of the Dutch. At home in famously tolerant Holland since the time of the Spanish Inquisition, the Jews had let down their guard. But even if they had grasped the full extent of Nazi fanaticism as soon as the war began, by then it was too late. Like their Christian neighbors, Holland's Jews put their faith in neutrality. Then they waited, "a little prayerful and very hopeful," in the words of the Dutch historian A. J. Herzberg, "with pounding hearts and closed eyes."

Those hopes had been betrayed. Before the war, the Jewish population of Holland was 140,000. Of that number, the Nazis killed 102,000. Some 25,000 had gone into hiding; 8,000 of them, including Anne Frank and her family, were found and killed. In perhaps the least anti-Semitic country in Western Europe, the proportion of Jews killed—73 percent—was highest.*

In their war against the Jews, the Nazis operated with cunning as well as brutality. They spoke only of deportation, for instance, never of extermination, and went to elaborate lengths to play up the charade. Prisoners who were taken to concentration camps but not killed at once were forced to send cheery postcards to their relatives at home. "I have now been here four weeks and I am well," read one such note, written at Auschwitz. "Work is not particularly heavy.... Food is good: at noon we have a warm meal and in the

* The comparable figure for France was 25 percent, for Belgium, 40 percent.

evening we get bread with butter, sausages, cheese, or marmalade." For their part, Jews still in the Netherlands were encouraged to send letters to their relatives who had been deported. "Tens of thousands of such letters were handed to the Germans," wrote the historian Louis de Jong. "Of course not a single one was ever delivered."

The blows directed at the Jews came singly at first and then in clusters, and finally they rained down uninterrupted. On January 10, 1941, all Jews were required to register with the authorities. In April, Jews living in Amsterdam were forbidden to move elsewhere in the country. In May, Jewish doctors and dentists were forbidden to treat non-Jews. In August, Jewish children were forbidden to attend school with non-Jews. In September, Jews were banned from parks, restaurants, hotels, theaters, swimming pools (both indoor and outdoor), art exhibits, concerts, libraries, and museums.

In March 1942, Jews were forbidden to travel by car. (Exceptions were made for ambulances and hearses.) In May, Jews were required to wear a yellow star sewn (not pinned) to their clothing, with the word *Jew* written on the star in black letters. In May, too, Jews were obliged to turn in their jewelry and art. (They were allowed to keep wedding rings, pocket watches, four pieces of table silver, and their gold teeth.) In June, Jews were required to hand over their bicycles. In July, Jews were ordered to remain in their homes between eight in the evening and six in the morning. They were forbidden to visit non-Jews, to travel by "public or private transport," or to use public phones.

On July 10, 1942, Anne Frank and six friends and relatives went into hiding. On November 19, Anne wrote in her diary that "countless friends and acquaintances have been taken off to a dreadful fate. Night after night, green and gray military vehicles cruise the streets. They knock on every door, asking whether any Jews live there. If so, the whole family is taken away. If not, they proceed to the next house. It's impossible to escape their clutches unless you go into hiding. They often go around with lists, knocking only on those doors where they know there's a big haul to be made. They frequently offer a bounty, so much per head."

By the end of September 1943, the Nazis had achieved their goal. With the roundup and deportation of even those Jews who had been in hospitals and old-age homes, Holland was finally *Judenrein*, Jew-free.

No NATION IS composed entirely of heroes, but the Dutch did better than most. In February 1941, after the Nazis rounded up and beat 425 young Jewish

men in Amsterdam (and later sent them to their deaths in a concentration camp), the workingmen of Amsterdam protested by going on strike. The city shut down. Stevedores closed down the port, streetcar drivers left their trams sidelined, shopkeepers locked their doors. After two days, the SS fired into a crowd of demonstrators, killing seven people and wounding forty-five, and the workers returned to their jobs. "This strike," Louis de Jong wrote proudly, "[was] the first and only anti-pogrom strike in human history."

But most people, neither heroes nor villains, did their best to keep their heads down and to survive. "One felt sorry for the Jews and congratulated oneself on not being one of them," in one Dutch historian's summary. "People gradually got used to Jews having the worst of it."

Anne Frank lived at 263 Prinsengracht, in what had once been a pleasant location along a canal. A ten-minute stroll away sat Van Meegeren's grand house at 321 Keizersgracht. The sound of sirens penetrated even those thick walls, but the partygoers enjoying Han van Meegeren's hospitality barely noticed.

9

<div style="text-align:center">❖</div>

THE FORGER'S
CHALLENGE

Van Meegeren never met the eccentric, fabulously successful inventor Leo Baekeland, but the forger's career owed everything to the inventor's genius. Without Baekeland's breakthrough, Van Meegeren would never have had his Amsterdam mansion, and no critics would have sung hymns to his paintings.

For Van Meegeren, making a painting that *looked* old was easy. The real challenge was making a painting that *behaved* as if it were old when subjected to the standard tests. This was where Baekeland came in.

Much of the technical side of forgery is largely a matter of care and research. The white paint used by Vermeer and all his contemporaries, for instance, was called lead white, because it was made from lead. It had notable virtues—it dried quickly and it covered well—but it also had the considerable defect of being poisonous. By about 1845, lead white began to give way to the newly invented zinc white, which is still standard today. Any forger must know such dates intimately, for chemists can easily distinguish paints that look identical. In a painting supposedly by Vermeer, zinc white would be impossible, as much a blunder as an iPod for the *Girl with a Pearl Earring.**

Carelessness is an occupational hazard for forgers, because every successful scam leads them to overestimate their own cleverness and their rivals' gullibility.

* Vermeer did not name his pictures, as far as anyone knows. The names in common use are largely a matter of tradition and vary slightly from writer to writer. Here and throughout the book I have followed the names in Albert Blankert's *Vermeer of Delft.*

(The acclaimed Elmyr de Hory once tried to sell a forged Matisse on which he had spelled the artist's name without the *e*.)* Van Meegeren was a creature of boundless vanity, which made for the occasional slapdash folly, but he had a methodical streak that helped balance his self-regard.

He knew, for example, that Vermeer's favorite blue was the rare, expensive ultramarine (so called because it came from far away, "across the seas"). In 1931, according to the records of the London art supplies firm Winsor and Newton, Van Meegeren bought as much ultramarine in a span of two months as the shop normally sold in five years.

But even the most finicky preparation could achieve only so much. Van Meegeren and every other forger of centuries-old masterpieces faced a built-in dilemma. He could, with enough trouble, replicate the materials of a seventeenth-century painter's studio. He could fashion (or buy) brushes like those the old masters had used, made of hair from a badger or marten. He could grind his own pigments and follow age-old recipes for making them into paint. What he could not do was cause three centuries to pass.

As TIME INFLICTS its toll, oil paintings change in two different but related ways: the paint hardens, and the painting's surface develops a network of miniature cracks. For Van Meegeren, the first problem was the more difficult. Solving it took him almost four years and countless failed experiments. When he finally succeeded, he burst into tears.

Watercolors dry in a straightforward way. Time passes, and the water evaporates. Oil paint is a diffent story, for although we still talk about the paint "drying," the true process is more complicated. A dab of red oil paint, say, is made by adding droplets of oil to a mound of ground-up red particles—the mound has the texture of a heap of cinnamon but the hot, intense color of arterial blood—and then working the oil and the pigment together with a palette knife. (In Vermeer's day, the red particles might have come from a lump of vermilion, made by heating mercury and sulfur. Dishonest apothecaries sometimes diluted the miraculous powder with brick dust.) The paint is ready when

* Some forgers have been as meticulous as De Hory was reckless. In one recent case, the Italian police seized three hundred fakes supposedly by the artist Mario Schifano, whose authentic work commands prices on the order of $100,000. One duped collector insisted that his painting could not be fake—he had a photograph of himself with his newly purchased painting, shaking hands with Schifano. Both "artist" and artwork turned out to be fake. The collector had shaken hands with a double who had been paid $150 to pose as Schifano.

its consistency is that of butter that has been sitting on the kitchen counter.

Over the course of months and years, as a result of a series of chemical and physical changes, that paint will not dry so much as harden. The hardness is key. The easiest test of an old master—and the one test almost certain to be carried out—is to dab the surface with rubbing alcohol. In a genuinely old painting, the surface will be hard, and the alcohol will have no effect. If the painting is new, the alcohol will dissolve a bit of paint, and the tester's cotton swab will come up smudged with color.

The test could hardly be simpler, but it poses a giant hurdle that every forger must leap. The forger's problem is that the hardening process drags on with excruciating slowness. It takes somewhere between twelve hours and three weeks for a painting to become dry to the touch but perhaps a *century* before it hardens fully.

In London not long ago, I spent a day at the National Gallery. In an always-crowded room lined with Impressionists and Van Goghs, I wriggled my way into the scrum in front of Van Gogh's *Sunflowers*, one of the museum's great treasures. The next day, I held the painting in my own two hands. Not Van Gogh's *Sunflowers*, in truth, but a stunning copy (complete with "Vincent" signature) by an English painter named Leo Stevenson. I could never have told it from the real thing (except, perhaps, that this version looked a bit *better* than the original, because Van Gogh used a paint called chrome yellow that has turned slightly gray-green over the years. Stevenson's yellow retains the freshness that Van Gogh's has lost.)

If somehow I could sneak into the National Gallery and replace the real *Sunflowers* with Stevenson's copy, not one visitor in a hundred would suspect a thing. The same art-loving crowds would elbow for a peek, the same enthralled couples would whisper their impressions to one another, the same devotées would hold their cell phones aloft and snap souvenir photos.

Stevenson, a well-regarded artist in his own right, is not a forger. Among many other projects, he puts together television programs on art for the BBC. He had made the *Sunflowers* painting for a show on Van Gogh and the Impressionists. He handed his picture to me. I took it gingerly, as if it really were the cult object it looked to be.

"You can handle it," Stevenson teased. "It's not a baby."

I patted the surface with the tip of my index finger.

"Go on. Feel it." Stevenson waved his outthrust thumb in the air.

I held this near-duplicate of the $50-million or $100-million masterpiece in my left hand and, following Stevenson's lead, pressed my right thumb against a sunflower. The hardening of oil paint involves chemical changes that require the presence of oxygen. Paintings harden like loaves of bread, from the outside in. Beneath its hard crust, the sunflower yielded to my thumb.

BY THE TIME a painting is three centuries old, roughly the age of a Vermeer when Han van Meegeren came along, it will be hard indeed. How was Van Meegeren to duplicate that hardness?

He began with easier challenges. First he needed to grind his paints, to replicate Vermeer's palette. This was not a matter of theatrics or establishing a mood, like dressing up in seventeenth-century garb, but a question of strategy. The particles in hand-ground pigments vary in size; the particles in modern, commercially-made paint are uniform. Forgery plays out as a kind of board game, where each player tries to anticipate his rival's next move. Van Meegeren had to be ready for an opponent with a microscope.

Until the advent of metal tubes for paint, invented in 1841, an artist's studio looked like a cross between an apothecary shop and a natural history museum.* (A household inventory carried out after the death of Vermeer's widow listed such possessions as "a stone table to grind paints on, with a grindstone as well.") In Vermeer's day, the pigments for black paint, for instance, came from charred peach pits or burned bones or ivory or even soot gathered from a smoky flame. Each material had its own merits and drawbacks.

Vermeer's dazzling blue, ultramarine, posed countless difficulties to its seventeenth-century admirers. Not least was obtaining the raw material, lapis lazuli, a vivid blue semiprecious stone found, in the 1600s, only at a single location in what is now Afghanistan. Next came the grinding and then a long series of filtrations to separate the blue grains from impurities in the stone.

In centuries past, the oils stirred in with the pigments also came in various forms. Linseed oil was the most widely used, but that left endless decisions about whether it should be boiled (which rendered it clear rather than yellow and therefore better suited to delicate blues and whites), and for how long,

* In addition to freeing painters from the chore of grinding and mixing their paints, the convenient new tubes made it far more practical to paint outdoors. "Without paints in tubes," Auguste Renoir observed, "there would have been no Cézanne, no Monet, no Sisley or Pissarro, nothing of what the journalists were later to call Impressionism."

and whether boiled oil should be thinned with ordinary oil, and if so, in what proportions, and so on. And what about poppy oil and a dozen others?

Oil painting derived its prestige not only from the beauty of the finished pictures but from the degree of know-how it demanded. In modern times, that specialist knowledge has faded away and artists today make their fore-bears sound almost like sorcerers. "More than with any other Vermeer," one twentieth-century painter and critic wrote, "*The Girl with a Pearl Earring* looks as if it were blended from the dust of crushed pearls." In reality, the task of pre-paring paints was less glamorous but nearly that difficult.

Every color called for its own finicky formulation; each had to be stored in a particular way. (Browns and yellows could be safely stored in bulk, in parchment-covered jars, but such costly preparations as ultramarine had to be prepared in small quantities and stored airtight, in a pig's bladder. The pre-cious paint was squeezed out of the bladder through a tiny hole that was ordi-narily kept plugged by a nail.) Each paint had to be tinkered with yet again just before the artist applied brush to canvas, by being thinned with some combination of oil and solvent that made it more workable.

Van Meegeren labored away at his grindstone, his well-worn copy of a Ger-man treatise, *On Fat Oils: Substitutes for Linseed Oil and Oil-based Pigments*, always close by. He would later tell an elaborate story about how he had found the booklet, but he loved tall tales, and the story sounds like a party piece made up for its entertainment value. As Van Meegeren told it, he had been window-shopping one day. "I saw a splendid seventeenth-century mirror in a little an-tique store. I bought it, and while the salesgirl wrapped it, a nice-looking leather-bound book caught my eye. Impulsively I looked in it. It contained chemical treatises assembled by an unknown writer. It seemed to be whisper-ing a telepathic message to me. A miraculous thing happened. On the page that the book opened to, I read a seemingly unimportant formula, but one that was the missing link for my work!"

The Dutch painter Diederik Kraaijpoel, who wrote one of the best studies of Van Meegeren's career, has a soft spot for forgers in general and for Van Meegeren in particular, but he discounts all such tales. Van Meegeren, says Kraaijpoel, was a habitual, incorrigible liar. "Never believe Van Meegeren!" His reminiscences are evidence of his charm, perhaps, Kraaijpoel says, but they are not evidence of any other sort.

For a skilled technician like Van Meegeren, persistence was vital. As he pored over the recipes in his German handbook, the notion of the artist as

inspired genius communing with his muse must have seemed far away. Curiously, we cannot be sure that Vermeer showed as much doggedness as his modern imitator. He may have left the grinding and mixing to a servant or bought his paints ready-mixed by an apothecary.

All these alchemical chores were necessary, but none helped Van Meegeren with his central riddle—how to make a new painting as hard as an old one. The problem was to find a way to harden paint without harming the picture. Heat, Van Meegeren knew, would play a crucial role. In 1932, he bought a large oven—large enough to swallow up a painting—and set to work baking test canvases. Like some hapless cook in ancient times who had seen a soufflé in a vision, Van Meegeren knew what he wanted but didn't know if it was possible. He smeared his paints on one test strip of canvas after another and cooked away, but no experiment yielded anything but frustration. Baked at low heat, his test paintings faded and yellowed like an old T-shirt left in the sun. Baked at a high temperature, the paint bubbled and blackened and the canvas scorched.

With too many variables to sort out systematically, Van Meegeren tried endless combinations of oven temperature and oil ratios and baking times. Disaster followed disaster, but the forger kept on. Van Meegeren was "obsessive" and "resourceful" and "indefatigable," in the words of Sheldon Keck, a New York University conservator and one of the great authorities on the scientific study of paintings. "He was the Edison of art forgers."

He was like Edison, at least, in his stamina. Before Edison came up with a lightbulb that worked, he tried filaments made of platinum and iridium and silicon and boron and cardboard and linen and wood and cornstalks and *two hundred* varieties of bamboo. What saved Han van Meegeren was finally stumbling upon an Edison of his own.

TIME MAGAZINE DEVOTED the cover of its September 22, 1924, issue to a mild-looking, now-forgotten man. His round, bald head, thick eyebrows, and droopy mustache gave him the appearance of a balloon that had been decorated by a child wielding a Magic Marker. Under the man's name, Leo H. Baekeland, *Time* ran a cryptic caption: "It will not burn. It will not melt."

Leo Baekeland was a Belgian-born scientist who helped invent the modern world. He made his first fortune, in 1899, with a new kind of photographic paper. With $1 million from Kodak in his pocket, Baekeland bought a rambling, turreted mansion on the Hudson River, built a private laboratory on the grounds, and set out in search of something else the world didn't know it

needed. He began prosaically. The new century saw the birth of the Age of Electricity. Baekeland saw his opportunity not in a better lightbulb or a vacuum cleaner or a refrigerator but in a cheaper form of electrical insulation.

The old form of insulation was shellac, named because it was made from the shell of the lac beetle. To make a pound of shellac took six months and fifteen thousand beetles. Baekeland set to work to find a synthetic alternative. Early on he pinned his hopes on a recipe that combined a sickly-sweet-smelling liquid, phenol, and a pungent, caustic liquid called Formalin, made from formaldehyde. For five years Baekeland tried again and again to cook phenol and Formalin together at high pressure in an oven he had designed. He produced only a series of batches of melted goo. And then one day in 1907, he opened the lid of his Bakelizer oven and found what today we would immediately recognize as a piece of plastic.

No such easy-to-shape, hard-to-damage ("it will not burn, it will not melt") substance had ever existed. Man had fashioned something unknown in nature. Almost at once it became clear that this new invention had endless uses. By the 1920s, the era of Art Deco, the whole world seemed to be fashioned from the astonishing material that Baekeland dubbed "Bakelite." The inventor himself retired to Miami, where he delighted in showing his guests his newest "invention," a way of staying cool on even the hottest days. With his visitors craning to see what he had come up with this time, Baekeland would step fully clothed into his swimming pool and slowly walk down the steps and away from the edge, the water rising past his white shoes, then past his white trousers and white shirt, and finally up to his chin. He would emerge soaked and dripping, with only his sun helmet dry, and quietly return to pouring drinks.

Baekeland had earned his time off, for his invention changed the world. *Time* could scarcely stop gushing. Bakelite was a miracle substance, its writer proclaimed, "born of fire and mystery," and destined to spread without limit. Within a few years, "from the time that a man brushes his teeth in the morning with a Bakelite-handled brush, until the moment when he removes his last cigarette from a Bakelite holder, extinguishes it in a Bakelite ashtray, and falls back upon a Bakelite bed, all that he touches, sees, uses, will be made of this material of a thousand purposes."

Han van Meegeren devised use number 1,001.

10

BARGAINING WITH VULTURES

In occupied Holland, the Jews suffered disproportionately, but almost everyone suffered. Strikes and demonstrations, which had been common at first, soon proved futile. Protests met with mass arrests and wholesale executions. Attacks on the Germans by Dutch saboteurs brought immediate, savage retaliation. On October 1, 1944, after an attack on a German car near the village of Putten, every male in the village was sent to a concentration camp.

In German eyes, Holland was little more than a piece of fruit to grab and suck dry. The Germans rounded up half a million Dutch factory workers and sent them to work in German munitions plants and at similar jobs. They confiscated food, clothes, and scrap metal and sent it home. They ransacked private houses. So many moving vans prowled Dutch streets, especially in Jewish neighborhoods, that the name of the biggest moving company, Puls, gave rise to a new verb, "to puls," meaning "to steal." Nearly everything was subject to plunder. When Hitler attacked Russia, Germany snatched a hundred thousand bicycles from their Dutch owners in order to reuse the metal.*

As the war dragged on, shortages grew ever more acute. Prices on the black market rose to a level one hundred times higher than official prices. By the "hunger winter" of 1944, coal and oil and electricity were nearly unavailable. When night fell, only lanterns and candles lit the darkness. (To rig a battery to run a radio or power a lightbulb was considered sabotage, and could mean

* To this day, German tourists in Holland occasionally hear a taunting request to "give me back my bike."

execution.) Daylight brought no relief. The Dutch scrounged in the dirt for tulip bulbs, to roast like chestnuts. "Dutch girls," the historian Walter Maass records bitterly, "sold themselves to German soldiers for a few cans of pea soup with sausages."

The cold was as bad as the hunger, Maass writes, and in desperation, the residents of Holland's proud cities ransacked their parks, chopping trees for firewood. Many of the poor burned their own furniture for heat. Then they tore apart abandoned or bombed houses so that they could burn scraps of window frames and stairs and doors. The Dutch clawed the wooden ties from railroad tracks. They resorted to burying their dead in cardboard boxes or blankets, because there was no wood for coffins.

"Beautiful old houses in the center of the city disappeared overnight," recalled a man who spent the war years in Amsterdam. "On every floor people were sawing, hammering, breaking away the wood. . . . Everywhere the trees were cut down. In the evening one stumbled and fell over the trunks. The white-painted railings along the canals were cut down."

Holland's streets streamed with silent, starving zombies. "Along the roads," the same observer continued, "there are endless processions of desperate people who are trying to find food—somewhere, sometime. Never have I seen so much misery and despair as in those silent processions. They are silent. Nobody talks, nobody complains. Most of the people are too tired, too embittered."

As the winter of 1944 dragged on, starving city-dwellers trudged into the countryside to forage for food or in the hope of bartering a ring or a plate or a shirt for a bite to eat. One observer recalled an "endless road behind Hoorn [in the north of Holland] filled with fearful, anxious, hungry Amsterdammers. They stumbled along, towing carts and carriages. Some dropped along the road; they couldn't go any farther and had no strength left. Women who had accompanied their sons or husbands sat on the carts. And they were whipped by the wind and drenched by the icy, streaming rain."

FOR THE NAZI higher-ups, Dutch desperation meant opportunity. Conquerors flush with cash cast a vulture's eye around the denuded landscape. The Dutch, for their part, took advantage of almost the only asset available to them, their extraordinary stock of art. Especially at the war's onset, the historian Lynn Nicholas observes, the Dutch still hoped that these dark days might somehow pass. In the meantime, "there was no reason to forgo the

enormous profits to be made at the expense of the enemy. Nowhere would these be greater than in the art trade, and nowhere was the survival of the otherwise doomed more possible than through the satisfaction of the collector's fever by which the Nazi leadership was possessed."

Art had intrinsic, lasting value and, conveniently for the new owners, it was portable as well. "Art soon became a major factor in the economy," writes Nicholas, "as everyone with cash, from black marketeers to Hitler, sought safe assets. As the trade heated up, prices rose and family attics were scoured for the Dutch old masters and romantic genre scenes beloved by the conquerors."

For the occupiers, it was a game with a deck stacked in their favor. The Nazis could buy whatever they wanted, with state money, from intimidated sellers. A cadre of eager agents helped them scout out special prizes and "bargain" with the owners. One of the most notorious was a Goering crony named Kajetan Mühlmann, an Austrian who held the title of "Special Commissioner for the Safekeeping of Works of Art in the Occupied Territories." This was lucrative work. In his role as middleman, Mühlmann pocketed a fortune, one 15 percent commission at a time.

IF THE NAZIS wanted paintings, one might think that they could simply have stolen them. And they could have. But they had scruples, of a sort, about stealing from "fellow Nordics." Instead, they concocted "legal" means of obtaining what they wanted. In any case, the Dutch would have responded to outright theft by hiding their art away. As it was, with the Nazis flush with cash and spending like sailors on a spree, and the Dutch eager to take advantage where they could, buyer and seller raced to meet each other.

Prices spiraled upward. The Nazis, their pockets stuffed with other people's money, had few qualms about high prices, and the Dutch took what they could get. Established German dealers raced to Holland to get in on the action; new dealers rose up overnight; newspapers ran ad after ad offering paintings. As more and more art sold, the spiral fed on itself—a buyer could rationalize paying a high price today on the grounds that his purchase would be only more valuable tomorrow.

For nearly everyone in Holland, the war years were the worst of times. For most people, sidestepping disaster was as much as one could hope for. But a few especially fleetfooted Dutchmen managed to turn the chaos and misery all around them into the opportunity of a lifetime. Han van Meegeren was

one of these nimble creatures, able to move more quickly than others in part because he did not carry the burden of a conscience.

Van Meegeren did not need a nation overrun with "art lovers" in military uniforms in order to thrive. He had flourished even in the Depression. But think of the opportunities that wartime provided him. First, the frenzy to buy art meant that paintings turned up out of nowhere, every day, and sold with no questions asked. Second, the Nazis had endless reserves of cash. Third, Hitler and Goering were rubes who fancied themselves connoisseurs. (In Goering's case, at least, his chief art expert was no great shakes, either.) Fourth, the Nazis were not the only ones in the market. Faced with the hideous prospect of Dutch masterpieces falling into German hands, Holland's art establishment and its great industrialists flung money at the sellers.

Best of all, from a schemer's point of view, all the wheeling-and-dealing went on at hyperspeed, with no time for reflection or second thoughts. With ordinary paintings, this urgency posed no great danger—faced with a middling work, one could make only a middling mistake. But make the purchase of a lifetime in haste and you might well make the mistake of a lifetime. And then, beyond all the other hazards, the occupation years carried one last, special danger for art buyers. No buyer could make a side-by-side comparison of a newfound painting and an established work, because the best pieces from Dutch museums had been hidden away for safekeeping, out of reach.

For a con man in the art line, times like these would never come again.

II

VAN MEEGEREN'S
TEARS

Han van Meegeren's artistic career, which began with prizes and one-man shows, quickly lost its early promise. But the disdain of the critics had nothing to do with commercial success, and in The Hague in the 1920s, Van Meegeren became *the* portrait painter for Holland's swells. As home to both the government and the royal court, The Hague abounded in judges and politicians and elegant spouses who wanted to commemorate themselves in oils, and Van Meegeren prospered.

His personal life was hectic, too. He fell in love with an actress named Jo de Boer. Jo was married to an art critic, one of those who, early on, had been impressed by Van Meegeren. The critic had come round for an interview, accompanied by his wife. In short order Van Meegeren had a new portrait subject and a new mistress. Van Meegeren's marriage fell apart and so did Jo's, and in 1928 Han and Jo married.

In the meantime, Van Meegeren had kept in touch with his artistic colleagues. He liked to party, but he favored quiet pleasures, too, and he had lolled away many a pleasant day playing chess and chatting about art and artists with a handful of close friends. Two painters made especially frequent visits to Van Meegeren's home. The older of the two, a Dutch artist named Theo van Wijngaarden, was also a restorer and, more important, a forger who liked to talk shop.* The younger man, Henricus Rol, also Dutch, soaked up

* In Dutch, the combination *ij* is used for the letter *y*. Wijngaarden's name is pronounced "Winegarden."

the tales of skulduggery but never indulged in artistic misdeeds of his own.* Joining the three painters on many occasions was a shady Englishman named Harold Wright, a mysterious art collector and dealer. On one occasion he sold a much-acclaimed Frans Hals, and on another a Vermeer that eventually made its way to the banker Andrew Mellon and from him to the National Gallery in Washington, D.C. Both paintings supposedly came from Wright's collection; both were later revealed as fakes; both turned out to be products of the Van Wijngaarden/Van Meegeren workshop.

Wright had made his money in business. His business was manufacturing paint. Perhaps it was Wright who gave Van Meegeren the hint that triggered his experiments with the newfangled plastic invented in America. At any rate, we know that by 1932 Van Meegeren had begun trying to use Bakelite to solve the riddle of making oil paints that would harden in the oven while keeping their color.

But as we have seen, even with that substantial hint Van Meegeren spent fruitless month after fruitless month. This was nasty, tedious work, for nothing seemed to go right and the chemicals reeked. Van Meegeren's skin was covered with rashes. His red-rimmed eyes teared constantly. (Van Meegeren would later claim that his wife had no idea what he was up to during all this time, but Jo could hardly have missed the stench or her husband's odd appearance. She put up with it because she shared Van Meegeren's vision of a giant payday down the road. Her hope, she once confided, was that "a little zero should be added to their capital.")

Van Meegeren began each round of experiment with a small amount of Bakelite, which he dissolved in turpentine. He added linseed oil, a standard ingredient in the paint recipes of his seventeenth-century forebears, and then he stirred in one or another of the pigments he had laboriously ground. With that newmade paint, he slapped a few strokes on a test canvas, set the oven to a temperature setting that had not already proved useless, and waited.

When he smelled smoke, when he had lost his patience, when he could not think what else to do, he opened the oven door. Usually he found a charred

* Rol had the talent to have made trouble, if he had been so inclined. Arthur Wheelock, a prominent Vermeer scholar, met Rol in the painter's old age. "Mr. Rol was quite a painter. I visited him at the time of the Mauritshuis Vermeer show [in 1996]. If I hadn't known that the *Girl with a Pearl Earring* was hanging in The Hague, I would have *sworn* that was it, hanging in his back room. It was amazing." Rol's version was a copy that he had painted for his own pleasure rather than for profit.

canvas or a bleached and faded patch of color. He never found anything even vaguely like a masterpiece. Even today, in an upstairs room in Van Meegeren's Roquebrune villa, some of the floorboards bear witness to these failed experiments, the stains of spilled paint impossible to scrub away.

Then, somehow, Van Meegeren decided that maybe linseed oil was the problem. He turned instead to lavender oil and, especially, lilac oil.* Both were known to the old masters, and in using them, Van Meegeren was following up a hint he had found "by chance, in an old book on oils and fats"—or so he later recalled, dismissively, although the "old book" was in fact his trusty and much-consulted German handbook of oil and pigment recipes. Oils made from flowers, Van Meegeren's handbook explained, are volatile, which is to say they evaporate quickly. Van Meegeren may have reasoned that once the lilac oil evaporated, the paint it left behind would harden more quickly and convincingly. He hoped, in other words, that the best way to simulate a paint made with linseed oil was to steer clear of linseed oil.

That seemed unlikely. Still, Van Meegeren tried some new formulations based on lilac oil. He tried them, because, Edison-like, he tried nearly everything. He was getting nowhere. What could it hurt? He gambled, too, that scientists would not detect the presence of Bakelite in his paint unless they tested for it specifically, which they had no reason to do.

When the momentous day finally arrived, it came without a signal. Van Meegeren had set up yet another test and had then gone to run errands. "On my way home from the doctor," he recalled years later, "I got a flat tire, which was a great bore because the oven was on. But I thought . . . , 'Well, after all the other failures, I can handle this one, too.' "

It took a long while to repair the tire, but Van Meegeren was glad to procrastinate. "When I came home, I didn't hurry; I had another drink and, without any expectation, took the panel out of the oven. I thought it would be scorched. But no, the white was still white! Hurriedly, I dabbed a cloth in alcohol and rubbed the paint. I rubbed ten times as hard as I needed to; when I looked—I hardly dared to look—the unexpected had happened.

The paint was no longer soluble in alcohol! I cried like a child, I could have yelled it from the rooftops!"

* The oils have a heavy, cloying smell. Van Meegeren liked to tell a story about how Jo came in unexpectedly during his lilac experiments and smelled what she took to be another woman's perfume. Unable to defend himself with the truth, Van Meegeren (supposedly) had no choice but to weather the attack.

* * *

THIS STORY SOUNDS closer to the mark than most of Van Meegeren's—it lacks the rococo details that usually marked his inventions—and it may well be true. In any case, he had indeed made a paint that passed the alcohol test. Moreover, this new paint *behaved* like paint—in color and tone it looked right on a canvas, and it felt right on the brush, so that the artist could put all his accustomed skills to work. That was a stunning accomplishment. The paint had a third virtue, too, one that Van Meegeren could not have anticipated. It was this third property that would, later on, bedazzle the very experts who knew the most about the technical side of forgery.

Kraaijpoel, the Dutch painter and writer, delights in Van Meegeren's inventiveness as well as his achievement. "Bakelite is a solid," Kraaijpoel observes. "Some types are soluble in turpentine, and the resulting solution can be mixed with sawdust or another filler, to thicken the suspension, and then a telephone can be poured from it. But you can also rub pigments in it, to make paint. I think that Van Meegeren was the first to think of it and to test it extensively. . . . Voilà, the most beautiful object ever made from Bakelite!"

Kraaijpoel is right to marvel. Vermeer died in 1675. Bakelite never existed until its creation, in a laboratory, in 1907. Van Meegeren fooled the world with a seventeenth-century painting made of plastic.

—•——•——•—

Hermann Goering and Johannes Vermeer

12

HERMANN GOERING

All armies loot, and some of them, like the French under Napoleon, even carried "shopping lists" and looted to order. The Nazis did not invent art theft. But by harnessing their greed to the might of the modern state, they managed to plunder Europe on a scale that had never been seen before. Holland and Italy were hit hard, and France hardest of all. "By the liberation of Paris, in August 1944," writes the historian Hector Feliciano, ". . . one-third of all the art in private hands had been pillaged by the Nazis."

For Europe as a whole, the figures soared almost beyond imagining. Over the course of the war's five years, hundreds of thousands of paintings, sculptures, and drawings vanished into German hands. Numbers like that reflected not only efficiency but zeal. Hitler fantasized endlessly about the sprawling art museum he would build in Linz, his dreary Austrian hometown. Goering, too, talked about the great gift he would someday leave the German people, though only occasionally and in vague and windy terms. For Goering, the prospect of someday bequeathing a museum could not compare with the visceral pleasure of reveling, today, in treasures that he alone possessed.

Even in small ways, he delighted in showing that he had what others did not. Albert Speer, Hitler's architect and one of the most prominent and polished Nazis, recalled a dinner at Carin Hall, Goering's palatial country house. After the meal, a servant poured an ordinary brandy for the guests. Then, solemnly, he poured a better bottle for Goering. "This is for me alone," Goering gloated, and he went on to explain which French chateau he had taken it from.

Speer was only one of countless visitors to Carin Hall startled and baffled by the perfumed monster at the head of the table. Handsome when young but then grown immensely fat—"at least a yard across the bottom as the crow flies," according to one American official—Goering took flamboyance to the point of self-parody.

"In his personal appearance he was so theatrical that you could only compare him with Nero," marveled Hjalmar Schacht, a German financier sometimes called "Hitler's banker." Goering once appeared at a tea, Schacht reported, "in a sort of Roman toga and sandals studded with jewels, his fingers bedecked with innumerable jeweled rings and generally covered with ornaments, his face painted and his lips rouged."

On state occasions, Goering restrained himself, but only a bit. He favored uniforms he had designed himself, often in white or pale blue or gray, and he changed outfits four or five times a day. He wore so many medals that Germans joked (quietly) that the decoration nearest the edge read, "Continued on the Back." When Goering visited Italy in 1942, Mussolini's foreign minister confided his scandalized first impressions to his diary: "He wore a great sable coat, something between what motorists wore in 1906 and what a high-grade prostitute wears to the opera."

EVERYTHING TO DO with Goering, from his ego to his ambition to his waistline, was outsized.* (Even the chairs in his office were so colossal, an American diplomat complained in a letter to President Roosevelt, that he found himself perched atop one "like some sort of animated flea.") Goering liked jewelry, for example, but he did not merely enjoy it, as many people do. He liked to pile up his favorite pieces in great heaps and then push his hands into the pile so that diamonds and rubies and emeralds would run through his fingers. At Carin Hall, he did not simply exchange his urban clothes for those of a country squire, as other wealthy men with rural retreats might do. Instead, Goering outfitted himself like a Germanic Robin Hood, in leather jerkin and high green boots and six-foot spear.

His favorite costumes reflected his dislike of the contemporary world. Though he was commander in chief of the Luftwaffe, the epitome of modern military power, Goering thought of himself as a Wagnerian warrior from

* The master race, Jews whispered to one another, would be "slim like Goering, blond like Hitler, and tall like Goebbels."

centuries ago. "He obviously would have loved to sail through the air on a wild condor, his overcoat flowing, hurling a spear at the enemy monsters," observed one of his fellow Nazis.

He would have liked the Luftwaffe, too, to go to war brandishing spears. Goering refused to outfit Germany's long-range bombers with navigational instruments, for instance, although the military advantages of such equipment were not in dispute. The problem was aesthetic. To him, pilots were gladiators, not technicians. "My flyers are no projectionists and my fighter craft no cinemas," Goering decreed. Other features of the modern world met with the same disdain. Goering liked to boast that he had no idea how a radio worked.

He seemed constantly to be starring in some sort of private play, and even those who had no problem with his politics found themselves bewildered by the man himself. A Nazi named Otto Wagener, a powerful figure in the Reich's early days, described a visit to Goering's Berlin apartment. The great man left Wagener waiting for him and finally made his appearance in a red gown and red Turkish slippers with turned-up toes. Wagener murmured something about giving Goering time to finish dressing, then realized his blunder.

Goering led the way to his den, a red room with red drapes, lit by immense candles on tall, ornate stands. Wagener tried to light his cigar at one of the tapers but found he could not reach as high as the flame. The Reich Marshal's desk and the area around it stood on a thronelike perch, raised high above the seating area reserved for visitors. Goering, in his sultan's robes, eased into his chair and took out an immense notebook and a fat, red pencil perhaps twenty inches long. "I felt," Wagener wrote in his memoirs, "as if I were in the cell of a mental patient."

THEN CAME CARIN Hall, and everything that had come before looked understated. Goering named the immense estate for his first wife, who had died of tuberculosis in 1931. Of his eight houses, this was his favorite. Built with millions in state funds, it sat two hours outside Berlin at the heart of a sprawling park stocked with bison, elk, and Goering's pet lions.

The house stretched room after glittering room, several of them devoted solely to the display of Goering's newly acquired trophies. Indoors, all was old masters and chandeliers and silver goblets heaped with diamonds. Outside, wrote the journalist Janet Flanner, were "carved French cupids, Greek satyrs, busts of blank-eyed Roman matrons," and countless tons of alabaster vases, Renaissance sundials, and weathered antiques.

Every design decision reflected Goering's taste, down to the details of the footmen's green and gold livery. A remote-controlled wall of glass in the great hall looked out onto the lake. Under a soaring dome, the library boasted a twenty-six-foot-long mahogany desk with inlaid swastikas and a table with legs carved in the shape of penises, each one nestled between a pair of carved breasts. Upstairs, Goering took special joy in a model railroad with hundreds of feet of track and, best of all, toy airplanes mounted on wires and rigged with "bombs" that Goering could drop on the trains.

Few pleasures could compare with taking visitors on a tour of these wonders. Goering dressed with special care for such occasions, in velvet and gold. As he walked, he liked to wave a manicured hand at his trophies and proclaim, "After all, I am a Renaissance man."

It was easy to dismiss such a man as a buffoon, and many did. But ludicrous as Goering indisputably was, it was a mistake to forget that he was clever and malevolent as well. "Goering is by no means the comical figure he has been depicted so many times in newspaper reports," warned a U.S. Army interrogator in May 1945, on Goering's first night in American custody after his arrest. "He is neither stupid nor a fool in the Shakespearean sense, but generally cool and calculating. . . . He is certainly not a man to be underrated."

13

ADOLF HITLER

In the early years of World War II, the only man in Europe who held more power than Goering happened to be the only man whose ambitions as an art collector matched Goering's in grandiosity. Any two collectors might find themselves in competition, but Adolf Hitler was no ordinary rival. Goering gave in quickly, for a contest with Hitler could have only one outcome.

In any case, Goering was as extravagant in his groveling as in his boasting. Whenever someone on Hitler's staff phoned him, Goering leaped up and stood at attention throughout the call. "I have no conscience!" he once announced. "Adolf Hitler is my conscience."

In a speech in 1938, Goering proclaimed his devotion with operatic excess. "How shall I say, my Fuehrer, what emotion fills us?" he asked. "How shall I find words for your deeds? Has ever a mortal been so loved as you, my Fuehrer? Was ever a belief so strong as that in your mission? God sent you to us for Germany. You rescued the German people from darkest night and brought the Reich to the glowing light."

For a short while Goering had played the dangerous game of setting his art dealers against Hitler's, in the hope that he could grab what he wanted and run off with it before Hitler noticed what had happened. It was serious while it lasted—Albert Speer called this skirmish "the picture war"—but the "war" ended as soon as Hitler caught on to it. Hitler dictated the surrender terms. The Reich Marshal might take what art he liked, but only after the Fuehrer had finished making *his* selections.

IT WAS ONLY a fluke, though one with fateful consequences, that the number one and number two men in the Nazi pecking order styled themselves

authorities on art. (The rest of the top Nazis, with rare exceptions, coveted only power.) Hitler and Goering had come to art by different routes. Goering fancied himself a connoisseur and "a man of many parts," but he conceded that he had never been able to paint or draw. Hitler, on the other hand, had aspired to a career as an artist from about the age of twelve. At age thirty-one, he still listed his occupation as "painter." Passionate about art but lacking any particular talent, he never made a go of it. Twice he applied for admission to Vienna's Academy of Fine Arts; twice he was turned down. In Vienna shortly before World War I, he lived in a homeless shelter and churned out hundreds of touristy watercolors that sold for the moden equivalent of about ten dollars apiece.

Hitler's fascination with art and architecture (and his grudge against authority, for rejecting him) never wavered. "After being appointed chancellor in 1933," the historian Frederic Spotts writes, "the first building he had erected was not a monument to his own triumph . . . but a massive art gallery."

Throughout the war, Hitler continued to feel architecture's pull. The day after an Allied bombing raid on the cathedral city of Cologne, Goebbels found Hitler studying a map of the ruined city, heedless of the German lives lost and delighted at the chance to rebuild according to his own designs.

Long after his world had fallen apart, Hitler drew comfort from his architectural fantasies. At the very end, hiding in his Berlin bunker in 1945, he spent hours every day contemplating a minutely detailed model of his hometown, Linz, as he dreamed of transforming it. While the Russian army drew ever closer, Hitler focused all his attention on his scale model. No detail was too small to ponder. Would the bell tower be tall enough to catch the light of sunrise?

14

CHASING VERMEER

When Hitler began collecting art, his advisors had almost no idea what they were doing. The first was Heinrich Hoffmann, Hitler's personal photographer. A cagey businessman, Hoffmann had no artistic qualifications beyond loyalty to the Fuehrer.

That devotion eventually made Hoffmann a rich man. Royalties poured in from such coffee-table books as *The Hitler Nobody Knows* and from an exclusive license to reproduce and sell photographs of Hitler, a fantastically lucrative perk in a state that made a cult of its ruler. (In one of Hoffmann's studios, Hitler met a young assistant named Eva Braun.) But Hitler's art-collecting ambitions soon outgrew Hoffmann's talents.

Enter Hans Posse. Balding and bespectacled, Posse looked like just another museum curator. He had a fine record as an art historian, in fact, but in June 1939 Hitler bestowed powers on Posse that set him apart from all his peers. For two decades, Posse had served as director of Dresden's well-regarded museum, the Dresden Gallery. Now Hitler offered him, in the words of Frederic Spotts, "an opportunity never before offered any museum director—unlimited authority and boundless funds to buy or confiscate whatever he wanted."

Posse, a man without scruples, seized the chance. His assignment, he wrote happily in his diary on the night Hitler made his offer, was to stock the Fuehrer's dream museum with "only the best of all periods from the prehistoric beginnings of art . . . to the nineteenth century and recent times."

Posse began by evaluating the paintings Hitler had accumulated without his help. This called for a certain delicacy. Not surprisingly, Posse praised

Hitler's eye. Many of the dictator's favorite paintings would surely occupy a prominent spot in the future museum. Still, Posse noted regretfully, many others were "not up to the level of the Linz museum, not as I imagine it."

Posse's first self-assigned task, according to the historian Lynn Nicholas, was to fill "the Vermeer Gap." Posse had been instructed, after all, to gather paintings for the world's best museum. Whom better to start with than Vermeer? And what better Vermeer than the extraordinary work called *The Art of Painting*?

Like nearly all Vermeers, this cryptic picture evokes both awe and perplexity. Vermeer himself presumably placed a high value on it, for we know that although he did his best to sell his works, he hung on to *The Art of Painting* throughout his life. He died without a penny in 1675, and the next year his widow turned the painting over to her mother to help settle a debt.

The work depicts an artist, brush in hand, seated on a stool and contemplating a young woman who is posing for him. He has just begun to paint her laurel wreath. A tapestry that serves as a curtain within the room has been pulled back and tucked behind a chair, allowing us to peep in at this quiet scene.

The temptation is to think that Vermeer has here offered us a tiny glimpse of himself (though from the back, with his face hidden), and many writers have yielded to temptation. Often they cite a brief description from the first auction of Vermeer paintings, in 1696: "Portrait of Vermeer in a Room with various accessories uncommonly beautifully painted by him."*

Two and a half centuries after that auction, the great art historian Kenneth Clark endorsed the idea that *The Art of Painting* is a self-portrait. The reclusive Vermeer "may have given himself away," Clark wrote, but the evidence he produced was weak at best. Clark directs our attention to the painter's eye-catchingly elegant waistcoat, with its dramatic sliced back, and reminds us that we have seen it in another Vermeer, *The Procuress*. In that work, painted about ten years before *The Art of Painting*, a young man wearing the slashed waistcoat and an artist's beret looks the viewer boldly in the face.

That cocky youth, Clark proposed, grew to be our reclusive genius. Another Vermeer scholar, Norbert Schneider, suggests that the room depicted in

* The art historian Willem van de Watering notes that, although this description is generally taken to refer to *The Art of Painting*, it is possible that it does not. The reference to a "portrait" is odd, Van de Watering remarks, and the asking price seems strangely low, at only 45 florins in comparison with 175 for *Woman Pouring Milk* or 200 for *A View of Delft*.

The Art of Painting is in fact Vermeer's own studio, because "the heavy oak table on the left is mentioned in his mother-in-law's inventory." Perhaps. But most authorities agree with Harvard's Ivan Gaskell, who contends that the proper response to all such suggestions is "doubt or disbelief."

As ALWAYS WITH Vermeer, we cannot be certain what he intended. Vermeer's own wife referred to this work as "The Art of Painting," and scholars once thought that it represented the artist at work. But what about that mysterious jacket, or the artist's red stockings, or his white leggings with their folded-over tops? That is the outfit of a dandy, not a working painter—certainly not a working seventeenth-century painter, at any rate, with his linseed oil and his turpentine and his grimy smock and his paints stored in pigs' bladders.

The painting shows not a day-in-the-life, modern historians feel sure, but an allegory. But an allegory of what? Who is the young woman in blue whom the artist is painting, and what are we to make of her laurel wreath, or the trumpet in her left hand and the large yellow book in her right? Does she represent Fame, or Art, or History, as one generation or another of scholars has contended? Does the inclusion of a mask (on the table) symbolize the competition between sculpture and painting, as some maintain? Why does the large map on the wall, its every wrinkle and shadow stunningly rendered, show the provinces of Holland not as they appeared in Vermeer's lifetime but as they had been nearly a century before?

Despite so many unanswered questions, the painting conjures up a feeling of calm rather than unease. Even the great Vermeer scholar Albert Blankert, an impatient man with a temperamental allergy to art critics who gush, interrupts his own analysis of the painting and simply marvels. "No other work so flawlessly integrates naturalistic technique, brightly illuminated space, and a complexly ordered composition," he writes. "Exquisitely worked out details— the chair in the foreground, the crinkled wall map, and the painter's jacket— may be enjoyed individually, and yet are perfectly integrated with the serenity of the larger sunlit space."

HANS POSSE, HITLER'S advisor, felt the same way. Now, in 1940, he saw a way to grab *The Art of Painting* away from the family who had owned it for more than a century. The painting belonged to two wealthy brothers who lived in Vienna, Eugen and Jaromir Czernin. Austria, Posse could not help noticing, was in Nazi hands.

A Czernin ancestor had acquired the painting back in 1813, from a collector who had, in turn, bought it from a saddlemaker. At that time and for decades after, the painting was attributed not to Vermeer, whose name had been nearly forgotten, but to the far more esteemed Pieter de Hooch.

Lynn Nicholas, whose superlative *The Rape of Europa* is the definitive account of Nazi looting, picks up the story. Though the Czernin collection was private, the family maintained a gallery that was open to the public. Vienna knew *The Art of Painting* well. So did collectors from around the globe. According to rumors in the art world, the great English dealer Joseph Duveen and the American tycoon Andrew Mellon both coveted it. Their offers, in the Depression, had supposedly soared to as high as $6 million. (In today's dollars, the equivalent sum would be roughly ten times as high.) The Austrian courts had ruled against all such deals, on the grounds that this treasure could not be allowed to leave the country.

But in March 1938, Germany had swallowed up Austria. From that date onward, the Nazis declared, the courts' decisions no longer applied. What belonged to Austria belonged to Germany.

In December 1939, a German industrialist named Philip Reemtsa made an offer to the Czernins of roughly $9.8 million in today's dollars for *The Art of Painting*. Reemtsa was a crony of Goering, and a sale to him was, in effect, a sale to Goering. (A few years before, Goering had established an "Art Fund" to provide his admirers a convenient way of demonstrating their support. Reemtsa contributed hundreds of thousands of dollars to the fund each year.) Goering sent a telegram with Reemtsa's offer saying that he welcomed the sale.

The head of the Austrian Monuments Office balked and made an appeal to Hitler. A national treasure like this should not disappear into private hands, he argued. If *The Art of Painting* was to have a new home, then surely it belonged in a "state museum."

The state museum the Austrian official had in mind, it went without saying, was Vienna's Kunsthistorisches Museum, the fine arts palace overflowing with the accumulated treasures of the Habsburg emperors. But with Hitler prowling around, any mention of the word *museum* was a tactical blunder. Ah yes, a museum! What better home could *The Art of Painting* have than the magnificent new museum at Linz?

First, Hitler pushed Goering aside. Goering gave way immediately and wrote a new telegram giving up his claim to *The Art of Painting*. His chief of

staff had "mistakenly sent off the [previous] telegram before I saw it," Goering wrote. The Vermeer would indeed have made him a fine birthday gift, Goering noted, but not, of course, if the Fuehrer had other plans for it.

Posse stepped in to negotiate a deal on the Fuehrer's behalf. Had the Czernins been Jewish, this would have been the work of a minute, but here outright confiscation would not do. Hitler called for a tax audit of the Czernins, in the hope of finding something to exploit. It failed to turn up anything. No chance of a deal, then, where the painting could be used to settle an outstanding bill. Then another roadblock: Eugen Czernin didn't want to sell. Posse persuaded him to reconsider.

By October of 1940, *The Art of Painting* was in Hitler's hands. In today's dollars, the final price was about $9 million, some $800,000 less than Goering had offered via Reemtsa. Count Jaromir Czernin wrote Hitler a short note expressing his "wish that the picture may, My Fuehrer, always bring you joy."

IN APRIL 1943, Hitler revealed the plans for his art museum to the public for the first time. The news came packaged in a special edition of Heinrich Hoffmann's sumptuously printed art magazine, *Kunst dem Volk*, timed to coincide with Hitler's birthday. Hitler had given his people a gift they would always remember, the magazine announced. (Hitler himself had gone over the wording.) Germany would never be able to repay "its debt of gratitude to its Fuehrer," whose devotion to the beautification of his nation was unbounded. Other museums had taken centuries to assemble their collections, the magazine noted, but in a few brief years Hitler and his Linz museum had outdone them.

One color illustration after another showed the best of these "acquisitions" from "private collections." There were fifteen illustrations in all—Leonardo da Vinci's *Leda*, Brueghel's *Hay Harvest*, and Rembrandt's *Hendrickje Stoffels* among them.*

The Art of Painting graced the cover.

* *Hendrickje Stoffels* has since been assigned to Rembrandt's workshop rather than to Rembrandt himself.

15

GOERING'S ART COLLECTION

Until the end, and past it, Goering baffled all those who would probe his mind. No one ever had the slightest doubt, though, about his mania for collecting art. Throughout the war, even at the most critical moments, he seemed focused as much on art as on battle. By the winter of 1942/1943, for example, momentum had finally shifted against the Nazis. In North Africa, Allied troops under General Montgomery threatened to push Rommel's Afrika Korps into the sea. Rommel made an urgent trip to Europe to plead for reinforcements. He warned Goering that time was short and defeat imminent, but the Reich Marshal refused to focus. Instead, while Rommel fumed, Goering launched into yet another monologue on his favorite painters.

Goering had invited both Rommel and Rommel's wife aboard his private train, which he directed to Rome so that he could shop for art. In the meantime, he showed a bewildered Frau Rommel such treasures as his emerald tie clip and his diamond ring. "You will be interested in this," he said, brandishing the ring. "It is one of the most valuable stones in the world." In the end, Goering promised Rommel men and supplies, then reneged on his promise, and finally reported to Hitler that "Rommel has completely lost his nerve." Rommel returned to Africa furious and empty-handed.

In Russia, too, the winter of 1942 marked a crucial moment in the war. The German invasion of the Soviet Union had neared its climax. Both sides knew that the battle for Stalingrad, which would prove to be one of the deadliest battles in history, would mark a turning point of World War II. Once again Goering was preoccupied.

On November 19 and 20, 1942, the Soviet Army swooped down on Stalingrad simultaneously from the north and south and trapped 250,000 German soldiers inside the city. Goering headed from his Berchtesgaden retreat in the Bavarian Alps to Paris, to shop for art. On November 23, he hurried to the Jeu de Paume, the museum that the Nazis had converted into a storehouse cum gallery for confiscated paintings. (The Jeu de Paume, with its unmatched collection of masterpieces, was a special Goering favorite. He visited twenty times between the beginning of November 1940 and the end of November 1942.) While the German army fought for survival at Stalingrad, Goering pondered his selections. "The following items were loaded aboard the Reich Marshal's special train today," began a memorandum dated November 24, 1942.* It went on to list the paintings and statues that Goering had selected for himself. The handpicked art filled seventy-seven crates.

IT WAS THE Nazi style to offer up a façade of legalisms and euphemisms for even the most overt crimes. Art confiscated from Jewish owners, for example, was supposedly being "safeguarded." International law decreed that a victorious nation could not simply take what it wanted from its defeated foes, but in certain cases, the Nazis asserted, the law did not apply. The Jews of France had no claim to their former property because "the armistice with the French state and people does not extend to Jews in France . . . who are to be considered 'a state within the state' and permanent enemies of the German Reich."

In France, the most prominent of those "permanent enemies" were the Rothschilds, the enormously wealthy banking family. The Rothschild family owned one of the world's greatest art collections. When war broke out, they hid part of their collection in chateaux around France and entrusted much of the rest to the Louvre, with the intention of reclaiming it when it was safe to do so. Then the Rothschilds escaped with their lives.

For the Nazis, hunting for the Rothschild treasures and for works of art hidden by other refugees was akin to sport. "As far as the confiscated art works are concerned," Goering wrote to a colleague in November 1940, "let me highlight my own success over a considerable period in recovering concealed Jewish art

* With art as with mass execution, the Nazis kept meticulous records. In Italy, for example, Hitler noted *to the penny* the amount he spent on art: 40,179,942 lire and 45 centesimi, including freight charges.

treasures. I have resorted to bribery and hiring French detectives and police officials to winkle these treasures out of their (often devilishly clever) hiding places."

Goering's success owed more to devilishness than cleverness. One admiring biographer detailed the resources at Goering's command: he had as much money for informers as he wanted, authority to rummage wherever he chose (including in safety deposit boxes), and tame art experts to tell him which collections held the choicest prizes.

The Nazis hunted for the Rothschild masterpieces with particular diligence. They found them quickly and pronounced them "abandoned." In all, the Germans confiscated 5,009 works from the Rothschild holdings, including paintings by Vermeer, Raphael, Rembrandt, Rubens, Titian, Goya, Van Eyck, and Ingres.

On February 3, 1941, one of Goering's private trains set out from Paris to Germany. Its cargo included forty-two crates filled with the Rothschilds' art. Those crates marked H1 through H19 had been earmarked for Hitler; G1 through G23, for Goering. Crate H13 contained Vermeer's *Astronomer*, a special prize. It went to Hitler, not Goering. This marked the second time that Hitler had grabbed a Vermeer that Goering had lusted after. Once again, Goering could only nod politely and hail his Fuehrer's taste.

THE ASTRONOMER DEPICTS a man absorbed in thought, his gaze focused on a celestial globe (showing the constellations), which he holds in place with the outstretched fingers of his right hand. Like many Vermeers, the painting is small, about twenty inches by seventeen. (*Girl with a Pearl Earring* and *The Milkmaid* and *A Street in Delft* are virtually the same size.)

Light pours in from a window on the left-hand wall and illuminates the painting's lone figure, as it does in so many Vermeers. The astronomer may actually be an astrologer—art historians continue to argue the point—but it is utterly characteristic that Vermeer has placed this student of the heavens indoors, in a meticulously rendered space. The astronomer's face is half in light, half in shadow, and so is his robe, which is a rich green rather than the famous Vermeer blue. (*The Geographer*, a painting so similar to *The Astronomer* in theme and composition that many take it to be a companion piece, shows a similar robe in blue.)*

* The Vermeer scholar Arthur Wheelock writes that *The Geographer* and *The Astronomer* de-

Unusually, *The Astronomer* is dated, one of only three Vermeers with a date. The year is written in Roman numerals, on a cabinet just above the astronomer's right hand. His left hand is nearer to us and deserves examination. The astronomer is in profile, with his left side toward us and his left hand resting on a table's edge. The hand emerges from a roomy sleeve that ends an inch or two above the wrist; there is a gap between the index finger and the other three fingers.

We should look closely at that hand because it is almost certain that Han van Meegeren studied it with the most minute attention.

pict the same man. Wheelock believes that Vermeer's model was Anthonie van Leeuwenhoek, the great scientist and one of the first people to peer through a microscope and describe what he saw. Van Leeuwenhoek lived in Delft at the same time as Vermeer and served as executor of Vermeer's will. It is hard to think of two men with a deeper interest in light and its properties, but scholars cannot prove that the two ever met.

16

<p style="text-align:center">❖</p>

INSIGHTS FROM
A FORGER

"There are only three motives for forgery," says John Myatt, himself convicted of art forgery in 1999 but for a run of nine years a hugely successful fraudster. "Greed, vengeance, and thrills. Or maybe a toxic soup of some combination of the three." It is not happenstance that greed comes first on the list. Forgery is usually about commerce, not art. A history of forgery would stretch back in time nearly as far as a history of prostitution.*

But as ancient as forgery is, it was not until Van Meegeren's day—not until the early decades of the twentieth century—that the price of art soared to levels beyond that of almost every other luxury. A great painting that suddenly appears on the market, the legendary journalist Janet Flanner once observed, is "inch for inch . . . the highest-priced newly discovered land known in the western world."

Myatt, a soft-spoken Englishman, has thought a great deal about forgery in general and Van Meegeren in particular. He considered trying Van Meegeren's strategy—put all your eggs in one carefully crafted, false-bottomed basket—but could never convince his partner in crime to take that chance. Instead, they opted for endless smaller scams, on the theory that no one transaction would bring full-scale scrutiny.

* Thomas Hoving is fond of a remark of Horace (65 BC–AD 8) that "he who knows a thousand works of art knows a thousand frauds." At about the time of Christ, the poet Phaedrus warned his fellow Romans that statues supposedly carved hundreds of years before by the great Greek sculptor Praxiteles were actually modern forgeries.

Perhaps the reason Myatt has spent so much time pondering his fellow forgers is that he found himself among their ranks only unexpectedly. He lives in a handsome farmhouse a few hours' train ride from London, amid green, rolling hills dotted with plump sheep. Nothing outside the house hints at anything special. But open the front door and step inside, and you see at once that no farmer ever lived liked this.

Above the kitchen table hangs an instantly recognizable Van Gogh, a quiet study of the green and yellow fields and whitewashed farmhouses near Arles. Every surface is cluttered with art. Paintings sit in a pile on a chair, they stand in stacks in a corner of the living room, they hang only a few inches apart on every wall. Mondrian, Cézanne, Modigliani, Braque, Chagall. A Monet jostles a Matisse, and a Giacometti painting of a striding man bumps elbows with a pink-cheeked Renoir.

A sketchpad sits open on the table—Myatt has been working this morning—next to a coffee-table book on Picasso turned to a section of line drawings. The book shows Françoise Gilot, Picasso's mistress, and so does one page after another in the sketchpad. Some of Myatt's "Picassos" are better than others, just as some of a pianist's practice runs up and down the keys would be better than others.

Myatt picks up a pencil. "I use the thickest one I can get," he says. "It's so soft it almost disappears in one go. It's a 6- or 7-B." He stands at the table, flips to a blank page in the sketchbook, and starts in. "It's all about the speed and confidence of the line. This line comes *right the way across*"—Myatt has drawn Gilot's jawline in a single, sweeping arc—"and speeds its way down *here.*"

The forger surveys his handiwork. "To Ed," he writes on the drawing, and then he adds a signature, "Picasso, 1940." The scrawled signature looks identical to the ones in the Picasso book.

To an amateur's eye, Myatt's paintings (and my new "Picasso" drawing) look startlingly, unsettlingly authentic. The only giveaways are circumstantial. No one but a billionaire could afford such a collection, and this does not look like a billionaire's home. And even an art lover with enormous wealth favors one style over another. Would any genuine collector have such eclectic taste?

None of Myatt's paintings or drawings is a literal copy, although each is distinctly "in the style of" one famous artist or another. "Here's a Monet

Haystack," Myatt says, as he flips through a stack of paintings. "Another Monet. Another. He did about twenty-eight of them altogether, so I just did three more."

The challenge for a forger is suppressing his own natural style, a task the art historian E. H. Gombrich likens to speaking a foreign language without an accent. Van Gogh was a great admirer of Millet, for example, and he made faithful copies of several of Millet's works. This was study and homage, not forgery, but the swirling brushstrokes that shout "Van Gogh" are unmissable.

Myatt has a knack for taking on the mannerisms of other artists and hiding his own. In the 1970s he worked as a studio musician, playing keyboard in whatever style that day's sessions happened to call for. Myatt was good—he wrote a pop song called "Silly Games" that made it to number one on the British charts—but his main skill was in quickly sizing up how to fit in without standing out.

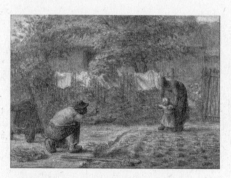

Collection of the Lauren Rogers Museum of Art, Laurel, Mississippi

The Metropolitan Museum of Art, Gift of George N. and Helen M. Richard, 1964 (64.165.2) Image © The Metropolitan Museum of Art

Millet, *First Steps, left,* Van Gogh's version, *right*

TWO FEATURES OF Myatt's story make it especially instructive. First, he is far more thoughtful and open about forgery than Van Meegeren, who spent his life in a sulk, embittered by the conviction that he was a neglected genius. Other forgers who have told their stories, like Eric Hebborn and Elmyr de Hory, tend toward the manic and the histrionic. Myatt has little

of the performer about him. He gives every appearance of being an ordinary man who found himself in extraordinary circumstances. (Myatt directs the choir at his church. The policeman who arrested him is now a close friend and hired Myatt to paint him a family portrait.) Myatt is an ideal guide to the art underworld because he never gave up his citizenship in the straight world.

More important, Myatt's success sheds light on Van Meegeren's, because the strangest feature of Myatt's career was that his successes turned out to have scarcely anything to do with his skill as a painter. Buyers want to believe they have found something extraordinary; the forger's task is to find ways to bolster that belief. Myatt did this (more accurately, his partner did this) by creating unquestionable credentials for each fake. Those perfect pedigrees imbued the paintings with virtues they did not truly possess, much as a fortune or a title can transform a troll into a heartthrob. "Some of my Giacomettis," Myatt says, "are just embarrassingly bad. You flip through a Christie's catalog or a Sotheby's catalog, and there they are, but you just cringe." Those paintings sold for prices as high as $250,000.

Early in his forging career, Myatt goes on, "I had to teach myself, and in the process of teaching myself, I did some really appallingly bad paintings, all of which we put on the market. Because I didn't know that they *were* appallingly bad until about two or three years later, and then I thought"— here Myatt moans in mortification—"'Oh no, *everything* about that's wrong, it's *all* wrong.' But you find yourself in the unbelievable situation where other people are saying, 'Oh, isn't it *wonderful!*' It was like being in a Monty Python film."

Myatt came to forgery almost inadvertently. It was 1986. He was teaching art in a local school and, with a wife and two babies, just getting by. Then his wife walked out. Left to care for a one-year-old and a three-year-old, Myatt had to cut down on his teaching. Bills piled up. "The bank was sending rude letters."

Tied to the house and unable to sell paintings under his own name, Myatt had a bright idea. Years before, in his days as a musician in London, his boss had once come back from lunch raving about the big shot he'd just met. The man had bought himself two paintings by Raoul Dufy, and had paid £80,000 for each. Can you imagine having money like that? Can you imagine owning paintings like that? Myatt, an art school graduate, jumped in.

"I'll paint one for you," he said.

In the end, Myatt painted *two* "Dufys." His boss paid £250 apiece, at the time roughly $500 a picture, and hung them in the office. "Mind you, this was 1970-something, and that was a lot of money," Myatt recalls. "Those two pictures fooled a lot of people. They weren't any good, but they fooled just about everybody who came through the door."

That had been a prank, not a scam. But five or six years later and in trouble, Myatt thought back on that easy payday. He took out an ad in *Private Eye*, a satirical magazine, offering "Genuine Fakes: Nineteenth and twentieth century paintings from £250." The paintings mimicked the style of well-known artists, but everything was out in the open—Myatt signed his own name on the back and stamped the paintings "Genuine Fake."

"It wasn't bad money," Myatt says. "If I did one a week, it paid the bills. And I didn't have to leave the house, which was a major thing for me because of the children." People ordered a Matisse or a Dufy. Sometimes they ordered instant ancestors—they brought in a photograph of their husband or their wife and asked Myatt for a portrait in the style of Reynolds or Gainsborough.

Most customers came and went. Only a handful bought more than one painting. One man, a physicist named John Drewe, returned again and again. He bought Dutch seascapes and a Dutch portrait or two, and then moved on to Matisse and Picasso and Chagall. "He just kept coming back," Myatt recalls. "By this time my prices had crept up to about £300 at a time. In the end Drewe ran out of ideas, and I thought, 'Well, that's been interesting,' and he said to me, 'What would *you* like to do?'"

Flattered, Myatt set to work on a Georges Braque. Soon he'd completed a small Cubist painting about the size of a placemat. Drewe seemed pleased.

Their next conversation differed from all its predecessors. "I reframed the painting," Drewe said.

"Fine."

"I brought it to Christie's, and they valued it at twenty-five thousand pounds"—around $40,000.

Myatt blanched. "They thought it was genuine?"

"If I sold it, would you like twelve and a half thousand pounds, in cash? Or would you prefer to keep the three hundred pounds?"

* * *

LOOKING BACK TODAY, twenty years afterward, Myatt smiles ruefully. "I could have said no. I could have said, 'Of course not, that's a terrible crime.' But I didn't. Twelve and a half thousand pounds was a year's pay. I said, 'I'd love it, that's fantastic, let's do it.' Later I rationalized the whole procedure by saying, 'It's good for the children.' Well, that's what started us off, and we went on from there for another seven or eight years."

Over the years, Myatt produced at least two hundred paintings. He painted at home from art books that Drewe sent to him, with bookmarks indicating the styles to mimic. "It was easy money," he recalls. "I'd put the children to bed about eight o'clock, read them a bedtime story, and then come downstairs and clear the table, and I'd do a pastiche, maybe Giacometti or Georges Braque."

Drewe, far more glib and outgoing than Myatt, did the selling. At their peak, Myatt's prices rose to several hundred thousand dollars. In a bathroom in Myatt's house today, framed sales receipts hang on one wall. For a work by Ben Nicholson, the modern British painter, £100,000, roughly $150,000. Another frame, another receipt, another Nicholson. This one, £200,000.

Those are big numbers, but nothing in comparison with art world records. Drewe and Myatt thrived in an era of anything-goes art prices. In 1990, at an auction at Christie's, Van Gogh's *Portrait of Dr. Gachet* sold for $82.5 million. Great paintings, a *New York Times* writer remarked in awe after a flurry of such sales, had reached the price of Boeing 757s. But Drewe, the strategist of the team, steered clear of the top of the market. He was a businessman, and his business plan revolved around high volume and steady, middle-level returns. Why risk everything on a single lottery ticket, even if the prize was a tens-of-millions-of-dollars bonanza?

Myatt was good at his job, but Drewe was brilliant. His key insight was that so long as the paperwork that accompanied a painting was too good to question, the painting itself merely had to be plausible. When visitors stroll through an art museum, many of them look at the label next to a painting before they consider the painting itself. In similar fashion, many collectors seem to care more about a painting's provenance—its pedigree—than its appearance.

John Drewe flung that door open and raced through. While Myatt concentrated on forging paintings, Drewe turned to forging the documentation that

proved that a painting was authentic. (Drewe had a long history as a con man. Even his claim to be a physicist, which had so impressed Myatt, was bogus.) The paperwork was so important, in fact, that Myatt and Drewe decided which artists to forge based on how easy it would be to create a convincing history for their paintings. "Anybody can paint a Picasso or a Matisse," Myatt remarks, "but they worked in France, and creating a paper trail for those paintings is very hard. It means you've got to go to France and all that nonsense. So John Drewe suggested we find British artists, or artists who exhibited here in England, and then it would be that much easier to create a false history for the paintings."

In Britain, the laws regulating museums work to a forger's benefit. "All the museums are funded with public money," Myatt explains, "so if you phone up and say, 'I notice you're not exhibiting such and such a painting, can I come and see it?' they'll say, 'Yes, when can you come down? Next week sometime? See you on Tuesday.' Which they have to, legally.

"Now, from a forger's point of view, that's brilliant," Myatt goes on, "because you can not only look at the front but also the back, and that's worth everything to someone who's trying to sell a phony painting—what it looks like from the back, what are the stickers on it, what kind of condition is it in, all that's so important."

WHILE MYATT DID his best to make sure that his paintings looked more or less right from the front, Drewe took charge of the back and all the paperwork that went with it. First, he needed a backstage pass. At the Institute of Contemporary Arts, in London, Drewe contributed two paintings—forgeries by Myatt—to a fund-raising auction. In gratitude, the institute welcomed him into its archives. At the Tate Gallery, Drewe made a donation of roughly $40,000 earmarked to helping the Tate revamp its records. He was rewarded with full access to the museum's research files. The National Art Library at the Victoria and Albert Museum proved even easier to crack. All they required was a letter vouching for Drewe. Like a schoolboy forging a note from his mother, Drewe wrote his own letter: "John Drewe is a man of integrity," it asserted.

With unlimited access to precisely those records that a conscientious gallery or collector would consult before going ahead with a major purchase, Drewe set to work manipulating history. In one brazen but typical ploy at the

National Art Library, he razored apart a catalog from a 1955 show at a London gallery that had since gone out of business. Then he created new pages with photographs of Myatt forgeries, added captions in the proper typeface, inserted the false pages among the real ones, reassembled the catalog, and set it back on the shelves.

The scheme, which focused not on the paintings themselves but on the documentation that proved the paintings' bona fides, was ingenious. Why bother going through surgery to change your fingerprints if you can change the fingerprint records in the FBI files?

Drewe thrived on the gamesmanship. At one point he hired himself out as a consultant to a New York dealer, Armand Bartos, who wanted to know if a Giacometti he had bought was authentic. Bartos had paid $250,000 for the painting, which was in fact a Myatt, not a Giacometti. Drewe met Bartos in London and dazzled him with impeccable paperwork, all of it his own creation. Bartos flew back to New York satisfied. Drewe billed him seven hundred dollars.*

In the end, the Myatt/Drewe forgery scam fell apart because Drewe ran out on his wife. She filled the trunk of her car with three or four trash bags stuffed with photos of forged paintings, phony letters from art galleries, and doctored bills of sale, and roared off to the police station. Then she stormed inside, dragged two dubious detectives to her car, and presented them with a ready-made case.

ABOUT 80 OF Myatt's fakes have been found. Presumably the other 120 are still in collections around the world, and their owners take great pride in them.

But even in the good years, Myatt lived in fear. "I expected every day to get arrested," he recalls. "Finally, it happened. It was six in the morning—they come so early because they want to make sure you're at home—and ten policemen came hammering on the door. I knew as soon as I saw them. 'Well, that's it then,' I said."

* Almost always, the owner of a painting that turns out to be a fake responds with the shock and humiliation of a betrayed lover. The fake *looks* identical after the revelation, but everything has changed. Not so for Bartos. To his credit, he insisted that his defrocked "Giacometti" retained all the visual allure that had drawn him to it in the first place.

Curiously, though, and despite his fears, Myatt had been astonishingly casual with his forgeries. The most rudimentary scientific test could have undone him in a minute. "I wasn't even using oil paint," Myatt says. "It was just ordinary housepaint, the kind you paint on the walls. I don't like the smell of oil paint; it gives me a headache. I told Drewe all this, but he was busy showing the pictures to all the experts and saying, 'What do you think of this?' And in many cases, they were saying, 'Oh, that's wonderful.' I just didn't see the point of going back to oil paint, which takes forever to dry and would have filled the whole house with the smell, which the children wouldn't have liked, either."

At least in the glory days of his career, with his Bakelite experiments, Van Meegeren had gone to enormous trouble to make sure that his paintings could pass the technical tests they were most likely to face. Myatt never bothered. He did carry out a series of homemade experiments, but the goal was only to give his housepaint the right feel for painting on canvas. "Here's a Miró," he says, pointing to a picture with faint stars in a pinkish sky. "That's what happens when you mix a bit of washing-up liquid [dishwashing soap] in with the paint." That hadn't worked well enough to repeat. But Myatt found that a glob of vaseline taken straight from the jar and stirred into his paint worked wonders, and he used that technique again and again. It would have been an instant giveaway, fingerprints at the crime scene, but no buyer ever carried out a single test.

To make his paintings seem as if they had been around for a few decades, Myatt dirtied them up a bit. Here, too, he favored the rough and ready. He would empty the contents of a vacuum cleaner bag over a painting, rub the grime around a little, and then vacuum away the excess.

Early on, Myatt had fretted more about technique. In New York once, he'd gone to an art museum and seen firsthand, for the first time, some of the Monets he'd been copying from art books. "I'd been spending ages pulling the brush hairs out of my paintings, but as you looked at the real ones in slanting light, you'd see hairs stuck in the paint." Myatt quit hovering over his Monets.

MYATT HAS DONE well from his life of crime. He did serve four months in prison, but that's over now (and even behind bars, Myatt found that his artistic skill served him well, as he bartered drawings of his fellow inmates for

phone cards and similar valuables). The notoriety of his case has brought him more work than he can handle. Once again he is selling "genuine fakes," but this time he shows them in London galleries, and the policemen who arrested him years ago now sip wine at the opening-night parties. Michael Douglas has bought the rights to his story.

Still, Myatt thinks occasionally of the bad old days. "We shouldn't have done hundreds and hundreds of paintings. What we should have done was two or three big paintings, a big Cubist painting by Braque, a big painting by Giacometti, or a Cézanne. It was always my little fantasy. Drewe would never have done that. I tried to talk him into doing it, strangely enough, which shows I wasn't as lily white as I like to pretend to be. Instead of doing a painting a week it would have been much better, from a criminal point of view, if we'd done one a year."

But what about the experts?

Myatt pooh-poohs the risk. "*Someone* would have said, 'No, these aren't any good.'* But someone else would have said, 'Oh yes, they are.' And that's what happens all the time anyway. If you came up with an *authentic* Cézanne, someone would say, 'It's a fake.' And someone else would say, "No, it isn't.' You just have to hope that *your* expert is more important than *their* expert."

Myatt mimics the plummy tones of an overconfident connoisseur. "'We have here an undiscovered Cézanne from the important period when he had moved to Aix-en-Provence when it was *dah de dah dah*, and this is a seminal study from the point at which his style matured into *blah blah*. And here he's considering the structure of the two-dimensional surface as well as the three-dimensional effect of the recessive colors that he's using in the half-distance . . .' Well, you can imagine it all, can't you?

"All you've got to do is go down to some flea market on the Left Bank and buy a painting from 1881 or something," Myatt continues. "Those paintings are right there. That's your first move. Then you've got to scrape the old paint off. You'd have to get authentic paints. I'm not sure how you'd do it. Presumably there's someone somewhere, some collector, who has a collection of tubes of oil paint. That's what sensible criminals would do. There are pitfalls

* Mary-Lisa Palmer, director of the Alberto and Annette Giacometti Foundation, had immediately recognized that someone was peddling fake, inferior "Giacomettis." But because Drewe's fake provenances were so good, Palmer's warnings went unheeded for years.

in the process I can't perceive, obviously, but if I can work my way around it intellectually, I'm sure there are people out there who have *done* it. And are doing it now, as we speak.

"I'm revealing a side of my character I'm not particularly proud of, but this is how it should have been done," Myatt says. He is a mild man, but, for the first time, his voice rises. "It was a crime, after all, so why not bloody well do it properly, instead of the way we did?"

———◆———

THE AMIABLE
PSYCHOPATH

No one doubted Hermann Goering was evil; no one suggested he was banal. Even those who knew his record well felt the man's pull. On the May night in 1945 when the Americans finally brought him in, Goering spent the evening drinking and singing with his captors. (The idea behind the soft treatment was that Goering might be more likely to provide useful information if he felt at ease.) He clapped along merrily during the choruses of "Deep in the Heart of Texas" and then called for his accordian and performed a makeshift concert of his own favorites 'til two in the morning.

Years earlier, on the night he first met Goering, the foreign correspondent Leonard Mosley had marveled at the Reich Marshal's charm and conversational flair. Mosley was no naif; he was an authority on Nazi Germany who had served as the Associated Press bureau chief in Berlin for twenty years and won the Pulitzer Prize for foreign reporting in 1939. To his surprise, Mosley found that Goering had little to say about politics. The Nazi leader seemed to brighten up only when the talk turned to nature or art.

"How had such a worldly, cultivated man got himself mixed up with such a sleazy and murderous gang as the Nazis?" Mosley asked himself after that first conversation, but then he saw Goering perform at a political rally. "I saw on the platform not the charming art and animal lover I had first encountered but a ranting, raving anti-Semite mouthing all the shibboleths of the party, a quivering mass of hate and rancor."

When it came to art, Goering put the ranting aside, but the bullying came through regardless. After dinner one evening in 1935, for example, Goering

showed his houseguests the paintings he had taken from the Kaiser Friedrich Museum. "The director did object," Goering said, "but I threatened to take twice as many if these were not brought over here first thing in the morning." (Goering used another painting "borrowed" from the museum, Rubens's *Diana at the Stag Hunt*, to hide his movie screen between showings.)

Over the years he improved his technique, acquiring a kind of oily charm. This was blackmail with the best of manners, extortion with a smile. Dealers and collectors knew perfectly well the danger they faced, of course, but Goering left the actual threats to his scouts and middlemen. "Goering was never unpleasant in his dealings," wrote the historian Lynn Nicholas. "He would arrive in high spirits on his palatial train, complete with oversize bathtub and phalanxes of elegantly uniformed adjutants, and go from one gallery to another. Even the most endangered agreed that he had a certain charm, and considering the amounts he spent, they were not reluctant to see him arrive."

Many times Goering favored an especially grim form of barter. In Holland in 1943, for example, the Gestapo arrested a Jewish art dealer named Kurt Bachstitz. It so happened that Bachstitz was married to the sister of Goering's art scout, Walter Hofer, and Hofer intervened on his brother-in-law's behalf. "Bachstitz is to be left alone," Goering commanded the Gestapo. On August 14, 1944, Goering's private detective escorted Bachstitz safely to Switzerland. Goering collected his fee in paintings.

GOERING HAD BEGUN indulging his acquisitive appetites from the moment he came to power. Nothing made him as angry as the charge that he was lazy, but his official duties seemed not to weigh too heavily on him. One colleague, writing in 1938, noted matter-of-factly that Goering's workday typically began with a sequence of visits—first his tailor, then his barber, art dealer, and jeweler.

In Germany in the thirties, everyone knew the rules of Goering's game. The titans of German industry lined up to offer tributes of art and high-class bric-a-brac, especially on his birthday. Little was left to chance. Hofer made the rounds of prominent galleries and left lists indicating which gifts his master would find suitable. Another functionary kept detailed records of who had given what. On those rare occasions when a German corporation acted so boldly as to charge for its services, Goering responded with cheery contempt. The movie studio UFA installed a private theater in the basement at Carin Hall, for instance, at a cost equivalent to some $500,000 today. Goering ig-

nored UFA's invoice, except to return it with a scribbled note expressing his thanks for the "magnificent present."

In April 1935, when Goering married an actress named Emmy Sonneman, the tribute system was on full display. The wedding hoopla would have suited a coronation. Goering and Emmy drove to the church in an open car festooned with narcissus and tulips. Thirty thousand troops lined the streets of Berlin. To ensure that the music would be satisfactory, Goering had dragooned singers and musicians from the opera. After the ceremony, two hundred planes roared overhead in a salute to the newlyweds.

"Gentlemen," Goering announced at the wedding celebration, "I have invited you to come here in order that I may show you the gifts my people have given me." The presents filled "two enormous rooms," Emmy reported excitedly. "The King of Bulgaria, for instance, sent to Hermann his country's highest decoration and to me a splendid sapphire bracelet. Hamburg had presented me with a sailing boat with silver sails which I had always admired on school visits to the City Hall."

Then came war, and with it the assurance that now the "gifts" would pour in not just from Germany and a royal household or two but from all Europe. And so they did, year after year, and every gift scrupulously noted. The donor list included a host of smaller names and such corporate giants as Lufthansa and I.G. Farben. The gifts were lavish: a Van Dyck, from the city of Berlin; a 2,400-piece service of Sèvres china; a hunting lodge taken from France and destined for one of Goering's country estates.

Other collectors have shared Goering's passion for acquiring new possessions. Few have matched his resources, for no mere private fortune could provide opportunities like those that came with the control of a gangster state. Goering was Hitler's officially designated successor, and also, at one time or another, minister of the interior for Prussia, Germany's largest province; head of the Gestapo; commander in chief of the Luftwaffe; and Reich Marshal. Each post brought immense power and the chance to steal either outright or by intimidation. Goering gleefully exploited his good furtune.

Perhaps Goering's most directly lucrative post was chief of Germany's Four-Year Plan, a role he took on in September 1936. In effect, the job was economic czar—Goering's mission was to ensure that, in four years' time, German industry would be ready for war. The focus was on stockpiling vital materials—steel, oil, rubber—but art was never far from Goering's mind. As keeper of the nation's checkbook, he had a free hand to buy art as he chose.

"I was the last court of appeal," he explained after his capture. "I always took enough money along on the train—I had a private train—I would give an order to the Reichsbank and they would get the money. I had to okay the order myself."

GOERING'S SWAGGER, HIS medals, his bombast, even his ever-swelling belly, somehow convinced the masses that he was a hero they could take to their hearts. Throughout Germany crowds of supporters called out to their "Hermann" at speeches and rallies and shouted, "Heil der Dicke! Heil der Dicke!" ("Hail to the Fat One!"). "The people want to love," Goering boasted, "and the Fuehrer was often too far from the broad masses. Then they clung to me." Even Goering's vanity seemed more an endearing foible than a damning flaw. One nightclub comic in Berlin could count on big laughs from a joke about how Goering had made himself a set of rubber medals that he could wear in the bathtub.

Goering had a knack for playing to an audience, whether it was a crowd of thousands or a single listener. "He can turn on a smile and turn it off like a faucet, almost at will or mechanically," noted one of his Nuremberg interviewers. Wary acquaintances and outright enemies spent endless hours analyzing Goering's tangled character, trying to sort out what was self-conscious performance and what was untrammeled self-indulgence.

In Goering's own mind, no one but he merited a moment's consideration. "When you use a plane on a piece of wood, you can't help making splinters," he noted blandly when someone dared to question him about the torture of political prisoners. He spoke of Jews with the same dismissive contempt. "Certainly as second man in the state under Hitler I heard rumors about mass killings of Jews," he conceded at Nuremberg, "but I could do nothing about it . . . [and] I was busy with other things."

His self-regard was boundless. He loved flying, he explained, because "I seem to come alive when I am up in the air and looking down at the earth. I feel like a little god." In fifty or sixty years, he boasted to an American psychiatrist at Nuremberg, "there will be statues of Hermann Goering all over Germany. Little statues, maybe, but one in every German home."

Mosley, the Associated Press reporter, wrote an acclaimed biography of Goering, but he never managed to resolve the Reich Marshal's contradictions. Nor did anyone else. One of Goering's interviewers at Nuremberg, a psychologist and a captain in the U.S. Army named G. M. Gilbert, had set him-

self the task of finding "what made those Nazis tick." After hours of interviews with Goering, Gilbert published an essay in the *Journal of Abnormal and Social Psychology* that all but proclaimed his bafflement. The essay's title: "Hermann Goering, Amiable Psychopath."*

The amiability, or the boisterousness that at times passed for amiability, should not be allowed to obscure the pathology. Goering was a mass killer who never suffered even a moment's regret. The record of his complicity in genocide fills volumes. At Nuremberg, where Goering was sentenced to death for war crimes, the chief American prosecutor made plain just who this man was. Goering was "half militarist and half gangster. He stuck a pudgy finger in every pie.... He was equally adept at massacring opponents and at framing scandals to get rid of stubborn generals. He built up the Luftwaffe and hurled it at his defenseless neighbors. He was among the foremost in harrying the Jews out of the land."

Hannah Arendt sat through all the grim testimony at Nuremberg. "For these crimes," she wrote, "no punishment is severe enough. It may well be essential to hang Goering, but it is totally inadequate."

* It was in a conversation with Gilbert in Goering's jail cell, on the night of April 18, 1946, that Goering offered what became a famous observation on mass psychology: "Why, of course, the *people* don't want war," he said. "Why would some poor slob on a farm want to risk his life in a war when the best that he can get out of it is to come back to his farm in one piece? Naturally, the common people don't want war; neither in Russia nor in England nor in America, nor for that matter in Germany. That is understood. But, after all, it is the *leaders* of the country who determine the policy and it is always a simple matter to drag the people along, whether it is a democracy or a fascist dictatorship or a Parliament or a Communist dictatorship."

Gilbert remarked that in a democracy the people have a say in the decision to go to war.

"Oh, that is all well and good," Goering replied, "but, voice or no voice, the people can always be brought to the bidding of the leaders. That is easy. All you have to do is tell them they are being attacked and denounce the pacifists for lack of patriotism and exposing the country to danger. It works the same way in any country."

18

———◆———

GOERING'S PRIZE

Twice, as we have seen, Goering had nearly closed his chubby hands around a Vermeer only to lose it to Hitler. In the case of *The Art of Painting*, he had not only missed out and endured a quasi-public reprimand, but he had suffered the further indignity of seeing Hitler flaunt his newest acquisition before the world.

Then came good news, indeed spectacular news. Walter Hofer, Goering's art scout, had found a new Vermeer in Holland! It was a religious painting, *Christ with the Woman Taken in Adultery*, that illustrated the famous "let he who is without sin cast the first stone" parable. Christ, long-haired and somber, addresses the adulterous woman, who stands before him with downcast eyes. The light falls from the left, as in so many Vermeers, and the colors are Vermeer's favorites—Christ's robe is blue, the woman's dress, yellow—but the painting as a whole is different from Vermeer's iconic masterpieces. It is not tiny, like so many of the others, but roughly three feet by three feet. Rather than showing a single person absorbed in thought, it depicts four figures. The setting is not a scrupulously observed Dutch interior, with ordinary people going about their ordinary lives, but one of the most hallowed of all biblical encounters.

Oddest of all, the painting is that rare thing, an ugly Vermeer. The figure in red behind Christ's right shoulder, in particular, looks almost apelike. That ugliness was presumably intentional, the repellent exterior meant to signal the moral rot within. But Vermeer customarily shied away from ugliness, even where it might have been expected. He owned a painting by Van Baburen called *The Procuress*, for example, and he himself painted a work called *The Procuress*. Van Baburen took pains to make his procuress old and creepy, with

hanging jowls and a slack jaw, and his prostitute is coarse and fleshy. Vermeer's procuress has a cagey, leering look, but she is not ugly, and his prostitute is a demure but radiant beauty.*

Nor is the overall look and feel of *Christ with the Woman Taken in Adultery* what we might expect. This is not a subtle, graceful painting where every reexamination reveals a new delight, like the glint of the chandelier in *The Art of Painting* or the crumpled folds in the carpet flung on the table in *The Geographer.* Here one texture looks like another, and we cannot quite work out the source of the light. The spacing, too, seems off. In most Vermeers, the illusion of three dimensions is so convincing that many art historians believe they can reconstruct the precise measurements of the rooms in the pictures. In nearly all Vermeers we see immediately where the people are in relation to one another, or how far they are from the nearest wall. (*The Procuress* is an exception.) But the four figures in *Christ with the Woman Taken in Adultery* seem crowded together, like passengers in an elevator. How close to one another they are meant to be we cannot tell.

Faced with so many surprises, an art lover who knew only such Vermeers as *Girl with a Pearl Earring* might have had doubts. The experts knew better. The large size of the new painting, for example, did not pose a problem. *A View of Delft* is bigger than *Christ with the Woman Taken in Adultery*, and so are *The Procuress* and *Diana and Her Companions.*

The religious subject, too, had precedents in Vermeer's work, though most art lovers do not associate Vermeer with biblical scenes. A painting that had been identified as a Vermeer only in 1901—a London art dealer had found a signature that had been hidden by varnish—also depicted a New Testament scene. For the dealer, that discovery was a fluke akin to a prospector's stubbing his toe on a gold nugget. That suddenly precious painting, *Christ in the House of Mary and Martha*, had changed hands shortly before, for eight pounds. (It happened to be yet another example of a large Vermeer, too, at a bit more than five feet by four feet.) Naturally the unlikely story of the signature aroused suspicion, but the skeptics had been wrong. *Christ in the House of Mary and Martha* did indeed prove to be a Vermeer.

And if *Christ with the Woman Taken in Adultery* seemed to have scarcely any connection with such favorites as *The Milkmaid* or *The Lacemaker*, it did bear a

* Dirck van Baburen's *Procuress* now hangs in the Museum of Fine Arts in Boston. Vermeer's *Procuress* is in Dresden's Staatliche Kunstsammlungen.

striking resemblance to a Vermeer that had turned up only in 1937. This was another religious painting, *Christ at Emmaus*. Bigger in scale than *Christ with the Woman Taken in Adultery*, it too showed four figures cloaked in rough-sewn, solid-colored clothes. The blue-robed Christ in *Emmaus* seemed a near match for the blue-robed Christ in the *Woman Taken in Adultery*. On its sudden discovery, *Emmaus* had been joyously hailed as perhaps the greatest Vermeer of all.

Now, in September 1943, this latest Vermeer had appeared. Hofer, Goering's scout, had heard about *Christ with the Woman Taken in Adultery* from a shadowy banker and sometime art dealer named Alois Miedl. German (but with a Jewish wife), Miedl had lived in Holland for years and knew everyone there worth cultivating. The chubby and balding Miedl looked innocuous, but his connections made him dangerous. Miedl knew Goering well and had enjoyed the Reich Marshal's hospitality at Carin Hall. From the earliest days of the occupation, when Hofer had first turned up in the Netherlands looking for art, Miedl had happily taken him in hand.

Miedl hurried to Carin Hall with the new Vermeer. He seemed scarcely to know where the painting had come from, and his asking price was enormous— 2 million Dutch guilders, or about $10 million in today's prices.

Still, a Vermeer . . .

Unwilling to meet the price but unable to part with the painting, Goering kept it on view at Carin Hall while he dithered. Months passed. On every tour of his new acquisitions, a ritual that Goering imposed on every visitor, *Christ with the Woman Taken in Adultery* was a mandatory stop.

Finally, in the winter of 1943, Goering found a way to hang on to his prize while still indulging his greed. Resorting to barter rather than sale, he "purchased" the *Woman Taken in Adultery* from Miedl by trading it for other paintings in his collection. In exchange for this one Vermeer masterpiece, Goering handed Miedl 137 paintings.

19

VERMEER

Since his rediscovery in the mid-1800s, Vermeer has been treated with a degree of reverence that would be hard to exaggerate. "It now seems uncontentious that Vermeer has overtaken Rembrandt as the supreme Dutch artist of the seventeeth century," one scholar noted recently, as if so self-evident a claim did not call for the bother of demonstration. The art-loving public espouses the same view. The best of Vermeer's paintings, writes John Updike, are "perhaps the loveliest objects that exist on canvas."

The Nazis admired Dutch painters in general, and Vermeer in particular, for half-baked reasons having to do with the artists' supposed "Germanness." Goering's eagerness for a Vermeer had even less to do with aesthetics. For the Reich Marshal, "Vermeer" was a brand name even better than "Rolls-Royce" or "the Ritz."

For the Dutch in the bleak years of World War II and the anxious years leading up to it, admiration of Vermeer took on a new dimension that had little to do with his marquee value. Art historians and ordinary art lovers alike saw embodied in the great painter the very qualities that Goering and his ilk had put most at risk. The Dutch embraced Vermeer as an emblem of sanity and levelheaded virtue. Shortly after the end of World War II, the great Dutch art historian P.T.A. Swillens published a quiet and scholarly book on Vermeer. In the preface he allowed himself a few sentences to speak personally. He had begun work on his book decades before, Swillens wrote, during the *First* World War. "In 1940," he went on, "when right was once more trampled on by foreign invaders and spiritual values were crushed, my manuscript was almost finished."

Then the Nazis had invaded Holland, and Swillens had been obliged to

put his nearly completed book aside. His memories of Vermeer's work consoled him in those dark times: Vermeer "stayed with me, his happy wisdom reached me amongst the orgies of idiocy and barbarism, and I enjoyed the purity of his character when lies and deception held high revel."

THREE CENTURIES BEFORE, Vermeer had come to know barbarism and bad fortune for himself. He had lived not in a dreamy Dutch idyll but in a time of war and economic collapse and waves of mysterious, unstoppable disease. In 1656, when Vermeer was a young man, plague swept through Amsterdam amd claimed eighteen thousand lives. Even Vermeer's seemingly tranquil hometown, Delft, proved no haven from the world. Earlier, in 1654, an explosion in a gunpowder arsenal had leveled half the town and killed hundreds of its citizens.* (The simple fact that Delft kept ninety thousand pounds of gunpowder at the ready shows how unsettled the times were.)

Perhaps the modern-day Dutch, beset by Hitler, felt so close to Vermeer because they sensed how their plight carried echoes of the artist's own. Holland's modern history began in blood, in 1568, in a rebellion against Spanish rule that continued intermittently over the course of decades. This was the era of the Spanish Inquisition, when mighty Spain ruled tiny Holland. Arrogant, abstemious, intolerant as a matter of policy, Spain's King Philip II believed God had commanded him to stamp out the heresy that seemed to thrive in Holland. He pursued that goal with zeal.

"Everyone must be made to live in constant fear of the roof breaking over his head," the Duke of Alva, the leader of the Spanish army, wrote to his king. And so they were. Thousands of Dutch citizens were broken on the wheel or burned at the stake or tied to horses and torn limb from limb when the horses galloped apart. Two centuries afterward, one well-regarded historian still seemed scarcely able to contemplate Philip's grisly record. "If there are vices ... from which he was exempt," wrote John Lothrop Motley, "it is because it is not permitted by human nature to attain perfection even in evil."

The revolt against Spain began on June 5, 1568, when two Dutch noblemen, the Count of Egmont and the Count of Hoorn, sought to negotiate with King Philip's representative in the Netherlands. By way of response, the Spanish

* One victim of the blast was thirty-two-year-old Carel Fabritius, Rembrandt's star pupil and Vermeer's neighbor. Fabritius was crushed to death when his house collapsed, as was the man whose portrait he happened to be painting.

official arrested the two Dutchmen and had them beheaded before a gaping crowd. Peace would not come for eighty years. The war was "still going on when Vermeer was born," one historian writes, "as it had been when his father—and probably his grandfather—were born."

Against this backdrop, Vermeer's achievement stands out all the brighter. A few years ago, the journalist Lawrence Weschler traveled to The Hague to cover the Yugoslav War Crimes Tribunal. There he fell into conversation with the tribunal's chief judge, who spent his days listening to detailed accounts of torture. The judge told Weschler the story of a torture victim who had gone mad. Weschler asked the judge how he coped with such testimony. On his lunch hour, the judge replied, he hurried to the Mauritshuis Museum "to spend a little time with the Vermeers."

Weschler, too, had been communing with The Hague's Vermeers. (*The Girl with a Pearl Earring*, *A View of Delft*, and *Diana and Her Companions* are at the Mauritshuis.) The judge's remark, Weschler wrote, opened his eyes to "the true extent of Vermeer's achievement—something I hadn't fully grasped before. For, of course, when Vermeer was painting those images which for us have become the very emblem of peacefulness and serenity, *all Europe was Bosnia* (or had only just recently ceased to be): awash in incredibly vicious wars of religious persecution and proto-nationalist formation, wars of an at-that-time unprecedented violence and cruelty, replete with sieges and famines and massacres and mass rapes, unspeakable tortures and wholesale devastation."

Perhaps it is not surprising that Vermeer chose to spend his days depicting quiet.

JOHANNES VERMEER, SUPERSTAR

For two centuries after his death, Vermeer disappeared into obscurity. When he came back, he came roaring back. In 1881, for instance, a little-known Dutch collector named A. A. Des Tombe had picked up a Vermeer picture at an auction for 2.3 florins, roughly $200 in today's dollars. The painting had suffered from grime and rough handling. It had not been deemed worthy of mention in the auction catalog, and its name, if it had ever had one, had been lost. Today we know it as *The Girl with a Pearl Earring*.

In 1902, Des Tombe bequeathed it and eleven other pictures to the Mauritshuis Museum. From the start, rapturous crowds gathered to see the gorgeous young woman in yellow and blue glancing over her shoulder. The painting's current market value would be almost beyond reckoning. Certainly it would go for many tens of millions.*

At around the turn of the twentieth century, two powerful, capricious forces

* The Mauritshuis treats its masterpiece as the star it is. In the summer of 2005, a giant banner depicting the *Girl with a Pearl Earring* hung outside the museum, beckoning tourists. The banner stretched perhaps ten feet across and extended from the roof to the ground. Inside, the giftshop sold *Girl with a Pearl Earring* jigsaw puzzles, drink coasters, playing cards, nut dishes, key rings, bookmarks, matchboxes, and, for three hundred euros, full-size reproductions of the painting itself.

At the same time, and in yet another sign of Vermeer's popularity, three similarly colossal banners flapped outside the Rijksmuseum in Amsterdam, each showing a detail from *The Milkmaid*.

met and magnified each other. Together they propelled Vermeer into the most
rarified ranks of celebrity. The first was a shift in taste—inspired in good mea-
sure by rapturous travelers' tales, Americans declared all things Dutch hugely
desirable. The frenzy was dubbed "Holland mania." The idea, explains the art
historian Arthur Wheelock, was that Holland and the United States were
spiritual kin. The values at the heart of American culture and democracy de-
rived from Holland, not Britain. The Dutch revolt against Spain served as a
forerunner to the American revolt against England, and Holland's seventeenth-
century Golden Age foretold America's just-dawning golden future.

The second trend was American, too. At about the time of Holland ma-
nia, America's robber barons decided they were no longer content to collect
railroads and shipping lines. They had long been hailed as kings of coal and
sultans of sausage, and now they wanted to display their aesthetic side. The
robber barons needed art, and price was no object.

Or, to be precise, price *was* an object, but only in the upside-down sense
that high prices were all to the good. In the eyes of the new tycoons, a gigantic
price for a painting was a sign of quality, first of all, and a demonstration of
their own status besides. The day of "the millionaire next door" had yet to
dawn. This was the era of the great Newport "cottages," and the explicit goal
of the new Medicis was to dazzle and outdo their rivals.

The great art dealers of the day, Colnaghi and Knoedler and Agnew,
swarmed the new collectors. The showiest dealer of all, London-based Joseph
Duveen, led the way. Early in his life, in the words of one biographer, Duveen
had "noticed that Europe had plenty of art and America had plenty of money,
and his entire astonishing career was the product of that simple observation."

Duveen and his rivals ransacked Europe for their eager clients, scooping up
paintings and tapestries, suits of armor and ancient manuscripts, canopied
beds and stained-glass windows. J. P. Morgan acquired not one but two
Gutenberg Bibles. William Randolph Hearst bought in such volume that his
trophies outgrew San Simeon, and he had to maintain several warehouses
(and a staff of thirty workmen) to store the overflow.

For the tycoons, this was sport, collecting as competition. In Boston, on
New Year's Eve of 1902, for example, Isabella Stewart Gardner unveiled the
Italian-style palace she had built to house her fast-growing collection of old
masters. She had been so worried that her secret might leak out early that
when she needed to test the acoustics of the music room in her new house, she
brought in singers from the Perkins Institute for the Blind.

Mrs. Gardner had, of course, acquired a Vermeer. (Her art advisor, the renowned Bernard Berenson, had once been reprimanded by the managing director of Colnaghi, the London dealer, for failing to take full advantage of his position. "It is important for both of us," the art dealer wrote, "to make hay while Mrs. G. shines.") Vermeer's American career had begun only three years before Mrs. Gardner's purchase, when the understated and lovely *Woman with a Water Jug* became the first Vermeer in an American museum. The painting was a gift to the Metropolitan Museum of Art from the New York banker Henry Marquand, in 1889. Marquand had bought it a year before, for $800 (roughly $16,000 in today's dollars), when it was thought to be a De Hooch.

Mrs. Gardner bought *The Concert* at an auction in Paris in 1892, discreetly signaling her bidding instructions to her agent with a handkerchief clutched in her tense fingers.* That purchase was early; in 1892 the fever for Vermeers had just begun to spike. Soon every millionaire worth knowing had thrown his checkbook into the ring. In 1900, Collis P. Huntington, the railroad tycoon, bequeathed Vermeer's *Woman Playing a Lute* to the Met. In 1901, it was Henry Frick's turn to buy, though the steel magnate kept his Vermeer for himself. This was *Girl Interrupted at Her Music*, which can be seen at the Frick today.

In 1907, J. P. Morgan got in on the game. Morgan collected art and other valuables on the grandest scale—Rembrandt, Hals, Van Dyck, among countless others—and at such a pace that sometimes he himself lost track. Shortly before the Vermeer purchase, Morgan's son had worked up his nerve to suggest that his formidable father might rein in his spending on art. "He did not object to my mentioning it," the son noted with relief, "which surprised me somewhat." He did not object, but he did not slow down.

At one point the elder Morgan sent a note to his librarian asking the whereabouts of a sculpture of Hercules, supposedly by Michelangelo. "This bronze bust is in your library," came the reply, "and faces you when sitting in your chair. It has been there for about a year."

Morgan had evidently paid just as little heed to the art world's excited chatter about Vermeer. When a dealer named G. S. Hellman showed him Vermeer's *A Lady Writing*, Morgan asked, "Who is Vermeer?"

Hellman explained. He spoke briefly about Vermeer's place in Dutch art

* The painting was stolen in 1990, along with eleven other paintings and drawings, in the biggest art theft ever. The total value of the stolen artwork was perhaps $300 million. "Tell them you'll be hearing from us," the thieves called to the guards as they left, but no one ever has.

and a bit more expansively about how few Vermeers there were and how coveted they were.

The price, Hellman said, was $100,000 (roughly $2 million in today's dollars).

"I'll take it," said Morgan.

VERMEER'S REPUTATION CONTINUED to soar in the early decades of the new century. In 1909, as if to highlight the new world's claim to the old world's art, the Met put together a show of Dutch masterpieces. Vermeer was outnumbered—among its 149 works, the show included 37 Rembrandts and 20 Halses, compared with only six Vermeers—but the art-loving public had found a new favorite.* "The rare and incomparable artist Vermeer," one newspaper reporter wrote, ". . . might be called the revelation and the bright, particular star of this grand collection."

Next came the critics and the book-buying public. In 1913, a painter named Philip Hale published the first American book on Vermeer. No superlative was too much. Vermeer was "the greatest painter who has ever lived," not just a "painter's painter" but "the supreme painter." He had "more great painting qualities and fewer defects than any other painter of any time or place."

By 1916, Vermeer had moved past renown and on to full-fledged stardom. *Ladies' Home Journal*, the most popular magazine in America, published color prints of two Vermeers—*Woman Holding a Balance* and *A Lady Writing*—for its 1.5 million readers. The prints came complete with framing instructions. For the price of a magazine, your home could have something in common with J. P. Morgan's mansion.

FROM THE AMERICAN side, the boom in the Vermeer market seemed like just another display of vitality in a proud new era. Europe took a less cheery view. As early as 1907, the Dutch press had rallied in support of Vermeer, their native son, and against the upstart Americans. The debate centered on whether Holland could raise the money to buy Vermeer's *Milkmaid*, which had come on the market when its longtime owner died. Editorial cartoons showed the milkmaid in her famous pose, stolidly attending to her work, while a lascivious Uncle Sam tried to drag her off with him.

* J. P. Morgan owned three of the Rembrandts in the show, four of the Halses, and one Vermeer, as well as many of the other pictures.

A Dutch art expert named Abraham Bredius, the director of the Maurit-shuis Museum, took a prominent role in the debate. Bredius, a wealthy collector and connoisseur as well as a museum official, talked about Vermeer as if the painter had been his personal friend. J. P. Morgan had designs on Holland's best-known milkmaid, Bredius warned, and the Dutch had to hang on to her. Eventually Bredius managed to get parliament involved. The state purchased the *Milkmaid*, and today she is one of the great stars of the Rijksmuseum in Amsterdam.

But despite one or two such setbacks, the battle over art seemed to be going the Americans' way. All six of the Vermeers in the 1909 show at the Met belonged to Americans, for example, and five of the six had been purchased within the previous dozen years.

And the trend was bound to continue, for the new collectors believed firmly that art had two astonishing, paired virtues—it advertised its owner's merits, and it was guaranteed always to increase in value. When Henry Frick wanted to praise an investment, he could conceive no higher praise than to compare it with art. "Railroads," Frick declared, "are the Rembrandts of investment."

THIS WAS A seller's market such as few had ever seen. The Americans had bottomless resources; they had a willingness, verging on eagerness, to pay record prices; they were desperately competitive; they all sought the same few brand-name artists; and they combined utter faith in their own judgment with a pristine and unsullied ignorance of art.

The frenzy of that market, which peaked in the 1920s, lured both dealers and forgers. The tricks they learned would come in handy a decade later, in the next episode of art mania, this one orchestrated by the Nazis.

—◆—

A GHOST'S FINGERPRINTS

By now scholars have devoted well over a century to ferreting out even the tiniest scraps of verifiable fact about Johannes Vermeer's life and career. What they have found would barely fill a folder. For art historians, this nearly blank record is a source of maddening frustration. For a con man, it was a priceless gift. Where nothing was known for sure, almost anything was plausible. For Han van Meegeren in particular, those gaps provided exactly the working space he needed.

We have no idea what Vermeer looked like, not even a hint from some traveler's journal about whether he was tall or short, a dandy with a taste for silk or a frump in a paint-spattered smock. He was a well-regarded artist in Holland in his own day, but if anyone ever painted his portrait, it vanished long ago. Nor did he fill that blank himself. We have seventy-odd Rembrandt self-portraits (and some forty self-portraits by Van Gogh), but not one by Vermeer.* "Rembrandt, the painter of mystery, is no mystery to us," remarked the painter Philip Hale a century ago, whereas "Vermeer—the painter of daylight—is engulfed in darkness."

We know Vermeer had a teacher, though we do not know who it was, and we do not know the names of his students, if there were any. (Historians can name *fifty* of Rembrandt's pupils.) We do not know the identity of any of the models in any of Vermeer's paintings, and can only guess if one of

* Unless we side with the historians mentioned in chapter 14, who believe that Vermeer painted himself in *The Procuress* and (from the back) in *The Art of Painting*.

those silent, contemplative women might have been the painter's wife or daughter or even a local girl who had been hired as a maid.

In only one document, and that one to do with a legal dispute, can we hear Vermeer's voice. At least in this single example, the great painter struck an impatient and far-from-serene note. He and several other artists had been called on to evaluate a collection of paintings supposedly by Michelangelo, Titian, and Raphael. Were they authentic? "Not only are the paintings not outstanding Italian paintings," Vermeer declared, "but, on the contrary, [they are] great pieces of rubbish and bad paintings."

What did Vermeer think of his own achievement? What goals was he striving to reach? We have not a single drawing or sketch or abandoned painting to give us a hint, and not a letter or a diary entry about his work. (Vermeer's dismissal of Italian "rubbish" is his only surviving comment on art, his own or anyone else's.) Would Vermeer have welcomed the words of the near-contemporary who, in 1699, hailed him as "full of warmth"? Or would he have preferred John Updike's awed praise of his "almost inhuman coolness"?

For better or worse, we have no choice but to confine our search for answers to the paintings themselves. Even here matters are not so simple, and not merely because we have only a tiny number of paintings by Vermeer to look at. The first step for an art historian studying Vermeer's career is to arrange the paintings in sequence, but, as noted earlier, only three paintings have dates: *The Procuress*, 1656; *The Astronomer*, 1668; and *The Geographer*, 1669. Thus every attempt at a chronology becomes an exercise in educated guesswork. Historians whose aim is to see how Vermeer changed and developed over the years find themselves caught. First they arrange Vermeer's paintings in an order that strikes them as fitting; then they use the arrangement they themselves have devised to draw conclusions about Vermeer. It is learned work but it bears a distressing resemblance to a dog chasing its tail.

VERMEER'S HOMETOWN, DELFT, has become a place of pilgrimage for art lovers. They find an unspoiled and lovely city, but they do not uncover many traces of Vermeer. At best the devotées can embark on a kind of shadow tour. They cannot explore the house where Vermeer grew up, which was torn down in the 1800s. As a distant second best, they can consult a detailed map of Delft from 1675, drawn by one Dirck van Belyswijck, which shows the house from above. Decades ago an eminent scholar believed he had located the house where Vermeer lived and worked, at 25 Oude Langendijk. That

house still stands, but the most thorough Vermeer archivist of all, the late J. M. Montias, showed that the correct house was not number twenty-five after all, but a long-since-gone house at the other end of the street, on the site of what is now a church. We are left to look at a drawing of that house, too, on the 1675 map.

The artists' guild that Vermeer belonged to is a shade less elusive—the Guild Hall was not demolished until 1875. The acolyte can study the original—a sharply detailed photograph has come down to us—or visit the rebuilt version, finished only this year. The buildings that Vermeer depicted in *The Little Street* vanished long ago, but the visitor to Delft can explore Piet Vonk's bicycle shop, which stands just to the left of the gateway shown in *The Little Street*. Even Vermeer's mortal remains have slipped from sight. He was buried in Delft's Oude Kerk, the Old Church, but the precise location has been forgotten. Someone made a best guess years ago and inscribed the name "Vermeer" on a stone. There tourists pay homage, though just what the stone conceals no one quite knows.

By coincidence Delft was Van Meegeren's city as well, in his student days. He attended the highly regarded Delft Institute of Technology, but he quickly found that the rigors of academic life were not for him. Students in Delft lived in rented rooms rather than dormitories. Ordinarily they moved often, but Van Meegeren seems to have found a landlady who let him bring in girlfriends, and he stayed put. For five years he lived within a few hundred yards of Vermeer's old neighborhood, above a store that today sells stuffed animals.

VERMEER WAS BORN in 1632, a generation after Rembrandt and two generations after Frans Hals. His father was an innkeeper who dabbled in art, though art in seventeenth-century Holland did not carry the cachet it has today. Rubens and Van Dyck and Velasquez might have won honors and riches elsewhere in Europe, the great Dutch historian J. H. Huizinga wrote, but in Holland, Vermeer and his peers were "generally ignored or completely forgotten." Painters were tradesmen who worked with their hands. Poets, who worked with words rather than pestles and powders, were the figures held in esteem.

The biographical scraps we do have serve mainly to deepen the Vermeer mystery. Certainly they do not seem to portend a career as art's preeminent connoisseur of calm and quiet. Vermeer's grandfather, for example, was a

watchmaker who strayed into coin forging. He managed to stay just ahead of trouble, but two of his accomplices were convicted and beheaded.

A bit more is known about Vermeer's own life, at least in outline. He married at age twenty-one and lived and worked in the house of his mother-in-law, who had originally opposed the match. He and his wife raised fifteen children (four died as infants). It is hard to picture his household as a refuge from the world's hurly-burly.

Eight months after his marriage, Vermeer registered with the Guild of St. Luke, a kind of trade union of sculptors, painters, weavers, and even booksellers. At age twenty-one, he officially became a "master painter." (In Vermeer's time the number of master painters in Delft ranged between thirty and fifty.)

For aspiring painters of the day, guild membership was mandatory. Vermeer had served a six-year apprenticeship—this, too, was mandatory, and it is only in this indirect way that we can be certain he had formal artistic training. Vermeer's signature is number seventy-eight in the guild's registry book; Carel Fabritius was number seventy-five, Pieter de Hooch, number eighty. The initiation fee was six guilders, roughly a week's pay for a manual laborer. Vermeer scraped together one guilder and a few cents. Two and a half years would pass before he paid off the remaining four-odd guilders.

In the decades to come, Vermeer would rise to a position as a member of the guild's board. More important, he painted *A View of Delft, The Girl with a Pearl Earring, The Milkmaid,* and some thirty more. The work met a respectful welcome, but no one was bowled over. Certainly no one spoke of Vermeer as a genius. But his work commanded high fees, and it continued to do so in the years shortly after his death, in 1675. At an Amsterdam auction in 1696, for example, twenty-one Vermeers sold at an average price of 72 guilders apiece. The *Lacemaker,* now at the Louvre, brought only 28 guilders, but the *Milkmaid* brought 175 guilders, and *A View of Delft* the highest price of all, 200 guilders.

Those prices were near the peak of what any artist in Delft earned. Two hundred guilders was a substantial sum, by the reckoning of Vermeer's biographer Anthony Bailey about a year's pay for a Dutch sailor of the day. The problem is that it was also about a year's pay for Vermeer, because he turned out so few paintings.

One Dutch scholar has made a careful estimate of how productive painters were in Holland's Golden Age—to earn a living, he calculated, most artists needed to produce one or two paintings a week. Rembrandt did not achieve quite that pace, but he completed about twenty-five paintings a year, year in

and year out. The exact tally is in dispute, as scholars debate which paintings are by Rembrandt himself and which by his followers, but the current estimate is on the order of 350. Vermeer painted only one tenth as many, a total of thirty-five or thirty-six paintings over the course of his entire, twenty-year career.* To boost his income, he worked as an art dealer, and that second job may have brought in more money than did his own paintings.

In 1672, France invaded Holland, and Holland fell into an economic depression. Perhaps because times were hard, perhaps for personal reasons, Vermeer could no longer sell his work. For three years, he sold not a single painting. He fell into "decay and decadence," his wife later declared, in a formal statement that was a mandatory part of the bankruptcy process. "In a day and a half," she went on, "he had gone from being healthy to being dead." Vermeer was forty-three.†

HIS NAME WOULD be lost almost until the age of the Impressionists. "The greatest mystery of all," in the words of the historian Paul Johnson, "is how his works fell into a black hole of taste for nearly two hundred years. He is now more generally, and unreservedly, admired than any other painter."

The notion that Vermeer fell into total obscurity has grown deeply entrenched. After the 1696 auction, writes John Updike, Vermeer's paintings "passed from owner to owner in the following centuries for less, ordinarily, than

* In July 2004, a buyer at a Sotheby's auction in London paid $30 million for what many believe to be the thirty-sixth known painting by Vermeer, *Young Woman at a Virginal*. The painting had been attributed to Vermeer at least since 1904, but if it is by Vermeer at all, it is not one of his best. In 1948, just after the Van Meegeren revelation, the highly regarded art historian A. B. de Vries dropped *Young Woman at a Virginal* from the list of definite Vermeers. The work lingered in limbo until the 2004 sale.

The painting is not by Van Meegeren—the 1904 date rules out that possibility—but the experts disagree vehemently as to whether it is by Vermeer. On the one hand, extensive scientific tests show that several of the paints match those used by Vermeer, and the canvas matches that of the Louvre's *Lacemaker* so closely that the two may have come from the same bolt of cloth. Those observations do not rule out forgery, since forgers can obtain authentic materials, but they seem to point to a seventeenth-century artist.

Even so, the experts are divided. Albert Blankert is one of the most forceful skeptics. "It has elements taken from Vermeer's pictures," Blankert says, "but the anatomy of the woman is wrong and the hands look more like pigs' trotters. It is an imitation."

† To pay off a debt she owed the baker, Vermeer's widow gave him *Lady Writing a Letter with Her Maid* and *The Guitar Player*. Today *Lady Writing a Letter* is especially revered. "Everything of Vermeer" is in that painting, in the judgment of the art historian Lawrence Gowing. Nowadays any Vermeer would command a fortune, but the price for *Lady Writing a Letter* would be astronomical. Vermeer owed the baker 617 florins, not quite $80 in today's currency.

the price of a suit of clothes." An old suit might have received gentler treatment than an old master, one standard account tells us. "An eighteenth-century owner of a Vermeer would not have thought a great deal more about hiring another painter to change the picture than a housewife would think today about having an easy chair re-upholstered."

The art historian Albert Blankert was the first to show that these gloomy tales had it only half right. In the 1700s, in particular, Vermeer's *work* never fell out of favor, though his name did. Collectors with the star power of the Duke of Brunswick and King George III bought Vermeers, although the paintings were mistakenly attributed to better-known artists. "Historical accuracy was not the strong point of eighteenth-century collectors and connoisseurs," Blankert notes. "Their taste, however, was superb."

Part of Vermeer's problem, in the days before photographs and coffee-table books and great museums, was his tiny output. With so few works, and with those few scattered and out of sight in private collections, the name "Vermeer" conjured up only the vaguest associations. Connoisseurs at the time had few tools but memory. Small wonder that Vermeer's paintings were assigned to a host of his more famous and more prolific peers, among them Metsu and De Hooch and Rembrandt.

Worse still, a long list of Dutch painters all seemed to be named Vermeer or Van Der Meer or something nearly identical. In Haarlem, two landscape painters were both named Jan Van Der Meer. Which was the father and which the son? What about the Utrecht painter named Johannes Van Der Meer? Was he the same person as the Delft artist named Johannes Vermeer, who painted ladies reading letters? No one knew, and not many cared.

THE VERMEER REVIVAL began in 1866, with the publication of three articles by a French art historian named Theophile Thoré-Bürger. (The odd name reflected the politics of the day. Thoré had been exiled from France for his part in a failed coup. While in Belgium trying to dodge Napoleon III's secret police, he adopted the pseudonym William Bürger. The word *Bürger*, German for "citizen," was intended as a sly allusion to Thoré's democratic views.) The long-neglected Vermeer was an "astounding" painter, wrote Thoré-Bürger, so much so that the historian dared to pose an unthinkable question: "After Rembrandt and Frans Hals, is this Van Der Meer . . . one of the foremost masters of the entire Dutch School?"

Thoré-Bürger's use of "Van Der Meer" is significant, as a reminder of how

little grasp anyone had on Vermeer. (Thoré-Bürger switched, haphazardly it seems, between "Van Der Meer" and "Vermeer.") In 1816, the authors of a highly regarded history of Dutch painting had known of only three paintings by Vermeer, and they had *seen* only two: *The Milkmaid* and *The Little Street*. Fifty years later, Thoré-Bürger still found Vermeer such a riddle that he dubbed him "the Sphinx."

But Thoré-Bürger's dogged hunt for works by Vermeer paid off in find after find. He crisscrossed Europe, burrowing into archives in search of dusty catalogs from forgotten auctions and scrambling up ladders to look at paintings hung in neglected corners. In Amsterdam he found *The Milkmaid* and *The Little Street*, both attributed to other painters. In Dresden he discovered *The Procuress*, attributed to "Jacques Van Der Meer, of Utrecht." In Brunswick he turned up *Woman and Two Men*, attributed to "Jacob Van Der Meer."

As GOOD AS Thoré-Bürger's eye was, this was difficult work. It is one thing to rhapsodize over a painting in a gilt frame on a museum wall, conspicuously labeled, and something else to recognize a prince dressed in a beggar's rags. At times Thoré-Bürger's enthusiasm for Vermeer led him astray. As he announced find after find, one fellow connoisseur sneered that "nowadays Mr. Bürger sees Delft just about everywhere."

Thoré-Bürger wrote enthusiastically about a "delightful" outdoor scene called *Rustic Cottage*, for example, that was "undeniably a landscape by Vermeer of Delft." But this theory was soon debunked—and Thoré-Bürger held up to ridicule—by a cocky young scholar and collector named Abraham Bredius. We've met Bredius before, agitating to keep *The Milkmaid* in Holland and out of the grasping hands of the Americans. We'll meet him again.

Today the *Rustic Cottage*, no longer assigned to Vermeer, is at most a footnote in art history. Bredius, on the other hand, progressed from this small triumph to a career as one of the most renowned and self-assured authorities on Vermeer.

The *Rustic Cottage* mistake was easy to make. To go wrong in the opposite way—to look at a Vermeer and say "not Vermeer"—was easy, too. Even when Thoré-Bürger restricted himself to a handful of indisputable Vermeers, he found himself amazed and bewildered by their variety. In the cityscape called *A View of Delft*, for example, the paint was slathered on thickly, and in the domestic interior called *Woman in Blue Reading a Letter*, it was almost transparent. "This devil of an artist must no doubt have had several styles," Thoré-Bürger grumbled.

Nor could mundane considerations like signatures resolve the riddles of brushwork and style. Where his eye told him "Vermeer," Thoré-Bürger waved signatures aside. (Signatures on paintings don't count for much with connoisseurs, who are always wary of the shenanigans of crooked dealers and status-conscious collectors.) Thoré-Bürger attributed several paintings clearly signed "J. Vrel" to Vermeer. "Hardly a Dutch name," he wrote, "nor is it found in any other language. Is it an abbreviation? A contraction? I do not know." Jacobus Vrel, it turned out eventually, was a painter in his own right, though he was no Vermeer.

Thoré-Bürger made mistakes, but he got the big story right—Vermeer was as good as Thoré-Bürger claimed. And Thoré-Bürger did more than simply argue his case in the press. He also purchased four Vermeers, which nowadays no one but a Bill Gates could manage, for the equivalent of a few thousand dollars each in today's dollars. They were *Woman with a Pearl Necklace*, now at the Staatliche Museum in Berlin; *The Concert*, stolen from the Gardner Museum in Boston in 1990 and still missing*; and *Young Woman Seated at a Virginal* and *Young Woman Standing at a Virginal*, today both at the National Gallery in London.

IN HIS THREE essays, Thoré-Bürger assigned seventy-three works to Vermeer. This was vastly too hopeful. Today the accepted number of Vermeers is only half that figure. Thoré-Bürger's essay ran with nine illustrations depicting works by Vermeer. Only four of the nine were in fact Vermeers.

The neglect of Vermeer had been an "injustice," Thoré-Bürger wrote, and he had no illusion that he had said the last word. On the contrary, he urged his fellow art lovers to help him in the search for more Vermeers. "I hope that researchers in all countries will have the chance to discover new paintings by Van Der Meer," he wrote, "and I will be grateful if they will communicate their discoveries to me."

For forgers, Thoré-Bürger's rediscovery of Vermeer opened the gates to the best of all possible worlds. What could be a more tempting combination than swooning enthusiasm for Vermeer coupled with vast ignorance of what counted as a Vermeer?

Han van Meegeren belonged to a later generation, but Thoré-Bürger had

* It was at an auction of Thoré-Bürger's paintings, after his death, that Isabella Stewart Gardner bought *The Concert*.

helped to propel Vermeer into the ranks of international stars, and he would stay there. Van Meegeren and his brethren welcomed Thoré-Bürger's drumbeating on Vermeer's behalf, but they had no desire to rummage through old auction house records. If collectors and connoisseurs wanted new paintings by Vermeer, there were easier ways to provide them.

Part Three

The Selling of Christ at Emmaus

22

<div align="center">—◦•◦—</div>

TWO FORGED
VERMEERS

As Vermeer's reputation soared ever higher, the frenzy to own a Vermeer grew in proportion. With demand so high, it was inevitable that someone would find a way to increase the supply. Suddenly, in the 1920s and '30s, after a near-drought that had lasted two and a half centuries, Vermeers began popping up everywhere.

The renowned art dealer René Gimpel kept a diary that covered the years between the world wars. References to newfound Vermeers dot the pages. On June 9, 1923, for example, Gimpel wrote excitedly that "a new Vermeer has just been discovered in Paris." (In 1929, he appended a somber footnote: "It is a frightful picture, probably by [the minor French painter] Bourdichon.")

Two weeks after Gimpel's find, the Paris office of Duveen Brothers, the biggest art dealer of the day, sent a cable to their New York branch: "VERMEER PORTRAIT," it shouted. "WONDERFUL, REPRESENTING PLEASING YOUNG MAN ABOUT 18 YEARS OLD, LONG CURLY CHESTNUT HAIR AND BROWN EYES."

In Paris and London and New York, the art world buzzed with excited chatter about Vermeer sightings. In August 1927, Duveen found a new Vermeer of a "girl doing lacework." In January 1928, Gimpel found "a new Vermeer" of his own. In February, he was at it again. "I've discovered another Vermeer," he exulted. In October 1929, it was Duveen's turn again. The latest Vermeer depicted a girl holding a cat. "Certainly very well painted and most attractive in every way," the Duveen agent reported, but he went on to say that one expert had judged the picture "too dainty, sweet and soft in conception and execution to be a Vermeer." This was discouraging, but the "picture so

satisfactory in many ways and so desirable if right," the cable went on, "that we are wiring Schmidt-Degener come see."

Schmidt-Degener was a Dutch Vermeer connoisseur with a reputation, in one scholar's words, as "an oracle of art-historical insight." He would eventually become one of the biggest fish snared in Van Meegeren's net. When Duveen presented him with the "girl with a cat" and asked if it was indeed by Vermeer, Schmidt-Degener spent a full day studying the picture. Then he delivered his verdict. The picture was probably the earliest Vermeer known, he announced excitedly, and he pointed out, one by one, the features that had convinced him. Delighted with this assurance that their painting was not kitsch but a masterpiece, Duveen telegrammed Schmidt-Degener's glad tidings to their New York office: "WE MUST SAY," they added cheerily, "THAT WE QUITE AGREE WITH HIM."

For today's art lovers, these allusions to paintings by Vermeer of curly-haired young men and girls holding cats don't conjure up anything, for the very good reason that Vermeer never produced such paintings.* Most of the crop of supposed Vermeers that turned up or changed hands in the twenties and thirties were authentic paintings by lesser artists that had been misattributed, sometimes by mistake and sometimes with a wink. Some were outright fakes. One or two may even have been genuine. In such a feverish climate, these discoveries and near-discoveries inspired more hope than cynicism. Every neglected painting in an attic or storeroom gleamed brighter, burnished by the possibility that it, too, might be a long-lost Vermeer.

EACH TIME A new Vermeer appeared, the discovery sparked a round of breathless coverage in the art press. In 1927, for example, the art historian Seymour de Ricci wrote an ecstatic essay about the Vermeer of a "girl doing lacework" that Duveen had just found. (The essay's title, "The Forty-First Vermeer," itself testifies to Vermeer fever. As noted earlier, scholars today put the number of genuine Vermeers at thirty-five or thirty-six.) The Duveen *Lacemaker* shows a large-eyed, timid young woman looking toward the viewer over her left shoulder.

"It was not without emotion that I held, unframed, in my hands, this precious canvas," wrote De Ricci. He described his slow, loving examination of

* The "girl doing lacework" that Duveen found in 1927 is *not* the tiny, exquisite *Lacemaker* in the Louvre. That painting, which is indisputably a genuine Vermeer, had been in the Louvre since 1870.

the painting. "At leisure, I made it reflect the setting sun, and little by little the beauties of detail showed up beneath my eyes. The analysis of a work so complete in its simplicity demands some patience from the collector. The eye is seized firstly by the impression of the ensemble, by the grace of the subject, by the general harmony of the tones."

Even then, De Ricci had yet to exhaust the splendors of this glorious painting. "Only works of certain great masters stand up under this severe test," he wrote. "The slightest defect of a painter appears under such profound examination. The artist, in this case, shows himself singularly the master of his tools; even a monochrome reproduction . . . will permit us to unify the pleasure based on our admiration and the perfect technique of this infinitely charming work."

De Ricci's tone was as important as the message. Not a hint suggested the possibility that the "infinitely charming work" might be a fake. All through the twenties and thirties, De Ricci and his fellow connoisseurs turned out similar essays, which moved back and forth between praise of the painter, for his talent, and of the critic himself, for his discernment. The great connoisseurs all had utter faith in their "eye." All one's peers were prone to error— that was part of the fun—but no expert ever doubted his own talent. Fakes, like car accidents, were disasters that happened to other people.

But the *Lacemaker* that so moved De Ricci *was* a fake, and a poor one. The painting belonged to Andrew Mellon, the leading American collector of the 1920s. Mellon had purchased his first Vermeer, *Girl with a Red Hat*, in Paris in 1925, for $290,000 (about $3.2 million today). Two years later he bought two more Vermeers, or so he thought: *The Lacemaker* and *The Smiling Girl*.

Mellon was an immensely wealthy banker and a major force in Washington— he served as Secretary of the Treasury for presidents Harding, Coolidge, and Hoover—but he did not fit anyone's image of a power broker. A slender man staggering under the weight of a bushy mustache, Mellon looked, according to one contemporary, like "a double-entry bookkeeper afraid of losing his job." He spoke so rarely and so softly that he was called the Apostle of Silence.

Mellon kept the *Girl with a Red Hat* on the piano in his enormous Washington apartment. In 1936, at age eighty-one, he wrote to President Roosevelt offering to leave his fortune and his art collection—including all three of his Vermeers—to found a new museum, the National Gallery of Art.

Mellon had not revealed any interest in art until about the age of forty, when he made a series of holiday visits to Europe, but when he took up

collecting, he went at it with vigor. The major dealers fought to win him as a client. Duveen, never one to wait for business to come to him, bribed Mellon's servants to keep him informed of their master's comings and goings. This was not casual eavesdropping. "Duveen," one biographer tells us, "kept a dossier on Mellon's movements, his visitors, his art collection, his dinner parties, and whatever thoughts were heard to escape from his lips." Duveen's spies hovered at the Treasury as well as in Mellon's home. One snoop gathered up Mellon's discarded notes and letters at the end of every workday. By the time Mellon had walked the short distance from the Treasury to his home in Dupont Circle, the contents of his office wastebasket were on the train to Duveen headquarters in New York.

THE FIRST DOUBTS about the Duveen *Lacemaker* were voiced as early as 1933, but the skeptics took decades to win the argument. In 1936, when Mellon donated his *Lacemaker* to the American people, the National Gallery labeled it a Vermeer; in 1973, it was by a "Follower of Jan Vermeer"; in 1978, by an "Imitator of Jan Vermeer." Mellon's *Smiling Girl* turned out to be a fake, too, although half a dozen of the leading experts of the day had endorsed both it and *The Lacemaker*. In recent years the National Gallery has banished the fake *Lacemaker* and *The Smiling Girl* to a "Special Collection," where the ordinary museum visitor will not see them.

Today the reigning Vermeer authority at the National Gallery, Arthur Wheelock, acknowledges that it is hard to see why these two fakes so impressed his predecessors. Wheelock is a soft-spoken scholar whose natural bent is understatement, but these "Vermeers" bring him as close as he comes to slapping his forehead in astonishment. "It's just impossible to believe that the two forgeries here could be Vermeers," he says. "I take first-year students to look at these paintings, and they say, 'Oh, eeeuw, they're *ugly!*' They really are not very good paintings, and they have nothing to do with the artist as we understand him.

"These students have only been studying art for six months, and *they* find it inconceivable. But when these paintings were first discovered, people used exactly the same words to describe them that I would use for a painting that I was really passionate about."

Wheelock, who has done extensive detective work in unraveling the true story of the two fake Vermeers, believes the same forger painted both pictures. That forger, he argues, was none other than Han van Meegeren's old mentor, Theo van Wijngaarden.

THE EXPERT'S EYE

Van Wijngaarden did not have as much painterly skill as Van Meegeren, but he did know how to reel in a sucker. His strategy could hardly have been simpler. He sprinkled his forgeries with touches that shouted "Vermeer" or "Hals" and he spun vague but romantic stories about how he had happened on the finds of a lifetime.

The jumble of allusions should have given the game away at once. Just as a person telling a story loses credibility if he drops names by the bucketful, a forger must not copy everything in sight. A single "quotation" is enough. Or so the experts always say when they talk about how forgers reveal themselves. But often they ignore their own warnings. Listen to Wilhelm Valentiner, an eminent art historian and for nearly twenty years the editor of *Art in America*. In 1928, Valentiner published an essay titled "A Newly Discovered Vermeer." Despite the title, Valentiner's subject was not one new Vermeer but two, Mellon's *Lacemaker* and his *Smiling Girl*.

No one knew yet that both paintings were fakes. Valentiner began by extolling their virtues while mocking those of his colleagues who had been taken in by non-Vermeers that had been attributed to Vermeer. "To hear almost every year of a newly discovered Vermeer may cause suspicion," Valentiner declared in his essay's opening line. That suspicion, he hurried to say, was justified. Many of the paintings attributed to Vermeer "cannot stand serious criticism."

Like all the critics who trumpeted their finds, Valentiner radiated smugness. "It seems that it should be an easy matter to recognize with certainty a

work by Vermeer," he went on, and yet, he regretted to say, many of his colleagues had somehow wandered astray. They had little excuse, for "after one knows a few works by the master the others are much more easily recognized than is the case with almost any other great artist of the past."

Vermeer's paintings shared an unmistakable family resemblance, Valentiner explained, and he spelled out the features that made identification so easy. The same curtains recurred in picture after picture, and so did the maps on the wall, and the glasses on the table. Vermeer repeated himself so often, Valentiner went on, that "newly discovered works by him frequently seem like puzzle pictures composed of pieces taken from different groupings in known paintings by him."

Then Valentiner took cart and horse and laboriously harnessed them the wrong way around. He compiled a long list of features that Mellon's two "Vermeers" shared with an undisputed Vermeer, *Woman and Two Men*. In all three, for instance, the head of the central figure was turned the same way in relation to the body, and the eyes were large and directed straight toward the viewer. The observations were correct. Only the conclusion Valentiner drew from them—the shared features "make certain that the same master is here at work"—was flawed.*

Valentiner picked out one feature of the fake *Lacemaker* for special mention. Here, too, he went out of his way to praise the very thing that should have set off alarms—the painting looked peculiarly modern. For forgers, the greatest stylistic challenge is time-travel. Artists and writers of every generation leave behind countless subconscious signs that reveal the era when they lived and worked. Look at a Dickens novel. The "choices" that Dickens made without thinking—the size of his book, the length of the sentences, the nature of the plot, the topics taken up and the ones scrupulously avoided—all signal "Victorian England." For a modern-day reader (or art lover), it takes a bit of effort to engage deeply with a work created centuries ago. When we find a work of art from long ago that seems so congenial and inviting that it might have been crafted only the other day, we should raise a cautious eyebrow.

And yet, consider the dramatic conclusion to Valentiner's essay. In his final sentence he highlighted two qualities above all others that made *The Lacemaker*

* Arthur Wheelock points out one especially silly borrowing—the forger who painted *The Lacemaker* copied the basin from Vermeer's *Woman with a Water Jug*, now in the Met. No one asked why a basin had turned up in a depiction of lacemaking.

a masterpiece. First, "The face of the girl is unusually pretty, as the features are smaller than in some of the artist's other types." Vermeer had painted a girl, in other words, who suited modern taste. In a second way, too, Valentiner noted approvingly, Vermeer had transcended the bounds of his own era. He had managed "a subtlety in the distribution of light and diffusion of color rarely to be found in the genre paintings of Holland in the seventeenth century."

It was as if Vermeer lived in the same world as twentieth-century art connoisseurs.

THE TWO MELLON "Vermeers" that ended up in the National Gallery were not Van Wijngaarden's first old masters. He had begun his forgery career not with Vermeer but with Frans Hals, and he had conned an expert even more eminent, and even more sure of himself, than Valentiner. Han van Meegeren would heed every detail of that early fraud.

Or perhaps he did more than watch and learn. It may well be that the fakes that Arthur Wheelock attributes to Van Wijngaarden were in fact Van Meegeren's all along. The division of labor between the two forgers may have been as Wheelock suggests, or Van Meegeren may have done the painting and Van Wijngaarden the "restoring," in this case not repairing the signs of age but simulating them. The important point is that the two swindlers' partnership was hugely successful. It would be a decade before Van Meegeren created the forgeries that would make him famous, but already the money was pouring in.*

The Frans Hals forgery ensnarled a Dutch art historian named Cornelis Hofstede de Groot, a dry stick of a man with a great reputation as a connoisseur. De Groot had the prissy, pedantic manner of a small-town librarian, but he knew the works of the great Dutch painters intimately.† The author of countless articles and a ten-volume opus, *Descriptive and Critical Catalogue of the Works of the Most Outstanding Dutch Painters of the Seventeenth Century*, De Groot's specialty was a kind of pruning of the artistic garden. The masters of

* In a discussion of the *Smiling Girl* and the *Lacemaker*, Mellon's forged Vermeers, the historian Ben Broos remarks that "it appears that there was a kind of Vermeer factory in operation at that time."

† There is no formal convention for shortening double-barreled Dutch names. Hofstede de Groot's Dutch peers would have called him Hofstede. Duveen and American art dealers called him De Groot, as have I.

Holland's Golden Age had attracted a great many imitators and pupils. De Groot focused much of his energy on sorting out whether a particular painting was a genuine Rembrandt or Hals, say, or whether the supposed masterpiece betrayed the hand of a mere follower. It was work that called for deep knowledge and unshakable faith in one's judgment.

In 1924, De Groot published a short article with the enticing title "Some Recently Discovered Works by Frans Hals." The first of these newfound paintings was a *Merry Cavalier*, a bleary-eyed, laughing man of the kind Hals painted so often. But this particular painting was not just another Hals, according to De Groot, but a "genuine and extraordinarily beautiful" example of his work, "magnificent in the contrast of colors and in a perfect state."

De Groot happily recalled his first sighting of the painting. "This little gem was shown to me in April, 1923," he wrote, "by a collector at The Hague." That supposed collector was Theo van Wijngaarden. After their meeting, De Groot's life would never regain its previous tranquillity.

In 1924 an auction house bought the *Merry Cavalier*, which came accompanied by a certificate of authenticity written by De Groot. Soon after the purchase, the auctioneers contacted De Groot with disturbing news—it appeared that the Hals was a modern forgery! They had paid a great deal of money for the painting, they went on, and they wanted De Groot to reimburse them for one third of the cost. De Groot refused. He had vouched for the authenticity of the painting, that much was true, but he was "not responsible for the amount paid by other parties."

The case went to trial: on one side, the auction house; on the other, the middleman who had sold them the painting. The charge: fraud. De Groot declared, as his expert opinion, that the painting was a genuine seventeenth-century work, in fact a masterpiece, by Frans Hals.

That anyone would question De Groot's opinion was insulting; that he would find himself caught up in a trial was unthinkable. The great man bellowed in outrage. If he was wrong, he roared, he would take all the paintings he owned and give them away, free, to Holland's museums. All he asked from his challengers was that they agree, if *they* were wrong, to present those same museums with a check for a mere one tenth the value of De Groot's art collection. And not only that. If he was wrong, said De Groot, then he promised "never to express another word, either in writing or verbally, about the genuineness of an unknown Frans Hals."

But he could not be wrong. He had studied art for forty years, he proclaimed

(and he noted, in Latin, that those forty years had been "not without glory"). If he was wrong, "I should have to admit that all art history and stylistic criticism are mistaken and that there is no basis for their existence."

OF COURSE, HE *was* wrong. An array of scientific tests carried out in the course of the trial left no doubt. Chemical analysis of flecks of paint showed that the blue in the merry cavalier's coat was artificial ultramarine, first used in 1826. A different blue used in the picture's background dated from 1820. The white of the cavalier's collar was zinc white, manufactured only after 1781. Hals died in 1666.

There was other evidence, too. The nails that held the canvas to its wooden stretcher were modern, quite unlike the nails used in the 1600s. (Cheap, machine-made nails came into common use only around 1850. Careful forgers reuse nails salvaged from antique furniture.) The nails were not decisive in themselves—a modern restorer might have replaced old nails with new ones, which is precisely what De Groot claimed that Van Wijngaarden had done. But the nailheads turned out to be paint-spattered, and *that* was tell-tale. Why? Because it meant that the twentieth-century nails had been hammered into position before the forger set to work.

The scientific tests revealed, as well, that the forger had devised an audacious, but easily detected, way to give his paint the hardness of a centuries-old work. Knowing that the standard test for hardness was dabbing a painting with alcohol to see if any paint came off, the forger had concocted a gummy, glue-y paint that dried quickly and passed the alcohol test with ease. The problem, it soon turned out, was that this new paint failed an even simpler test—if you dipped a cotton swab in water, the paint came off on the swab as soon as you touched it. An authentic old painting would never soften in that way. The forger's gamble was that if anyone tested his painting at all, they would stick with the one test in standard use.

Like the James Thurber character who huffed that "mere proof won't convince me," De Groot found himself unimpressed by the evidence. He could not explain how modern paint had turned up in an old painting, he conceded, but no matter. "As I am firmly convinced of the authenticity and antiquity of the picture, I feel confident that a solution for this problem will be found." The so-called evidence, De Groot insisted, merely demonstrated "the inexpertness of the experts." He was the victim of an injustice "so enormous . . . that it could be compared only with that committed in the Dreyfus case."

Seeing where things were heading, De Groot settled the case before a verdict could be handed down, by buying the *Merry Cavalier* for himself. Then he did two even more remarkable things. First, in 1924, the same year as the *Merry Cavalier* fiasco, he bought and authenticated *another* newly discovered Frans Hals. This one, a picture called *A Boy Smoking*, showed a cheerful long-haired boy with a pipe. It was "probably painted about 1625–30 in the master's freest style," according to De Groot. "The picture has great attractiveness as a subject and marvelous handling of the brush, every stroke of which can be counted."

De Groot purchased *A Boy Smoking* "from a dealer at The Hague," just as he had purchased the *Merry Cavalier* from "a collector at The Hague." Three guesses.

De Groot's second surprise emerged the next year, in 1925. He might have gritted his teeth and waited out the embarrassing publicity that the trial had stirred up. Instead, De Groot gave the controversy new life by publishing an angry booklet attacking his critics and defending his own expertise. It was entitled *True or False? Eye or Chemistry?* and proclaimed that the only way to resolve questions of artistic authenticity was by relying on the connoisseur's eye. Scientific investigations were beside the point at best and misleading at worst. "In the art of painting," wrote De Groot, "the eye must be the benchmark, as in music it is the ear. Neither the tuning fork nor the test tube will do."

A forger could scarcely imagine a more welcome message.

24

A FORGER'S LESSONS

Even a man less cynical than Han van Meegeren might have pricked up his ears when his chum Theo van Wijngaarden bragged about his latest scams. Perhaps the two con men worked in tandem; perhaps Van Wijngaarden showed the way. (The author of one of the best essays on Van Meegeren, Hope Werness, declares outright that it is "all but certain that the two 'Hals' were painted by Van Meegeren.") In any case, Van Wijngaarden's younger, more ambitious colleague quickly surpassed his partner.

Van Meegeren drew three lessons from those early days peddling fake old masters. The first had to do with provenance, the history of a painting's passage from the hands of the artist who created it through all its successive owners. Or so it works ideally, though in practice the record may have long gaps.

As we have seen, the British con man John Drewe took considerable trouble in preparing histories for his forgeries. That is a time-honored strategy, for mundane details like bills of sale and identification numbers on a frame often seem objective and authoritative in a way that a connoisseur's opinion cannot. In 1799, for example, the city of Nuremberg agreed to lend a famous self-portrait by Dürer to a painter named Abraham Küffner so that he could make a copy. Dürer had painted himself looking straight at us, a handsome, self-assured young man, twenty-eight years old, with lovingly tended hair cascading down to his shoulders. The painting was on a wooden panel about half an inch thick.

Küffner sawed the panel in half by cutting parallel to the picture plane, as if he were slicing a thick slice of bread into two thin slices. That left him with

two pieces of wood, one with the Dürer portrait on its front and the other with various seals and identification marks on its back. Then Küffner turned his attention to the panel with the authenticating seals. He forged a copy of the Dürer on its front side and sent it to the owners, with heartfelt thanks for their generosity. He kept the real Dürer for himself.

Nuremberg put its forged Dürer on display. No one noticed anything odd. The scheme might never have been uncovered if, six years later, Küffner had not sold his genuine, stolen Dürer to a collector. That buyer promptly re-sold the picture, and the new owner put his prize on exhibit in Munich. The proud burghers of Nuremberg soon learned, to their dismay, that their cherished Dürer was on display in two places at once.

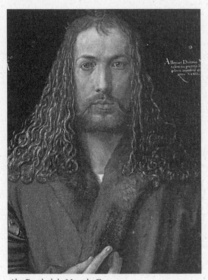

Alte Pinakothek, Munich, Germany *Germanisches Nationalmuseum, Nuremberg*

Left, Dürer self-portrait detail; *right*, forgery

The first lesson to be learned from the Hals trial was that there was no need to go to all that trouble. Detail work was not Van Wijngaarden's style. He preferred the grand gesture. His account of how he had come into possession of the *Merry Cavalier*, the Frans Hals forgery at the center of the De Groot court case, was so vague that it might as well have begun "Once upon a time, in a land across the sea . . ." Van Wijngaarden's story, in the prosecutor's summary, was that "he had had the good fortune to discover a collection of seventeenth-century paintings in the possession of an old family to whom he

was distantly related, and this painting had come from that collection."

It should never have worked. For obvious reasons, the rule of thumb is that the more expensive the painting, the more important its provenance. But Van Wijngaarden had proved that you could take the opposite route and succeed beautifully, provided you could find a buyer too eager or too sure of himself to bother with paperwork and background checks. Rather than spell out every detail in a fanciful pedigree, Van Wijngaarden outlined a fairy tale and let his eager-to-buy, eager-to-believe audience conjure up its own fantasy.

When the time came, Van Meegeren would recycle almost exactly the same strategy.

THE SECOND LESSON Van Meegeren drew from the Hals case was to pay attention to the science. He and Van Wijngaarden had been far too reckless. To try to palm off a painting that could be unmasked by anyone with a damp rag was just silly. Van Meegeren threw away tens of thousands on parties and call girls and he drank himself into oblivion, but in some ways he was a serious man. Van Wijngaarden's strategy, such as it was, depended on the experts' carelessness. As his Bakelite experiments showed, Van Meegeren preferred a more active role. He could cross his fingers and hope that no buyer would perform a test that would unmask him. He chose instead to do his best to ensure that his forgeries would pass the tests likely to come their way.

We have already discussed the resistance to science in the art world. The connoisseurs' skepticism about science sounds like old-fogeyism, but as we have seen, it has some merit. De Groot might have chosen to emphasize the limits of science's usefulness. Instead, he rejected science altogether. That extreme position, based largely on wounded vanity, left him dangerously exposed. The discovery of paint from 1820 in a work purportedly created in 1620 should have struck him as noteworthy.

For Van Meegeren and his fellow forgers, hardheadedness like that on the experts' part was welcome news. It led directly to the third of the Hofstede de Groot lessons.

THE LAST LESSON was to get an expert on your side. Since science can never give a painting a definitive thumbs-up, the determination that a painting is

truly a Rembrandt or a Vermeer will remain a judgment call.* The greatest asset a forgery can have is an authority's endorsement.

Fooling those experts isn't easy, but in the struggle between forger and expert, the forger has one built-in advantage. He works in secret; the expert is a public figure whose taste and judgments are a matter of record. In the case of De Groot, the great man's public declarations made him vulnerable. Like a restaurant critic who had proclaimed himself a sucker for any dish cooked over a wood fire and seasoned with balsamic vinegar, De Groot had spelled out exactly which paintings of Frans Hals he liked best and which of their features he most admired. He particularly liked, for instance, Hals's painting at the Schwerin museum, in Germany, of a young boy holding a flute. Imagine his delight, years later, to see "evidently the same boy" turn up in *A Boy Smoking*. Little surprise that the esteemed connoisseur could not refrain from cooing contentedly about the "great attractiveness" of the "marvelous" dish that had been cooked up especially for his delectation.

That sort of made-to-order effort to snag a celebrity endorsement was worth a forger's while, for in many cases buyers tore open their checkbooks as soon as an expert gave a painting his blessing. "In no other field," marveled the art historian Harry van de Waal, "is it possible to take a heap of scrap, tinker about with it a little and then sell it as a Rolls Royce, covered by a statement signed by a highly reputed expert, in which the latter declares that 'to the best of his knowledge' he considers the one to be the other."

That had been the case with the two forged Frans Halses authenticated by De Groot, and it had been the case with the two forged Vermeers that ended up in the Mellon collection. Those fake Vermeers had been authenticated by some of the great names in connoisseurship. The director of the Mauritshuis, Willem Martin, declared that there could be "no doubt whatsoever" that both the *Smiling Girl* and the *Lacemaker* were by Vermeer. The formidable Wilhelm von Bode agreed.† For more than twenty years, Bode served as director of the Kaiser Friedrich Museum in Berlin, which had been created under his leadership. For many of those years he also held the title of director-general of all Prussian museums. Bode had clout. When, in 1926, he

* The English painter Leo Stevenson claims that "art history is the only branch of history where opinion carries the same weight as fact."

† Bode was the mentor of the art historian Wilhelm Valentiner, whose enthusiastic endorsement of Mellon's forged Vermeers we discussed in chapter 23.

proclaimed the *Smiling Girl* a "characteristic, fairly early work of the Delft Master Vermeer," the painting sold almost at once to a Berlin collector, who quickly resold it to Joseph Duveen, who sold it to Andrew Mellon.

Van Wijngaarden's *Lacemaker* enjoyed almost exactly the same free ride. Bode endorsed it enthusiastically—it was not merely a marvelous Vermeer but "one which, up to the present, has been entirely unknown!"—and, on the strength of that praise, a buyer snatched it up and soon sold it to Duveen, who sold it to Mellon.

In the case of *The Lacemaker*, other eminent experts chimed in, too. The esteemed Vermeer scholar Eduard Plietzsch echoed Bode's enthusiasm, for example, and so did the renowned art historian Max Friedländer. These were titans in the world of scholarship. Friedländer succeeded Bode as director of the Kaiser Friedrich Museum; he was the author of a fourteen-volume tome called *Early Netherlandish Painting*. (Later he would devote a chapter of yet another opus, *On Art and Connoisseurship*, to the subject of detecting forgeries.) When men like these endorsed a newfound painting as a Vermeer, it was as if the king had conferred a knighthood.

FOR A FORGER, a chorus of praise like the one for *The Lacemaker* was all to the good, but it was not essential. The major dealers, many of whom were experts themselves, frequently made their own judgments without bothering with outsiders. Sometimes, as with Bode, a single authoritative voice silenced any doubt. At other times—if a painting seemed not to fit with the rest of an artist's work, or if the price was especially high, or if the art world was awash in gossip and doubt—a would-be buyer might seek a second opinion. If the experts disagreed, there was no rule about who would prevail, any more than there is a rule in the courtroom about which expert witness will sway a jury.

Many times the experts did disagree, with glee and vigor. That was not necessarily a problem. A painting did not need unanimous support to make its way, for each scholar was perfectly prepared to dismiss his colleagues' opinions. Art is a notoriously catty field, perhaps because it depends so heavily on value judgments. Feuds are rampant, and elegant insult an art in itself.*

* Bernard Berenson's dismissal of *A Lady Professor of Bologna*, by Giorgione, perfectly captured the sought-after tone. The portrait, said Berenson, was "neither a lady, nor a professor, nor of Bologna, and least of all by Giorgione."

(One specialist in Dutch old masters lauded a colleague's "highly imaginative" catalog of Vermeer's paintings, a bit of sarcastic praise akin to lauding an accountant for his creativity.)

In Van Meegeren's day, and today as well, the experts like nothing better than to ridicule their rivals by showcasing their errors in judgment, preferably in a tone of mock bewilderment. "Gratuitous nastiness is part of the art historian's weaponry," observes Christopher Wright, himself a veteran of many duels at dawn.

A forgery could make its way without a big-name sponsor, but a celebrity's endorsement could make a painting a star. When it came to Johannes Vermeer, it was widely believed, the best man you could have on your side was Abraham Bredius.

BREDIUS

By the time Van Meegeren gave up work in his own name in favor of full-time experiments with old-master forgeries, the best-known authority on Vermeer was an elderly, eminent man. Long retired from his official posts in Holland, Abraham Bredius now held court in Monaco, in the Villa Evelyne, where he had moved in 1922. Late in life—a bit *too* late, in his view—he had won honors that served as more or less the Dutch equivalent of a British knighthood, and he gloried in the titles of officer in the Order of the Lion of the Netherlands and grand officer in the Order of Orange-Nassau.

In his Monaco retreat, he entertained a stream of visitors and issued pronouncements on art. He had a glittering record, and he liked recounting his triumphs. Bredius had been the first to draw attention to some of the world's best-loved paintings. He had spotted Rembrandt's now world-famous *Polish Rider* hanging in obscurity, for example, and he had been the first to praise *Girl with a Pearl Earring* in print. He had turned seventy-five in 1930, but he had every intention of adding new triumphs to his résumé.

The Dutch old masters were his specialty, and Rembrandt and Vermeer his particular loves. Bredius was a wealthy man—his family had been well known as far back as the 1600s, when the forebears of Rembrandt and Vermeer were struggling to stay out of the way of bill collectors—and he had set out on a grand tour of Europe's art museums in his twenties. This was in the 1880s, about a generation before the birth of art history as a formal academic discipline in Holland. The field was open to amateurs, and a talented, well-connected, brash young man could rise quickly.

Bredius was a roundish man, with thin, wavy hair and a wispy mustache. A pair of small, round eyeglasses gave him the air of a quizzical owl. The soft

appearance was misleading. Bredius thrived on conflict. When, for instance, one scholar wrote that he believed some paintings attributed to Rembrandt were, in fact, forgeries, Bredius erupted in fury. His colleague's book was "horrible," Bredius declared, and its author likely to end his days "in a madhouse."

For twenty years, from 1889 to 1909, Bredius served as director of the Mauritshuis Museum in The Hague. The position provided him both a pulpit and a large cast of colleagues to battle. Bredius undoubtedly had the best interests of the Mauritshuis at heart—over the years he lent the museum twenty-five of his own paintings, including four Rembrandts, and he left them to the museum when he died—but he seemed unable to conceive that anyone could have sincere reasons for disagreeing with him. Those who thwarted him, especially when it came to decisions about buying paintings for the museum, were scoundrels, drunks, Machiavellian schemers.

Even when art was not involved, it did not take a cosmic issue to trigger Bredius's wrath. In 1906, when he was still living in The Hague, he found himself irritated by the crowd of children in the playground next door. He installed a foghorn and blasted away for hours every week, in the hope of driving his tormentors away.

"Jumpy, agitated, nervous and testy, fierce and enthusiastic," in the words of the director who succeeded him at the Mauritshuis, Bredius was a man who felt himself perpetually at war. From 1891 to 1896, for example, he clashed continually with his deputy director, our old friend De Groot. Bredius mocked his by-the-book deputy for his schoolmarmish ways, and De Groot curled his lip and called Bredius a dilettante. Bredius delighted in running to the press with every quarrel.

Bredius kept up the feud even after his rival's death. De Groot had bequeathed his papers to the Netherlands Institute for Art History. Bredius frequently needed to consult with the institute's director, but out of disdain for De Groot's memory, he refused to enter the premises. He would proceed only as far as the porter's lodge, where the director had to come to him.

Bredius's battles extended beyond the art world. He was a homosexual, and on more than one occasion, conservative Holland showed its disapproval. In 1909 someone wrote a brochure announcing Bredius's homosexuality to the world and claiming that the art expert had an eye for dashing young soldiers. Bredius sued for libel and won. In 1920, a great tabloid scandal erupted when some forty people, many of them prominent, were arrested for patronizing a

"boy bordello." This was the Heidi Fleiss scandal of its day. Bredius's name came up, though he was not arrested, and so did the name of Prince Hendrik, Queen Wilhelmina's husband.* For months the police kept Bredius's house under surveillance. Two years later, the newspapers screamed out the story of yet another scandal, this one the "murder of the century." On New Year's Eve in 1921, on a train from Amsterdam to The Hague, someone murdered an attorney named Jacques Wijsman. The killer was never found. Every kind of rumor swirled around Holland. According to one story, Wijsman had been carrying on with a lover of Bredius, and Bredius had ordered him killed.

None of these accusations had any substance. The Dutch cite a proverb that "the tall trees catch the wind," and Bredius made a conspicuous target. He never spoke of his private life, but it was an open secret. He lived for decades with a man named Joseph Kronig, also an art historian and nominally Bredius's "secretary." Kronig was thirty-two years younger than Bredius and had, Bredius believed, a superb eye for art. Some of Bredius's fiercest battles with De Groot turned on the quality of Kronig's connoisseurship. De Groot refused to see Kronig's merits; the reason, said Bredius, was that he was "consumed by jealousy." In the end, Bredius would leave his considerable fortune to Kronig.

IN PERSON, BREDIUS was jittery and touchy, constantly slamming doors and losing his temper. In print, he usually managed to rein himself in. When he could tamp the fury down, he sounded worldly, condescending, not so much indignant as amused by the naïveté of his peers.

By age twenty-eight he had found his voice. For the next half-century, it would grow only louder and more self-assured. He first showed his style in an essay called "A Pseudo-Vermeer in the Berlin Gallery." The point was to highlight a blunder made originally by Thoré-Bürger, the art historian who had rediscovered Vermeer, and then repeated by a long series of misguided souls. Thoré-Bürger had assigned a work called *Rustic Cottage* to Vermeer. Bredius disagreed (as do present-day scholars).

Bredius believed he saw something modern in the painting and attributed it to a Dutch artist named Derk Jan Van der Laan, whose career spanned the

* The prince had a reputation as a playboy and a lush. In a popular joke of the day, Queen Wilhelmina was reviewing the troops one summer day and fainted in the heat. An officer hurried to the rescue, raised the queen's head, and held a flask of brandy under her nose to revive her. The queen took a sniff and opened her eyes groggily. "Hendrik," she whispered, "is that you?"

decades around 1800. To have mistaken Van der Laan for Vermeer was not ludicrous. Van der Laan had talent. He had painted other Vermeer-like works—for his own amusement, as far as anyone can tell—and over the years people had occasionally taken them for the real thing. Once or twice someone had improved a Van der Laan by adding a Vermeer signature. Bredius raged against such ignorance. "What a heresy, is it not, to declare a picture of the 18th or 19th century to be a Vermeer?" he thundered.

IN PRIVATE CORRESPONDENCE, though, Bredius's personality boiled over. He wrote letters by the dozen, and even the most mundane notes sputter with the indignation and impatience of a great man beset by plodders who need to be grabbed by the collar and throttled. Every other word is underlined for emphasis, and nearly every sentence ends with an exclamation mark, or two, or three. Only when he reached the point of adding his signature did Bredius pause for breath. His signature was a work of art, an ornate series of swirls and loops worthy of adorning not merely a letter but a university diploma or a nation's constitution.

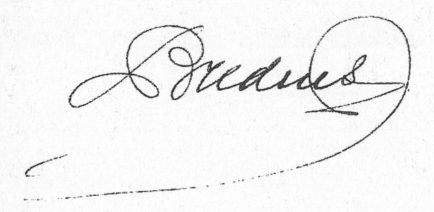

Oddly, for a man so caught up in the gritty gamesmanship of everyday life, Bredius did his most important work in the silence and solitude of a thousand dreary archives. His specialty was the dogged pursuit of facts: Who sold what painting when? For how much? To what buyer? This was magnifying-glass-to-the-ledger work, detail work of the most unrelenting kind.

Facts were an end in themselves. "Rembrandt becomes closer and more precious to us with every detail of his life that we succeed in uncovering,"

Bredius declared in a brief essay that came as near as he ever would to spelling out a philosophy. He was the first to try to chase Vermeer into the open by perusing Delft's endless "notarial archives," which contained municipal documents drawn up over the centuries—marriage licenses, wills, bankruptcy declarations, and the like. Two generations of Vermeer scholars have followed his lead. Bredius himself had no interest in looking for a larger meaning in those myriad details, but perhaps someday a writer with an eye like Seurat will use them as the basis for a pointillist biography.

THE DETECTIVE WORK that brought Bredius fame was of a more dramatic kind. He had been unearthing old masters and old masterpieces since the beginning of his career. In 1897, he made his way to an obscure spot in what is today eastern Poland. There, in a remote castle stuffed with mediocre French furniture and so-so art, he gazed in rapture at the painting now known as *The Polish Rider*. "Just one look at it," Bredius wrote, "a few seconds' study of the technique, were enough to convince me instantly that here, in this remote fastness, one of Rembrandt's greatest masterpieces had been hanging for nigh on a century."*

A few seconds study of *Bredius's* technique would demonstrate that the note of certainty and triumph was utterly characteristic. Nearly thirty years later, to choose one example from a host of possibilities, he published a brief report entitled "An Unknown Rembrandt Portrait." "A short time ago," Bredius wrote, "I experienced the very great pleasure of coming upon a little portrait in oil which could not possibly be the work of any other artist than Rembrandt.... That the picture is by Rembrandt goes without saying. Indeed, I have very rarely been confronted with a painting before which I was able with less hesitation to satisfy myself as to the authorship. A single glance was sufficient to convince me that the portrait was the work of the great artist himself."

Even for an expert, Bredius's faith in his own judgment was remarkable. He was constantly evaluating art, both formally and informally. "His door was always open," one biographer wrote. "Every Sunday people could go to him to

* The industrialist Henry Frick bought *The Polish Rider* in 1910. Today the painting is one of the great stars of the Frick Collection in New York. In recent years, the Rembrandt Research Project has created immense controversy by suggesting that the painting might not be by Rembrandt after all. The issue, which is still unresolved, is brilliantly explored in Anthony Bailey's *Responses to Rembrandt*.

ask his opinion on a painting." He handed down his verdicts immediately, secure in the belief that he was delivering not opinions but facts.

At almost the same time that he unveiled his "Unknown Rembrandt," in the mid-1920s, Bredius wrote an essay on the qualities necessary in the director of an art museum. Academic training was fine but not essential. A love of art was crucial. So was the investment of endless hours contemplating paintings. But nothing was as important as "a shrewd, innate sense of discernment and good taste." The word *innate* was the essential one. "Without this natural aptitude," Bredius declared, "all efforts will be fruitless. Many are called, but few are chosen."

Those who had not been tapped by a magic wand might accumulate paper credentials, but to what end? "Let us not forget," Bredius warned, "that the most brilliant *summa cum laude* cannot guarantee that the aspiring director will be able to tell a copy from an original."

"WITHOUT ANY DOUBT!"

Bredius had discovered Vermeers as well as Rembrandts, three times in all, an astounding record in view of Vermeer's tiny body of work. The story of the first find, *Allegory of Faith*, is the most straightforward. The painting, now in New York at the Metropolitan Museum of Art, was hidden beneath a double disguise when Bredius spotted it in a Berlin art gallery—the picture bore the signature of one artist, the now nearly forgotten Caspar Netscher, but was thought to be actually the work of the somewhat better-known Eglon van der Neer. Bredius believed he saw Vermeer's hand, and he convinced the world (which remains convinced) that he was correct. "With this acquisition of the new Delft Vermeer," one Dutch newspaper crowed, "Dr. Bredius has once again found a bargain with his perspicacious eye."

The find, in 1899, enhanced Bredius's already high reputation, and in time it would fatten his wallet, but Bredius never cared much for the picture itself.* "A large but unpleasant Vermeer," in Bredius's words, *Allegory of Faith* is a complicated religious work complete with a crucifixion scene (in a painting within the painting) and an array of such symbolic touches as a fallen apple and a crushed, bleeding snake. Bredius picked up the picture for almost nothing, lent it to the Mauritshuis and then the Boymans Museum for nearly thirty years, and finally sold it to an American collector for $300,000 (roughly $3.8 million in today's dollars).

* Nor do many other Vermeer lovers. Arthur Wheelock, for one, called *Allegory of Faith* Vermeer's "one mistake."

The story of Bredius's second Vermeer find is more of a detective tale. It began in 1876, at an auction in Paris. A buyer for the Mauritshuis Museum bought a dozen paintings, including one by Rembrandt's pupil Nicholaes Maes. *Diana and Her Companions*, as it is known, shows Diana, goddess of the night, and four of her attendants. The mood is quiet and somber. One woman bathes Diana's feet. All the faces are hidden or in shadow, all the women lost in contemplation.

In the 1600s, subjects taken from mythology or religion or history like this one were deemed better suited than any others to serious art. Landscapes, still-lifes, interior scenes with serving girls or ladies reading letters, all took second place, usually a distant second. Two centuries would pass before tastes shifted. In the late 1800s, when the Impressionists claimed Vermeer as an honorary ancestor, they hailed his fascination with color and the play of sunlight, but just as important, they endorsed his focus on everyday life. The Vermeers they liked best—as we do today—were the domestic interiors. But Vermeer seems to have begun his career as a more-or-less conventional painter of "important" subjects, as in this scene from Roman mythology.

The director of the Mauritshuis scolded his buyer for paying too much for *Diana*. Three years after the purchase, in a guide to the museum's collection, he was still complaining. "A Nicholaes Maes, *Diana and Her Companions*, would have been an important painting," he wrote, had it not suffered so much damage through the centuries.

Then, in 1892, Bredius, who had taken over as the Mauritshuis's director, helped reveal something remarkable. When a sharp-eyed observer thought he saw something odd in Maes's signature, Bredius called in the Mauritshuis's restorer. While Bredius and his deputy, De Groot, looked on, the restorer dabbed at the signature with a swab dipped in alcohol. The three men saw at once that someone had tampered with the painting. The Maes signature— more accurately, an *NM* monogram—had been fashioned from a signature lying beneath it. The original signature: IV Meer. That was huge news, for this was how the great Vermeer signed his paintings!* Evidently some duplicitous soul had done his best to remove the signature of the then little-known IV Meer; after that, he converted the traces that remained to the monogram of the more desirable Nicholaes Maes.

* Vermeer experimented with a number of different but closely related signatures. The *I* stood for Iohannes, an alternative spelling of Johannes.

But the mystery was not yet resolved. At the Mauritshuis, *Diana* hung in the same room as *A View of Delft*, which was indisputably a Vermeer. The two paintings looked nothing alike. Could the same man really have painted both? Moreover, *Diana* seemed to show Italian influences, especially in the richness and depth of its colors. Vermeer, as far as anyone knew, had never visited Italy. Bredius suggested that perhaps the IV Meer who had painted *Diana* was not Vermeer of Delft but his less renowned contemporary, also named Vermeer, from Utrecht. (And the Utrecht Vermeer *had* apparently visited Italy, where he produced paintings similar to *Diana*.)

Here matters stood, unresolved, all through the 1890s. In the meantime, in Britain, a religious painting called *Christ in the House of Mary and Martha* had been kicking around barely noticed. It shows Christ seated at a table with Mary on a stool before him, watching attentively, and Martha, eyes downcast as so often in Vermeer, standing at Christ's shoulder and offering a basket of bread.

Where the picture had been before about 1880, no one knew. In 1884, a furniture and antiques dealer sold it to "an old lady" for ten pounds, according to a collector who acquired the painting years later. We know nothing more of this mysterious elderly buyer except that she quickly resold the painting for thirteen pounds. It turned up a few years later, again without making a stir, in Bristol, England, in 1901. There an art dealer threw it in as a bonus to a buyer who had just spent £140 on two paintings.

The new owner brought his three purchases home to London and showed them to a friend and art dealer named Norman Forbes, a partner in a gallery called Forbes and Paterson, on Bond Street. Forbes waved aside the two "finds" and homed in on the religious picture, the afterthought in his friend's deal. "I told him it was a Vermeer and a very excellent one at that," Forbes recalled. "He was incredulous, so I told him to get a little spirit and clean off the varnish in one corner. He did so, and found Vermeer's beautiful signature."

Word raced through the art world, and Bredius came running to London. The newly discovered Vermeer signature on *Christ in the House of Mary and Martha* looked identical to the Vermeer signature Bredius had found nine years before on *Diana and Her Companions*. At Forbes and Paterson, Bredius scrawled an excited note with his usual jumbled syntax and frantic, almost random underlinings. "Exactly as the M[aurits]huis Diana. Very colorful & *exactly the same colors without any doubt* by the same hand."

It took one last round of debate to convince nearly all the art world that both *Christ in the House* and *Diana* were indeed by *the* Vermeer, Vermeer of

Delft, and not by Vermeer of Utrecht. In the end, Bredius's deputy, Willem Martin, made the argument that won the day. (De Groot, the former deputy, had moved on.) Everyone agreed, Martin pointed out, that the same artist had painted *Christ in the House* and *Diana.* Furthermore, the colors in *Diana* looked just like those in *The Procuress*, a painting that was definitely by Vermeer of Delft. Therefore *all three* paintings were by Vermeer of Delft.

IF ANY FORGER had been paying attention, the story would have put a large grin on his face. As we have seen, Thoré-Bürger, the historian who rediscovered Vermeer, had assigned a great number of unlikely works to him. But that had been decades before. The discovery of *Christ in the House* and *Diana* in 1901 showed once again that Vermeer had sides to him that no one had ever suspected. In time, that uncertainty would open the door to all sorts of mischief.

Half a century later, the eminent scholar P.T.A. Swillens still refused to believe that either *Diana* or *Christ in the House* was by Vermeer. "*Diana* never can have been his," and *Christ in the House* was even worse. Everything about it was wrong—the subject, the light, the shadows, the folds of the cloth, the gestures. "In no single part, conception, composition, treatment, size or technical execution is there a single similarity to be discovered with any authentic work of Vermeer whatever. The whole is born of a completely different spirit which has nothing in common with Vermeer."

But at the time of Bredius's discovery, no one voiced doubts like that. Instead, they hailed Bredius. And then, only five years after his discovery of *Christ in the House of Mary and Martha*, Bredius struck again. In 1906, he had gone to Brussels to look at a private collection of Rembrandt drawings. Bredius happened to glance up.

"Suddenly my eye fell on a small picture, hanging up high," Bredius recalled. "Am I permitted to take this down once, as it appears to be something very beautiful?"

His host gave permission.

"And yes!" Bredius concluded his story, for once making his point in a whisper rather than a shout. "It was very beautiful."

Bredius attributed the unknown painting to Vermeer. The world (including Bredius's archrival De Groot) raced to second his judgment. In the first decades after its discovery, the painting's price increased ten thousand-fold. The picture, now known as *Young Girl with a Flute*, eventually ended up in the

collection of the National Gallery in Washington, D.C. Today its status is in doubt. The National Gallery labels it "Circle of Johannes Vermeer." In 1989 the great scholar J. M. Montias suggested that Vermeer began the painting but abandoned it for some reason, and a later artist finished it.*

But in 1906, the *Young Girl* reigned unchallenged. Bredius's newest triumph puffed him up in the eyes of the world and in his own mind as well. *Young Girl with a Flute* was just the latest proof of his unmatched intuition. Not only had he found three Vermeers (he did not claim credit for *Diana*, which would have brought the tally to four), but his discoveries had been different from one another. Though *Young Girl with a Flute* looked like a Vermeer, *Allegory of Faith* and *Christ in the House of Mary and Martha* did not. The identification of the two religious works was perhaps more impressive because they were so strange, so unlike the common notion of a Vermeer. Here was irrefutable testimony to the power of Bredius's eye.

But all three discoveries dated from around 1900. Bredius had been young then, just entering his prime. What could be better, thirty years later, than to cap his career with one final announcement that would amaze the world?

* The first to dispute the attribution to Vermeer was Swillens, in the same book in which he rejected *Diana and Her Companions* and *Christ in the House of Mary and Martha*.

THE UNCANNY VALLEY

Han van Meegeren, a methodical man when it came to forgery, gave serious thought to which old masters best suited him. After his arrest, police found four finished but unsold paintings in his studio in Nice, all four presumably experiments.

One of the four was a portrait, meant to evoke Vermeer's contemporary Gerard ter Borch. Another was a picture of a tipsy woman, signed FH, for Frans Hals, and two were "Vermeers." Each fake was a near copy of an authentic painting or a pastiche built of pieces plucked from several paintings. It turns out to be no great feat to produce a painting that will make a layman say "Vermeer" or "Rembrandt" or "Picasso." In principle, the forger's task is not terribly different from that of the editorial page cartoonist. The cartoonist latches on to cues like Hitler's mustache or Lincoln's top hat and beard; Van Meegeren threw together a meditative woman, a blue jacket, a pearl earring.

It might seem doomed to failure. Think, for instance, of the Nixon masks that still turn up on the occasional trick-or-treater. Everyone who sees the ski-slope nose and the dark jowls recognizes Tricky Dick, but even if Nixon were still on the scene no one would ever confuse the spoof with the real thing. But forgers do often manage to pass off their caricatures. Look at Van Meegeren's *Woman Reading Music*, a close imitation of a real Vermeer, *Woman in Blue Reading a Letter*. This was one of the experimental paintings that Van Meegeren did not attempt to sell. Breathtaking masterpiece or shoddy fake? Can you tell? Certainly most casual viewers would be far more likely to hail *it* as a Vermeer than any of the fakes that made Van Meegeren's reputation.

We have a hard time judging the picture honestly because we know that it is fake, and we cannot discard that knowledge. For a fair test we would need an art-loving amateur who happened to come on Van Meegeren's *Woman Reading Music* unaware. Would that man on the street be fooled?

By good fortune, we have such a man. Meet Jan Gerritsen, an editor at Holland's best and most serious newspaper, *NRC Handelsblad.* In February 1996, an exhibition hall in Rotterdam called the Kunsthal put on a show devoted to Van Meegeren's forgeries. (Not by coincidence, the renowned Mauritshuis Museum in The Hague had mounted a blockbuster Vermeer exhibition at the same time.) The Kunsthal designed a handsome poster announcing its show and slapped copies up all over town. The poster featured Van Meegeren's *Woman Reading Music.* By happenstance, somebody taped one to a lamppost in front of Gerritsen's apartment. On February 19, he wrote a short but furious editorial and signed it with his initals.

Under the headline "Art as Dung," Gerritsen complained about the Kunsthal's lack of scruples. Just as the dung beetle happily lived on others' waste, he wrote, the Kunsthal fed on any sort of attention, no matter how unsavory. All publicity was good publicity. Even the Kunsthal posters were a lie: "Van Meegeren's name is printed above a depiction not of an attractive Van Meegeren (because there aren't any), but of Vermeer's *Woman Reading Music*, which belongs to the Rijksmuseum."

Oops! The newspaper discovered its mistake after the presses had rolled but before the paper hit the street. The top editor phoned the Kunsthal's director to offer a preemptive apology. It turns out we've made a bit of a mistake. No hard feelings, I hope.

The Kunsthal settled for a letter to the editor, which announced gleefully that Van Meegeren had struck again. "JG Discovers a Vermeer!" the letter crowed. The Kunsthal basked in the publicity.

THIS WAS ALL good fun, but Van Meegeren's decision not to try to sell *Woman Reading Music* was the right one. The trouble with close copies is that they work best on amateurs, whose opinions carry no weight. A major painting, one that commands serious money and close attention, will bring the experts running. They have spent their careers steeped in authentic Vermeers and other genuine masterpieces. That day-in, day-out immersion produces, first of all, a huge amount of specific knowledge. When experts look at a painting, they automatically compare it with a vast number of other works

and ponder countless details beyond the obvious. What does it mean that the lion's head finials on the chair in Vermeer's *Girl with a Red Hat* face backward, away from the seat of the chair, for instance, while the finials on the identical chair in *Girl Asleep at a Table*, *Girl Reading a Letter at an Open Window*, *The Glass of Wine*, *Woman with a Water Jug*, *Woman in Blue Reading a Letter*, and *Lady Writing a Letter* all face forward?*

Far more important, every expert acquires a feel for an artist that runs deep but is too subtle to capture in words. (Samuel Taylor Coleridge once saw some unsigned poems written by his great friend William Wordsworth. "Had I met these lines running wild in the deserts of Arabia," Coleridge exclaimed, "I should have instantly screamed out 'Wordsworth!'")

Such knowledge is real. It seems esoteric, but that is only because few of us spend our days contemplating literature or art. Every one of us makes "expert" judgments every day, too many to count. When you identify your father's voice from a single word over a crackly phone line or recognize your sister's walk by the funny way she swings her arms, even in dim light and from a block away, you are exercising precisely the skills of a connoisseur who glances at a painting and immediately says "Vermeer" or "second-rate."

We have seen already that experts can mistake a close copy for the real thing—for that matter, that girl with the funny walk might turn out to be a stranger and not your sister at all. For a forger with colossal talent, the close-copy strategy might be the best way to go. And Van Meegeren, whose skills were adequate but not stellar, did fool renowned experts with barely modified "Vermeers." But trying to palm off a close copy carried great risks.

The first was straightforward. Van Meegeren did not have Vermeer's talent. Of the billions of humans who have come and gone, very few have. By some magic of hand-eye coordination or psychological insight or who knows what, Vermeer could do what others cannot. For museumgoers who want only to gaze and marvel, that is not a problem, any more than it was a problem for ballet lovers to sit in a concert hall and watch Baryshnikov leap across the stage. But pity the dancer who tried to duplicate Baryshnikov's performance, bursting from the wings only a yard behind him and stepping, stepping, leaping just as he had done.

* Albert Blankert thinks it means that *Girl with a Red Hat* is not a Vermeer and was instead painted by someone unfamiliar with seventeenth-century Dutch furniture. (Blankert has a host of additional objections to the painting.) Arthur Wheelock believes it means that Vermeer thought his composition worked better with the lions turned around.

The second problem with the close-copy strategy was subtler, and it applied not only to Van Meegeren but to forgers generally. The closer a forger comes to getting an imitation exactly right, the more the experts grow uneasy, even though they almost certainly cannot articulate what the trouble is.

Curiously, the best analysis of the forger's dilemma comes not from the world of fine art but from the realm of robot design and video graphics. The writer Clive Thompson spelled out the problem in a brilliant article called "Why Realistic Graphics Make Humans Look Creepy." "In 1978," Thompson wrote, "the Japanese roboticist Masahiro Mori noticed something interesting: The more humanlike his robots became, the more people were attracted to them, but only up to a point. If an android became *too* realistic and lifelike, suddenly people were repelled and disgusted."

People liked R2-D2 and C-3PO. No one cared that they looked as much like vacuum cleaners as like human beings. To be 50 percent humanlike was fine. "But when a robot becomes ninety-nine percent lifelike," Thompson went on, "so close that it's almost real, we focus on the missing one percent." Something about the skin strikes us as wrong; the dead eyes make us cringe; the herky-jerky movements turn us off. The once-appealing robot suddenly looks like a mechanized zombie. "Our warm feelings, which had been rising the more vivid the robot became, abruptly plunge downward. Mori called this plunge 'the Uncanny Valley,' the paradoxical point at which a simulation of life becomes so good it's bad."

Van Meegeren had never heard of robots, but he had stumbled on the same insight as the Japanese scientist. At some point he realized that if he tried to fool connoisseurs with a near-twin of a real Vermeer, he, too, might fall into the Uncanny Valley. Every human is an expert on what real faces and bodies look like, and when something is close but not quite, we know it immediately, and we recoil. Connoisseurs are experts on paintings, and they, too, instinctively recoil from near-misses.

For would-be forgers, the Uncanny Valley concealed an additional, though closely related, danger. It was not simply that a close copy inevitably looked a bit off. More important, it looked off in a particular way—it lacked psychological subtlety. If Vermeer had painted only still-lifes or landscapes, perhaps Van Meegeren could have gotten away with straightforward imitations more easily. But one of the qualities we esteem in Vermeer is his genius for conveying character. A close-but-not-quite imitation will not bring us close to those psychological depths. On the contrary, we will end up dismayed and uneasy, but not sure why.

A painter who wants to involve viewers emotionally needs to leave us some work to do ourselves. Once having collaborated, we find ourselves hooked. Artists figured it out long ago. A painstaking, seemingly perfect depiction of reality has its charms, the art historian E. H. Gombrich explained, but a painting that contains less hard "information" may nonetheless seem more real and more compelling. The reason is the Uncanny Valley again. Gombrich cites a Manet oil of horses thundering down a track, all blur and commotion and energy. "No wonder," says Gombrich, "that the greatest protagonist of naturalistic illusion in painting, Leonardo da Vinci, is also the inventor of the deliberately blurred image."

Nor is it only great artists who have learned that less is more. Jonathan Franzen points out that "an old shoe is easier to invest with comic personality than is, say, a photograph of Cary Grant. The blanker the slate, the more easily we can fill it with our own image.... The most widely loved (and profitable) faces in the modern world tend to be exceptionally basic and abstract cartoons: Mickey Mouse, the Simpsons, Tintin, and, simplest of all—barely more than a circle, two dots, and a horizontal line—Charlie Brown."

Now consider where this left Van Meegeren. A genius like Vermeer can conjure up psychological depths. An illustrator like Charles Schulz, Charlie Brown's creator, can draw a rudimentary line or two and trust viewers to supply the depth for themselves. But imagine the plight of a forger chasing a genius. He has set himself a goal he cannot reach, and the closer he comes, the further he falls short.

For Van Meegeren, the moral was clear. The close-copy strategy carried enormous risk. Instead, like robot builders and video designers but decades ahead of his time, he opted for the 50 percent solution—he would do 50 percent of the work toward creating a Vermeer, rather than 99 percent, and let his eager viewers collaborate in building their own trap.

28

---•◆•---

BETTING
THE FARM

Van Meegeren had taken the trouble to forge Ter Borch and Frans Hals, but in the end he chose to devote his real energy to Vermeer. To a minor extent, this was a question of taste—Vermeer was the painter Van Meegeren admired most. The Delft connection, which may have appealed to Van Meegeren's mischievous side, may have played a small part, too.

The real reasons behind the choice had little to do with Vermeer as an artist and everything to do with his fame, the giant prices his works commanded, and his biography—his lack of biography, more to the point. Van Meegeren could fill in the gaps as he chose. "For me," he once confided happily, "a blessed terrain lay fallow."

But to choose Vermeer, despite all the advantages, was to ask for trouble. Arthur Wheelock, the Vermeer expert at the National Gallery, points out that even from a strictly mercenary point of view, Vermeer was a dangerous choice. "If I were a forger," Wheelock says, "I wouldn't be worrying about Rembrandt or Vermeer. I'd be painting Pieter Klaes and Frans van Mieris, second- or third-tier artists, who sell for $800,000, maybe $1.5-million, which isn't a bad living. Nobody's going to think forgery. They're going to think 'School of...,' 'Follower of...'

"Who else would be a good choice?" Wheelock wonders aloud, and then he quickly answers his own question. "Any artist you've never heard of. For most people there are only three Dutch artists—Rembrandt, Vermeer, and Frans Hals. Beyond that, take your pick."

Van Meegeren had little of Wheelock's prudence. He wanted a bonanza,

not a dozen middling successes. He *had* painted a Hals as an experiment, and Hals had done well for Van Meegeren and Van Wijngaarden when they worked together, but even Hals seemed not quite renowned enough. That left Rembrandt and Vermeer. Which to choose?

Wim Pijbes is the art historian who put together the Van Meegeren exhibition in Rotterdam that stirred up all the fuss about posters and dung beetles. Pijbes, now the director of the Kunsthal, is a tall, slim man with blond hair combed straight back off his forehead. But the elegant mask cracks, and Pijbes almost cackles with delight, when he puts himself in the shoes of a forger trying to decide whether Rembrandt or Vermeer would be a better choice.

If it's a big name you want, Rembrandt is hard to beat. "But with Rembrandt, everything is too complicated," Pijbes says. "We know too much. We know who his pupils were, we know many, many, many of his drawings, we know his early work and his late work and everything in between. We know where he lived, we know all the household arrangements, we have letters, we can compare the paintings with one another. But Vermeer is special, almost unique in the art world, because his oeuvre is so small and so admired and yet so unknown in a way, because there are thirty-five icons in the world, and that's it."

But how to con experts who had spent their lives in the company of the real thing? They were a small, gossipy bunch; they all knew Vermeer; and most of them knew one another. It would be like trying to crash a family reunion.

LADY AND GENTLEMAN AT THE HARPSICHORD

In 1932, Bredius, now seventy-seven years old, grabbed the spotlight again. In an article in one of the leading art journals, *The Burlington Magazine*, he announced the discovery of a new Vermeer. This one was not merely important, like *Allegory of Faith*, but "one of the finest gems" Vermeer ever created. "An Unpublished Vermeer," the headline shouted, and the article continued in the same excited tone.

Though Bredius could not have known it, his most fascinated reader had newly taken up residence only twenty-odd miles from Bredius's home in Monaco. Van Meegeren and his wife, Jo, had truly found Roquebrune by accident, when their car broke down there on their summer holiday in 1932. Like many other visitors to the French Riviera, they felt the pull of sunshine and the Mediterranean, especially in contrast with the dark and gloom of Holland. They succumbed to that pull partly because it came at the same time as a push out of Holland, or so Van Meegeren felt.

The Hague had an active artistic community, and the city's artists had banded together in a group called the Art Circle. In April 1932, Van Meegeren declared his intention to run for a position as an officer of the group. Thirty young members responded by threatening to resign, out of fear that "Van Meegeren will not be objective enough to give due recognition to all opinions."

Deeply offended, Van Meegeren not only withdrew his candidacy but quit the Art Circle entirely. The board accepted his resignation at once, without

making any effort to change his mind. Their pro forma note praising his service served only to damn him as over the hill. "We regret exceedingly to learn that you have resigned from the Circle," the note read. "This will be a loss since you represented a spirit in the artist's world that is dying out."

Forty-three years old, scorned by the critics, declared irrelevant by his peers, Van Meegeren rounded up Jo and headed off in search of a warmer welcome.

ABRAHAM BREDIUS WAS a man who could strut standing still, and he took a few moments at the start of his Vermeer article to preen. He began by reminding his readers of just how many people had looked for Vermeers and how few had succeeded. "No more intense detective work has been carried on in the field of art," he declared, but "as all the world knows, only some forty genuine paintings by this great little master are known to us today."

Then, in his role as master of ceremonies, Bredius paused to point out the hazards that lay in wait for unwary art lovers. "It is not, therefore, surprising," he went on, "that the 'fakers' have found in the brief and broken catalogue of his works a happy hunting-ground for their activities. No end of forgeries by these gentry have been submitted to me for what is now called 'expertising.'"

Some of these forgeries, Bredius wrote, were little more than old pictures touched up with a streak of Vermeer's yellow or blue, and many were "shockingly unlike" anything Vermeer might have painted. "But a few are so cunningly contrived by masters, if not of the art of painting then of sleight of hand, as to deceive even very good judges."

More in sorrow than in anger, Bredius went on to list several of his renowned colleagues who had stumbled into error. "The late Dr. Bode himself" had declared three fake Vermeers authentic.* Then came the turn of Bredius's old rival De Groot. He had died two years before, but Bredius cuffed him around a bit, too, for attributing a second-rate painting to Vermeer. "An obviously French portrait of an obviously French boy . . . ," Bredius wrote, obviously enjoying himself, "'discovered' by the late Dr. De Groot, enjoyed the advantages of wide and elaborate publicity, but it now seems to have mysteri-

* One of the three fakes endorsed by Bode was the much-admired *Smiling Girl*, discussed in chapter 22, that Andrew Mellon would later donate to the National Gallery in Washington, D.C. Bredius correctly rejected the painting, and was the first to do so, in this 1932 essay. The casual tone of his dismissal—"a very intriguing Vermeerish laughing girl . . . inspired by the famous girl in the Hague Gallery [i.e., *Girl with a Pearl Earring*]"—was as characteristic as the passion of his many endorsements.

ously disappeared!" The ironic exclamation point, to make sure that no one missed the point, was the academic equivalent of an elbow to the ribs.

Bredius detailed a second blunder by De Groot and happily recalled their "sharp passage of arms on the subject in the Dutch newspapers." Once again De Groot had called a non-Vermeer a Vermeer, and once again Bredius had proved correct. "In the end, everybody agreed that the picture was spurious."*

But Bredius had no wish to gloat. "I could name dozens of fakes of this kind," he went on, "but I prefer to rejoice the hearts of my readers by the production of a very beautiful authentic Vermeer which has recently been discovered." He did not know who had first laid eyes on the painting, Bredius wrote, but "I was struck with amazement when I first saw the beautiful thing. The splendid harmonious coloring, the true Vermeer light and shade, and the gentle, sympathetic theme proves it to be one of the finest gems of the master's oeuvre."

As if that were not enough, Bredius threw in a bonus. Vermeer had painted a picture within a picture. The smaller picture was a landscape, and Bredius thought that it was based on a full-scale painting by Vermeer. "The landscape on the wall [in the painting] is interesting. The form of the trees would suggest that this may be a lost picture by the painter himself." Bredius had found not one missing Vermeer, but, almost, two!

The painting, *Lady and Gentleman at the Harpsichord*, is almost certainly Van Meegeren's work. It shows a young woman in a blue-and-white gown who has briefly interrupted her playing. A gentleman caller in a gray cloak and black hat leans on the harpsichord, his face in shadow but his gaze directed at his shy companion. The landscape with the telltale trees hangs just behind the two figures, dominating an otherwise bare wall.

How did Bredius know that the painting was by Vermeer? He did not bother to explain, because his knowledge was deeper than words. But he did list several features of the painting that delighted the eye. If Bredius had been on guard—if he had heeded his own warning that in Vermeer "the 'fakers' have found...a happy hunting-ground"—the sheer abundance of these recognizable-at-a-glance Vermeerian touches would have sent him fleeing.

Instead, Bredius pointed out half a dozen bits and pieces, lifted magpie-style from various Vermeers, that revealed the master's hand. The curtain

* De Groot had treated Bredius just as sharply. When Bredius called Rembrandt's *Portrait of an Elderly Man* a nineteenth-century forgery, for example, De Groot described how "sad" it made him that "a man like Bredius should not immediately recognize such a picture as a masterpiece of the very first order."

matched the one in *Allegory of Faith*, for instance, and also in *The Art of Painting*. The blue of the gown's bodice was unmistakable. So were "the large pear-drop earrings which Vermeer loved to paint."

Then, having made one error, Bredius turned around and made a mistake of the opposite kind. He found a feature of the painting that seemed *unlike* Vermeer and seized on it to draw a surprising moral—the discrepancy was not a danger signal pointing away from Vermeer but a welcome proof that here Vermeer had outdone himself by revealing a gift no one had expected. What looked like a red flag was in fact a welcome burst of color. And not only had Vermeer surpassed his usual high standard, Bredius noted, but he had done so in a way that seemed to speak to us across the centuries. "The greatest attraction of this picture," Bredius wrote, "lies in the subtle expression of the young girl, timid and yet inwardly well-pleased with herself. It is not often that we find such a delicacy of sentiment in a Vermeer face."

All that was left was a resounding wrap-up: "A picture, in short, which may indeed be called a masterpiece of the Great Man of Delft."

So Bredius proclaimed, using one of the art world's biggest megaphones. No other expert seconded him. *Lady and Gentleman at the Harpsichord* disappeared from view almost at once, and it has never returned. Even books on Vermeer that make room for controversial paintings accepted by some authorities and rejected by others (such as *Girl with a Flute* and *Saint Praxedis*) pass over *Harpsichord* without a word.

The few references to the painting in today's art literature are little more than digs at the foolishness of connoisseurs past. "Stripped of his cloak and clothes," one modern writer observes, "the cavalier would demonstrate a frightening case of anorexia nervosa."

The experts of Bredius's own day were evidently just as disdainful, though they did not publish their opinions. In a memo dated October 19, 1932—the same month that Bredius's article appeared—Edward Fowles, one of the leading figures at Duveen Brothers, wrote that "it is common talk in Berlin that the picture is wrong." The eminent Parisian dealer Nathan Wildenstein, who had been offered the painting at the beginning of September, rejected it as "quite modern and not worth anything." Allen Loebl, from the Kleinberger gallery in Paris, traveled to Budapest to see the picture for himself—what it was doing in Budapest is a mystery—and complained that he should have stayed home and saved his train fare.

The first major books on Vermeer after Bredius's discovery both appeared in 1939, seven years after Bredius found *Harpsichord*. Both authors were authoritative figures, one the German art historian Eduard Plietzsch, the other the Dutch historian Arie B. de Vries. Each looked closely at Vermeer's entire output. Neither mentioned *Harpsichord*, not even to reject it. This was no oversight, the present-day Vermeer scholar Albert Blankert remarks, but a demonstration that Bredius's opinion was considered so misguided that it was better ignored than refuted.

Not everyone got the word. The German banker and art collector Fritz Mannheimer purchased *Harpsichord* for himself in the fall of 1932, at exactly the same time the great art dealers were snickering to one another. Mannheimer was a man of colossal wealth and flamboyant taste—he drove a Rolls-Royce and he gave one of his mistresses a gold bathtub—and it seems he found Vermeer's name irresistible.

But soon after his purchase, Mannheimer apparently caught wind of the rumors and removed *Harpsichord* from his wall. Bredius could hardly contain his indignation. He suggested that his one-time protégé Schmidt-Degener had poisoned Mannheimer's mind. "The Vermeer at Mannheimer . . . is pure as gold too and is stored away (on S.D.'s advice?) in the safe," Bredius fumed in a private letter.

THE ART WORLD'S rejection of Bredius's newest Vermeer marks a crucial turning point in our story. All the standard accounts of Van Meegeren's career paint Bredius as a figure who commanded universal respect. His word was law, we read again and again. Once he delivered a verdict, everyone in the art world trembled and fell into line. Bredius "knew himself to be supreme," writes one Van Meegeren biographer, "his reputation unshakable, his authority unchallenged."

It makes for a tidy tale, but it is not so. Had it been true, Van Meegeren's task would have been far easier. All he would have had to do was fool one man, secure in the knowledge that all the lesser experts would echo their leader. But *Harpsichord* sputtered on the launch pad despite Bredius's endorsement.

In the art world in the 1930s, insiders thought of Bredius not as a giant but as a codger who had a bad habit of shooting his mouth off. Albert Blankert, one of the few experts on the Dutch Golden Age who has also done original research on Van Meegeren, declares flatly that "Bredius' authority on Vermeer matters had already sunk to zero in those years."

His credibility with respect to Rembrandt had fallen nearly as low. In 1935, the year Bredius turned eighty, he published a detailed roster of Rembrandt's body of work. This was a grand project, an assessment of exactly which paintings traditionally attributed to Rembrandt were truly his and which should be reassigned to students or followers or other artists entirely. In the world's eyes, this was a magnum opus that capped the great scholar's career. To those in the know, the true story of the seemingly authoritative *Rembrandt: The Complete Edition of the Paintings* was one of disaster barely averted. Bredius's assistant, Hans Schneider, had scrambled to safeguard the project, using all his tact and energy to exclude Bredius's worst misattributions from this formal tally.

Bredius was still a big name—and the farther from Holland, the higher his reputation—but his judgments had grown erratic and his influence unpredictable. This didn't mean he could be ignored, but it did mean that seducing him was no guarantee of seducing the world at large.

Only one other person could have been as dismayed as Bredius by *Harpsichord*'s failure. That was Van Meegeren, its creator. He had painted his best "Vermeer" yet, but it had not lived up to his hopes. *Harpsichord* had met with applause from one connoisseur and sneers from all the others. Van Meegeren had conned a wealthy buyer, but his ambition was not only to add to his fortune but to make fools of everyone in the art world. "I meant to have my pictures hang in a Dutch national collection," he insisted.

Harpsichord, like the two experimental Vermeer forgeries, was a Vermeer look-alike. Van Meegeren had taken that approach as far as he could, but he had fallen short. The Uncanny Valley had claimed another victim.

It was time to change strategy.

DIRK HANNEMA

The *Harpsichord* saga showed that Bredius, on his own, lacked the power to anoint a painting a masterpiece. But he was not on his own. Fortunately for Van Meegeren, Bredius had the ear of a colleague who was just as prominent, just as enamored of Rembrandt and Vermeer and their fellow titans, and just as sure of his artistic judgment. This was Dirk Hannema, director of Rotterdam's Boymans Museum.

Hannema and Bredius made an unlikely pair—side by side, the plump old connoisseur and the tall young director looked like the number ten—but they got along well. Hannema was more reserved, Bredius more temperamental, and both were genuine authorities on art. Hannema was forty years younger, but he greatly admired his older colleague. To Bredius's way of thinking this credential alone testified to Hannema's merit. But of all the links between the two men, by far the most important was this: Hannema's pronouncements on art were every bit as erratic as those of Bredius. Van Meegeren never dealt directly with Hannema, but if there had been no Hannema, there would have been no Van Meegeren.

Tall, handsome, aristocratic, Hannema seemed to live only for art. He was born to enormous wealth and throughout his long life retained the air of one set apart from the ordinary run of mortals. He had begun buying paintings as a teenager. By his old age he had put together one of the best collections in Holland—including works by Rembrandt, Goya, Van Dyck, and more modern figures such as Van Gogh, Picasso, and Duchamp. These works he displayed in his home, which was in fact a castle complete with moat, drawbridge, and roaming peacocks.

Hannema was named director of the Boymans Museum in 1921, at the age

of twenty-six. Almost at once the energetic young collector and art historian began to transform what had been an out-of-the-way museum into one with grand ambitions and an international reputation. He roamed Europe in search of bargains, poking into tiny galleries and wooing prospective donors. Hannema's taste was eclectic—tribal artifacts from New Guinea, old masters, Japanese swords. He pursued art wherever the trail led. In Paris one day, where he had been invited to look at a Georges de La Tour, he found a family in mourning. Perhaps it would be better to come back tomorrow? No, monsieur, please. Today would be best; the funeral will be tomorrow.

"I did not feel good about it," Hannema recalled, "but La Tour was just beginning to draw attention, and maybe I could pick it up for a reasonable price." The black-clad family pushed Hannema into a candle-lit room. The painting hung on the wall above an old, emaciated woman lying dead in her bed.

"Please, monsieur. Just look."

Hannema took off his shoes, borrowed a flashlight, and climbed onto the bed. The old woman's body shifted a bit as Hannema studied the painting from different angles. It was a pleasant picture, he announced when he turned off the flashlight, but unfortunately a fake.

HANNEMA TREATED THE Boymans as his personal kingdom—the museum's flower arrangements could not be changed without his approval—but he managed to enlist powerful allies on his side. To start with, Rotterdam was a wealthy city. Better yet, it was a wealthy city with an inferiority complex. Rotterdam stood to Amsterdam roughly as Chicago to New York, a city of energy and bustle and new money that resented and envied the manicured nails of its tonier, more cultured rival.

Rotterdam's money came from shipping. Though standoffish by nature, Hannema knew how to woo and charm when he had to. He courted Rotterdam's two biggest shipping tycoons, one named Van der Vorm and the other Van Beuningen, and coaxed one large donation after another from them. Van der Vorm was the earthier of the two, with a deep interest in dogs and horses, but he also fancied himself an art collector. Van Beuningen was more civic-minded, more interested in chamber music and opera and suchlike, and an art collector on a grander scale. Both men had bought themselves Rembrandts, but Van Beuningen also owned drawings and paintings by Michelangelo and

El Greco and Dürer and Hals and Van Gogh.* (Despite their wealth, neither man spent money recklessly. Van Beuningen saved half-smoked cigars to finish later, as if to flaunt his thriftiness. "Never throw anything away," he would say as he rummaged through his cigar case for a usable stub.)

The two millionaires were rivals, and Hannema cagily played them off against each other. Had Van der Vorm recently raised his profile by helping the Boymans finance a purchase? Perhaps Van Beuningen, with his deep understanding of art, might see fit to help the museum, too, as he had already done so often and so generously?

Grootvorst aan de Maas: D. G. van Beuningen,
Harry van Wijnen

Grootvorst aan de Maas: D. G. van Beuningen,
Harry van Wijnen

Left, D. G. van Beuningen; *right*, W. van der Vorm

In time, when the two magnates began competing to put their hands on a Vermeer, their rivalry would put millions of dollars into Van Meegeren's pocket. Throughout Van Meegeren's story, rivalry was a major theme. Rotterdam and Amsterdam were rivals for prestige; so were Van der Vorm and Van Beuningen; so were Hitler and Goering. In the 1930s and '40s, these various rivals had one thing in common: they all wanted a Vermeer for themselves.

* Van Beuningen refused suggestions that he install his collection in specially designed rooms and explained that he thought of his paintings as friends he liked to keep close by. One horrified houseguest watched Van Beuningen fry his bacon and eggs only inches from Brueghel's *Tower of Babel*.

Competition sometimes inspires contestants to do better than they had known they could. Not here. In these contests, the spur of competition would drive the rivals to plunge blindly ahead, consequences be damned. Han van Meegeren's great skill, or great good fortune, was to turn that mindless fever to his own advantage.

BY 1927, THE Boymans Museum had outgrown its home. Prodded by Hannema, the city of Rotterdam announced that it would finance a grand, new museum, "a building with serenity and of noble appearance, the best possible." Hannema and his architect visited eighty museums across Europe looking for ideas they might draw on. Construction took several years, and amid great fanfare Queen Wilhelmina herself made a tour of inspection as the building neared completion.

On July 10, 1935, to the button-popping pride of the good citizens of Rotterdam, the new museum opened its doors. To celebrate the opening, Hannema had put together a blockbuster show called "Vermeer—Origins and Influences." This was the first show focused entirely on Vermeer, and in the words of the art historian Ben Broos, it offered Delft's great painter "what to many had long seemed his by right: eternal fame."

The show included a total of 130 paintings. Towering above the others were 15 Vermeers, representing nearly half the world's total and lent by such institutions as the Louvre, the Met, and London's National Gallery. Never in living memory, boasted Hannema, had so many Vermeers been gathered together. One hundred thousand enthralled visitors gazed at the masterpieces. The catalog, written by Hannema, spelled out Vermeer's place in the pantheon. "Next to Rembrandt," museumgoers read, "the figure of Vermeer rises above all other artists of the great age of the 17th century." Hannema's enthusiasm boiled over. "Each creation [of Vermeer's] forms a polished and complete entirety. . . . Intellect and emotion are in perfect balance."

There was only one problem, though few suspected it at the time. Of the fifteen Vermeers that Hannema had assembled, six were not Vermeers at all. One of the six was rejected almost as soon as Hannema proclaimed its importance. This was a painting called *Mary Magdalene Under the Cross*, which Hannema, in his catalog, proudly "attributed here, for the first time, to Vermeer." The doubters surfaced immediately. A Dutch art historian argued in the newspapers that the picture was by the French painter Nicolas Tournier. In their

Vermeer books in 1939, the scholars De Vries and Plietzsch simply ignored *Mary Magdalene*, as they had ignored Bredius's *Harpsichord*.

By the time Hannema put together his show celebrating Vermeer and his new museum, Van Meegeren was deep into his forging career. But if Van Meegeren needed encouragement, Hannema's exhibition served as proof that his timing was perfect. (And Hannema's personal endorsement of *Mary Magdalene* gave any forgers who happened to be listening a remarkable hint—a new, biblical Vermeer might go over nicely.)

It was not just that the hoopla pushed Vermeer's reputation, already high, to a new peak. More than that, Hannema had practically auditioned for a spot next to Bredius as dupe-in-waiting. First, his blockbuster show all but proclaimed that he happened to be one of the people in all the world most eager to find a new Vermeer. Better still, his position as director of a museum that was striving for fame meant he was ideally placed to unveil any newfound masterpiece on an international stage. Best of all, as his profoundly flawed homage revealed, Dirk Hannema didn't know what a real Vermeer looked like.

THE CHOICE

For Van Meegeren in the thirties, the decision to focus on Vermeer had long been made. But what kind of Vermeer should he forge? When *Harpsichord* failed on liftoff, Van Meegeren decided that what was called for was not a better imitation, not a more lustrous rendering of pearl earrings or a more luxuriously blue gown, but a painting that was *not* pieced together from known Vermeers. He would paint not merely a new Vermeer but a new kind of Vermeer.

He came up with a picture called *Christ at Emmaus.* "It is unique in the history of faking," the art critic and historian John Russell observed, "in being quite unlike any known painting by its supposed creator." Venturing so far from Vermeer's familiar paintings had two advantages. First, it let Van Meegeren sidestep the hazards of the Uncanny Valley. The second was more personal. Van Meegeren was driven not merely by greed but by ambition and vanity. To fool the world with a "Vermeer" that was to a large extent a Van Meegeren would prove, he reasoned, that he truly was a genius on a par with the most admired figures of the past.

Christ at Emmaus was unquestionably the greatest achievement of Van Meegeren's career. Without it, none of the rest of the story would have been possible. With it, the whole complicated fiasco played out like a train wreck choreographed by Rube Goldberg.

In essence, as we have said, Van Meegeren's challenge was to win acceptance at a family reunion. *Harpsichord* had proved that it wasn't enough to fool one of the family patriarchs. Nor did it help to fool some peripheral figure, like the caterer—though that was easy enough to do. (Van Meegeren had conned Mannheimer, the banker, but that shallow triumph hadn't pulled anyone else along.) In order to succeed, Van Meegeren had to fool the entire

family. That ruled out trying to pass as anyone well known. The only hope, he concluded, was to impersonate a long-lost relative, one who had disappeared decades before and never been heard of again.

No forger had ever tried such a thing. That meant either that Van Meegeren had devised a strategy so brilliant that it had eluded all his predecessors or so foolish that they had all rejected it out of hand.

In real life, how would a con man overcome a family's suspicions?* He would start with the right family, first of all—unless they had lost track of a few relatives over the years, the scheme would be over before it began. Then he would do a bit of snooping to turn up some family lore and, perhaps, forge a document or two. Maybe an old passport or a driver's license? Some physical cues. Tinted contact lenses to evoke the family's famous blue eyes? But in the end a fair bit of nerve would have to go a long way. Maybe a mention of the old days at Uncle Henry's place on the lake, or a reference to the bad-tempered German shepherd who had to be given away when he bit the mailman?

As he thought it through, Van Meegeren had to know that this was the longest of long shots.

IN CHOOSING VERMEER, Van Meegeren had at least picked the right "family." It seems plausible that some Vermeers have been misplaced over the years; perhaps that's why we have so few today. But that still left Van Meegeren in a predicament: if his plan was to put a new "Vermeer" into circulation, and if the whole point was that it looked different from other Vermeers, how would anyone know what it was supposed to be?

A signature would provide a heavy-handed hint, but the art world rarely places much faith in signatures. An expert on Jackson Pollock once explained why. "How long would it take you to learn to sign Pollock's signature?" he asked, "and how long would it take you to learn to *paint* like Pollock?"

Even without a signature, Van Meegeren's challenge might have been manageable if Vermeer's paintings happened to fall into a tidy sequence except for a few gaps along the way. But to forge a missing link—in either sense of the

* Perhaps the most famous trial in Britain in the nineteenth century centered on precisely such a case. The heir to one of England's largest fortunes vanished at sea in 1854. He was presumed dead. Thirteen years later, the drowned man—or was it an imposter?—reappeared. The newcomer, a massive man who had been working as a butcher in Wagga Wagga, Australia, seemed far different from the slender aristocrat who had disappeared. But the bereaved mother took one look at the "Tichborne claimant," as the mysterious newcomer came to be known, and declared that this was indeed her long-lost son.

word *forge*—you need a chain. Vermeer's body of work doesn't lend itself to
any such arrangement. There are two problems. First, Vermeer's paintings fall
into two distinct groups: "On one hand there are the rare works of his youth,
large in size, with something un-Dutch in their appearance," as Hannema
wrote in a 1936 book on the Golden Age of Dutch painting, "and on the other
hand there are the well-known masterworks from his maturity."

Within each group, the paintings show a family resemblance. In the group
of large, early works, for instance, *Diana and Her Companions* looks something
like *Christ in the House of Mary and Martha.* In the second group, works such as
Woman with a Pearl Necklace and *Woman in Blue Reading a Letter* and *Woman Weighing
Gold* are as close in appearance as their names suggest.

But the great riddle is that the two groups seem to have almost nothing to
do with each other. Even today scholars point at the gulf in bewilderment.
Many of them cite *The Milkmaid* as Vermeer's first masterpiece, the earliest
painting in Hannema's second group. But eloquent as the scholars are in praise
of *The Milkmaid*, they stammer when they try to sort out how Vermeer achieved
the new look. "It is," the art historian Christopher Wright observes, "as if Ver-
meer had suddenly decided to change his style almost out of recognition."

How Vermeer jumped the gulf scholars can only guess. Van Meegeren had
to do more than guess. Since he had already decided that he could not imitate
a painting from *within* either group, his task was to invent a plausible transi-
tion between two groups of paintings that seemed unrelated.

That mysterious gap was only the first problem in sorting out Vermeer's
career. The second has to do with chronology. Despite Hannema's glib assign-
ment of paintings to Vermeer's youth or to his maturity (and the assignment
of *The Milkmaid* to a particular spot in line), there was no agreement in the
1930s about which paintings came early and which came late. For a forger,
confusion was always welcome. But it was a complicated gift that posed diffi-
culties of its own. If there had been agreement on which paintings Vermeer
did when, then Van Meegeren could have proceeded methodically, by choos-
ing a year and looking at the paintings on either side of it. Then he could have
crafted something that resembled both neighbors, and the experts would have
delighted in a discovery that fit so perfectly with their expectations.

That was essentially the story of another of the twentieth century's great
hoaxes, Piltdown Man. In 1912, a pair of English scientists announced that
they had found the "missing link," fragments of an ancient skull and jawbone
that came from a creature midway between ape and human. England's most

eminent anthropologists and paleontologists soon embraced the discovery. They hailed it as monumentally important and staked their reputations on it. Decades later the truth emerged: pranksters had taken fragments of a human's skull and an orangutan's jawbone and buried the bits together at a research site where scientists were sure to find them.

Clues that should have given the game away went overlooked for forty years. The teeth, for instance, showed scrape-marks from a file that someone had used to simulate wear and tear. Once the tampering had been pointed out, it was impossible to see how anyone had missed it. On the other hand, every scientist *had* noticed the skull's strikingly human-like appearance. No one thought "fraud" because the large brain fit perfectly with scientific theory. The Piltdown find was so important, one distinguished anthropologist explained at the time, precisely because it proved once and for all the long-held belief that "Man at first . . . was merely an Ape with an overgrown brain."

VAN MEEGEREN'S CHALLENGE was related but harder. Art scholars of his day did have pet theories that simultaneously focused and narrowed their vision, and which a forger could try to exploit. But that exploitation could not take the form of forging a missing link, since so much of Vermeer's career seemed to be missing.

Van Meegeren never explained his choice of *Christ at Emmaus*, which proved to be brilliant, though we can make some guesses. Some of his reasons had to do with art history, and we will turn to them in a moment. But Van Meegeren's personal history played at least as large a role.

A decade before he set to work on his forgery, Van Meegeren had painted a *Christ at Emmaus* in his own name. He had included the painting in his 1922 show, and it was one of those works that the critics had damned as insipid and uninspired. What better way to expose the art world's hypocrisy than to paint a new version, slap Vermeer's name on it, and watch the praise roll in?

The forger Han van Meegeren was a small, dapper man who raked in tens of millions from fake old masters. He had twin motives—greed and eagerness to avenge himself on the art-world critics who had sneered at the work he produced in his own name.

A vain, elderly, bad-tempered art connoisseur named Abraham Bredius was the greatest authority on Vermeer in the 1930s. Bredius had soared to fame by helping to discover three Vermeers over the years—and in all the world there are only thirty-five or thirty-six—but he had been young then. He yearned to find one more.

Rijksbureau voor Kunsthistorische Documentatie, The Hague

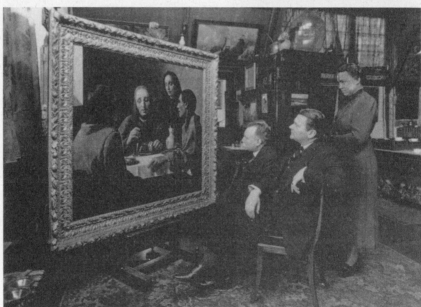

Museum Boymans—van Beuningen, Rotterdam

In 1937, Bredius announced that he had discovered the greatest Vermeer of all, *Christ at Emmaus*. Amid frantic excitement and at Bredius's desperate urging, the Boymans Museum in Rotterdam purchased the picture. Here the museum director, Dirk Hannema (center), and the museum's chief restorer, H. G. Luitwieler (far left), study the masterpiece.

Adolf Hitler and Hermann Goering, the two most powerful men in Nazi Germany, pose at a hunting lodge. Goering adored hunting, Hitler detested it, but art was a shared preoccupation. Each man fancied himself an expert. With the aid of dealers and scouts, they looted museums and private collections throughout Europe and gathered trophies by the thousands. Goering, always ready to grovel to stay on Hitler's good side, knew better than to compete openly. When Hitler grabbed a Vermeer that Goering had coveted, Goering could only look on miserably. In time Van Meegeren would provide Goering a "Vermeer" of his own.

Library of Congress, Washington, D.C.

Library of Congress, Washington, D.C.

Goering had a taste for every indulgence. "After all, I am a renaissance man," he boasted. He liked to pile up diamonds and rubies and emeralds in great heaps, and run his hands through them. Here he shops for jewelry.

Library of Congress, Washington, D.C.

A man of boundless vanity, Goering posed at his dressing table with an array of perfumes and oils. He changed uniforms several times a day and once appeared at a tea, a fellow Nazi reported, "in a sort of Roman toga and sandals studded with jewels, his fingers bedecked with innumerable jeweled rings and generally covered with ornaments, his face painted and his lips rouged."

Goering had been handsome as a young man but grew immensely fat, "at least a yard across as the crow flies," according to one American official in Berlin. As this *New Yorker* cartoon from 1943 shows, he never lost his taste for pomp.

Saul Steinberg, Hermann Goering. Ink on paper, Originally published in The New Yorker, *March 6, 1943,* © *The Saul Steinberg Foundation / Artists Rights Society (ARS), New York*

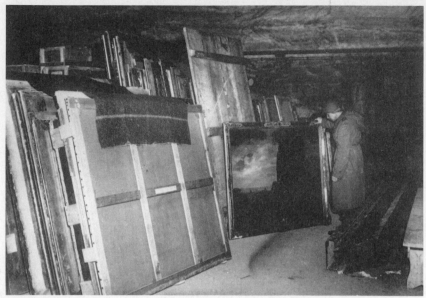

In the spring of 1945, with Germany in ruins, the Nazis worked desperately to hide away their stolen art. Deep inside a salt mine the Nazis had converted into a colossal art warehouse, an American soldier inspected a looted painting. Thousands more paintings filled endless racks.

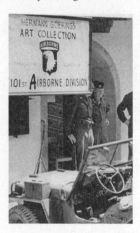

Goering tried to hide his looted art near Berchtesgaden, in the Bavarian Alps. The Allies found it, and the men of the 101st Airborne arranged an impromptu art show in a local hotel. The paintings alone filled forty rooms.

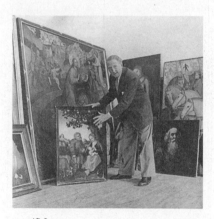

Walter Hofer, Goering's personal art curator, spent the war years helping Goering choose paintings to "purchase." Here he poses amid the looted pictures on display at the 101st Airborne art show, as proud as any legitimate collector.

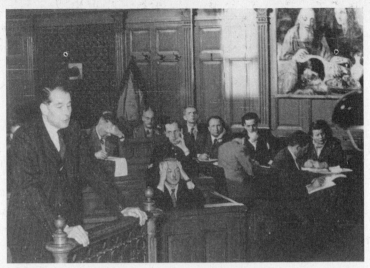

On October 29, 1947, Han van Meegeren was tried for forgery. His "Vermeers" lined the courtroom, the first time they had ever been displayed together. *Isaac Blessing Jacob*, a "Vermeer" that sold for the equivalent of $6.1 million today, can be seen on the right. Van Meegeren is at the center of the photo, head in hands.

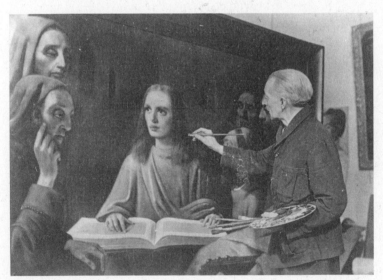

To prove the truth of his claim that he had painted the Vermeers that all Europe had admired, Van Meegeren painted one more while in police custody. He chose yet another biblical "Vermeer," this one called *Jesus Teaching in the Temple*. Jesus rests his hands on an open Bible, a small joke on Van Meegeren's part.

Rijksvoorlichtingsdienst, The Hague

Van Meegeren was fifty-eight at the time of his trial, though he looked older. In many ways the trial—and the opportunity to tell the world how he had fooled it—marked a highlight of Van Meegeren's life, but the game was over, and he knew it. Two months later, he was dead of heart disease.

THE CARAVAGGIO CONNECTION

The story of *Christ at Emmaus* comes from the Gospel according to Luke. Three days after the crucifixion, Jesus's tomb has been found empty. Two downcast disciples who have not yet heard that Christ is risen trudge their way along the road from Jerusalem. Jesus joins them but does not reveal his identity. In the town of Emmaus the three travelers sit down to supper. "And it came to pass," Luke tells us, "as he sat at meat with them, he took bread, and blessed it, and brake, and gave to them. And their eyes were opened, and they knew him; and he vanished out of their sight."

What artist could resist a scene that so dramatically combined joy and astonishment? Not Rembrandt or Dürer or Velasquez or Rubens, nor a host of lesser names. Caravaggio painted two different versions. Van Meegeren chose the second of these two Caravaggios, painted in 1606, and stuck close to it.

Why Caravaggio?

Van Meegeren needed to take *someone* as a model, that much was clear, for he was simply not good enough to leap to Vermeer's height from ground level. Caravaggio was a brilliant, mischievous choice because there had long been speculation in art circles that Vermeer had studied Caravaggio's work and been much influenced by it. Some historians even argued, though without proof, that Vermeer had traveled to Italy and studied Caravaggio on his home ground. But even if Vermeer never left Holland, which may well be the case, he knew Italian painting well—recall that he had been called as an expert in a legal case that turned on the authenticity of a collection of Italian paintings. Moreover, the city of Utrecht, only a short distance from Delft, had been

home to a group of painters so indebted to Caravaggio that they were called *Caravaggisti*, followers of Caravaggio. Vermeer indisputably knew their work.

When Hannema put together his Vermeer exhibition in 1935, he had titled the show "Vermeer: Sources and Influences," and he went out of his way to link Vermeer and Caravaggio. "In the exhibit's first room," Hannema wrote in his catalog, "a number of works by Utrecht masters like Honthorst, Baburen, and Terbruggen will be found." Lest anyone miss his meaning, Hannema spelled out the reason he had included works by the *Caravaggisti* in a show dedicated to Vermeer. "They are related to early works by Vermeer."

Every forgery is a game of "I think that you think that . . ." The forger needs to anticipate the connoisseur's expectations and build in precisely those touches that will move the expert to say, "Just as I figured." Van Meegeren could be sure that any connoisseur would murmur appreciative words about a painting based on a work by Caravaggio but incorporating allusions to Vermeer.

The Hannema show had called enormous attention to Vermeer. But experts on Dutch art wanted to do more than argue in favor of a Caravaggio-Vermeer link. They yearned to *prove*, once and for all, that the link was a solid, tangible fact. Two months after the Hannema exhibition closed, the Dutch critic Pieter Koomen suggested that one day a new Vermeer might be discovered that would establish the Caravaggio-Vermeer tie beyond any question. Caravaggio had influenced Vermeer, Koomen wrote in the highly regarded *Maandblad voor Beeldende Kunsten*, but that influence had been subtle and elusive. Then Koomen went on to write one of the astonishing sentences in the entire Van Meegeren saga: "Perhaps tomorrow we will discover a thus far unknown painting, and next year another one, which will convincingly show this influence."

Such a discovery would be almost too much to hope for. But if by some fluke such a Vermeer *did* appear—a painting that precisely vindicated Hannema's view of Vermeer—one thing was sure: Hannema would move heaven and earth to acquire it.

Hannema and Koomen had not quite fallen into the trap of the Piltdown paleontologists—they had not predicted the existence of a missing link. But they had done Van Meegeren almost as great a favor. By highlighting the Vermeer-Caravaggio connection, they had handed the forger an answer to the knotty question of how he could make people think "Vermeer" without copying him.

Van Meegeren knew from the time he started work on *Christ at Emmaus* that

it would be the most ambitious, most difficult forgery he ever undertook. Nearly all the dates in the Van Meegeren saga are hard to pin down, but probably Van Meegeren began to paint *Christ at Emmaus* a month or two *before* Koomen's article appeared. Even without Koomen's broad hint, that is, Van Meegeren had decided that his greatest forgery would be a "Vermeer" modeled closely on a Caravaggio. Not for the first time, he had gauged the mood of the day perfectly. In December 1935, at precisely the moment of Koomen's public plea for a new Vermeer, Van Meegeren had begun to paint the very picture that the experts hoped to find.

NEARLY ALL THE artists who painted versions of *Christ at Emmaus* focused on the most dramatic moment—the instant of Jesus's revelation or its immediate aftermath. Rembrandt depicted the awed disciples gaping at an empty chair. In Caravaggio's first version, *Supper at Emmaus*, which today is one of the treasures of London's National Gallery, a clean-shaven, red-cheeked, robust Jesus makes his startling announcement, and the excitement nearly undoes the two disciples. One clutches his chair, as if he is about to leap up. The other, whom we see in profile, flings his arms apart in shock and bewilderment. His left hand, a tour de force of foreshortening, thrusts straight at us. It seems almost to burst out of the canvas and materialize before us, larger and more powerful than any hand in the ordinary world.

But Vermeer would never grab us in a meaty paw to get our attention. And just here Van Meegeren did something brilliant. He decided to model his version of *Emmaus* closely on Caravaggio's *Emmaus*, but he chose Caravaggio's second version of the painting rather than the first. If Van Meegeren's choice of Caravaggio as a model was clever, this choice of Caravaggio's second version of *Emmaus* was inspired.

The second painting shows a close kinship with the earlier version—in 1606 as in 1601, Caravaggio focused tightly on the table, with Jesus in the center, facing us. In both pictures, one disciple sits facing Jesus, his back to us, and one sits at Jesus's left, his profile toward us. Both pictures feature Caravaggio's intensely focused light and an astonishingly rendered array of shadows, though the later painting is darker and quieter.

In the 1601 Caravaggio, Jesus is rosy and youthful. In 1606, Caravaggio depicted a more familiar Jesus, bearded, careworn, and weary. But a far more important difference between the paintings is the moment Caravaggio has chosen to represent. In 1606, Caravaggio painted the moment *before* Jesus's

revelation; in 1601, he had painted the moment *after*. The subtler 1606 version is the painting that Van Meegeren took as his model. An instant from now, the light will dawn—almost literally—but we are not quite there yet. The disciple with his back to us is on the brink of understanding; he has just begun to lift his hands in surprise. But at this instant everything is still pending. The mood is quiet, intense, watchful, subdued.

The moment, in other words, was exactly the one Johannes Vermeer would have chosen had he set out to paint *Christ at Emmaus*.

33

IN THE FORGER'S STUDIO

Van Meegeren began to work on *Christ at Emmaus* in the fall of 1936, soon after he and his wife returned from the Summer Olympics in Berlin. These were the famous "Nazi Olympics," a carefully choreographed spectacle starring Adolf Hitler and meant to show the world the superiority of "Aryan" athletes. Leni Riefenstahl made a famous propaganda film documenting the pageantry and the splendor of the competitors. Jesse Owens, the black American track star, spoiled the storyline somewhat by winning four gold medals.

After he put the hubbub of Berlin's roaring crowds behind him, Van Meegeren settled into the solitude of his Roquebrune studio. In addition to his artistic choices, he had a number of technical problems to think through. His aim was to create a painting that looked so convincingly old that connoisseurs would take for granted that they were dealing with an object from the seventeenth century. From that moment they would be doomed, because every question they asked would be beside the point. Let the experts debate whether this newfound painting showed Caravaggio's influence or fit with Vermeer's other religious paintings. Nothing would please Van Meegeren more. What he feared were nuts-and-bolts questions like, Where has this picture been for two and a half centuries? Who owned it last?

Van Meegeren took fanatic care, as we have seen, in his Bakelite experiments. But finding a paint that would harden quickly was only one of some half-dozen technical challenges that confronted him. He began with a trip to Holland, where he haunted galleries in search of genuine seventeenth-century paintings. He took not the slightest interest in the paintings themselves. The

picture was not the point. It was the canvas beneath it that he needed, because canvas could be dated.

Eventually he found a painting called *The Raising of Lazarus.* It was "badly painted," Van Meegeren recalled years later, but that was all to the good because it kept the price to a reasonable 200 guilders (roughly $1,400 in today's dollars). The canvas was big, about forty-five inches high by seventy wide, which was appropriate for the grand sort of picture Van Meegeren had in mind. For an elegant jewel of a painting like *The Lacemaker*, Vermeer had chosen a canvas that measured only nine inches by eight. By seventeenth-century standards, though, the dignity of a biblical scene called for a more imposing scale.

Lazarus was a bit *too* big, in fact, since the biggest painting Van Meegeren could slide into his oven was about fifty inches by fifty inches. That was a nuisance, since it meant that he would have to cut the canvas down to size, but as he turned *Lazarus* over to examine its back, his eyes lit up.

He saw that the stretcher—the wooden framework behind a picture that holds the canvas taut—was the seventeenth-century original.* That was rare. One modern-day expert estimates that fewer than one painting in a hundred from Vermeer's day still has its original stretcher. The nails that attached the canvas to the stretcher were original, too. Van Meegeren didn't *need* old wood and old nails—in the course of three centuries, it would make perfect sense to anyone questioning a work's authenticity that one restorer or another had seen fit to replace an old stretcher with a newer, sturdier one and had hammered it in place with shiny new nails. But he knew that the antique bits and pieces would make a good first impression.

With *Lazarus* safely home, Van Meegeren's first task was to remove the picture from its stretcher. He put aside the stretcher and nails to reuse later. Then came a bit of tailoring—the canvas had to be cut down about twenty inches in width so it could fit in the oven (allowing for a little extra fabric to fold around the stretcher). Next, carpentry. The old stretcher had to be cut down so that, when the time came, it would fit the newer, smaller picture. To disguise the new saw cuts, Van Meegeren rubbed a bit of grime into the exposed surfaces.

* *Lazarus's* stretcher consisted of two parts. The first and more important was a wooden rectangle with essentially the same dimensions as the picture itself. The canvas was stretched over this rectangle and nailed in place. The stretcher also included four additional pieces of wood, for sturdiness, arranged in a diamond shape with its corners at the centers of the rectangle's four sides.

After those small jobs came a chore that called for little more than elbow grease and long hours of tense tedium. Van Meegeren could not simply paint over *Lazarus.* That meant he had to remove the paint and—this was the tricky part—do so without harming the canvas.

He might have gone to such trouble partly for the artistic reason that he preferred to paint on a perfectly smooth surface. But Van Meegeren's main motive was strategic. If someone X-rayed his forgery and saw another painting beneath it, there could be trouble, even if the newly revealed painting was suitably old. Art historians know from X-rays of paintings by Vermeer that he sometimes changed his mind as he worked—the famously bare white wall behind *The Milkmaid*, for example, once featured a large map—but he rarely or never painted over someone else's completed picture.* Even if Van Meegeren didn't know this, his only prudent course was to assume that Vermeer began work on a clean canvas.

X-rays posed another danger, too. If an X-ray of a forgery revealed a hidden painting that someone could identify, that clue might point the way to a dealer and a buyer and eventually to Van Meegeren himself.

And so Van Meegeren set to work scraping. Now the hardness of oil paint, which he had devoted so many months to imitating, came to bedevil him. Hardened paint is extraordinarily tough, far sturdier than canvas, especially centuries-old canvas. In its first year or two, oil paint might yield to turpentine or even soap and water, but when a painting is older than that, scraping and patience become the only options. With pumice stone and putty knife in hand, Van Meegeren would have set to work, picking away at the tiny fracture lines that lace the surface of old paintings one paint fleck at a time. The canvas in front of him measured sixteen square feet.

When, finally, he had obtained a clean canvas, Van Meegeren had only to clamp the loose canvas firmly to a board and set to work. With brush and Bakelite paints, he retreated to the seventeenth century.

* *The Girl with a Red Hat* seems to be an exception to the rule. It is the only painting by Vermeer with someone else's work beneath it (and one of only two Vermeers on a wooden panel, not on canvas; the other is the controversial *Girl with a Flute*). X-rays of *Girl with a Red Hat* reveal a portrait of a man with a big hat and long, curly hair (Vermeer flipped the panel upside down). Arthur Wheelock says that the man's portrait is not in Vermeer's style and suggests that it may have been the work of Carel Fabritius.

34

CHRIST AT EMMAUS

For the seven years between 1938 and 1945, Van Meegeren's *Christ at Emmaus* was the most famous and the most admired Vermeer in the world. It was the picture that popped into every art lover's mind when someone said "Vermeer," just as *The Night Watch* was when someone said "Rembrandt."

The actual painting took Van Meegeren six months. The artistic challenge was formidable, for even Vermeer, with all his skill, worked from human models. Van Meegeren, painting in secret, had no such luxury. The picture shows four large figures crowded around a small table. Jesus, in a blue robe, faces us. Opposite him, with his back to us, sits a figure in gray; at Jesus' left, with his left side turned toward us, sits a second disciple, in yellow. A serving girl, in a brown robe, stands between Jesus and the yellow-robed disciple.

The arrangement is virtually identical to Caravaggio's 1606 version of *Emmaus*. Even in the details of Jesus' pose, right hand raised in blessing with index finger extended, Van Meegeren followed Caravaggio. The only substantial difference in layout is that Caravaggio included two servants, Van Meegeren only one.

But though the figures in the two paintings are in similar poses, Caravaggio painted men and women who were unmistakably creatures of flesh and blood—too much so, in the eyes of many of his shocked contemporaries. Even in his depictions of Christianity's holiest figures, Caravaggio's favorite models were prostitutes and barflies. He knew their gritty world well. In 1606,

the year of *Emmaus*, Caravaggio killed a rival in a street brawl and was nearly killed himself. With a death sentence looming over him, he ran from the authorities. No one looking at a Caravaggio would have trouble recalling that Jesus and his disciples were laborers who worked with their hands and sweated to earn a living.

Not so in Van Meegeren. "He did not copy Caravaggio's rather robust Christ," observes the painter and art historian Diederik Kraaijpoel. "He needed someone more pathetic. Instead, he invented a zombie Christ in the hope that this sad figure would move his spectators." And so it did. In Van Meegeren's *Emmaus*, not only Jesus but the disciples and the serving girl are pale and sickly, and all three men have long, limp, greasy hair. (The girl's hair is hidden under a hood.) Van Meegeren's *Emmaus*, says Kraaijpoel, "threw the pious Dutch art audience into rapturous convulsions."

The critics fell under the same spell as the art-loving public. They marveled at the painting's "serenity" and its "melting light." They stared entranced at the "infinitely soft" faces, as beautiful as those in the famous domestic interiors but with "a higher and more sacred significance." They basked in the contemplation of *Emmaus*'s "elevated peace."

To remind his audience that it was in the presence of greatness, Van Meegeren had thrown in an array of touches meant to evoke the beloved Vermeer. Some were generic, trademarks of a sort, like the blue and yellow of the robes or the light streaming from a window in the left-hand wall. Others were allusions to specific paintings. The jug on the table is a near copy of one that Vermeer painted again and again, in such works as *The Music Lesson* and *Girl Asleep at a Table* and *The Glass of Wine*. Generations of museumgoers have marveled at the way the light in *The Milkmaid* skitters across the loaf of bread; the *pointillé*, the dots of light on the bread in *Emmaus*, come straight from *The Milkmaid*. The disciple clutching the table has more than a passing resemblance to Vermeer's astronomer. Beyond a doubt his left hand and arm come directly from *The Astronomer*, though Van Meegeren botched what Vermeer rendered splendidly.

The signature, a neat "IV Meer" in the painting's upper left-hand corner, is a stroke-for-stroke copy of the one that appears on such Vermeers as *Lady Seated at a Virginal*. Van Meegeren liked to go on about that signature. "Do you know how long I practiced?" he asked. "Think of that, writing that signature

a few hundred times a day, and then finally finding the courage to do it on the canvas itself! For days I dreaded it."

But that was just storytelling fun. In truth it would have been far harder to forge an ordinary signature scribbled on a piece of paper. When he took brush in hand, Vermeer painted his name with great care, each letter separate and distinct. Van Meegeren had no great difficulty forging his predecessor's name.

UNDERGROUND TREMORS

Once Van Meegeren had finished painting *Emmaus*, he needed to harden his Bakelite paint. That meant sliding the picture into the oven, setting the thermostat to 250 degrees Fahrenheit, and closing the door for two nerve-racking hours.* But the six months at the easel, and then the two hours of baking, would all have been wasted unless the two minutes after that went as planned.

Look closely at an old painting and you see a delicate network of ever-so-shallow cracks that join and crisscross seemingly at random. Like wrinkles in a person's face, cracks are a sign of age. Forgers pay careful heed to that craquelure, as the cracks are known, because they have learned that authentic paintings from centuries ago will almost certainly show these signs of time's passage.

Shallow as the cracks are, they fill with dust and dirt as the decades pass. (It will turn out to be important that this debris, when examined under a microscope, is just as heterogeneous as the litter—old shoes, paper cups, hub caps, plastic bags—that accumulates in a roadside ditch.) In time the cracks take on the appearance of spidery black lines. In the lighter areas of a painting—on a pale cheek or a white tablecloth or a milky sky—they are particularly easy to spot.

Van Meegeren had to replicate those cracks, and the task was harder than

* Two hundred fifty degrees sounds surprisingly low for an oven—it is not hot enough to bake a cake or a loaf of bread—but Van Meegeren had found by trial and error that a long baking at a low temperature was the only way to avoid scorching his paint and making his canvas dangerously fragile.

it sounds. The oven was unlikely to solve the problem for him. The heat would produce cracks, but not just any cracks would do. Restorers, who have scrutinized countless paintings and learned to recognize the signs of aging, are the great authorities on craquelure. To listen to them talk about age cracks in paintings is like listening to makeup artists talk about crow's feet and puffy eyes. A poor imitation of craquelure is as unconvincing as a bad face-lift. *Emmaus* would have to fool these savvy pros.

Mauritshuis, The Hague

Vermeer, *Girl with a Pearl Earring*, detail

Exactly what they look for restorers have difficulty putting into words, but they offer a few hints. In seventeenth-century paintings, for example, cracks are typically sharp-edged and divide a painting's surface into discrete, tiny "islands." The surface of a seventeenth-century painting, magnified, looks like a dried-up mud puddle. In works from the nineteenth century, the cracks are often rounded and more delicate. A close-up of a nineteenth-century painting calls to mind an alligator's hide, and restorers call the cracking process "alligatoring."

Left, alligator skin; *right*, dried riverbed

Craquelure arises because an oil painting is a complicated, multilayered object. We sometimes call a painting a picture, but the picture itself—the depiction of a milkmaid working or a woman reading—is only part of a complex structure. In a typical seventeenth-century oil painting, the artist began with an untreated canvas (or, less often, a wooden panel). Then came a succession of layers, each with a distinct role. First, the canvas was sealed with a thin coating of glue made from rabbit skin, to protect its fibers from the slightly acidic layers soon to come. Next came the so-called gesso layer, this one of glue and chalk, meant to fill the gaps in the canvas's weave and produce a smooth surface. There followed an oil-priming layer, made up of chalk and linseed oil. The aim here was to smooth the surface even further, the better to be painted on, and also to seal off the gesso layer. If a careless painter skipped the oil priming, the absorbent gesso would suck the oil out of the paint and produce a leathery, wrinkled surface.

At last, after all this preparation, came the picture itself. It, too, consisted of layers, because paints differed in just how opaque or translucent they were. In Vermeer's day, many colors could not be reached in one step. When Vermeer wanted a warm, golden yellow, for instance, he first had to paint an opaque layer of lead-tin yellow, which by itself is whitish and cold. When that dried, he put on a glaze with transparent gold ochre and thus got the desired effect. "Nowadays you just use cadmium dark yellow," says the painter and art historian Diederik Kraaijpoel, "and you get the right hue immediately."

Finally came a protective layer of varnish, made from tree resin. All the many stages, and of course the process of painting itself, were finicky and time-consuming. The rabbit glue layer and then the gesso and then the oil-priming layer each had to dry, for example, and then each had to be smoothed with a pumice stone or a piece of sharkskin. Haste or sloppiness would soon make for a cracked and broken painting, but not even the most painstaking care could head off the cracking problem altogether.

When a painting is subject to changes in temperature and humidity, which is almost bound to happen sooner or later, it begins to expand and contract. Canvas itself copes well with changing conditions because it has some give to it. One reason, in fact, that artists began painting on canvas in the first place was that canvas, unlike wood, neither cracked nor warped. (Canvas was lighter and cheaper, too, and better suited to huge paintings.) But as flexible as canvas is, eventually its expanding and contracting causes trouble. And since the layers that form a painting do their best to cling to one another, and since each

layer expands and contracts at its own rate, trouble in one layer tends to induce trouble in other layers.

In some ways, this is geology in miniature. The stresses and strains and zones of weakness that can rip great gouges in the natural landscape have counterparts that can make for micro-damage to an artist's landscapes, too. "Like miniature tectonic plates, the different layers heave and tug at each other until something gives," says Leo Stevenson, the English painter and art historian. "Sometimes the forces are deep and strong and the cracks you see on the surface come from deep down, and at other times the forces are all at the surface and all the effects are local."

It is impossible to foresee precisely the pattern of cracking that will emerge as a painting ages. In Van Meegeren's case, the results were even less predictable than usual. Conventional artists worked with paints whose properties had been observed for centuries; Van Meegeren painted with strange, plastic-like paints of his own invention. Ordinary paintings hung in comfortable rooms where the heat and humidity stayed within fairly narrow bounds; Van Meegeren planned to cook his masterpiece in an oven.

What was a forger to do? Van Meegeren devised a two-part strategy. First, when he scraped *Lazarus* off its canvas, he left the ground layer in place. Over the centuries it had acquired its own, genuine craquelure. Van Meegeren hoped that, as *Emmaus* baked, those authentic cracks would give rise to a similar-looking network of cracks in the painting's surface, in much the way that a subterranean fault can produce cracks and fissures in the ground above. He knew, though, that this outcome was far from guaranteed. It *could* happen, but there was no reason to count on it.

Second and more important, Van Meegeren knew that baking his painting would make it brittle, whether or not it produced the craquelure he hoped for. For a picture that needed cracks, brittleness was all to the good. Van Meegeren exploited it fully. When he slid *Emmaus* out of the oven, he applied a coat of varnish and set the picture aside to cool. Then came the crucial two minutes. After all the fastidious preparation, this last step in producing a beautiful craquelure was almost laughably low-tech. Van Meegeren took his brittle painting and bent it over a table's edge or across his knees. Then, pushing gently but firmly with his hands, he cracked it. To make sure that the cracks formed at random rather than in a telltale series of parallel lines, he turned the painting at an angle and repeated the process.

Van Meegeren would later claim that, as he prepared *Christ at Emmaus*, he

precisely controlled the craquelure pattern by rebaking the painting each time he added a new layer. In this way, he said, he replicated the authentic craquelure from the ground layer over and over again. Stevenson and other experts scoff. There is no way of predicting how cracks pass from one layer to another, they insist, and in any case no canvas could stand up to repeated baking. Canvas is a natural product. Bake a three-hundred-year-old piece of linen repeatedly and it will grow so delicate it will break under a brush's pressure.

In creating a new kind of paint, Van Meegeren really had displayed technical wizardry. Despite his stories, his method of creating craquelure was nowhere near as impressive technically. No matter. By far the most important feature of Van Meegeren's craquelure was its appearance, and its appearance was ideal. That was an unexpected bonus. Van Meegeren's years of experimenting with Bakelite paint had been directed at another problem entirely. He had labored to devise a paint that would pass the alcohol test. It was a gift from the gods that paint formulated to pass that test also happened, when baked and bent across a knee, to break up in a spidery network that precisely replicated the look of a seventeenth-century painting.

VAN MEEGEREN WAS an ingenious man and a high-stakes gambler, and he must have gotten a kick out of a nervy little game he played to finish up his fake. The last step in creating a convincing craquelure was to darken the cracks so that they looked as if they had been accumulating dirt for centuries. But how could anyone tamp down dirt into a complex network formed of thousands of ditches each only a tiny fraction of an inch deep?

Van Meegeren's solution was to use not dirt but India ink. If he could somehow spill ink into the cracks, and nowhere else, he would achieve exactly the spider's web look he was after, and he would avoid all the shoveling-and-tamping heartache. This was a colossal gamble—if anyone tested the "dirt" with a microscope, the game would be up in an instant. Van Meegeren, so prudent in some steps of the forging process and so reckless in others, shrugged and pushed all his chips into the center of the table.

The question was when to spill ink onto the picture. Should the ink go on the painting before the varnish, or after? It would have been disastrous if some ink found its way into the painting itself, rather than into the cracks. Van Meegeren's plastic paint had hardened as it cooked, but it could have been slightly porous nonetheless. Even the hardest substances, such as rock and

bone, can be porous. Ink shouldn't be able to penetrate paint, but Van Meegeren couldn't know that he had ground and mixed his paints perfectly.

So the answer was, *first* the varnish, *then* the ink. Van Meegeren took his newly baked forgery from the oven, varnished it, and cracked it over his knee. Then he covered the entire cracked and varnished surface with a layer of India ink. He let the ink sit. Eventually some of it seeped its way into the cracks; the rest, sitting harmlessly on top of the varnish, could easily be cleaned away.

The varnish, too, had come in for some special care. Van Meegeren had made sure to give it a brownish tint, since he knew that on so old a painting a bit of discoloration was only to be expected.

The forger topped off his work with one final, cynical flourish. Having labored for months to create a brand-new old painting, Van Meegeren immediately damaged it, to simulate wear and tear. First he scraped the picture in a few random places. Then, in one not quite random spot, the back of Jesus' right hand, he tore the canvas. (For forgers, the question of where to inflict random damage demands serious thought. Faces always escape unharmed.)

Van Meegeren repaired the tear just poorly enough to call attention to the need for a better job. Then he retrieved the stretcher and nails he had set aside. He lovingly tapped the seventeenth-century slats of wood into place on the back of his picture.

At this point, no one but Van Meegeren (and perhaps his wife) had ever seen *Emmaus*. Now the world would have its chance.

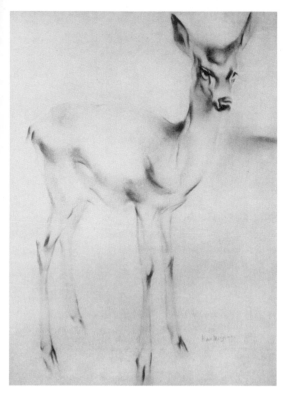

Deer by Van Meegeren,
Teekeningen I, 1942

Han van Meegeren was a competent artist
who believed he was a genius. He had a
taste for the sentimental (above) and the
creepy (right). His big-eyed deer was the
most popular drawing he ever made and
once could have been found in nearly
every Dutch home.

Skull and Top Hat by Van Meegeren,
Teekeningen I, 1942

Dancing Sailor by Van Meegeren,
Teekeningen I, 1942

Pictures like the *Dancing Sailor* and *Blowing Bubbles*
brought Van Meegeren prosperity but not the
respect of the art establishment. As a young man,
he had painted biblical scenes and other serious
subjects, but the critics condemned his work as
shallow and insipid. He turned to more
approachable themes, and to forgery.

Blowing Bubbles by Van Meegeren,
Teekeningen I, 1942

A Boy Smoking by Van Meegeren, Groninger Museum, Groningen

Van Meegeren made a fortune—$30 million in today's dollars—from his forgeries of old masters. This fake Frans Hals, *A Boy Smoking*, was one of several Hals forgeries that the critics fell in love with.

The Portrait of a Man was meant to evoke Gerard ter Borch. Perhaps because he was dissatisfied with the result, or because Ter Borch was not famous enough, Van Meegeren never tried to sell the picture.

Portrait of a Man by Van Meegeren, Rijksmuseum, Amsterdam

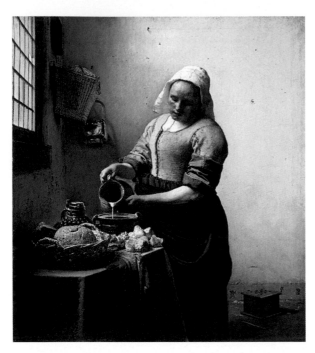

Vermeer's *Milkmaid* is one of his best-loved domestic interiors. The light streaming through a window in the left-hand wall, the use of yellows and blues, and the dots of light on the bread were all Vermeer trademarks that Van Meegeren would steal, magpie-style.

The Milkmaid by Vermeer, Rijksmuseum, Amsterdam

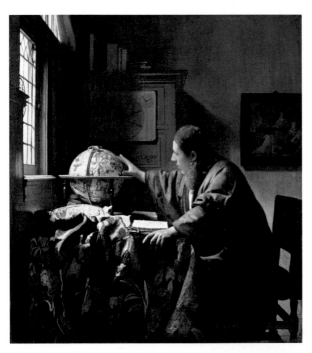

Vermeer's *Astronomer* is another classic image. Van Meegeren studied the astronomer's left hand and forearm and painted an almost exact—but botched—copy in his most famous forgery, *Christ at Emmaus*.

The Astronomer by Vermeer, Louvre, Paris, France

Vermeer's output was tiny, only 35 or 36 paintings in all. Each one is immensely valuable. *Christ in the House of Mary and Martha* is by Vermeer, though we do not usually associate him with biblical works. This painting was lost until 1901. Its discovery raised hopes that more Vermeers might turn up.

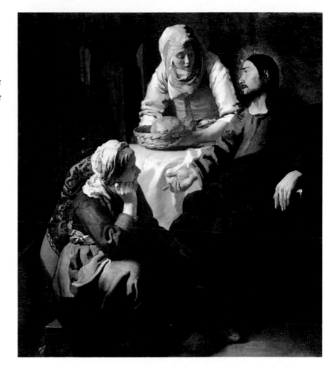

Christ in the House of Mary and Martha by Vermeer, National Gallery of Scotland

Vermeer's *Allegory of Faith*, another religious painting, was discovered in 1899. The man who found it, a renowned Vermeer scholar named Abraham Bredius, hoped for the rest of his long life to cap his career with one more spectacular Vermeer find. He was destined to become Van Meegeren's greatest victim.

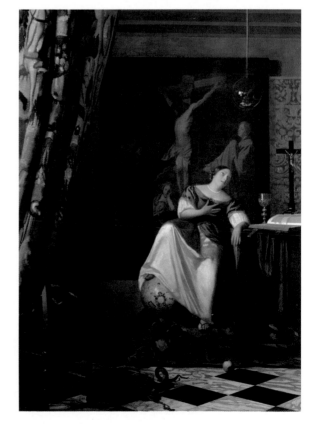

Allegory of Faith by Vermeer, Metropolitan Museum of Art, the Friedsam Collection, bequest of Michael Friedsam, 1931 [32.100.18]. Photograph copyright 1994, Metropolitan Museum of Art

Woman in Blue Reading a Letter by Vermeer, Rijksmuseum, Amsterdam

Van Meegeren began his "Vermeer" career by making close copies of well-loved originals. *Woman in Blue Reading a Letter* is a genuine Vermeer, *Woman Reading Music* a Van Meegeren forgery. This fake was an experiment that Van Meegeren never tried to sell. Perhaps he judged that it might fool a layman but not an expert.

Woman Reading Music by Van Meegeren, Rijksmuseum, Amsterdam

The Lacemaker by Vermeer, Louvre, Paris, France

Vermeer's *Lacemaker*, now in the Louvre, is one of his most admired pictures. In the 1920s, this fake *Lacemaker*, supposedly by Vermeer, was considered just as dazzling. It was one of the gems of Andrew Mellon's art collection, and when that immensely wealthy banker died, he bequeathed the prize to the National Gallery. After the picture was revealed as a fake, it was banished to a "Special Collection."

The Lacemaker by imitator of Vermeer/forgery, National Gallery of Art, Washington, DC

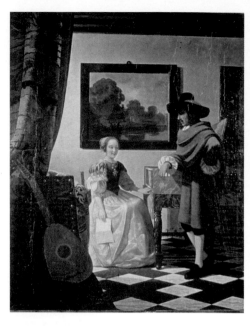

Lady and Gentleman at the Harpsichord by Van Meegeren, Rijksdienst Beeldende Kunst, The Hague

This ambitious Van Meegeren forgery, *Lady and Gentleman at the Harpsichord*, fizzled. "The cavalier," says one present-day critic, "would demonstrate a frightening case of anorexia nervosa." *Woman Playing Music* was another experiment in forgery. Van Meegeren invoked a number of Vermeer touches—a solitary woman in blue in a quiet room with light pouring from the left—but he did not try to sell this painting.

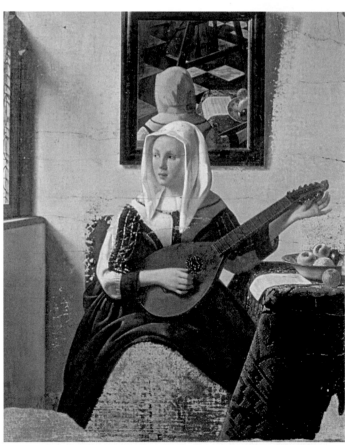

Woman Playing Music by Van Meegeren, Rijksmuseum, Amsterdam

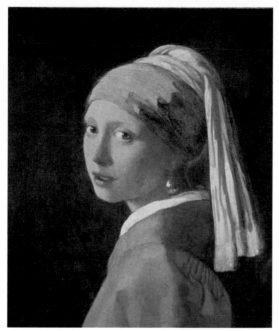

Girl with a Pearl Earring by Vermeer, Mauritshuis, The Hague

Girl with a Pearl Earring is an authentic Vermeer (which was lost until 1881, when a buyer picked it up for the equivalent of $200 today). In comparison, two Van Meegeren forgeries look like waxwork dummies. But the *Smiling Girl* ended up in Andrew Mellon's art collection and then in the National Gallery, and critics in the 1940s judged the woman in the *Last Supper* a match for the *Girl with a Pearl Earring*.

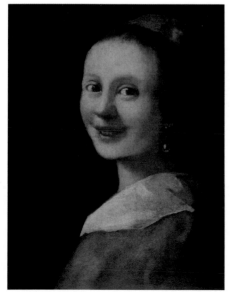

The Smiling Girl by imitator of Vermeer/forgery, National Gallery of Art, Washington, DC

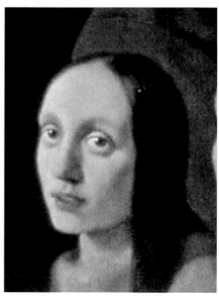

The Last Supper [detail], by Van Meegeren, Caldic collection, Rotterdam

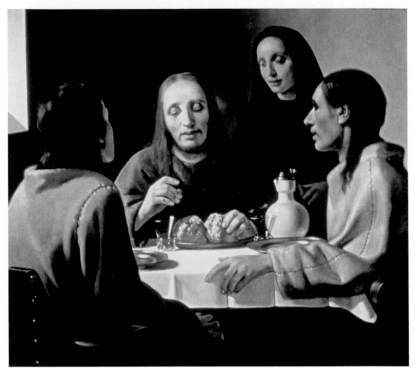

Christ at Emmaus by Van Meegeren, Museum Boymans-van Beuningen, Rotterdam

Van Meegeren changed tactics. When nearly all the critics ignored *Lady and Gentleman at the Harpsichord*, he abandoned the close copy strategy. Instead, he decided to create a painting unlike any known Vermeer. *Christ at Emmaus* was his most successful forgery. This painting was hailed as Vermeer's greatest masterpiece.

Christ at Emmaus on display at Museum Boymans-van Beuningen, Rotterdam, 1938

Christ at Emmaus was unveiled at a blockbuster show in Rotterdam in 1938. Rapturous critics and huge crowds gazed at it in silent reverence. Today it looks lifeless and awkward, and the great mystery is why those early admirers swooned before it.

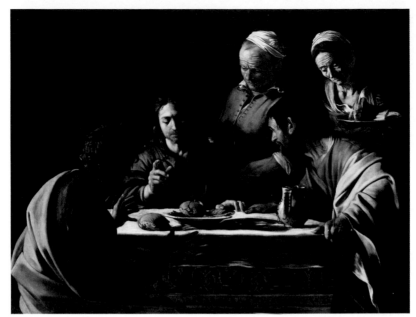

The Supper at Emmaus by Caravaggio, Pinacoteca di Brera, Milan, Italy

Vermeer never painted a *Christ at Emmaus*, but Caravaggio painted two versions. Van Meegeren modeled his composition on Caravaggio's 1606 version, above. In the version below, from 1601, Jesus has just revealed his identity, and the disciples have nearly fallen over in astonishment. Van Meegeren chose to follow the quieter version, which depicts the moment *before* the revelation. The mood is intense, watchful, subdued. Van Meegeren's brilliant choice was to evoke precisely the moment that Vermeer would have chosen.

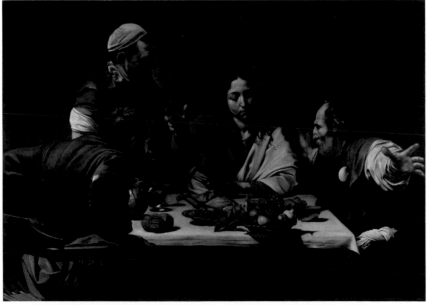

The Supper at Emmaus by Caravaggio, National Gallery, London

Head of Christ by Van Meegeren, Museum Boymans-van Beuningen, Rotterdam

Christ at Emmaus was such a colossal hit that Van Meegeren followed it up with five more biblical "Vermeers." He sold this *Head of Christ* to a collector (for the equivalent of $1.5 million in today's dollars), claiming it was a study for a lost picture. Then, months later, he announced astonishing news—the lost painting had turned up! Van Meegeren sold *The Last Supper* to the same collector who had bought the study, for the equivalent of $8.6 million today, his highest fee ever.

The Last Supper by Van Meegeren, Caldic collection, Rotterdam

Isaac Blessing Jacob by Van Meegeren, Museum Boymans-van Beuningen, Rotterdam

Van Meegeren cranked out one biblical forgery after another, each one worse than the ones before, and each one selling for millions. The figures in *Isaac Blessing Jacob* look like paper cutouts, and in *The Washing of Christ's Feet* something has gone dreadfully wrong with Christ's right arm. Van Meegeren explained away his carelessness. Why try harder, he asked. "They sold just the same."

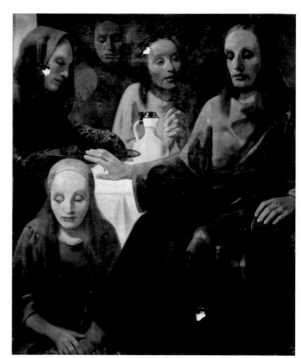

The Washing of Christ's Feet by Van Meegeren, Rijksmuseum, Amsterdam

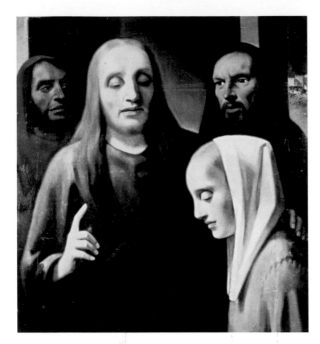

*Christ with the Woman Taken
in Adultery* by Van Meegeren,
Rijksdienst Beeldende Kunst,
The Hague

Hermann Goering, second only to Hitler in the Nazi pecking order, fancied himself
an art connoisseur. He looted artworks from across Europe, literally by the trainload,
and he craved a Vermeer. In 1943, his buyer found him this one, *Christ with the Woman
Taken in Adultery*, actually a Van Meegeren forgery. Goering traded 137 pictures from his
collection for this lone "masterpiece."

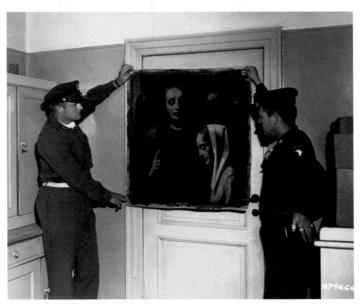

When the war ended, Goering tried to hide his stolen paintings. The 101st Airborne
found his stash of treasure in the Bavarian Alps, including his prize "Vermeer."
Photo of *Christ with the Woman Taken in Adultery*, National Archives

The Art of Painting by Vermeer, Kunsthistorisches Museum, Vienna, Austria

Goering had tried to grab *The Art of Painting*, one of the most famous and admired Vermeers of all. Hitler, a failed artist intent on assembling the world's greatest art museum, "purchased" it for himself.

American soldiers found much of Hitler's stolen art, thousands of paintings in all, hidden in a salt mine. The painting at the right is Willem Drost's *Officer in a Red Beret*. (Topham/The Image Works)

The Pianist Theo van der Pas with the "Ghosts" of Mozart, Beethoven, Bach, Brahms, Schumann, Chopin, and Schubert by Van Meegeren, *Teekeningen I,* 1942

Christ at Emmaus struck its Dutch audiences as almost holy, a sublime and uplifting work of art. Van Meegeren had tried to create the same mood in his own work, as in *The Pianist Theo van der Pas with the "Ghosts" of Mozart, Beethoven, Bach, Brahms, Schumann, Chopin, and Schubert.* The art historian Albert Blankert notes that when Van Meegeren painted in his own name, critics scoffed at his sentimentality. But when he presented that same "elevated pathos" under the name Vermeer, the world fell at his feet.

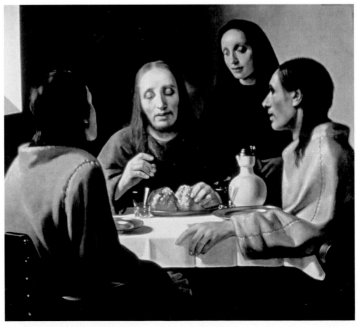

Christ at Emmaus by Van Meegeren, Museum Boymans-van Beuningen, Rotterdam

36

THE SUMMER
OF 1937

Van Meegeren's first target was his old dupe Bredius, the Vermeer con-
noisseur who had swooned over *Lady and Gentleman at the Harpsichord* five
years before. The old man had fallen hard for one forgery. The art world had
failed to go along, but perhaps Bredius was worth another try.

Like other forgers, Van Meegeren seldom risked venturing into the open.
He needed a middleman, preferably one above suspicion, to do the actual
work of selling *Emmaus*. He found the perfect candidate almost on his front
stoop.

Gerard A. Boon was a friend of Van Meegeren's from The Hague. He was
tall, slender, well spoken, and well connected. For fifteen years he had repre-
sented the high-minded Liberal Party in the Dutch parliament. He and Van
Meegeren had crossed paths because Van Meegeren had been the pet artist of
The Hague's upper crust. When an industrialist or a politician wanted a flat-
tering portrait, they turned to Van Meegeren.

Boon was far more than a charming dinner guest. Few people in Holland
had more solid reputations. In 1931, he had received one of the state's highest
honors, the Order of the Dutch Lion. Progressive in his politics, he had ar-
gued in favor of women's rights in the 1920s and against fascism throughout
the '30s. As early as 1933, when much of the world still viewed Hitler more as a
buffoon than a menace, Boon had already begun to speak out. "Germany has
to realize," he declared, "that the entire civilized world will stand against it
until the shameful mistreatment of its Jewish minority comes to an end."

In June 1937, after he lost a bid for reelection, Boon traveled to the French

Collection Gemeentearchief, The Hague
G. A. Boon

Riviera to vacation in the sun. There, by chance, the earnest ex-politician bumped into the artist he remembered so well. Van Meegeren promptly spun a story custom-made to seduce his old friend. He had a favor to ask, Van Meegeren explained, and it would be a favor not merely to him but, what was more important, to a Dutch family living in Italy and suffering at the hands of the Fascists. "They were confirmed anti-Fascists and were being spied on by the black-shirts and their agents," as Boon later recalled the story. "The family was in danger and they desperately wanted to emigrate to America."

The family needed to raise money in a hurry, which was where Van Meegeren came in. They owned an art collection that had been assembled two or three generations before. As he sensed Boon yielding, Van Meegeren added a few details to enhance the story's credibility. The collection numbered 162 paintings and included works by Holbein, El Greco, Rembrandt, and Hals. Half the art belonged to a woman with the unusual name of Mavroeke, and half to her daughter. Mavroeke had fallen in love with Van Meegeren. She had asked him to sell one particularly striking painting on her behalf, but she could not let the Italian authorities know what she was planning. If she could smuggle the painting into France, Mavroeke had asked Van Meegeren, would there be any chance he could find a buyer?

But he was a better artist than a salesman, Van Meegeren told Boon sadly. Perhaps his friend could lend a hand? Obviously, so delicate a transaction would call for discretion. But, after all, Boon was a tactful man. And though it seemed crass to mention it, of course there was a commission involved. A generous commission, in fact, since we were, after all, talking about a master-piece. Van Meegeren suggested that the painting might fetch several million.* Even a small percentage of so great a sum would go a long way. If Boon could see his way clear to helping out, Van Meegeren went on, he would happily share his cut with him.

Boon offered, at once, to do his best. Van Meegeren suggested that a pru-dent first step might be to seek out the opinion of an eminent authority on art. Did Boon happen to know the name Abraham Bredius?

BOON IMMEDIATELY CONTACTED Bredius at Villa Evelyne, his home in Monaco. At the end of June 1937, Boon knocked at Bredius's door. He had *Christ at Emmaus* with him. While a servant struggled to free *Emmaus* from its packing crate, Bredius warned Boon not to hope for too much. Few "discover-ies" panned out. Only the day before someone in Austria had sent him a pho-tograph of what they thought was a Van Dyck. Bredius had written back right away. Stay home. Save yourself the trip. The photograph is enough to tell me not to bother with the painting.

Boon slumped a bit. Bredius turned to look at *Emmaus*.

From his first glance, Bredius said later, he knew he was in the presence of a "delicious Vermeer." In his long career—by the time he set eyes on *Emmaus* he was eighty-two years old—nothing else compared with this "wonderful moment." Bredius found himself nearly dizzy with excitement, "in an almost overwrought state of mind, in ecstasy."

Or so he later declared, repeatedly. But something deeply fishy was going on.

For only days after Boon's visit to Monaco, Bredius's "secretary" and long-time partner Joseph Kronig sent a most curious letter to a notary—in Hol-land, a prestigious post roughly comparable to a hybrid of a lawyer and a judge—in The Hague. "As requested by Dr. A. Bredius of Monaco," the letter began, "I write to ask you to try and obtain information about the reliability and integrity of the attorney G. A. Boon, a former member of Parliament and a resident of The Hague." Why the suspicion of Boon? The letter's next

* *Emmaus* would eventually sell for the equivalent of about $3.9 million in today's dollars.

sentence spelled out the answer: Boon had turned up with a painting that he wanted Bredius to evaluate, but Bredius "distrusts both the painting and its provenance."

Then, after a brief description of the painting, this summary: "Dr. A. Bredius remains in doubt, given the situation, that this painting can be ascribed to Vermeer."

The story now takes an even odder twist. Kronig sent off his letter questioning Boon and *Emmaus* on July 1, 1937. Two months later, on August 30, 1937, Boon wrote a long handwritten letter to Bredius. He told a fanciful story of where *Emmaus* had been all these years—this account differed a bit, for reasons no one has ever explained, from Van Meegeren's tale of a Dutch heiress named Mavroeke—and, strangest of all, he wrote as if Bredius had never laid eyes on the painting!

"Dear sir," Boon wrote to Bredius,

As the executor of the property of a family living abroad, whose father, deceased some 25 years ago, was Dutch, I found in a back room a painting of great beauty, though one which the family had never paid much attention to. All they knew was that the father had bought it some 40 or 50 years before, somewhere in the [southwest of Holland]. The longer I looked at it, the more convinced I became that this was the work of one of the greatest old Dutch masters. This was also the judgment of one of my friends, who—though a layman—has studied 17th-century art carefully, and whom I therefore brought with me to ask his opinion. I of course know full well that these opinions of ours are without any value. That is why I immediately decided to ask the opinion of the greatest connoisseur in this area, that is, Dr. Bredius. And as I was going to spend my vacation in St. Jean Cap Ferrat, near Monaco, six weeks later—as I do every year—I thought I would wait until then. I have the picture with me, and my question is if you would be willing to receive me. After that, I could leave the picture with you for a few days so that you can examine it. I hope that you will not find my request too immodest and that you will tell me when you can receive me.

Within days of receiving this letter, Bredius trumpeted to the world the news of his magnificent discovery. Both in published articles and in private letters, he told and retold the story of this monumental, career-topping find. From the moment he first saw the painting, he declared, he had recognized it as the greatest Vermeer of all.

That claim directly contradicts Kronig's account in his July 1 letter. What happened between Boon's two visits to Monaco? Why did Bredius "distrust" *Emmaus* in July and praise it extravagantly in September? And if Boon showed *Emmaus* to Bredius at the beginning of the summer, why did he write eight weeks later as if no such meeting had ever taken place?

Boon and Bredius kept diaries, which could have untangled the mystery, but both diaries seem to have disappeared. We can devise stories that account for the facts, but we have too few facts and too much leeway, like ancient sky-watchers who picked out a handful of stars and conjured up the image of a hunter. In a different mood, they might have seen a swan.

Perhaps the simplest scenario is this: When Boon showed up in Monaco in June, Kronig sized him up as a pest and sent him off with a white lie about how Bredius was unavailable. Later Kronig panicked—had he overreached?—and sent a letter to The Hague asking if Boon was legitimate. When he quickly received an emphatic "yes" in reply, he encouraged Boon to pay another visit. The reason that Boon and Bredius referred to their second meeting as if it were the first, in this scenario, would be that it *was* in fact their first encounter.

But Albert Blankert, the Dutch art historian, believes that events played out quite differently. Bredius *did* meet with Boon in June, Blankert suggests, but could not decide if *Emmaus* was legitimate. Wary of making a fool of himself after his last blunder with a Vermeer "discovery," Bredius sent Boon on his way without a commitment. Soon after, Kronig's letter brought the news that Boon had an impeccable reputation. That would prove especially important because Bredius, in Monaco, did not have access to the auction files and other records that would have let him probe the painting's history. He focused, instead, on the eminence of the messenger who had brought such intriguing news. (It is curious that Kronig, not Bredius, wrote the letter asking about Boon. Bredius wrote letters by the score, and ordinarily he wrote even the most routine notes himself rather than delegate the task to Kronig. Could it be that Kronig wrote *this* letter because he believed in *Emmaus* more than Bredius did, and he was the one pushing Bredius to take a second look?)

Bredius's devotion to Kronig was professional as well as personal, and in this second scenario that devotion played a large role. Bredius believed ardently that the younger man had a deep understanding of art and an impeccable eye, and he had lobbied the art world (with only middling success) on Kronig's behalf for years. Bredius gave more credence to Kronig's views on art

than to anyone else's. Did Kronig campaign for *Emmaus* over the course of the summer, eventually manage to persuade Bredius to take a second look, and finally win Bredius over to his point of view?

Boon's letter at the end of the summer, in this version, would have been a put-up job. The true purpose of the letter was not to tell Bredius about a painting called *Christ at Emmaus*, since he had already seen it, but to create a historical document that could withstand posterity's gaze. Museums like to document their acquisitions (and, indeed, Bredius would later forward Boon's letter to the museum that purchased *Emmaus*, with a note saying that "it belongs in your archives"), and this carefully composed letter would have looked far more presentable than a true account of Bredius's hemming and hawing through the summer of 1937.

WE CANNOT BE sure of Bredius's state of mind in 1937. We can only be certain that, whether he fell in love with *Emmaus* at first sight or wrestled with his doubts all summer, he ended his long career by destroying the reputation he had built up over a lifetime. If he was indeed a true believer, that would be poignant in its own right.

But if it is sad to think of Bredius going wrong decisively, it is far sadder to think that proud, high-strung Bredius could not make up his mind about whether he had truly found one last, great Vermeer. For in that case, Bredius would have been caught in a predicament that made candor impossible. He saw himself as a leader, a man who commanded respect. To confess that he was unsure if *Emmaus* was genuine would be to forfeit all credibility. A general might as well shout, "Charge! No, wait!"

Just as important, Bredius believed with all his heart that the mark of an art connoisseur was the ability to make correct judgments in the blink of an eye. To hesitate was to confess ignorance. An expert who knew Vermeer recognized him as surely and as quickly as he recognized his own spouse. So Bredius believed, and so all his peers believed.

Imagine his shock in 1932, then, when he proclaimed *Lady and Gentleman at the Harpsichord* an authentic Vermeer, and the art world sneered. Floundering and bewildered, Bredius found himself betrayed by the skill he prided himself on most. And then along came Boon, with *Emmaus*, asking Bredius what he thought.

Even if he didn't know what he thought, he couldn't say so. Even if the only

thing he knew for sure was that his reputation would rise or plummet depending on whether he made the right call, Bredius had no choice but to present himself as overflowing with confidence.

ON SEPTEMBER 9, 1937, Bredius wrote to Hannema, the director of Rotterdam's Boymans Museum. "I am in a state of anxiety, in ecstasy. I have before me a Vermeer. . . . No other connoisseur has ever seen it."

In September, too, Bredius prepared an official "authentication" of *Emmaus*, a declaration to the world meant to assure prospective buyers that *Emmaus* was a masterpiece. Bredius wrote out the endorsement in longhand on the back of a photograph of the painting, with all his characteristic fervor: "This gorgeous work by Vermeer, the great Vermeer from Delft, has emerged from the dark—thank God!—where it had been hidden for years, untouched, exactly as it left the artist's studio. Its subject is nearly unique in his oeuvre. It radiates a depth of feeling not found in any of his other works. When I was shown this masterpiece I had difficulty controlling my emotions, and that will be the feeling of many of those privileged to view this painting. Composition, expression, color—all join to form a unity of the highest art, the most enchanting beauty."

Bredius's penmanship was clear and bold, and his swirling, looping signature his customary work of calligraphic elegance. Never, in the years to come, would he make any reference to the mysterious circumstances of his first encounter with this "gorgeous work."

THE LAMB AT THE BANK

With the personable Boon out front playing the role of salesman—Bredius pronounced him "a charming man"—Van Meegeren could stay out of sight in Roquebrune, watching and waiting to see who nibbled at his bait.

The forger's choice of Bredius as first target showed his shrewdness. After the *Harpsichord* fiasco, Van Meegeren had no way of knowing how Bredius would respond to the appearance of another Vermeer. Two opposing outcomes seemed plausible. With *Harpsichord*, Bredius had taken a public position only to find that no one backed him. He might shy away from taking a similar risk a second time. On the other hand, perhaps he would leap at an opportunity to vindicate himself. Given a second chance, would Bredius work all the harder to round up support, to show the world that his judgment was as keen as it had ever been?

Faced with such contrary possibilities, Van Meegeren had made the decision to turn to Bredius once again. Almost at once, events would prove that he knew his man.

Bredius's campaign in support of *Emmaus* began immediately after Boon's August visit and continued at full force for months. He started with Hannema, at the Boymans Museum. In countless letters, Bredius praised *Emmaus* in bursts of wild, italicized prose ("Vermeer's most important painting . . . *surely* his most beautiful work. *Here* he gives his *soul*."). He bombarded Hannema and many others with schemes about how to raise the fortune that it would surely take to purchase *Emmaus*. He wrote to the Rembrandt Society, whose

mission was to acquire works of art for Holland's museums, about how important the painting was and how tragic it would be if Holland were to lose it. He wrote to the minister who headed the Department of Arts and Sciences proposing that the state confer one of its greatest honors, the Order of the Dutch Lion, on the wealthy buyer who stepped forward to purchase *Emmaus* for the nation.

Emmaus obsessed Bredius. Driven by the conviction that the picture's acceptance would provide him both fame and vengeance at a stroke, he fought for it with manic, reckless zeal. Two thousand years before, a Chinese philosopher had anticipated the whole story. "When an archer is shooting for nothing, he has all his skill," wrote Chuang Tzu. "If he shoots for a brass buckle, he is already nervous. If he shoots for a prize of gold, he goes blind or sees two targets—he is out of his mind! His skill has not changed. But the prize divides him. He cares. He thinks more of winning than of shooting—and the need to win drains him of power."

Bredius knew Vermeer's work backward and forward. But when he saw a prize of gold, he forgot all he knew.

BREDIUS HAD LEARNED the limitations of solo combat with *Lady and Gentleman at the Harpsichord*. In Hannema, his first recruit, he found an ally whose ardor matched his own. Swept away by Bredius's descriptions of *Emmaus*, Hannema overflowed with excitement before he ever saw the picture. It was Hannema who had put together the blockbuster Vermeer show in 1935, Hannema who had hoped against hope for a new Vermeer that would confirm his theories about the great artist's career. "IN RAPTURES ABOUT DISCOVERY," he telegrammed Bredius in September 1937. "WOULD LOVE TO SEE PAINTING. COULD YOU ARRANGE MEETING?"

For both men, the overriding goal was to keep this greatest of all Vermeers where it belonged. Bredius had been fighting to keep Vermeer's best work away from the upstart Americans for thirty years, since his long-ago tug of war over *The Milkmaid*. Hannema, the director of a museum yearning for a place at a table dominated by haughty Amsterdam and the mighty Rijksmuseum, was desperate to win this one-of-a-kind jewel for himself.

Hannema had an extra incentive, though he hardly needed one. Nearly a century before, Rotterdam had kicked away a chance at one of the best-loved Vermeers of all, *The Lacemaker*. Through all the succeeding decades, the pain of that loss lingered on. The story began with the death of a Rotterdam art

collector in the 1860s. For a moderate payment to the collector's heirs, the city could have acquired *The Lacemaker* and the rest of the collection, but the mayor and town council declined. Art was fine, they agreed, but Rotterdam had its port and bridges to think of, and these cost money. Half a century later, in 1909, the man who was then director of the Boymans Museum recounted the sad old tale as if it had just happened. "These bargains were for somebody else," he lamented in a history of the museum, "and for 3635 florins *The Lacemaker* became the property of the Louvre.... The prospect of the Boymans Museum ever acquiring a work by Vermeer is non-existent."

Two decades later, Hannema, by now director of the Boymans himself, felt just as aggrieved. "If only those in power in those days had better understood the value of art," he lamented bitterly, "*The Lacemaker* could have been hanging in the Boymans from 1869 on." Throughout Hannema's tenure as director, the thought of this missed chance gnawed at him. Rotterdam had "lost its opportunity," he moaned in 1932.

And then, from Boon and Bredius, came news of a second chance.

BOON DANGLED THE prize in front of Hannema and then snatched it away. Hannema's mood veered from frenzy to despair. "Mr. Boon informed me that he plans to send the painting to America," Hannema wrote to Bredius on September 21. "I asked him to permit the Boymans Museum to attempt to acquire it, and I fervently hope that he'll keep that in mind." Hannema closed his letter with a plaintive request to Bredius to help plead the Boymans's cause. "Perhaps you could steer things in that direction?"

Then, for Bredius and Hannema, calamitous news. Boon announced that he was off to Paris to show *Emmaus* to Duveen Brothers, the best-known art dealer of them all! Joseph Duveen had made a fortune—he had recently become Lord Duveen of Millbank—by persuading America's tycoons to decorate their mansions with acres of old masters, at astonishing prices. They bought and they bought, and when prices rose, they bought even more eagerly. Duveen had been the one to plant in Andrew Mellon's mind the idea that he should found a national art museum in Washington, D.C., with his own collection as its core. Mellon occasionally resisted Duveen's advice, but many of the new millionaires treated the art dealer's suggestions as tantamount to orders. The railroad magnate H. E. Huntington once gestured toward two nondescript andirons in his fireplace. "If Duveen offered me two identical andirons and told me that they were remarkable and asked me seventy-five

thousand dollars apiece for them"—three-quarters of a million dollars today—"I would gladly pay it."

And now Boon was headed to Paris to offer Duveen the greatest prize in Europe. Bredius tore his hair. "Lord Duveen will immediately sell it in America for a large sum," he moaned. "I'm beside myself."

Then, in Paris, something astonishing happened.

ON SEPTEMBER 14, 1937, Boon sent Bredius a one-sentence letter. He had arrived in Paris with the precious "lamb"—*Christ at Emmaus*—and had stored it in a vault at the Crédit Lyonnais bank.

This Paris trip was a remarkable gamble by Boon and Van Meegeren. They already had Bredius and Hannema clamoring for the opportunity to throw money their way. Adding Duveen to the mix might lead to a bidding war, if all went well, but why not pin down a Dutch offer first?

On October 4, at the bank, Boon unveiled *Emmaus* to two of Duveen's best-regarded art experts. Edward Fowles would one day run Duveen Brothers. Armand Lowengard, Duveen's nephew, had the reputation of having "an almost infallible eye." The two men took one glance and gasped in astonishment. "The moment we looked at it we knew it was a forgery," Fowles recalled later. The supposed masterpiece looked like "a poor piece of painted up linoleum."

For the rest of his life, Fowles looked back on the Van Meegeren affair with bafflement. "The thing I never can understand," he wrote in a letter more than a decade later, "is how anybody who has ever seen a Vermeer can be taken in by the one that I saw. It was so dead, without any of the sparkle or life which is so prevalent in pictures by the master."

Fowles and Lowengard immediately sent a telegram to Duveen's New York branch, on Fifth Avenue. In case of prying eyes, they put several key words in code—*Vermeer* became *villa*, *Bredius* became *bruin*, *pounds* became *south*, *picture* became *Peter*, among others—but there was no missing their meaning. "BOTH SEEN TODAY AT BANK LARGE VILLA ABOUT FOUR FEET BY THREE," the telegram began. "CHRISTS SUPPER AT EMMAUS SUPPOSED BELONG PRIVATE FAMILY CERTIFIED BY BRUIN WHO WRITING ARTICLE BUSBY BEGINNING NOVEMBER STOP PRICE SOUTH NINETY THOUSAND STOP PETER ROTTEN FAKE."

Boon made no attempt to keep the news from Bredius. The stakes were enormous—£90,000 was roughly $5.5 million in today's dollars—but Boon passed along the disastrous news as if he found it of no great interest. It was,

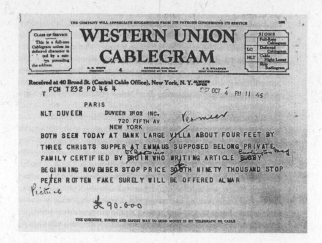

he allowed, mildly puzzling. Could it be a bargaining ploy on Duveen's part? Had Duveen's men truly hated the painting, or were they scheming to knock down the price so that later they could grab it for less?

Bredius responded with fury and indignation and doubled his efforts on *Emmaus*'s behalf. The problem, he wrote in an anguished letter to Hannema, lay with his former protégé Schmidt-Degener, who was now director of the Rijksmuseum. "Fortunately you have seen the wonderful, authentic Vermeer!!" Bredius wrote, scattering italics and exclamation points with even more vigor than usual. "Schmidt-Degener seems to be campaigning against it, and especially against me! I am said to be over the hill and unable to see. He, who *can't* see, who can't admire this authentically signed!! untouched Vermeer, which has hung in a dark room for almost fifty years without being recognized, should keep his trap shut."

As he contemplated the depths of Schmidt-Degener's treachery, Bredius grew angrier still. Just think of his long career and its many triumphs. Now contrast that with the record of the pygmies who presumed to criticize him. Bredius tormented himself with the thought of *Lady and Gentleman at the Harpsichord*, his Vermeer discovery of five years before. That great find had fallen victim to a whispering campaign. Probably Schmidt-Degener had been behind that, too. "Of course I wouldn't be human if I hadn't been mistaken a few times in 82 years. And once or twice very badly so. But what discoveries I also made!"

In case Hannema had forgotten those coups, Bredius listed them. "How many Vermeers did SD discover???" he demanded, so overcome with emotion

that his usually impeccable handwriting degenerated into a scribble. Bredius composed himself and signed his name, and then added, as a kind of post-script, "Pen dipped in *bitterness.*"

FOR BOON AND Van Meegeren, a rejection as vehement as "rotten fake" by a dealer as eminent as Duveen might have doomed *Emmaus.* At the least it could have derailed Van Meegeren's hope of making a fortune from the paint-ing, because with Duveen gone, the American tycoons might well be gone, too.

For Bredius, the stakes were nearly as high, though in his case it was the reputation built up over half a century that was at risk. He made no secret of Duveen's thumbs-down. Instead, he worked to spin the disaster as an oppor-tunity. Duveen had missed his chance, and that left the way open for Hannema or another Dutch buyer. And perhaps the price would be better than if Du-veen had never come along.

But after Duveen's verdict, Bredius's letters took on a desperate, panicky undertone. Perhaps the vehemence was merely the exuberance of a devout be-liever. More likely, it seems, Bredius talked so loudly and so boldly to reassure himself that he had not made the mistake of a lifetime. He took to writing, next to his signature, "the old man, past his prime!!"

38

"EVERY INCH
A VERMEER"

In early September 1937, Bredius completed his article announcing this greatest discovery of all. On September 22, the editor of *The Burlington Magazine* thanked him and promised to hurry it into print. Then, on October 4, Duveen sent his "rotten fake" telegram.

The "no" vote from Duveen left Bredius at the farthest end of a very shaky, very conspicuous limb. He faced a hard choice—he could endure the humiliation of withdrawing his article (but at least no one outside a small circle would know how close he had come to reliving the fiasco of his *Harpsichord* endorsement), or he could swallow hard and bet his reputation that this time he had it right.

The *Burlington* article appeared in November, with a photo of *Emmaus*. Bredius's text was bold and rapturous. "A New Vermeer," the headline proclaimed, and Bredius wasted not an instant. "It is a wonderful moment in the life of a lover of art," he began, "when he finds himself suddenly confronted with a hitherto unknown painting by a great master, untouched, on the original canvas, and without any restoration, just as it left the painter's studio! And what a picture!"

The entire article was only a few paragraphs long, and the tone was ecstatic throughout. If Bredius had wrestled with doubts during the summer, he dropped not the slightest hint of them now. On the contrary, he emphasized how certain he had been, from the first moment that Boon had turned up on his doorstep, that he was gazing at a Vermeer. "Neither the beautiful signature

'I.V. Meer' nor the pointillé on the bread which Christ is blessing is necessary to convince us that we have here a—I am inclined to say *the*—masterpiece of Johannes Vermeer of Delft."

The downplaying of the signature (while praising its beauty) looked like a routine remark but was in fact a subtle chess move. Just as Van Meegeren had anticipated, Bredius had been wowed by Vermeer's signature. "Go and see the painting and the *real* signature sometime," he had advised one skeptic who had been unimpressed by a photograph of *Emmaus.* "There is no arguing with that. And the pointillé, a second signature."

But Bredius's reliance on a signature was a sign of weakness, and he knew better than to write about it openly. Neither the presence nor the absence of the artist's name should have counted for much. Many of the greats, including Michelangelo and Raphael and Vermeer himself, sometimes neglected signatures. Titian, one story has it, signed only paintings that his students had helped with. Work that he had done entirely by himself, he reasoned, shouted out his name without a signature.

The question of the signature was so touchy that Bredius enlisted Boon's help to tidy up the historical record. To Bredius's fury, Holland's leading newspaper had noted that *Emmaus* carried a handsome signature, which made identifying it as a Vermeer no great feat. This was perfectly accurate. Nonetheless, Bredius immediately set Boon the task of writing a letter to the editor to set the record straight.

Boon dutifully informed the newspaper that its account was "in total disagreement with the facts." Bredius had been "enthralled" by the painting's colors and its overall composition; the signature had played scarcely any role in his thinking. Boon claimed to recall the scene vividly. Bredius had stared intently at the picture for a few minutes, then spun around in an unsteady but joyful pirouette. "This is a Vermeer," he told Boon. "Without any doubt a very beautiful Vermeer."

Bredius had looked at *Emmaus* on two consecutive days, Boon wrote, and on the first day the light had not been good enough to reveal the signature. Even so, Bredius had recognized Vermeer's hand at once. Boon had watched the old connoisseur's performance, spellbound. Out of the blue, he had been asked to evaluate a painting he had never heard of, and he had not hesitated even for a moment. "I still remember with admiration Dr. Bredius' immediate response," Boon declared.

* * *

BREDIUS FOLLOWED UP at once on his signature comment with another chess move, this one in the nature of a preemptive strike. *Emmaus*, Bredius declared, stood apart from the rest of Vermeer's work; it was "quite different from all his other paintings and yet every inch a Vermeer." This was simultaneously an endorsement and a warning. Bredius knew, he was saying, that skeptics would come along to argue that *Emmaus* had elements that looked nothing like Vermeer. By making the point himself, he hoped to undercut its force. He had taken the picture's surprising features into account and still concluded "Vermeer." This painting *was* different, and the differences only made it better.

After the gamesmanship, Bredius returned to his hymn of praise. *Emmaus*'s colors were "magnificent" and "splendidly luminous" and "in perfect harmony," the expressions on the various faces "wonderful" and "marvelous," the picture as a whole "unique" and "magnificent."

Bredius cited the depiction of Jesus as perhaps the most impressive of Vermeer's many achievements. "Outstanding is the head of Christ, serene and sad, as He thinks of all the suffering which He, the Son of God, had to pass through in His life on earth, yet full of goodness." Here Vermeer had truly outdone himself. "In no other picture by the great Master of Delft do we find such sentiment, such a profound understanding of the Bible story—a sentiment so nobly human expressed through the medium of the highest art."

Then Bredius interrupted himself for a moment to deal with a practical question. When had Vermeer painted this picture? "I believe it belongs to his earlier phase—about the same time (perhaps a little later) as the well-known *Christ in the House of Mary and Martha*."

EUREKA! HERE IS the very spot, we might think, where we see Van Meegeren grinning maliciously, confident that his master stroke has just hit home. For it was Bredius himself who had discovered *Christ in the House of Mary and Martha*, back in 1901. What could be more natural than to assume that Van Meegeren chose *Christ at Emmaus* as his subject precisely because he expected Bredius to take one look at this new biblical Vermeer and immediately think of the biblical Vermeer he had found decades before?

This is precisely the line taken by Van Meegeren's most serious biographer, Lord Kilbracken. In Kilbracken's telling, *Christ in the House* was the key to Van Meegeren's strategy. The forger's "conscious and deliberate decision," writes

Kilbracken, was to seduce Bredius by providing "enough similarities of composition and brushwork to make comparison [between the two paintings] certain."

It makes perfect sense, and it may indeed have been Van Meegeren's plan. But the delicious, ironic truth is that he need not have bothered. Bredius embraced *Emmaus* and fell for Van Meegeren's scam without ever linking the new painting to his earlier find. Bredius's reference to *Christ in the House* was an afterthought he inserted in his essay when he had declared himself finished writing. It was an improvisation to satisfy a pesky editor, not a reflection of a deeply held belief. "I notice that you do not say anything about the date of the picture and its place in the evolution of Vermeer's work," Herbert Read, editor of *The Burlington Magazine*, had complained when he received Bredius's *Emmaus* essay. "If you would care to add a sentence about this, I think it would increase the value of the article."

Probably, in fact, Van Meegeren had *not* meant for *Emmaus* instantly to evoke *Christ in the House.* If it had been up to him, Van Meegeren would likely have preferred that *Emmaus* be taken for a late work, since Vermeer's late paintings commanded the highest prices and the most respect. The "beautiful signature" that so impressed Bredius, for example, was copied from a late Vermeer; his early signatures had a markedly different look.

But questions of "early" or "late" were secondary. Either would do. What Van Meegeren needed above all else was that experts believe the new painting was a Vermeer, of whatever era. The strategy Van Meegeren adopted was not to choose between early and late. He threw in some easy-to-spot allusions to the late works (the light, the pointillé, the blue and yellow) and, to hedge his bets, some obvious nods to the early works (the religious subject, the large size, the Caravaggio influence). That way a critic might still say "Vermeer" even if he didn't say "late Vermeer."

But it was a gamble. Putting all those Vermeer markers into one painting risked making it seem incoherent and clumsy. When art lovers discuss Vermeer, after all, they speak of "harmony" and "balance"; they do not use the term "hodgepodge." When the Duveen experts denounced *Emmaus* as not merely a fake but a rotten one, its grab-bag messiness was one of the problems they had in mind.

Astonishingly, most experts had no such qualms. With the exception of Duveen and a tiny handful of others, the leading scholars of the day all shared

Bredius's opinion that *Emmaus* was a masterpiece.* They focused their atten-
tion on the Vermeer touches they liked best and ignored or downplayed the
others. Nearly everyone glided past the allusions to *Christ in the House of Mary
and Martha*; the great majority of connoisseurs attributed *Emmaus* not to Ver-
meer's early years, the era of *Christ in the House*, but to his middle or late career.
The enthusiastic judgment of the critic Cornelis Veth was typical: "*Emmaus* is
from the painter's late period, the period of his highest abilities, from which
we know only the classically beautiful interior scenes." If Van Meegeren really
had meant to evoke *Christ in the House of Mary and Martha*, his trap worked even
though his victims never touched the tripwire.

Bredius responded to *Emmaus* in a way that almost no one else did—he
judged it to be an early work *and* he called attention to virtually all the clues
that Van Meegeren had planted, early and late alike. If Van Meegeren had
been there to watch Bredius check off one Vermeer quotation after another,
he would have trembled in fear. Where could this be heading but to the Du-
veen verdict of "Fake!"? How could one painting be both early and late?

But if he could have kept his cool, Van Meegeren would have heard Bredius
deliver startling news: the reason *Emmaus* combined early and late elements,
Bredius explained triumphantly, was that this painting came at the precise
moment in Vermeer's career when the painter demonstrated, for the first time,
that he was in full command of all his powers.

For Van Meegeren, this was a completely unexpected response, and the
best one imaginable. Bredius's verdict was far more than a reprieve. At what
could have been the moment of his execution, Van Meegeren had been handed
the keys to the kingdom.

WHY DID BREDIUS respond to *Emmaus* so oddly? The legend has grown up
that Van Meegeren fooled Bredius by delivering a forgery tailor-made for
him. The story is that Bredius had famously forecast that someone, someday
would find a Vermeer with characteristics x, y, and z, and then Van Meegeren
came along and painted it for him.

And so he had, in a manner of speaking. The odd part is that Van
Meegeren almost certainly never encountered Bredius's forecast. He painted

* One notable exception was J. H. Huizinga, the eminent Dutch historian. Huizinga had
an abiding interest in art, but he was not an art historian. In 1941, before Van Meegeren's un-
masking, Huizinga wrote that "it may be rather bold of me to say that Vermeer fails precisely
when he depicts holy scenes, for instance *Christ at Emmaus*."

Emmaus as he did for the long list of reasons we have been considering, having to do with such things as the high status of biblical paintings. Those reasons had nothing to do with Bredius. If Bredius had never existed, Van Meegeren would still have tried to evoke Caravaggio (because conventional wisdom in the art world favored a Caravaggio-Vermeer link), he would still have chosen to depict the Emmaus story (because he had tackled the same subject in his own name), and so on.

But Bredius did exist. And he *had* once written a brief article that would have made the forger rub his hands in glee, if only he had known about it. Shortly after his discovery of *Christ in the House of Mary and Martha*, Bredius had discussed that painting and another early Vermeer, *Diana and Her Companions*. His focus was on the unexpected links between the two paintings. Bredius mentioned three surprises. First, neither painting showed "a single spot of the peculiar pointillé that characterizes all the work of Vermeer." Second, both works had "biblical and mythological subjects that occur in no other work by Vermeer." Third, both paintings "deviate from all Vermeer's other work," because "in this period he was more influenced by the 17th-century Italian school."

Contrary to the legend, the article was not famous but inconspicuous and insignificant. It appeared in a newspaper rather than an art journal, hidden on an inside page. It was not even a freestanding story but included in a roundup on "Literature and Art." In any case, it ran in 1901, when Van Meegeren was only eleven years old. But without ever reading Bredius's remarks, Van Meegeren produced a "missing Vermeer" that might as well have been painted to order from his specifications. No wonder poor Bredius fell so hard.

TWO WEEKS AND COUNTING

Throughout the fall of 1937, Bredius continued exhorting, encouraging, and pleading on behalf of *Emmaus*. "There are only 40 Vermeers and this is the most important one (and in my judgment, the most beautiful one)," he wrote Hannema on December 7. "If we wait, we'll lose it."

The next day Hannema wrote back in despair. He had just learned that Boon had transferred *Emmaus* to one of the biggest art dealers in Amsterdam, D. A. Hoogendijk. Hannema feared that the price would shoot up. "I had assembled a considerable sum already," he moaned to Bredius, "but now I'm afraid all my efforts are in vain. This is a miserable story . . ."

Bredius fell into agonies, too, but his misery drove him to even more frantic efforts. He sent a barrage of letters flying around Holland. To the director of the Mauritshuis Museum: *Emmaus* is *"authentic as gold . . . as* important as *The Nightwatch."* To the president of the Rembrandt Society: "There *has* to be a rich man who could buy it." To everyone he lamented his own lack of resources: if only *he* could afford to buy the painting for Holland.

Finally, on December 13, some headway: The executive committee of the Rembrandt Society met to discuss *Emmaus*. Hannema testified to the painting's greatness and pleaded for help with its purchase. The president of the society read rapturous excerpts from Bredius's letters and telegrams. Willem Martin, once deputy director of the Mauritshuis under Bredius and now director in his own right, made an impassioned plea: "Everything possible must be done to preserve this unique work of art for the Netherlands."

The committee pondered what it had heard and reached two conclusions.

They would offer 50,000 guilders for the painting, roughly $300,000 in today's dollars, and those committee members who had not yet seen *Emmaus* for themselves would go to Hoogendijk's.

Two days later, Boon wrote to Bredius. The Rembrandt Society had trooped off to see *Emmaus*, and they had been wowed. The painting *was* a beauty and a masterpiece. They were wowed by the price, too. Hoogendijk was asking 520,000 guilders ($3.9 million today), and he had set a two-week deadline. If they hadn't raised the money by then, the deal was off.

We can imagine Bredius, frail and frantic, with Boon's note shaking in his hand as he read the lawyer's honeyed threats. "I fervently hope they will be successful," Boon wrote, for he regretted to say he would have to "categorically decline" any lower offer. "Would it, to my great regret, not be possible" to come to terms with the Rembrandt Society, there would be no choice but to let "America and England move into the picture." It was all he could do, Boon hinted, to fend off the swarms of would-be buyers. He had already been in correspondence with one eager art lover who was "married to one of the four wealthiest women in America." It would be a great pity, Boon noted in closing, if *Emmaus* could not be saved for Holland. "If that fails, well, at least we can say we tried."

Bredius immediately wrote to the Rembrandt Society, offering to put up 12,000 guilders of his own money (roughly $90,000 in today's dollars) and reminding them, yet again, that Vermeer was "a master of the *utmost greatness.*" Nothing could be more important than securing this treasure. "It would be a *disaster* if it were to leave our country."

The pressure fell mainly on Hannema's shoulders. As director of the Boymans Museum and a member of the Rembrandt Society's executive committee, he spent all his time scheming to solve the money problem. As the clock ticked toward the two-week deadline, he scarcely slept.

And then, on December 24, 1937, with Hoogendijk's deadline only days away, Hannema announced glorious news. He had found his patron: Van der Vorm, the Rotterdam tycoon, had agreed to donate 400,000 guilders to the Rembrandt Society to purchase *Emmaus.*

The Rembrandt Society raised another 100,000 guilders. A handful of smaller contributions, including Bredius's 12,000 guilders, brought the grand total to the required 520,000 guilders. With the world still mired in the Great Depression, this was an enormous amount to spend on a painting. (It was, though, about one third lower than the asking price cited in Duveen's "rotten

fake" telegram; Duveen's harsh judgment had presumably scared off some buyers.)

Boon and Hoogendijk, the art dealer, divided the equivalent of $1.3 million between them. The lion's share of the purchase price, $2.6 million, went to Van Meegeren. Bredius exulted in the news that the sale was final. "Do I need to tell you how happy your telegram, and now your letter, have made me?" he wrote to the president of the Rembrandt Society.

Then, in an undated note apparently from Christmas Day 1937, or the day after, Bredius wrote to congratulate his friend and colleague Hannema: "People will talk for a *long time* to come of Hannema *who bought that delightful Vermeer!!*"

40

<div style="text-align:center">✦</div>

TOO LATE!

Hannema didn't have to wait long for the talk to begin. The morning after he put together the deal to buy *Emmaus*, but before he had told anyone about it, the phone rang in his office at the Boymans Museum. The head man at the government's Department of Arts and Sciences was on the line. Would it be possible for Mr. Hannema to come to an urgent meeting?

Hannema hurried over. There he found J. K. Van der Haagen, the arts minister; Van Hasselt, the vice chairman of the Rembrandt Society; and Schmidt-Degener, director of Amsterdam's renowned Rijksmuseum. Like Hannema, Schmidt-Degener was a member of the Rembrandt Society's executive committee. When Hannema had frantically lobbied the society for funds, the executive committee had responded with enthusiastic talk but not much money.

Bredius had spent much of the past few months railing against Schmidt-Degener (the museum director was "Duveen's little man-servant"), convinced that he had taken it on himself to badmouth *Emmaus*. The feud seems to have been largely a product of Bredius's imagination. Early in the fall of 1937, Schmidt-Degener had been shown a photograph of *Emmaus* and had responded halfheartedly. But as soon as he saw the actual painting, he joined the chorus of praise. Bredius continued to nurse his grudge even so. A late conversion was scarcely better than outright apostasy.

But Schmidt-Degener was as forceful a character as Bredius. "A connoisseur's eye is like a musical ear," he had once testified in a trial about a painting that might or might not have been by Leonardo. Schmidt-Degener was explaining to the court how he knew the painting was not authentic. "A man who is sensitive to music tells you a certain sound is false and if you ask him

why he thinks so he will say: 'It is false, don't you hear it?' So it is that I can look at a painting and tell you when it was done."

So Schmidt-Degener knew when a painting was not what it purported to be. More to the point, he knew a masterpiece when he saw one. *Emmaus* was a masterpiece. And now Hannema saw the purpose of the meeting he had been asked to join. Surely the proper home for a painting of such stature, the arts minister suggested, was the nation's best-known and most important museum? Surely *Emmaus* belonged in the Rijksmuseum.

Schmidt-Degener turned to Hannema. The art world owed a great debt of gratitude to the Boymans Museum, and to its illustrious director for his efforts to obtain *Emmaus* for Holland. How unfortunate that those efforts had fallen short of their goal. Perhaps he could take the liberty of making a suggestion that would honor Hannema's investment of time and energy, and also work to everyone's benefit? Schmidt-Degener offered up his idea: the Rijksmuseum would buy *Emmaus* for itself, and as a gesture of gratitude to the Boymans for stepping aside, it would hand over *two* gems from its Dutch seventeenth-century collection, Pieter de Hooch's *Woman with a Child in a Pantry* and Vermeer's *Love Letter*.

Hannema listened politely and then dropped his bombshell. It was too late! He had, just the night before, bought *Emmaus* for the Boymans, thanks to a generous gift from Mr. Van der Vorm. He thanked the gentlemen for their kind offer.

Hannema strode away in triumph. Schmidt-Degener slunk off, to console himself as best he could with a De Hooch and a Vermeer that did not quite measure up.

THE LAST HURDLE

Hannema knew Vermeer and he knew blockbusters, and he began at once to prepare a show that would present *Christ at Emmaus* to the world. The exhibition would open in 1938, as part of the celebration of Queen Wilhelmina's Jubilee, honoring her fortieth year on the throne. For once, all eyes would be on the Boymans Museum.

In the meantime, there was much to be done. Hannema set to work negotiating the loan of paintings for his exhibition. Bredius continued to beat the drums for *Emmaus*. He talked the painting up incessantly, and he prepared yet another article proclaiming *Emmaus*'s greatness, this one for the art journal *Oud Holland*. He began by comparing his feelings on first seeing *Christ at Emmaus* with his feelings on finding *Christ in the House of Mary and Martha* three decades before.

Even to make such a comparison was to proclaim his own authority. Who else could reminisce about the different Vermeers he had found? But in truth, Bredius explained, there was no comparison. The earlier painting was a Vermeer, true, but there was Vermeer and then there was *Vermeer*. "What a difference," Bredius exclaimed. In *Emmaus*, the "depth of grief" in Jesus's face would "stay forever with anyone who is receptive to the exalted in art!"

The question that troubled Bredius was not why Vermeer had painted this uncharacteristic work but why he had not probed those depths again and again. "Why only those few biblical paintings? Why never again a canvas where he expressed *so* deeply the stirrings of his soul?" The answer, Bredius surmised, must have been that Vermeer found it easier to sell small domestic

scenes than large biblical ones. But Bredius was in too good a mood to linger on such melancholy topics. "Let us rejoice that his greatest masterpiece, *Christ at Emmaus*, has been obtained for the Netherlands," he concluded, "with feelings of gratitude for everyone who helped make it possible."

Then Bredius heard distressing news. Almost as soon as it had begun to look as if *Emmaus* really would end up with Hannema, Bredius had started agitating against the chief restorer at the Boymans. "If only it doesn't get into the hands of that destroyer of paintings Luitwieler," he had fretted in early December 1937, and he continued to hammer away at the same theme for months. Luitwieler "murdered" the pictures entrusted to him. "Do you know what I'm scared to death of?" Bredius asked Hannema, who knew perfectly well. "Of that killer of paintings, Luitwieler, 'cleaning' the Vermeer."

Despite his fretting, Bredius had little to fear. Luitwieler was an old pro with a good reputation. It was Van Meegeren who should have been scared to death. Unlike the connoisseurs, who placed enormous faith in their immediate, instinctive response to a painting, restorers were down-to-earth, detail men. Their job wasn't to pronounce on a picture's aesthetic merits—though they had scrutinized thousands of works in their careers—but to make an inch-by-inch study of just how a particular painting had weathered the centuries.

Vermeer died in 1675. Van Meegeren finished *Emmaus* in 1937. Now, in 1938, Hendrik Luitwieler had been entrusted with examining and, if need be, repairing it. As he stared intently at his museum's newest and greatest masterpiece and scanned it front and back, would he observe contentedly that this three-century-old work looked just as it should? Or would he rise in fury from his workbench and demand to know who dared to pass off this brandnew fraud as an old master?

Luitwieler began by removing the discolored and "aged" varnish that Van Meegeren had applied a few months before. Then he examined the craquelure, comparing it with the mental image of seventeenth-century cracking that he had acquired in his years of work. Was the depth of the cracks right? Did the cracks' pattern make sense? Had they become filled with the grime of centuries? He studied the rip in the canvas that Van Meegeren had deliberately inflicted on Jesus's right hand and then clumsily repaired; Luitwieler repaired it properly.

He decided that the canvas needed to be relined, or backed with a new piece of canvas. This was common practice—few seventeenth-century paintings

retained their original canvases—but a tense business nonetheless. The relining process was major surgery, roughly akin to a skin graft. Luitwieler began by removing *Emmaus* from its stretcher and placing it facedown on a piece of paper, to protect its painted surface. Then he heated a pot of homemade glue, probably with beeswax as its major ingredient, and cut a new piece of canvas that matched *Emmaus* in size. Next he slathered glue evenly across *Emmaus*'s back, set the new canvas in place, and pressed the new canvas onto the old with strong, careful hands and a wooden tool shaped like a squeegee.

The next step was the most difficult. Luitwieler heated a heavy, metal iron and stooped over *Emmaus* once again. This was the point when Van Meegeren and Bredius and Hannema—if they had somehow been watching—would have covered their eyes and muttered their prayers. Ironing the two canvases accomplished two things; the heat sealed the canvases together, and it fixed any loose paint flakes in place. But it was tricky and dangerous work, and paint that had survived three centuries could scorch or melt in an instant.

But under Luitwieler's skillful hands, it did not. He was not yet finished with his work, but his final tasks were routine. He repainted the areas that Van Meegeren had purposely damaged. He built and installed a new stretcher to replace the seventeenth-century original that Van Meegeren had been so pleased to find when he had purchased *Lazarus* in the first place.

Luitwieler did all this, but what was most surprising was one thing he did not do—he did not sound an alarm. Could he *really* have been bamboozled so completely?

The museum world is hierarchical even today, and in Holland in the 1930s it was more so. All the men at the top—Hannema and Bredius and the Rembrandt Society and Rotterdam's moneyed collectors—had declared in public that they had never seen a Vermeer that compared with *Emmaus*. They had raised a fortune to buy it and proclaimed it a national treasure. Would any mere craftsman, regardless of his private doubts, have dared to speak up, to say, "Excuse me, but this is a fake"?

But if Luitwieler felt himself caught in a crisis of conscience, like some tormented character in Ibsen, he never left a sign. One cryptic photo has come down to us. It shows Hannema and Luitwieler gazing at *Emmaus*. Luitwieler is in the background, his expression impossible to read. Is he filled with contempt, for himself and for all the "experts" who genuflected to a fraud? Or is he basking in pride, knowing that he has been closer than anyone else to one of the world's great treasures?

Michel van de Laar, the chief restorer at the Rijksmuseum today, laments that we will never know. Despite Luitwieler's skill, says Van de Laar, he may well have been fooled.* Van de Laar has studied four of Van Meegeren's forgeries (but not *Emmaus*). Like a detective who comes to admire a thief's careful planning, he speaks of Van Meegeren with the respect of one professional for another. The hallmark of Van Meegeren fakes, Van de Laar notes wryly, is that they were "ripe for the restorer." The scrapes and tears and grime cried out for repair and cleaning, that is, but the cries never seemed histrionic. Luitwieler, presumably noticing nothing amiss, busied himself with his accustomed tasks.

Van Meegeren had worked hard to earn that inattention. His care in choosing and then preparing a genuine seventeenth-century canvas, his success in crafting paints that would emerge from the oven lush and bright, his knack for inducing authentic-looking cracks in a painting's surface, all served to disarm and distract his would-be investigators. (Neither Luitwieler nor anyone else ever subjected *Emmaus* to a single scientific test until after Van Meegeren's arrest, in 1945.) When it came to the technical side of forgery, says Van de Laar, Van Meegeren displayed something close to genius.

* On July 18, 1945, when the authenticity of *Emmaus* was still in doubt, Luitwieler told the Dutch newspaper *Het Parool* that he had studied and worked on the painting over the course of three months and guaranteed it was genuine. A week later *Newsweek* quoted an unnamed "restorer who had recently transferred the painting to new canvas" as saying that if *Emmaus* was indeed a fraud, then the forger was a genius.

THE UNVEILING

Hannema presented *Christ at Emmaus* to the world on June 25, 1938. He had gathered 450 Dutch paintings for an exhibition entitled "Masterpieces of Four Centuries, 1400–1800." *Christ at Emmaus* was the centerpiece of the show, the star of stars.

It hung nearly alone in a large room, not on an ordinary wall with the other paintings but on a specially built, brocaded backdrop that rose halfway from floor to ceiling. In its ornate gilt frame, in splendid isolation on its special wall, huge in its own right and magnified in scale by the backdrop (which had its own gleaming frame), the newest Vermeer shouted out its uniqueness.

On opening night, many in the crowd wore formal dress. Everyone was there—directors from other museums, Holland's leading politicians, art critics, journalists. "I can still see the painting that evening," one eyewitness recalled half a century later, "dazzling in the light. Bredius had stepped forward and unveiled it with a magnificent gesture. Everyone was stunned, gasping with admiration."

The cover of Hannema's catalog showed only a single painting, *Emmaus*. Inside, the first illustration depicted *Emmaus* once again. Beneath the painting a proud caption noted simply, "Johannes Vermeer—Museum Boymans, Rotterdam." The next page was filled entirely with a detail of Jesus, eyes downcast, bread (and pointillé) before him, right hand raised in blessing. "Johannes Vermeer," the caption read. On the next page, again given over entirely to *Emmaus*, a close-up of the servant girl's face. "Johannes Vermeer." Next page, another *Emmaus* close-up, this time the head of the disciple at Christ's left. "Johannes Vermeer."

Finally, on the fifth page of illustrations, another artist managed to break Vermeer's monopoly. This was Rembrandt, relegated to half a page.

Time magazine's art critic made his way through the jostling crowd in the Boymans and hurried to *Emmaus*, "the greatest attraction of all." The painting had not only its artistic merits to set it apart, *Time* noted, but its story. For art lovers, *Emmaus* "had as much novelty as if it were dated 1938, for a year ago it was not known to exist."

Art lovers knew, too, the astounding price that *Emmaus* had commanded. That price signaled desirability and magnificence, and onlookers lost their bearings as they would in any brush with celebrity. "Dutch visitors, who like to look at works of art in absolute silence, complained that the parquet flooring in the room where *Christ at Emmaus* is hung was noisy," wrote *Time*. "Carpets were immediately provided and religious silence prevailed."

VAN MEEGEREN LIKED to tell a long, detailed story about the Boymans show. He had blended into the crowd, he said, and patiently waited his turn for a close look at the museum's new masterpiece. For all the other museumgoers, the exhibit meant a pleasant day out and perhaps a respite from the dire political news. For Van Meegeren, who had put up with endless sneers, the Boymans show was redemption at last. The magnificence of the setting, the size of the crowd, the connoisseurs' praise and the painting's astronomical price, the endless references to "genius" and "a masterpiece"—the thought of all these made the forger almost dizzy with joy. He leaned a bit closer to his painting, admiring his handiwork in a happy trance.

A guard hurried over. "Please, sir, step back. It's a very valuable painting."

Sometimes Van Meegeren added a coda. In this version, he would turn to one of the swarm of spectators gathered near *Emmaus* and excitedly discussing its merits. Van Meegeren would say that he didn't think much of the painting. His shocked listeners would ratchet up their praise. Van Meegeren would counter. Vermeer never painted pictures like this, he would explain. His listeners would enlighten him. Van Meegeren would go further still. This so-called "Vermeer" was probably a fake. Ridiculous, he would be told, and then his new acquaintances would launch into a heated rebuttal.

Perhaps it happened, though the story smacks more of an outcast's revenge fantasy than of an actual event. But unadorned reality provided Van Meegeren with revenge aplenty. The ecstasy over *Emmaus* was nearly universal. In smoth-

ering Van Meegeren's forgery in praise, Bredius and Hannema were in the best of company.

PHYSICISTS TALK OF parallel universes, an infinity of worlds each cut off from all the others, some totally different from the world we know and others like ours in almost every way up until one particular fork in the road. Somewhere, for instance, is a world in which a weary Abraham Lincoln decided not to attend the theater on an April evening in 1865. To look at the art world in the 1930s as it appeared to the greatest connoisseurs of the day is to plunge into one of these alternative realities.

In the parallel universe that came into being when the Boymans Museum unveiled *Emmaus,* Vermeer commands all the admiration he does in ours, but the name "Vermeer" conjures up something far different. In that world, Vermeer's greatest achievement was not *The Milkmaid* or *Girl with a Pearl Earring* but *Christ at Emmaus.* "The discovery of *Emmaus* is the most important art historical event of this century," declared one scholar. "The painting shows Vermeer at his best."

To flip through the pages of art books from the thirties is almost dizzying. Perhaps the most authoritative early work on Vermeer was a thick tome published in 1939, titled simply *Jan Vermeer of Delft.* The author was the eminent Dutch scholar A.B. de Vries. (Later, De Vries would be in charge of recovering Dutch art looted by the Nazis, including Hermann Goering's "Vermeer," painted by Van Meegeren.)

The book's cover is solid black with no decoration but a thin gold border and Vermeer's monogram in gold. The text is sober and intelligent. *Christ at Emmaus* is emphatically proclaimed a masterpiece, a standout even in comparison with the rest of Vermeer's work, "since it strikes a hitherto unknown chord." The painting itself rates a full-page reproduction. So does a detail showing Jesus' hand raised in blessing, and so does a detail of the servant girl's face.

Duveen and one or two others had called Van Meegeren's bluff, but De Vries's view was the standard one among those best qualified to express an opinion. It seems impossible, but if not for the knock on Han van Meegeren's door in 1945, perhaps we, too, would still be making pilgrimages to Rotterdam to pay homage to Johannes Vermeer's greatest work.

And then, also in 1939, a far more important bit of good fortune came Van Meegeren's way. For Europe, this was the dreadful year when war began. In

August 1939, the Boymans Museum decided that it had to move its collection to a location safe from bombs and invaders. The museum gathered its paintings, *Christ at Emmaus* chief among them, and hid them in an air raid shelter. There Vermeer's newest masterpiece remained out of sight, wearing its colossal reputation like a royal robe. Through all the years of war it stayed safely underground, where no looters could steal it and no connoisseurs could re-examine it or place an authentic Vermeer next to it for comparison.

Part Four

———◆———

Anatomy of
a Hoax

43

<center>──◆──</center>

SCANDAL IN
THE ARCHIVES

Today, visitors to the Boymans Museum will not find *Emmaus* in a place of honor. For years they would not have found it at all. Its banishment now past, it hangs high above the ground—the bottom edge of the painting is perhaps six feet above the floor—on a wall with such miscellaneous objects from the museum collection as a toy truck inside a glass box and an ordinary metal chair that looks as if it came from a sixties dining room. The painting bears a label, but it is mounted on the frame's top edge and cannot be read from ground level. The museum's audio tour skips over *Emmaus*. So does the postcard collection in the gift shop.

But to the dismay of the Boymans's curators, *Emmaus* is the picture that most visitors want to see. "It's awful that it's one of our most famous paintings," laments Jeroen Giltaij, a specialist in the Dutch Golden Age. Out of politeness, Giltaij forces himself to stand in front of *Emmaus* and discuss it for a minute. Does it make sense that connoisseurs once believed this was a Vermeer?

He winces. "It's rubbish; it's a terrible painting. It's astonishing that anyone ever thought it was by a seventeenth-century artist."

When you look at *Emmaus*, what stands out?

"You see these sickly faces, with the huge eyelids. That was the image of beauty in the thirties, but if you look at it now you think that everyone had a terrible disease." Looking harder now, Giltaij rattles off failing after failing. "The tone of the skin, the bulging eyes, the way the hair hangs so limp and dead. The left arm—you see a hand coming from the sleeve, but where does it

come from? And what about the sleeve! Cloth is supposed to hang, but the sleeve is stiff and completely hollow, like a drainpipe."

But if the painting is that bad, how did Giltaij's predecessors get the story so wrong?

And not only did they get it wrong, but they got it wrong time after time. *Emmaus* was only the first of *six* forged Vermeers that Van Meegeren sold between 1937 and 1943. He grew increasingly sloppy and careless through the years—why wouldn't he, since even the crudest fraud brought him millions?— and each new painting was uglier than its predecessors. "They sold just the same," Van Meegeren would later marvel, and they sold at once, and nearly every one brought in even more money than *Emmaus* had.

THAT STRING OF successes testifies to Van Meegeren's cunning. The forger was right to lavish care on *Emmaus*, because its acceptance cleared the way for all the fakes that followed. "It's not what anyone would have called a Vermeer in the past," the experts reasoned each time Van Meegeren put another biblical forgery on the market, "but the resemblance to *Emmaus* is unmistakable, and that's the greatest Vermeer of all."

His triumph calls to mind the episode, following the French Revolution, when the new rulers created an improved system of weights and measures and designated a particular metal bar as the "official meter." Enshrined in the National Archives, it lay in precisely controlled conditions of temperature and humidity, like Lenin in his glass casket. The bar was merely symbolic, because no one truly depended on it to know how long a meter was. But *Emmaus* was more than a symbol. In effect, Van Meegeren had sneaked into the Archives and substituted a false meter for the real one.

With *Emmaus* as the new benchmark, Van Meegeren no longer had to compete with Vermeer. Now he could churn out forgeries that only had to measure up to his own far more forgiving standard. Even better, each new fake broadened the definition of what counted as a Vermeer, so Van Meegeren's task grew easier and easier as his "Vermeers" grew worse and worse. The result was an innovation in forgery as impressive as the use of Bakelite—not content to sneak a single, familiar-looking work past the arbiters of the art world, Van Meegeren invented an entirely new and self-contained chapter in Vermeer's career. And so, year by year, new Vermeers appeared. *Christ at Emmaus* begat *Head of Christ* which begat *Last Supper* which begat *Isaac Blessing Jacob* which begat *Christ and the Adulteress* which begat *The Washing of Christ's Feet.*

Six Vermeers in all, and each one sold at prices that ranged between $2.5 million and $8 million in today's dollars. Six paintings in six years, moreover, with barely a question asked, even though only thirty-odd Vermeers had turned up over the course of the previous three *centuries*.

The sudden appearance of half a dozen masterpieces might have set the art world shouting for the police. But Van Meegeren's luck held again. When *Emmaus* came along, the experts pointed out that this new Vermeer didn't look like any of his other paintings. They rejected the obvious possibility—perhaps it's *not* a Vermeer—and concluded instead that Vermeer had more to him than they had ever suspected. Now came a cascade of paintings by an artist famous for his tiny output. Did *that* raise any doubts?

Remarkably, it didn't. Again, *Emmaus* was the key, and again it was that painting's difference from other Vermeers that beguiled the experts. Vermeer had ventured down a new path, they explained, and he had emerged with *Emmaus*, a treasure. In the experts' eyes, the conclusion was self-evident—it stood to reason he would have explored the same territory further, in search of similar rewards. Each new biblical "Vermeer" that came along served not to raise new doubts among the learned but to confirm their expectations.

IN SELLING THESE follow-up forgeries, Van Meegeren stuck with the strategy that had rewarded him so lavishly with *Emmaus*. Immediately after he sold *Emmaus*, and perhaps before he realized that Vermeer was a vein he had only begun to tap, Van Meegeren turned out a couple of so-so De Hoochs. No great shakes, these forgeries would have quickly been forgotten if not for Van Meegeren's later notoriety. The prices weren't up to Vermeer standards, but this was easy money even so. For the two De Hoochs, Van Meegeren pocketed a total of what today would be another $3 million.

Many of the familiar figures from the *Emmaus* drama turned up once again as the new forgeries came on the market, like actors in a sequel. Bredius, for instance, published an article in the art magazine *Oud Holland*, in 1939, called "A Gorgeous Pieter de Hoogh."* He began in his usual rush: "What appeared impossible has in fact happened. A work by Pieter de Hoogh, which had hung for many years in a private home in Paris, has surfaced! It appears to be one of his most beautiful works, from his best year, 1658, and is modestly signed PDH."

* Most writers today use the spelling *De Hooch*.

The echoes of the *Emmaus* story cannot be missed. "In 1658 De Hoogh painted the famous pieces now in the National Gallery and Buckingham Palace," Bredius wrote. "I have no doubt: were one to choose, this painting would win. Let us hope that this work of art will not leave our country. Fortunately we do possess several beautiful De Hooghs, but we lack a piece like this one."

The Rotterdam tycoons Van der Vorm and Van Beuningen showed up again, too, still competing for old masters. Back and forth they went, snatching up each new forgery as if they would never have such an opportunity again. Van der Vorm had struck first, in 1937, by putting up the lion's share of the money for *Emmaus*. In 1939, it was Van Beuningen's turn; he bought a Van Meegeren "De Hooch" for $1.7 million in today's dollars. In 1941, Van der Vorm countered by buying the "gorgeous" De Hooch forgery that Bredius had praised, for $1.3 million. Then the rival collectors turned back to "Vermeers," taking turns again while prices soared ever upward.

By the time they put their wallets away, Rotterdam's two most acclaimed collectors owned *five* Van Meegeren forgeries between them. In the three-year span from 1939 to 1942, they had paid out more than $20 million in today's dollars. Van Meegeren, awash in cash and seemingly able to sell any daub he produced, had grown ever more reckless. For his monumental *Last Supper*, yet another "Vermeer," he had not even bothered to scrape the old canvas clean to guard himself against the prying eye of an X-ray machine, as he had done so meticulously with *Emmaus*. Now he simply bought an old picture and painted over it, confident that nobody would take the trouble to look beneath the surface.

No matter how many parties he threw, Van Meegeren could not spend all his money on women and drinking. He tried. He fancied himself an expert on Vermeer and on women, prostitutes mostly, and one acquaintance recalled that "he bought women by the dozen." He lavished a fortune on prostitutes at every step of the social scale, from the cheapest and most wretched to the most elegant of courtesans.

And still a fortune remained. Van Meegeren turned to real estate; by one account, he bought some fifty houses and nightclubs, most of them in Amsterdam. He stashed his money in thick wads and hid them throughout his house. (In 1942, when the government issued an edict calling for the surrender of all 1,000-guilder bills, then worth roughly $400 apiece, Van Meegeren turned in 2,800 bills. That stack of cash was the equivalent of more than $10

million today.) He updated his old story about having won the French lottery. Now he told people he had won it twice.

Van Meegeren's forgeries grew almost shockingly crude, far worse than *Emmaus*. His fifth Vermeer, for instance, depicted *Isaac Blessing Jacob*. The figures are as flat as paper cutouts, and Jacob looks as if he is braced to receive a karate chop to the neck rather than a blessing. But nothing could slow the juggernaut. Van der Vorm bought *Isaac Blessing Jacob* for $6 million in today's dollars.

The Dutch state proved as gullible as any private buyer. Eager to make amends for having missed out on *Emmaus*, the state soon found a new Vermeer of its own. That painting, *The Washing of Christ's Feet*, may be even worse than *Isaac Blessing Jacob*. Jammed with Van Meegeren's familiar zombies, the picture shows Jesus and four other figures squeezed near a table. It is impossible to make out what space the table occupies or where the figures are in relation to one another. Jesus' arm seems broken at the elbow. His right hand—the spiritual focus of the picture—extends toward Mary, to bless her, but as one modern critic notes, "It looks disturbingly as though Christ is trying to prevent Martha from bumping her sister with the bread platter."

The Rijksmuseum appointed a team of seven experts, Hannema among them, to advise it on the proposed purchase. One of the seven, a University of Amsterdam art historian named J. Q. Altena, declared *The Washing of Christ's Feet* a forgery. Even so explosive a charge did not derail the purchase, or even delay it. "None of us liked it very much," Hannema said later, "but we were afraid it would go to Germany." Instead, it stayed in Holland. The price in today's dollars was just under $6 million.

By this time the Van Meegeren saga had no place for a voice of reason. Instead, made foolish by fear and greed, buyers rushed to grab these strange masterpieces before they lost their chance. No one turned up in the middle of the action as often as Hoogendijk, the Amsterdam art dealer (and the dealer who had sold *Emmaus*). Van Meegeren sold *five* of his forgeries via Hoogendijk. Astonishingly, there is no evidence that the dealer ever realized he was caught up in an enormous fraud.

When the truth finally came out, Hoogendijk sounded more dazed than angry, like the victim of a stage hypnotist who snaps awake to find that he has been waltzing around the floor with a broomstick. "I do not understand how it could possibly have happened," he moaned. "A psychologist could explain it better than I can."

44

━━◆━━

ALL IN THE
TIMING

Despite *Emmaus*'s flaws, the critics had all fallen on their knees in rapture. Later, when the truth came out, they could muster no better explanation than to say they had been caught in a wave of hysteria. Centuries before, "tulip mania" had swept through Holland, and men spent more on a single bulb than it would have cost to buy the grandest house in Amsterdam. After *Emmaus*, connoisseurs talked as if they had fallen under a similar spell.

Hannema had declared that "a nobler creation has, perhaps, never been rendered in art." His enthusiasm for *Emmaus* was entirely predictable, but scholar after scholar delivered similar judgments in hushed and reverent tones. Many connoisseurs noted the links between the new "Vermeer" *Emmaus* and Caravaggio's *Emmaus*, and more than a few preferred Vermeer. The comments of one art historian will stand for those of many others. "After a comparison of both works," wrote J. L. van Rijckevorsel, "the greatness and the individuality of the master from Delft is even more apparent." To Dutch eyes, Caravaggio was perhaps a bit boisterous. "In contrast with Caravaggio's loud realism, we respectfully offer Vermeer's devout modesty."

Both the public and the critics fell so hard partly because *Emmaus* was perfectly suited to the times. Albert Blankert argues that in 1938, with war and invasion looming, *Christ at Emmaus* offered the beleaguered Dutch exactly the solace they craved. "Amidst the anxious and seemingly hopeless events of the late 1930s," Blankert writes, "the quiet and peace of Vermeer exercised magic on men's minds." *Emmaus* overflowed with what Blankert calls "elevated pathos." The same mood permeated the paintings Van Meegeren made in his

own name. In pictures by a nobody called Han van Meegeren, Blankert observes, that pathos struck viewers as saccharine and overdone. But when the same sentiment was sanctified by the magical name Vermeer, what had been sickly and maudlin became moving beyond words.

In December 1944, as an exhausted Europe struggled through a war that had begun five long years before, a *New York Times* foreign correspondent contemplated the Dutch landscape. "Because Holland was so sturdy and self-respecting, so triumphant over nature," Anne O'Hare McCormick wrote, "it is in some respects the saddest battlefield of all. Nearly a fifth of the land salvaged with infinite effort from the sea is already flooded. Scores of her neat smiling villages lie in ruins. Tulip fields are mined and trampled."

In the midst of such gloom, McCormick had witnessed something that brightened the soul. The world above ground was little but "mud and blood" and "roads crowded with endless lines of men and lorries moving forward and ambulances moving back." But beneath the ground, all was light.

McCormick had been allowed underground into an enormous sandstone quarry outside Maastricht, Holland, where she had passed through several sets of gleaming steel doors and entered "the best art gallery in all of Europe." Here Holland had hidden its most priceless works of art. McCormick was an old pro—she had won the Pulitzer Prize in 1937—but she found herself overwhelmed. "It is difficult to convey the sense of life flowing out of the glowing color and exuberant vigor of these immortal works of art," she wrote. There were eight hundred paintings in all, including Rembrandt's *Night Watch* (rolled up like a dorm-room poster). McCormick also had the great privilege of seeing "two early Vermeers, *Diana with Nymphs* and *Pilgrims at Emmaus*, quite unlike his later pictures." Glorious and immortal, the treasures hidden in the quarry "might have been painted yesterday if anyone alive yesterday could have painted them."

IN A TROUBLED time, a work of art that provides consolation will win admirers by the thousands. In our own day, the critic and classicist Daniel Mendelsohn has looked at the astonishing success of the recent novel *The Lovely Bones*. His analysis of the novel throws light on *Emmaus*'s success, too.

The Lovely Bones was released in June 2002 with only middling expectations. Three weeks after its appearance, nearly one million copies were in print. For five months this first novel by a little-known writer sat atop the *New York Times* bestseller list.

Why? According to Mendelsohn, not for reasons of plot or prose but because the message fit the mood of the time perfectly. The novel's popularity was all the more startling because its subject could hardly have been darker. The second sentence reads, "I was fourteen when I was murdered on December 6, 1973." The dead girl, Susie, narrates her own story, of rape and murder, from Heaven.

Reviewers and the reading public hailed *The Lovely Bones* for its unsentimental examination of the grimmest facts. The true appeal, Mendelsohn argues, was not confrontation but comfort. The novel offered reassurance to a nation newly traumatized by the murder of three thousand innocents on September 11. *The Lovely Bones*, writes Mendelsohn, is "bent on convincing us that everything is really OK." Mendelsohn quotes Susie's ghost, in the final pages of the novel. "We're here. All the time. You can talk to us and think about us. It doesn't have to be sad or scary."

Critics had called the novel "the book of the year," Mendelsohn notes. And so it was, he argues, but only in the sense that it delivered the message that readers in 2002 most wanted to hear.

During its brief reign, *Emmaus* was the picture of the year, for several years running. Dutch art lovers, laymen and connoisseurs alike, embraced *Emmaus* because this three-centuries-old picture resonated so powerfully with their own tastes and values. It resonated not because Van Meegeren cynically catered to tastes he scorned. On the contrary, *Emmaus* embodied precisely those qualities—mystery, stillness, piety, sobriety, modesty—that both Van Meegeren and his audiences esteemed the most. If he had lived half a century earlier, Van Meegeren would have produced a different sort of Vermeer forgery, lighter and brighter, more influenced by the Impressionists all around him. By the twenties and thirties, the light touch of the Impressionists had given way to an earnest, somber style. The motto of the new day was "Return to Order." Van Meegeren responded to that vision wholeheartedly because he believed in it himself.

In some key ways, Van Meegeren's vision differed from Vermeer's. The most important was the depiction of Jesus. "With the old masters," says the painter and art historian Diederik Kraaijpoel, "Christ was often seen as ravished but his expression was never pitiful. That was because people used to believe that in spite of his misery, he remained divine, with his eyes fixed on exalted value. I believe the defenseless, pitiable, human Christ was invented in the course of the 19th century."

That newer vision of Jesus moved Van Meegeren and the Dutch nearly to tears. "Death seems truly conquered here, clad in mystery and full of promise," one critic marveled. It seems almost blasphemous to say so, but if the real Vermeer had been moved to paint *Emmaus*, art lovers in the 1930s might still have preferred Van Meegeren's overblown and sentimental version to the real thing.

Art from past centuries, the art historian Otto Kurz pointed out, is written in a dead language. "Forgery is a kind of short-cut that translates the ancient work of art into present-day language." Van Meegeren spoke the same language as his audience, and they soaked up every word. When Bredius looked at *Emmaus* and reported that "I had difficulty controlling my emotions," he had all of Europe for company.

EVERY FORGER OF old masters is a time traveler hoping to stroll unnoticed down a sixteenth- or seventeenth-century street. It's not easy. "The past is a foreign country; they do things differently there," the novelist L. P. Hartley famously observed. In particular, they paint pictures differently there. Time travel trips up most forgers. It tripped up Van Meegeren, but his mistakes—like his modern-day depiction of Christ—all worked to his advantage.

When the critic Kenneth Clark was still young and little-known, he asked an impertinent question about a Botticelli Madonna that had just been purchased, at great expense, by an English collector named Lord Lee. The painting was universally hailed as a masterpiece, but Clark wondered aloud if perhaps this Madonna from the 1400s looked a bit too much like a generic Hollywood starlet from the 1920s. Scientific tests soon proved that the painting was as modern as Clark suspected.

No Kenneth Clark came along to unmask Van Meegeren. This was more a matter of good fortune than good planning. The problem for Van Meegeren and most forgers is that, even as they try to travel into the past, they bring the trappings of their own world with them. Their peers don't see anything awry because they share the same blind spots, but sooner or later a new generation will come along and giggle. In similar fashion, science fiction always tells as much about the era when it was created as about the era it tries to imagine. In the future as it was portrayed in the fifties, for instance, husbands commuted to work in personal rockets and wives stayed home and cooked up meals in a pill. For a decade or two, readers found it all quite plausible.

In art, the rule of thumb is that fakes have about a forty-year lifespan.

"Forgeries must be served hot," the great art historian Max Friedländer once observed. Art historians are fond of Friedländer's rule, for it implies that time is on the side of the good guys.* But the rule has a flip side that is often over-looked and that played an enormous role in Van Meegeren's success. It's per-fectly true, as Friedländer pointed out, that forgers of old paintings may run into trouble because they cannot help revealing that they live in our world and share our assumptions. But, precisely for that reason, as we have seen, it's also true that sometimes we *prefer* a fake to an original.

Authenticity can be off-putting. When we listen to early music played on period instruments, for example, it often sounds *worse* to us than what we are used to, thinner and less powerful, because our ears have been conditioned by the new sounds of the intervening centuries. Van Meegeren tried to imperson-ate Vermeer. He failed, and that failure was the key to his success.

Van Meegeren's pictures bore the taint of the modern world, but his audi-ences sensed only something unusual, not something amiss. What was unusual, they decided, was that *these* seventeenth-century paintings spoke with greater authority and depth than other paintings from the Golden Age.

And then, before anyone had time to catch his breath and take a sober second look, *Emmaus* was whisked offstage. Van Meegeren was arrested only seven years after *Emmaus's* first appearance. The arrest was disastrous for Van Meegeren but ideal for his reputation. Perhaps he would have been one of those fortunate forgers whose misdeeds are never uncovered. More likely, he would have had a grace period of a generation or two. After that, his paintings would probably have come to look silly. James Dean is in the pantheon in good measure because he died before he could lose his hair and grow a paunch. Even in his undoing, Van Meegeren benefitted from perfect timing.

* It is a rule with a worrying amount of elbow room. Some forgers, like the goldsmith Reinhold Vasters, flourished for decades and were found out only by a fluke. Vasters worked in the late 1800s, specializing in elaborate productions supposedly from the Renaissance. He went undiscovered for nearly a century. More generally, as the Met's Theodore Rousseau once remarked, "We should all realize that we can only talk about the bad forgeries, the ones that have been detected; the good ones are still hanging on the walls."

45

---·◆·---

BELIEVING
IS SEEING

A tale of a con man who pulls off a bold and ludicrous fraud and wins the applause of adoring crowds is sure to evoke thoughts of the emperor's new clothes. But Van Meegeren's story was *not* an updated version of the famous old fable but something altogether stranger.

In Hans Christian Andersen's story, everyone saw the truth, but only a little boy dared to say aloud what everyone knew. In the Van Meegeren saga, the loyal citizens lining the parade route genuinely believed that the emperor had never looked more splendid. They gazed at their naked ruler and saw a sumptuous robe of purple velvet with golden braid gleaming in the sun. They cheered themselves hoarse, and the cheering was nearly universal and utterly sincere.

Perhaps it is not such a surprise that the public thrilled to *Emmaus*. The greatest experts in the land had proclaimed its beauty and its importance, and it would have been hard not to get swept away. "We have a saying in the art world," says Wim Pijbes, director of the Kunsthal in Rotterdam. "'You don't look with your eyes, you look with your ears.'"

Peer pressure is everywhere in human culture, and there is no reason to think art lovers should be exempt. A crowd is a powerful thing. Theater managers used to hire claques to cheer at plays, and ancient Romans hired mourners to weep at funerals, because they knew how easy it was to manipulate emotions. Television producers found early on that audiences would take their cues from a laugh track, not even a crowd but a mechanized imitation of one.

We see depth and nuance in a painting the moment a museum singles it out

for special notice. When a gallery marks a painting "sold" with a red dot, new offers pour in. Oscar nominations guarantee new ticket sales. "The main reason why a scholar gets an honorary degree," observes the historian of science Michael Ghiselin, "is that somebody else has already given him an honorary degree."*

And so the crowds lined up to marvel at *Emmaus*.

THE SURPRISE, PERHAPS, is that the experts fell every bit as hard as did the general public. This time peer pressure was only part of the explanation. The experts' inclination, after all, was to dismiss other peoples' opinions in favor of their own. One thing that led them astray was Van Meegeren's success in producing a painting that looked convincingly like a physical object from the seventeenth century. Theodore Rousseau, the late chairman of the European Paintings department at the Met, was an authority on both old masters and Van Meegeren. "One of our most prominent scholars in Dutch paintings told me," Rousseau once recalled, "that when he saw the article in *The Burlington Magazine* and the photographs of *Emmaus*, he said to his pupils, 'That's a forgery.' But then he went to Holland, and when he saw the picture in front of him, with its convincing craquelure, convincing colors, convincing aging, he began to doubt his own first impression. There, close to it, he saw all the convincing details and not what was wrong with the style."

That was a tribute to Van Meegeren's technical skill. But even so, how was it that the experts missed "what was wrong with the style"? In his more impatient moods, Albert Blankert, one of today's leading art historians, contends that there is no great mystery to unravel. Experts sometimes get it wrong because their task is difficult and they are only human.† A skeptical and worldly man, Blankert rattles off a list of human frailties that undo our judgment— vanity, gullibility, fear of losing face. And besides, the experts weren't so expert. "Before the second world war, most museum people in Holland were amateurs who happened to have money."

* In 1977, a prankster demonstrated that the expectations game works the other way around, too. Writing under a pseudonym, he submitted a typed copy of Jerzy Kosinski's National Book Award–winning novel *Steps* to fourteen publishers and thirteen literary agents. Every single one turned it down, including Random House, who had published the novel in the first place.

† To cry "fake!" is, moreover, to make a very serious charge. The art world holds to a belief analogous to the legal view that it is better to let a dozen guilty people go free than to imprison a single innocent person.

But on a different day, when he is feeling more expansive, Blankert brushes aside his own explanation as too glib. When he was a young man and a budding connoisseur in his own right, Blankert recalls, he decided that he had better look into cases where his predecessors had lost their way. In the years since, he has dissected several notable fiascos involving forgery and false attributions, for essentially the same reasons that safety officials probe the cause of airplane crashes.

"Connoisseurship is a crazy business," Blankert says. "Think of the days before Archimedes, when people tried to tell if gold was genuine or not. Archimedes sat in his bathtub and figured out how to do it, and since then it's been 'Yes, it's gold,' or 'No, it's not.' But gold was valued very highly long before there was any reliable or scientific way of finding out if it was the real thing. Well, even in those days there must have been gold scholars and gold experts and gold priests." Blankert laughs. "That's what we are, in a way."

The system endures because no one has yet found a tool that compares with an expert's eye. When he goes through a new museum, Blankert likes to play the game of trying to identify each painting by artist and era without looking at the labels. Nearly always he's right. "Mostly it works," he says. "It's not like oracles reading messages in the intestines of birds."

Unlike oracles, connoisseurs have a testable, demonstrable skill. If only that were enough. Blankert calls attention to an argument proposed by a Dutch art historian named Harry van de Waal, a member of the generation that followed Bredius and De Groot. Connoisseurs, wrote Van de Waal, come to new paintings with years of expectations about, say, what makes a Vermeer a Vermeer. Once the expert buys into a particular reading—"here we have an early Vermeer heavily indebted to Caravaggio"—there is almost no shaking free of it. If he is certain that a particular painting is a Vermeer, he'll be unable to see what is right in front of him. The expert falls for a fake, Van de Waal contends, precisely as a child who believes in Santa Claus sees Santa, and not his uncle, no matter how ludicrous and ill-fitting the uncle's fake beard and red jacket.

So primed are we to see what we want to see (and to reject what runs counter to our hopes and expectations) that psychologists and economists have coined an entire vocabulary to describe the ways we mislead ourselves. "Confirmation bias" is the broad heading. The idea is that we tell ourselves we are making decisions based on the evidence, though in fact we skew the results by grabbing up welcome news without a second glance while subjecting unpleasant facts to endless testing.

This form of self-deception pops up in the most ordinary circumstances and in the most momentous. When the number on our bathrooom scale is the one we hoped to see, the psychologist Daniel Gilbert points out, we happily hurry off to get dressed. When it brings dismaying news, we step off and try again; we dry off even more thoroughly; we see if perhaps we can do better by standing at a different spot on the scale. On the battlefield, generals respond to good news and bad news in much the same way.*

Science teaches us to challenge our preconceptions, but that kind of skepticism does not come naturally. One small demonstration illustrating the point involved an experiment where volunteers watched films of babies they didn't know. Half the babies were identified as males, half as females (the babies were so young that they looked alike). The babies were playing with a jack-in-the-box. When the box popped open, the startled babies pulled back. "When people were asked, 'What's the child feeling?'" the psychologist Elizabeth Spelke explained, "those who were given a female label said, 'She's afraid.' But the ones given a male label said, 'He's angry.' Same child, same reaction, different interpretation."

When the stakes are low—when it is only a question of skipping dessert for a few nights—we may be able to acknowledge the facts we've been trying to avoid. But what if our pride and sense of professional identity are at risk? What if changing course would mean admitting the possibility of having gone disastrously, humiliatingly wrong?

Bredius never backed away from *Emmaus* or any of Van Meegeren's other "Vermeers." De Groot went to his deathbed maintaining that his Frans Hals forgeries were legitimate, despite incontrovertible proof to the contrary. He clung to the paintings throughout his life and left them to the Groningen Museum in his will.

"A man with a conviction is a hard man to change," the psychologist Leon Festinger once marveled. "Tell him you disagree and he turns away. Show him facts or figures and he questions your sources. Appeal to logic and he fails to see your point."

* "Even before the war [Hitler] had forbidden 'warning memoranda,'" one biographer writes, "[and] now he regarded all sober assessments of the situation as a 'personal insult.'"

46

THE MEN WHO KNEW TOO MUCH

Even if we concede, though, that the connoisseurs clung to their pet beliefs far, far too long, we have yet to take on one central question. How did the experts come to hold their false beliefs in the first place? How did Van Meegeren get away with it?

The flippant answer—by choosing foolish victims—misses the mark. (In matters of art, Goering *was* an ignoramus, and tricking him was no coup, but Bredius and the others were not fools.) The modern-day magician Teller, writing about hoaxes generally, made a far more useful suggestion. "When you're certain you cannot be fooled," Teller observed, "you become easy to fool."

A little knowledge is famously a dangerous thing, but a lot of knowledge can be dangerous, too, if a fraudster knows how to exploit it. "There are some mistakes it takes a Ph.D. to make," Daniel Moynihan once observed. The trick, as in jujitsu, is to find a way to turn a rival's apparent advantage into a drawback.

Bredius himself compared the best forgers to magicians, though merely as a rhetorical flourish. For once, Bredius did not take his own opinion seriously enough. Magicians and con men fool us by making us jump to unwarranted conclusions. The savvier we are, the quicker we jump, because we see at a glance (or so we think) which way the story is heading.* Adults know (but

* The eminent astronomer Percival Lowell explained in 1895 that the reason he could see that the canals on Mars were man-made (or Martian-made) was that he, unlike other observers, understood what he was looking at. "The expert sees what the tyro misses," Lowell wrote, "not from better eyesight but from better mechanism in the higher centers. A very slight hint from the eye goes a long way in the brain of the one; no distance at all in the eye of the other."

small children don't) that two metal rings that clang together are solid. Bredius and his fellow connoisseurs knew that Vermeer painted specks of light shimmering on loaves of bread and favored the color blue. The forger drops a hint, and the connoisseur follows it off a ledge.

A magician named Jim Steinmeyer has put considerable thought into identifying which people can be tricked. "It's not as simple as finding stupid people who are willing to accept what they're told or happy to overlook obvious clues," he explains. Just the opposite. The ideal audience knows a great deal about how the world works and, just as important, prides itself on that knowledge. Any magician would rather take on a roomful of physicists than of five-year-olds.

"The key," Steinmeyer says, "is finding smart people who bring a lot to the table—cultural experience, shared expectations, preconceptions. The more they bring, the more there is to work with, and the easier it is to get them to make allowances—to reach the 'right' conclusion and unwittingly participate in the deception."

Who would make perfect victims? Perhaps a group of smart people who knew everything there was to know about the Dutch Golden Age, who believed as an article of faith that they could make flawless snap judgments, who knew that forgers could fool other people but could never fool *them*?

WHAT MAGICIANS LIKE Steinmeyer have learned onstage, psychologists have confirmed in formal experiments. In one classic study of confidence and overconfidence, researchers asked subjects an array of "random knowledge" questions. What is the capital of Ecuador? In the United States do more people die annually from suicide or homicide? The subjects were asked to answer each question and then to rate how sure they were that their answer was correct. "Quito, 80 percent."

Two trends quickly emerged. First, most people vastly overestimated their knowledge. Not only did they give wrong answers, but they put the odds that they were wrong at one in ten thousand or even one in a million. More surprisingly, the researchers could not shake this baseless confidence, no matter how they tried. With a new group of subjects, the psychologists postponed the test until they had presented a long tutorial, complete with slides and tables, about probability and the meaning of such expressions as "one in a thousand." Their labors had distressingly little effect.

Maybe the reason for the overconfidence was that nothing was at stake? The psychologists rounded up new volunteers and this time asked if they would be willing to bet real money on their answers. Yes, they would. And when the panicky researchers explained later that they didn't actually intend to pay off, some subjects were furious.

In another refinement of the original study, the psychologists drew questions from areas the subjects knew well. Accuracy grew, but overconfidence grew faster. In one psychologist's summary, "It is therefore most important to be wary of our overconfidence, for this overconfidence is *at its greatest* in our own area of expertise—in short, just where it can do the most damage."

THE FORGER'S MAIN task is to trick his victims into focusing their attention where it does not belong. To fool the experts who are sure to study their work, they need to lure them into focusing *here* while the real action takes place *there*. "You know what forgers do," says Thomas Hoving. "They put something in a piece that will draw most of your attention, such as a simulated-antique repair. They usually do it so the repair looks kind of rinky-dink." *Nothing up my sleeve!*

Van Meegeren was a master at drawing the experts' attention and making sure they focused just where he wanted them to. So are all successful forgers. Experts truly *are* expert, so the forger needs to find a way to induce tunnel vision.

The strategy need not be subtle. Around 1920, for intance, one of England's great classical scholars happened to spot a rare and highly valuable silver coin, from ancient Greece. If someone had turned up at the British Museum with a silver decadrachm, Sir George Hill would immediately have been on guard and wary of a fake. But instead a forger had mounted the coin in a necklace and enlisted an attractive Greek woman to wear it to a party. When Sir George spotted her and chatted her up and spied the coin nestling in her cleavage, and then found that the charming lady herself had no idea of the coin's significance, he could scarcely wait to announce his find.

Hill's problem had nothing to do with the depth of his knowledge. His mistake lay in forgetting that a gift for connoisseurship was only half the battle. Out of natural but misplaced pride, many experts make the same mistake. Max Friedländer compared the connoisseur of art to the connoisseur of wine. The wine connoisseur immediately recognizes, "with full certainty," the

year and vintage of a given bottle, Friedländer wrote, "and in the same way, the connoisseur of art recognizes the author on the strength of the sensually spiritualized impression that he receives."

And, indeed, experts in both specialties *do* nearly always get it right, presuming of course that the test is fair. Which is where the con man comes in.

In 2002, for instance, a French wine researcher named Frédéric Brochet gave fifty-four experts an array of red wines to evaluate. Some of the glasses contained white wine that Brochet had doctored to look red by adding a tasteless, odorless additive. Not a single expert noticed the switch. Curiously, amateurs did better than experts. "About two or three percent of people detect the white wine flavor," Brochet says, "but invariably they have little experience of wine culture. Connoisseurs tend to fail to do so. The more training they have, the more mistakes they make, because they are influenced by the color of the wine."

Bredius and his fellow dupes knew an immense amount about seventeenth-century Dutch art in general and about Vermeer in particular. Faced with an honest question—what does Vermeer's depiction of light owe to De Hooch?—they could deliver useful and learned answers. In the same way, a wine connoisseur could reliably answer questions like, how does a St. Emilion from 2000 compare with one from 1998?

But ask a question built around a lie—built around a Van Meegeren masquerading as a Vermeer or a glass of white wine disguised as red—and the expert might make a mistake that an amateur would not. Why? Because the expert is far more likely than the amateur to go zooming off down a false trail of his own devising.

For the pro, the name "Vermeer" and the category "red wine" carry countless associations. Each association points to further questions; each question calls for further exploration. For the amateur, "Vermeer" and "red wine" are unknown territory. The amateur makes a casual comment—"What an ugly picture!" "I don't like this wine"—and then has no more to say. The amateur is unlikely to go wrong because he's unlikely to go anywhere.

As the experts at Duveen Brothers demonstrated when they pronounced *Emmaus* a "rotten fake," it was possible to look at the painting and reject it. Van Meegeren was performing magic tricks, not magic. But each time *Emmaus* won a new admirer, it made the downfall of the next connoisseur that much more likely.

What was at work was a subtle form of peer pressure—peer pressure with a college education. The public oohed and ahhed at *Emmaus* because everyone else was doing so. *Emmaus* was in fashion, as narrow ties or long skirts might be. But the art critics oohed and ahhed because they firmly believed they had discerned depths and subtleties in the painting that demonstrated its unique value.

Art experts in the thirties discounted the thought that *Emmaus* was too ugly to be a Vermeer. That would have been the immediate response of any amateur who knew Vermeer only from *Girl with a Pearl Earring*, but the pros had no such ignorance to safeguard them. "When I studied art history," recalls Marina Aarts, a specialist in seventeenth-century art, "the first thing they told us was, 'Look, whether you like it or not isn't important. Our subject is the painter's style. If it's beauty you want, go to the museum on your own time.' That's what happened with *Emmaus*. Nobody asked 'Do I like it?' That question wasn't important. The only question was, 'Is it a Vermeer?' And the answer was, 'Yes, we think it is a Vermeer.' And *that* made it beautiful."

When we look at the world, our beliefs and expectations color what we see. We're seldom aware of it—each of us takes for granted that we're simply describing the reality in front of us—but there is no such thing as a neutral description. When Americans look at the Arabic word for *cat*, they see only squiggles. Arabs see a furry creature that laps up milk and says meow.

Before Van Meegeren was unmasked, the critics looked at *Emmaus* and found themselves overwhelmed by its "serenity" and "calm" and "elevation" and "dignity." Then came the astonishing news that the supposed masterpiece had nothing to do with Vermeer. The critical response turned 180 degrees, immediately. A Dutch art historian named Sandra Weerdenburg demonstrated the flip in irrefutable detail in her doctoral thesis. Weerdenburg found that the old critics didn't change their minds, or at least didn't say so. Almost without exception, they simply stole away in silence. But a new cast of critics appeared at once, and many of them singled out for scorn the very elements that had won praise only a few years before. What had been hailed as "serene" was now damned as "static," what had been "dignified" had grown "lifeless," what had been "tender" had become "sentimental."

What had changed? The two camps of critics came to *Emmaus* bearing different expectations, which primed them to respond to the picture in different ways. Psychologists call this built-in bias "perceptual set"—try as we might to

see the world without preconceptions, we each gaze through our own set of lenses. History matters. Researchers have devised a set of homey experiments that hint at just how much.

Consider this little drawing:

A viewer coming to it fresh would probably see a bald man with big glasses.

Now consider the same drawing as the fourth in a series:

For most people, the man has become a mouse. In Van Meegeren's case, the art connoisseurs approached *Emmaus* by way of a series of judgments rather than a series of drawings. The first series ran "serene," "dignified," "tender," and ended with an exultant cry of "Vermeer!" The second series, after the truth had come out, ran "static," "lifeless," "sentimental," and ended, almost inevitably, with a judgment of "Worthless!"

* * *

IN THE REAL world rather than the psychology class, history matters even more. Not only do experts see what they expect to see—they literally do have their own views—but they sport ideological blinders that make them cling to their own judgments and dismiss all others.

In the 1600s, a few scientists peered through their microscopes and saw tiny human beings curled up inside sperm cells. "Who would have believed that in them was a human body?" one wrote. "But I have seen this thing with my own eyes."

How was that possible? One modern embryology text delivers a simple answer, which also helps explain the downfall of Bredius and his fellow connoisseurs. "We see what we look for," the authors warn, "not what we look at."

47

BLUE MONDAY

In art more than in many fields, connoisseurs face a special challenge—inconsistency and unevenness come with the territory. No wine lover would expect the first sip from a glass to be ambrosia, the next vinegar. But art historians talk about "Monday mornings," when even the best painters reveal that they are human. Artists paint for a living, day in and day out, and things go better on some days than on others. Energy or creativity can flag, experiments can go wrong, bright ideas can fizzle. Homer nodded, and Vermeer occasionally ran aground.

The experts saw clearly that Vermeer had made mistakes in *Emmaus*, and prominent ones, too. The most glaring of all, for it is front and center, is the left arm of the disciple in the yellow robe. Look at the disciple's hand, resting on the tablecloth, and then follow his forearm as it disappears into a voluminous sleeve. After several inches, the forearm simply stops; it is impossible to imagine how to extend it so that it meets the rest of the disciple's arm. Once the forearm catches your eye, it comes to look like a Halloween prop, a severed stump jammed into a sleeve.

That hand seems even less plausible when we compare it with the model that surely inspired it. Look at the left hand of Vermeer's *Astronomer*. That hand, too, rests on a table's edge, with the fingers separated in the identical fashion and the hand vanishing into a roomy sleeve in just the same way. But in the genuine Vermeer, the arm makes perfect sense—angled up from the table, arm meets body so naturally and convincingly that we linger over it only to marvel, not to cringe.

In Van Meegeren's version, the layman might think that we have a dealbreaker—a job so mangled that it could not have been the work of an art-

Museum Boymans-van Beuningen

Van Meegeren, *Emmaus*, detail

Louvre, Paris

Vermeer, *Astronomer*, detail

ist with Vermeer's mastery of technique. But the experts knew better. Look at Vermeer's *Woman and Two Men*, beyond dispute an authentic work.

The painting depicts a man flirting with a woman who is meant to be laughing coyly. Something has gone dreadfully wrong with her mouth. Her proportions, too, seem out of kilter. The distance between waist and knee

Herzog Anton Ulrich-Museum, Brunswick

Left, Vermeer, *Woman and Two Men; right*, detail

seems to extend forever. If she were to stand up, she would almost scrape her head on the ceiling.

Or look at *The Art of Painting*, one of Vermeer's most acclaimed works. The

Kunsthistorisches Museum, Vienna

Vermeer, *The Art of Painting*, detail

artist's right hand looks swollen and shapeless, as if the poor man had been stung by bees.

One of the controversies embroiling the Rembrandt Research Project involves paintings traditionally assigned to Rembrandt but marred by clumsy passages. One group of scholars contends, in effect, that Rembrandt could do no wrong; any flawed painting supposedly by Rembrandt must be the work of a follower instead. But a rival group maintains that Rembrandt liked to experiment, which made for some misfirings, and that at other times he simply lost interest in what he was doing. The curious result is that some scholars contend that an awkward patch or two in a disputed painting counts as evidence that Rembrandt *did* paint it.

Look at Rembrandt's *Bathsheba*, "the most beautiful nude of Rembrandt's career" in the judgment of Simon Schama. Bathsheba, who was married, had the bad fortune to have caught King David's lecherous eye. In Rembrandt's painting, in her right hand she holds a letter from the king commanding her presence. Both hand and letter, which are at the artistic and storytelling center of the painting, are beautifully done. But Bathsheba's *left* hand seems like an afterthought. It looks "like a limp crab . . . painted with almost incomprehensible cursoriness," one critic complains, "and does not even come close to

Louvre, Paris

Rembrandt's *Bathsheba, left;* details, *right and center*

anatomical accuracy." Look closely at Bathsheba's left thumb. How does it attach to her hand?

For Rembrandt scholars, says Bob Haak, one of the most eminent among them, "It is a question of not just how well he could paint, but how badly." Even when it involves only authentic paintings, that question ties scholars in

knots. When you throw fakes into the mix, matters become trickier still. How to tell a forger doing his inept best from a genius in a hurry?

IT'S NOT EASY to place ourselves in the position of art critics of the 1930s—we know about Van Meegeren and they didn't, which means that we have peeked into the answer section at the back of the book—but the painter and art historian Diederik Kraaijpoel has tried hard to play fair. He has studied *Emmaus* carefully. His verdict: no masterpiece, but not a bad picture.

Kraaijpoel cites specific weaknesses in the painting. Both the tablecloth and the disciples' robes look stiff, for instance, as if they were made of wood rather than cloth. Vermeer was a master of texture and drapery; cloth flows, and every material, whether a sleek fur or a nubby carpet or a perfect pearl, is distinct and invites a viewer's touch. But look at the lower right corner of *Emmaus*, where sleeve and chair and tablecloth meet. Robe and cloth and wood might all be the same material, and the tablecloth juts into space like a rigid object.

Emmaus is two pictures in one, a still life surrounded by four figures. The still life is by far the better of the two. (The police would later find seventeenth-century pitchers, glasses, plates, and a map in Van Meegeren's studio.) The objects on the table show far more life and animation than the human beings around it. The shadows on the pitcher and the glints of light on the glasses are particularly good.

But all the humans look dismayingly alike, and none looks quite alive. (Vermeer and his contemporaries would have made a point of portraying different sorts of faces and bodies, just as they demonstrated their skill by conveying the different textures of wood and pewter and silk.) Painting in secret, Van Meegeren had to conjure up his models from his imagination. Still, he indignantly kicked aside that ready-made excuse. "If you have painted two or three thousand heads in all lights," he boasted, "it is not necessary to have models."

48

HE WHO
HESITATES

Van Meegeren's hubris might have done him in, except for the marvelous fact that when it came to swagger and self-delusion he was no match for the experts he needed to outwit. The connoisseurs' exaggerated regard for their own views was more than a quirk. It is a striking feature of the art world that experts have little choice but to put enormous faith in their own opinions. Inevitably, that opens the way to error, sometimes to spectacular error.

The problem is not merely that every expert regards his judgments about a painting's authenticity as superior to those of everyone else. The deeper problem is that the experts rely on such subtle and hard-to-verbalize cues that they have the greatest difficulty persuading one another to see things their way. "Sometimes it is a question of lovely equipoise," wrote Max Friedländer, "sometimes of stark, exciting vividness, sometimes again of an intensification of the sense of life, or a sense of pathos, of boundless abundance, of heroic exaltation—and every time the accent is unmistakable."*

Experts command an immense store of facts, but the speed of their judgments is every bit as impressive as the breadth of their knowledge. Connoisseurs believe they can tell, within moments of looking at a work of art, whether it is first-rate or second-rate, genuine or fake. They *know* by looking, and they know for sure and at once. Just as important, they believe that such

* Friedländer had a daunting reputation (and was an authority on forgeries), but in 1941, when he made this observation about the "unmistakable accent" of authenticity, *Emmaus* was the world's most cherished Vermeer.

snap judgments are the gold standard in their line of work. Hesitation is a sign of uncertainty, not prudence. Their view echoes that of the chess grandmaster José Raúl Capablanca, who once snapped at a weaker player, "You figure it out, I know it."

What was crucially important was that Bredius believed this, too. This was why he insistently repeated that he had immediately recognized that *Emmaus* was authentic and why he instructed Boon to write his letter to the editor repeating the same point.

"He was as good at recognizing Vermeers at a glance, he imagined, as you are at recognizing your wife in a crowd or her voice on the telephone," remarks Albert Blankert. "He did it immediately and without the slightest doubt. He would have been perfectly ready to testify to the truth of his judgments in court."

So were his peers.

To walk through an art museum with an expert is humbling, like trying to keep up with a pro on the tennis court. The judgments seem so sure and automatic—so much, indeed, like recognizing your spouse—that it is easy to see how quickly you could fall victim to the delusion that your opinions were more akin to revelations, as if the muse of art herself had whispered in your ear.

Malcolm Gladwell began his book *Blink*, about the power of snap judgments, with a story about Thomas Hoving. In the early 1980s, the Getty Museum was considering buying a marble statue called a kouros, a depiction of a nude male. The statue was 2,600 years old, the price nearly $10 million. Before they agreed to buy the kouros, the Getty spent fourteen months investigating it. Lawyers scrutinized its provenance, which was impeccable and stretched back decades. A University of California geologist analyzed a sample of the marble with an electron microscope and other sophisticated tools. Everything checked out. The geologist managed to identify the particular quarry the stone had come from, and he found that the statue's surface was covered with a thin layer of a material called calcite, which forms naturally on the surface of marble over the course of hundreds or thousands of years. This statue was old.

The connoisseurs weren't so sure. An art historian named Federico Zeri thought the statue looked wrong, though he wasn't sure just what the problem was. An expert on Greek sculpture named Evelyn Harrison agreed with Zeri. Then came Hoving's turn. A Getty official showed him the statue.

"Have you paid for this?" Hoving asked.

No reply.

"If you have, try to get your money back. If you haven't, don't."

In the end, the Getty went ahead with its purchase. The statue turned out to be a fake, made not in 600 BC but around 1980. The connoisseurs and curators had seen at a glance what the scientists had failed to find in more than a year.

IT IS EASY to draw the wrong moral from the Getty story. The point is not that soulless scientific tests always fall short of human judgments, in the way that frozen food always falls short of a home-cooked dinner. Nor is there anything mystical about the talent of Hoving or the others, though it can seem that way. Hoving can spot a fake in seconds because he has invested tens of thousands of hours in examining works of art. Did it take him two seconds to make up his mind about the kouros, or two decades?

Connoisseurs have brought some of the confusion on themselves. They are rationalists who talk like revivalists. Whistler claimed that he could tell whether a Velasquez was genuine because "I always swoon when I see a Velasquez." In truth, swooning has nothing to do with it. Identifying a Velasquez or a Vermeer is an intellectual task, not an emotional one. Making a decision about a new painting involves the same kind of pattern-recognizing skills that let us recognize a man we last saw twenty years ago, when he weighed thirty pounds less and had hair to his shoulders. It may sound like divine inspiration, but the expert's cry of "Fake!" is a rational judgment.

As if to make matters worse, connoisseurs talk incessantly about their eye, which makes it sound as if they have an inborn gift akin to perfect pitch. They don't. An "ear" is innate*; an "eye" is testament to long practice, like an athlete's muscles. Hoving put together a book called *Master Pieces* that shows just how much practice is involved. The book is based on a game that art curators play—given only a photo of a tiny snippet of a painting and a verbal hint, can you identify the painting? Hoving played for years. He is the least laid-back of men, and this was not idle chat but competitive sport. Even looking at paintings, Hoving believes, is best done "fiercely." He proudly recalls his finest moment in the game—"picking out, in seconds, the fuzzy left ear of the huge

* The pianist Lorin Hollander recalls that one day, when he was three and a half, a car horn sounded outside. For the fun of it, Hollander's father (a musician himself) asked his son what note the sound was. "F sharp," the toddler announced. The father clinked a glass with a spoon. "B flat."

dog at the feet of the family in Renoir's portrait *Madame Charpentier and Her Children.*"

Hoving has made a specialty of what he calls "fakebusting," and his list of coups is long and undisputed. A patrician who affects the language and the impatience of an overworked cop, he shrugs off by-the-book approaches to telling genuine paintings from forgeries. "Provenance is a laugh," Hoving says, "the fact that it came from so and so, and so and so gave it to the prince of so and so. Fuck off, that can all be faked up. Same thing with iconography. All of that stuff is superfluous and of no importance."

Instead, Hoving starts a new case with a bout of total immersion. "If I'm going to see a Vermeer," he says, "what I do is spend three solid days with all the Vermeers I can get my hands on. You go to the ones in the Met, you go to the Frick, and you saturate yourself. And then you have it brought in. You don't look right away. Then, bang! You look at it and you look away, and you record that first, split-second impression."

If you're in the presence of greatness, Hoving insists, you'll know it. "You don't have to know anything about the Italian Renaissance or Florence or marble or the Bible to know that the *David* by Michelangelo is an absolutely unbelievable and earth-shattering thing," he says. "The image of this boy just coming out of adolescence who's looking confident and yet scared to death—it's absolutely superb, and it talks on its own. That's what art is for."

"Be stupid!" Hoving cries. "When you look at a thing, have a totally blank mind and be dumb—let *it* do the talking. 'Talk to me, baby.' If you let it talk to you, it will."

The problem—and the great opportunity for crooks like Van Meegeren—is that so-so experts may not hear what Hoving hears. Second-rate experts may swoon in the presence of second-rate paintings.* Worse yet, they will deliver their misguided views with every bit as much sincerity and self-assurance as Whistler or Hoving.

"That's the trouble with an 'eye,'" says the historian Marina Aarts. "You can fool it. These people looking at *Emmaus* believed their eye was infallible, but it's not true. Your eye is connected to the brain, there's information in that brain, and that information depends on the age you live in."

* And genuine experts may have blind spots. Hannema had a "two-track mind," says Albert Blankert: nearly all his judgments were acute, but he made bewildering mistakes when it came to certain masters, notably Vermeer.

49

THE GREAT CHANGEOVER

Until its last act, forgery is a contest like many others. But the moment the forger's victims take his bait, a strange thing happens. The forger's dupes immediately become his greatest allies. Any doubts they may have held are abandoned, and almost invariably the new believers work with all their might to tell the world of their discovery.

For Van Meegeren, with his grand ambition, this switch was vital. In his eyes, selling a forgery was only the beginning. Hannema paid a fortune for *Emmaus*, but Bredius's campaign on behalf of "*the* masterpiece of Johannes Vermeer" was praise beyond price.

What accounts for the strange partnership between the con man and his victims? It happens in many fields where one side is trying to scam the other, not just in art. In World War II, for example, the worst news a spymaster could hear was that the enemy had captured one of his agents and "turned" him. When a spy delivered information that turned out to be false, therefore, his own side tried mightily to find a benign explanation—maybe the enemy had changed its plans at the last second. The Nazis' willful blindness was "sometimes so thorough and persistent as to strain credibility," wrote Sir John Masterman, who ran teams of double agents for the British in World War II. "It appeared that the only quality which the German spymaster demanded was that he should himself have discovered the agent and launched him on his career. . . . It was extremely, almost fantastically, difficult to 'blow' a well-established agent." Like a starry-eyed lover with a two-timing girlfriend, the spymaster was often the last to catch on.

The dupes went wrong in the first place by letting their hopes sway their judgment. "Look at it from Bredius's point of view," says Thomas Hoving. "He'd been looking all his life to make the great discovery of an unknown Vermeer. It was the same story with the Getty kouros—everyone knew that the Getty wanted a kouros more than anything else in the world. So when one shows up, you're deadened by the fact that you *really* want it. That's what happened to Bredius—he fell because he was hoping beyond hope that he'd found the treasure of a lifetime. That's why it's crucial not to give a damn when you're a collector. If you care, you're dead."

But the connoisseurs *did* care, and with all their hearts. That made their second mistake almost inevitable. Having committed themselves, the experts could not back away from the stand they had taken. Instead, with their reputations on the line, they spent all their energy trying to ensure that everyone else saw the world as they did.

IN PRINCIPLE, THE dupe's ardor is easy to understand—no one likes losing face. But in practice, the self-deception grows to such grotesque proportions that sometimes even the con men themselves can hardly believe their good fortune. The story of a notorious hoax perpetrated by the novelist Clifford Irving provides an especially relevant example. In 1969, Irving wrote a biography of the art forger Elmyr de Hory. A year later, it dawned on him to apply the lessons he had learned in a scam of his own. The billionaire recluse Howard Hughes was still enormously famous in 1970, though he had not been seen in public for more than a decade. Imagine the sensation, then, when Irving told his publisher that Hughes had contacted him, offering his full cooperation on a biography.

Armed with a few letters he had forged in Hughes's handwriting, Irving sold the project to *Life* and McGraw-Hill for something on the order of $750,000. (*Life* had unwittingly handed Irving one of the tools he used to rob them; he had learned to copy Hughes's handwriting by studying a photo in the magazine.) Irving had never met Hughes or even spoken with him by phone. His scheme hinged on two bold propositions: The first was that Hughes would not come out of hiding to challenge him. The second was that he could count on his victims' cooperation. "They'll help us all the way," Irving reassured an accomplice who had begun to lose his nerve. "Whenever we stumble, they'll pick us up. Don't think of them as the enemy. They'll turn out to be our best allies."

And so they did. Dazzled by Irving's success in obtaining a story that no one else had, hypnotized by the fortune they stood to make, and hooked too deeply to wriggle free, *Life* and McGraw-Hill rationalized away one warning signal after another. Though Irving claimed to have spent endless hours transcribing tape-recorded interviews, for example, no one ever asked to listen to a single tape. His publishers swallowed stories about how Hughes had paddled a canoe to meet Albert Schweitzer and swum naked with Ernest Hemingway.

Still, Irving's accomplice couldn't hide his panic. McGraw-Hill was bound to realize they'd bought a fake. "It's got to occur to them. How can they be so naïve?"

Irving knew better. "Because they *believe*," he said. "First they wanted to believe, and now they have to believe."

The experts have to believe because, if they dared admit the possibility of fraud, the consequences would be too grim to contemplate. If the story held up, on the other hand, careers would be made and downcast rivals would look on in helpless envy.

And so Van Meegeren and his fellow con men waltzed along, carefree, while the experts who might have unmasked them in a moment instead devoted all their efforts to perpetuating a fraud.

Part Five

The Chase

THE SECRET IN THE SALT MINE

By the winter of 1944/1945, the Nazi vision of conquest and glory had collapsed. Then began a desperate race. Goering and his fellow Nazis tried frantically to hide their art from the advancing allies. "In the last weeks of the war," wrote one foreign correspondent traveling with Patton's Third Army, "they scuttled madly from place to place hiding what they had stolen in caves, mines, wells and cemetery vaults."

No one on the Allied side knew—perhaps, in their panic, the Nazis themselves did not know—just what the point of the hiding was. Did the Nazis dream that somehow they could cling to what they had taken, or was their goal to protect their stolen art from bombs, or did they simply mean to deprive their enemies of what they could not keep for themselves? Quite likely the attempt to cling to their treasure was more a reflex than a plan, like a shipwreck victim's clutching a bag of gold coins as the waves close around him.

"At the height of its war effort," the journalist Janet Flanner wrote a few years afterward, "the United States had almost three million men under arms in the European Theater of Operations. Exactly one dozen men out of these millions were functioning ... as a *rarissimo* group known as Monuments, Fine Arts, and Archives." Unlikely soldiers, most of the so-called Monuments Men were art historians, curators, and artists. In the chaos of war, their almost impossible task was to do their best for the preservation of art—to try to keep to a minimum the number of cathedrals flattened and paintings grabbed as souvenirs or chopped into pieces for kindling.

Shortly after the Nazis surrendered, the number of Monuments Men

reached a peak of perhaps eighty. They came from the Fogg Art Museum and the Met, the Brooklyn Museum and the National Gallery, and universities large and small. With the fighting ended, their mission changed—now they were engaged in an Easter egg hunt to find works of art hidden across an entire continent—but their task still dwarfed their numbers. The whereabouts of tens of thousands of paintings and sculptures, including Goering's prized "Vermeer," were unknown. Ill-equipped, the art men thumbed rides and commandeered bicycles and chased down countless rumors, terrified that they would arrive too late at a bonfire set by the Nazis and fueled with Raphaels and Rembrandts and Titians.

In April and early May 1945, American soldiers found hidden troves of art at fifty-three different locations in Germany. Each was an Aladdin's cave crammed with treasure. Many of the biggest finds came about through happenstance, the product of a wrong turn or an overheard conversation. On the night of May 5, for instance, a chance meeting between an American military policeman and two Frenchwomen ended up in the discovery of a salt mine crammed with art and Nazi gold.

The MP, a private named Mootz in Patton's Third Army, had stopped two women out after curfew. The women had wandered out of a displaced persons camp near Merkers, Germany, and they had no papers. It was an emergency, they told Mootz. A woman in the camp was about to give birth; they had to find a midwife. Mootz, dubious, hustled the women back to where they belonged. The Frenchwomen chattered the whole way, something about the baby, and they asked Mootz a strange question—what did the Americans plan to do about the mountain of gold in the salt mine?

Mootz relayed the story to his superiors. They asked around. "Everybody in town was amazed at such ignorance," recalled the Australian journalist Osmar White. "Of course there was treasure in the salt mine—the gentlemen in charge of it were staying at the local hotel! And so they were—three prim men in black clerkly coats, wearing eyeglasses and short haircuts. They were frank. They disclosed all with an air of undisguised relief."

White tagged along with the first American party to investigate the Merkers salt mine. The journalist and several officers squeezed into a tiny elevator that rattled its way into the blackness. Twenty-one hundred feet below the ground, they stepped into a passageway where a sign on the wall read, "Heil Hitler!" They set out down a long hall and eventually arrived at an enormous cavern that stretched fifty yards and had train tracks running down its center.

On both sides of the tracks, all the way to the deepest part of the cave, canvas bags stood in knee-high piles, row upon endless row.

An officer pointed at the bags. "Open one of them," he commanded. Someone reached into a bag and dragged out a gold brick. Fifty pounds, maybe? The gold, it turned out, had been brought from Berlin a few weeks before. Huge teams of slave laborers had staggered into the mines carrying bags of gold, trip after trip, for seventy hours. White began counting: 4,522 bags in all. He calculated for a minute. Something on the order of 100 tons of gold.

Down another passageway, White looked into a room filled with countless neatly labeled sacks of paper money. "At the end of the stack was a small, gentle-faced man in a rumpled gray suit, sitting disconsolately on a couple of million dollars." This was Paul Rave, curator of the German state museum. "With weary courtesy," White wrote, "he showed us crate after crate of Greek, Chinese, and Egyptian ceramics, packing cases full of canvases by Menzel, Dürer, Manet, Constable, Raphael, Titian, Van Dyck, Leonardo da Vinci." The crates stood in stacks on the floor. Occasionally a bit of salt sprinkled down from a cave wall.

—◆◆◆—

THE DENTIST'S
TALE

The soldiers of Patton's Third Army made the next colossal find, too, and if anything it was even more of a fluke. It began with a toothache. Lincoln Kirstein would go on to a renowned career that included such milestones as co-founding the New York City Ballet (with George Balanchine), but in May 1945 he was a private in the U.S. Army, and a Monuments Man. The army had reached Trier, Germany. Kirstein's captain had a throbbing wisdom tooth. The private's job was to find a dentist.

Kirstein wandered into the streets and beckoned a young boy over to him. They had no common language, but Kirstein puffed out his cheeks and moaned, to mime a toothache. For a payment of three sticks of gum, the boy grabbed Kirstein's hand and led him down the street to a doorway beneath a large painted picture of a tooth. The dentist spoke English, and he liked to talk. He took care of Capt. Robert Posey's tooth and then settled in for a gabfest. What were the Americans up to? Protecting art? Really? What an astonishing coincidence—would you believe that my daughter's husband is in the art preservation line, too?

The dentist led Kirstein and Posey to meet his son-in-law, who proved as talkative as the old man. For twenty minutes, though, the talk never got beyond chitchat. In a study lined with art books, Hermann Bunjes talked about his academic career—he had studied in Bonn and at Harvard. Bunjes and Kirstein swapped anecdotes about Harvard and the art world. Had Kirstein known Kingsley Porter? And his lovely wife? "I tried to decipher his face," Kirstein wrote later. "Kind? Dangerous? Servile? Clever?"

Finally, over Courvoisier, the truth emerged. Bunjes sent his wife out of the room and then admitted that he had spent the war in Paris with the SS, helping Hitler and Goering identify art suitable for stealing. Bunjes, one historian would later write, "was almost the nastiest piece of goods in the game." Now that he had decided to talk, he laid out all the ugly secrets of his trade. He handed Posey and Kirstein detailed catalogs of looted artwork, listing titles, sizes, and "purchase" prices. And had his visitors heard of the salt mine at Alt Aussee, in the mountains near Salzburg, and did they know what was stored there?

"Information tumbled out, incredible information," Kirstein recalled, "lavish answers to questions we had been sweating over for nine months, all told in ten minutes. It must have been as great an exercise of discipline on Captain Posey's part as on mine to betray no flicker of surprise or recognition. He almost seemed to assume we knew it anyway."

Bunjes interrupted his torrent of talk to confide in his fellow scholars. He feared for his life. The SS was not popular. In return for the information he had provided, would the Americans guarantee him and his family safe passage out of the country?*

POSEY AND KIRSTEIN were desperate with excitement and frustration. According to Bunjes, Alt Aussee contained the best of all the Nazis' stolen paintings and sculptures, the ones expressly intended for Hitler's museum. The treasures had been well cared for in their underground home. Platoons of workmen had built thousands upon thousands of storage shelves, four tiers high in some places. The mine itself was a good repository for art because its temperature and humidity scarcely varied throughout the year. But the Nazis had supposedly given orders that the mountain and all its contents be blown to bits if that was necessary to keep Hitler's possessions out of enemy hands. Alt Aussee had no particular military value, but Posey bombarded the commanders of the Third Army with urgent pleas to race into the Alps and up to the mine.

By the time Kirstein and Posey reached Alt Aussee, American military engineers were already at work defusing explosives. The mine was cold and gloomy, a mysterious kingdom unto itself honeycombed with caverns and guaranteed

* No help was forthcoming. Soon after, Bunjes killed his wife and child and then shot himself.

to disorient outsiders. Historical documents showed that it had been worked since 1310, and presumably for centuries before that. Countless generations of miners had followed one another into the dark, and the American soldiers told one another tales of bent and inbred gnomes laboring with pickaxes and wheelbarrows.

Following a German guide, the two Monuments Men made their way half a mile down a long tunnel. Light from their lamps revealed sticks of dynamite in the walls. The guide stopped at an iron door and opened two padlocks. Kirstein and Posey stepped through the doorway and found themselves inside a cavern.

There they beheld one of the glories of Western art, eight panels of Hubert and Jan van Eyck's *Adoration of the Lamb,* painted some five hundred years before.* The Ghent altarpiece, as it was known, had been near the top of Kirstein and Posey's wish list. Like detectives with "missing person" photographs, the Monuments Men had shoved pictures of the missing altarpiece in front of every stranger in Europe. Months had passed while they chased down rumors that the altarpiece was hidden in a mine, or at Goering's Carin Hall, or in a Berlin bank vault, or in Switzerland or Sweden or Spain. Now here the panels were, unwrapped but unharmed, resting atop four empty cardboard boxes in a cavern beneath a mountain. Kirstein and Posey studied the ancient paintings in the flickering light of their acetylene torches.

In another chamber in the mine the two men found Michelangelo's *Madonna and Child,* an almost life-size statue carved a few years after the *Pietà.* It lay on its side on a brown-and-white-striped mattress, wrapped in a piece of tarpaper. Both the Van Eyck altarpiece and the Michelangelo statue had been stolen from Belgium. The *Madonna*'s trip to Alt Aussee had been especially precarious, with the statue jouncing its way over the mountains in the back of a truck, on a mattress, while Allied bombs meant for German troops fell all around.

* The altarpiece included twelve panels in all. Posey would discover three more panels in another chamber of the salt mine. The twelfth and last panel had been stolen in 1934 and has never been seen since. More accurately, the painting on one side of it has not been seen since 1934. The missing panel is one of eight that was painted on both sides. Immediately after the 1934 robbery, the thief sent the bishop of Ghent a note demanding a ransom of 1 million francs. Along with his ransom note he sent a ticket to a railway station locker. In the locker the police found one side of the missing panel, depicting John the Baptist, but then negotiations fell through. The case, one of the most important in the annals of stolen art, is still open.

The largest and most remote "gallery" in the salt mine contained portions of entire looted collections as well as lone masterpieces. Here were painting upon painting stolen from the Rothschilds in France and from Goudstikker in Holland, among others, and a dizzying miscellany of Titians and Tintorettos and Van Dycks and Rubenses and Rembrandts. Statues and sculptures represented every nation and every historical epoch, from Egyptian tombs to Roman villas and French chateaux. One solitary treasure, acquired in Vienna by Hitler, stood out as perhaps the best of all. This was Vermeer's *Art of Painting*.

Goering was well represented at Alt Aussee, too. In March, fifteen cases packed with art stolen from the Naples museum had arrived at the salt mine. The cases, which contained the gems of a far larger collection, had been carried off by the soldiers of the Hermann Goering Division, an elite Luftwaffe unit. The plan had been to present the works of art—including Titian's *Danaë*, Raphael's *Madonna of Divine Love*, and Brueghel's *Blind Leading the Blind*—to the Reich Marshal as a birthday present.

George Stout, one of the most renowned of the Monuments Men, compiled a list of just how much art the Nazis had stashed in this one hiding place—"6577 paintings, 2300 drawings and watercolors, 954 prints, 137 pieces of sculpture," the tally began. On and on it went. The Alt Aussee find was so immense, and the Monuments Men so overwhelmed with the task of cataloguing it, that the last entry in Stout's list read simply, "283 cases contents completely unknown."

GOERING ON
THE RUN

Goering had begun shipping his treasures from Carin Hall in January 1945, after careful consultation with his chief art consultant. What he could not send away, he buried in trenches scattered around the sprawling grounds of his estate. His silver vanished under the earth, as did much of his wine collection and a marble statue of Venus. To ensure that the hiding places stayed secret, Goering sent the soldiers who had done the digging to the deadly fighting on the Russian front.

The loot that Goering squirreled away underground was, compared with the rest, only bits and pieces. Convoys of trucks loaded with art shuttled from Carin Hall to a nearby railroad station. In the meantime, engineers planted explosives throughout the enormous house, to make sure that when the conquerors arrived they would be deprived of this splendid trophy.

When he was not pondering places to hide his art, Goering turned his attention to military affairs. With the war going badly, he issued a handful of death sentences to German officers for desertion and cowardice under fire. He ordered one Luftwaffe general shot for using military trucks to carry huge quantities of champagne, cigarettes, and coffee to his home in Germany. The condemned man, Goering charged, had even stolen art! "From one private house in Serbia he stole valuable works of art: a watercolor, a carpet, and two vases."

The prizes of Goering's collection filled two private trains outfitted with eleven extra boxcars. Once his trains were safely loaded, Goering shot four bison from his private menagerie (presumably to keep the animals, too, from

enemy hands), signaled for his chauffeur, and drove off. A few hours later, the engineers set off their dynamite charges and Carin Hall exploded into rubble.

By the spring of 1945, Germany lay in ruins. Hitler cowered in his bunker, crazy or close to it, while the Allies marching from the west and the Red Army marching from the east came ever closer to Berlin. On April 23, as rumors and panic spread, Goering sent Hitler a telegram. Unless he received orders to the contrary, "I as your deputy . . . assume immediately total leadership of the Reich." Martin Bormann, Hitler's closest aide and Goering's sworn enemy, screamed to Hitler that Goering was attempting a coup. Bormann sent out two telegrams of his own. The first, in Hitler's name, informed Goering that Hitler, and Hitler alone, remained fully in charge of Nazi Germany. The second, from Bormann to two SS commanders, ordered Goering arrested for treason. The orders were impossible to misinterpret. "YOU WILL BE RESPONSIBLE FOR THIS WITH YOUR LIVES," the telegram read.

Against this backdrop, no one quite knew what had become of Goering's stolen art. Even in quiet times, the logistics would have been complicated—three trains had left Carin Hall headed toward Nuremberg, and another art-filled train had pulled out of Berlin. But as Germany fell apart, so did Goering's plans. The wonder was that Goering's scheme worked as well as it did. "The German army was retreating on all fronts in utter chaos," wrote one historian. "Wounded German soldiers were everywhere. Some were trying to save themselves on horse-pulled wagons. Others, the unlucky ones, remained lying in the mud and snow, dying a slow death where they had fallen because there was not any means of transporting them to safety. In the midst of all this suffering, Goering had commandeered two primary and two secondary trains in full operation for the pleasure of his personal entourage."

In the end, the trains came to rest in the mountain town of Berchtesgaden, Germany, near Salzburg and the Austrian border. Berchtesgaden had long served as a retreat for the top Nazis. Hitler, Goering, and Bormann all had houses there.

Goering had traveled to Berchtesgaden on April 21 to take charge of his art, but the Nazis had arrested him as soon as Bormann sent his telegram. They placed him under house arrest, first in Berchtesgaden, and later in his childhood home, Mauterndorf Castle, where he had grown up fantasizing that he was a medieval warrior.

Then, on April 30, Hitler killed himself. With no one left to forbid it,

Goering ordered his chauffeur to pack the suitcases and prepare for an immediate departure. Goering, his wife, Emmy, and their young daughter climbed into the back of his black Mercedes and off they went. On roads crowded with weary, wounded soldiers, they traveled like royalty. Altogether their entourage numbered seventy-eight; two trucks were jammed full of luggage, each piece bearing Goering's initials, and other trucks carried food and liquor and champagne.

Even with their country devastated, German soldiers cheered Goering when they caught sight of him, whooping approval and rushing over to shake his hand. In one such scrum, the head of a Seventh Army search party, an American soldier named Jerome Shapiro, spotted his man. Lieutenant Shapiro's orders were to bring Goering in alive and unharmed. Pvt. Alfred Frye covered Shapiro with his machine gun. Shapiro stepped out of his Jeep and approached Goering's Mercedes. Goering handed Shapiro his revolver. A week before, Shapiro had been one of the American soldiers who liberated Dachau. Now the Jew from Brooklyn took the Nazi Reich Marshal into custody.

Goering, relieved that it was the Americans rather than the Russians who had found him, offered no resistance. Operating under the delusion that he would soon be meeting with General Eisenhower to negotiate surrender terms, he settled in as if he were not a prisoner but a diplomat.

Goering was a very big fish, but Eisenhower had no intention of bargaining with him. Interrogation began on May 8, the day after the arrest. First, though, the Americans ordered Goering to remove his medals, his diamond ring, his solid gold baton, and his solid gold epaulets.

THE RED ARMY had reached Carin Hall too late, and the Allies had not immediately found Goering's trains and their priceless cargo in the Bavarian Alps. Goering's plan had been to unload his artwork secretly and hide it away, but the local villagers had found the trains first, hidden (unsuccessfully) in a tunnel. Improvising desperately, Goering's curators had managed to unload a considerable stash of art inside a room deep within an air raid bunker; they sealed off the makeshift vault with cement in the hope that it would be overlooked. In the meantime, the trains were under siege. "The whole population seemed to be on their legs fighting to get into the cars," one policeman recalled, "carrying heavy loads, sawing up big carpets, beating and scratching each other in their greed to capture a part of Goering's heritage."

Then the looters found Goering's stores of champagne and wine, a prize far better than carpets and paintings. Grabbing anything they could carry, swigging from upturned bottles, the rioters staggered off with their finds. The Monuments Men had yet to learn of the trains' whereabouts. Goering knew, but he had not told his captors. The Americans had decided to wean him off the morphine he was addicted to, and he was sullen and only fitfully cooperative. Even so, a Monuments Man named James Rorimer—destined one day to become director of the Metropolitan Museum of Art—had primed Goering's interrogators with questions to ask. On the night of May 13, Goering and an officer named Zoller stayed up drinking until one in the morning. Goering's mood improved as the night wore on. The last time he had seen his art, he eventually told Zoller, his train was in a railway tunnel near Berchtesgaden. Zoller relayed the information to Rorimer.

The Americans and the French were already in the vicinity, and the French happened on the looted trains. Not much interested, they sprayed one car with machine gun fire for the sport of it, and moved on. Rorimer directed the Americans to the scene. The men of the 101st Airborne took charge. A lieutenant named Raymond Newkirk turned up rumors of a secret cavern stuffed with art, and a team of engineers managed to find the sealed-off room inside the bunker. There they found crate after crate of paintings. The Germans had flung tapestries on top of the crates to keep off dripping water—priceless artifacts serving as tarpaulins.

The American soldiers collected Goering's art from the bunker and combined those finds with the far larger treasure trove still in the trains. Soon they had converted a three-story "rest center" for railworkers into a makeshift museum. The paintings alone filled forty rooms. Sculptures spilled out into the halls, where they stood almost as close together as commuters on a subway. The exultant Americans mounted a large sign over the door—"Hermann Goering's Art Collection Through the Courtesy of the 101st Airborne Division"—and welcomed their fellow soldiers for a visit.

THE NEST EGG

Maj. Harry Anderson, who put together the 101st Airborne's art exhibition, had heard rumors that some of Goering's most valuable paintings were still with his wife. She was supposedly in the nearby town of Zell am See. Anderson found Emmy Goering holed up in a castle, just as the rumors had said, and indeed in possession of several stolen masterpieces. Anderson, a Monuments Man, confiscated the pictures while Emmy wept at the injustice of it all. The pictures were *her* property, she told Anderson, not her husband's. Anderson told Emmy he had heard rumors that Goering had given her a Vermeer. Where was it? Emmy claimed to have no idea what Anderson was talking about.

Then, as Anderson turned to leave, Goering's longtime attendant and nurse, Christa Gormanns, ran from the room. She returned carrying something bulky inside a blanket. She handed the package to Anderson. Goering "told me to keep this, and I'd never have to worry about money again for the rest of my life."

Anderson pulled back the blanket and found a painting wrapped around a four-foot-long piece of stovepipe. This was Goering's cherished Vermeer, *Christ with the Woman Taken in Adultery*. Anderson hurried back to the rest house to add this new prize to his exhibition. The next day's *New York Times* carried a story on the discovery. "Goering Gave Nurse a $1,000,000 Vermeer," the headline read.

THE AUSTRALIAN WAR correspondent Osmar White was one of the first reporters to visit Major Anderson's impromptu exhibition. Walter Hofer, Goering's art advisor, led White on a tour with all the quiet glee of any proud

collector. "A large bedroom was almost filled with unframed canvases and panels," White recalled. "Hofer shuffled amongst them with gentle haste, peering, tilting, commenting in thick English, his spatulate fingertips exploring the paint anxiously for blemishes." That single room contained *seven* Rubenses, Hofer boasted. He slid one out from behind the others and turned it toward the light. "Ah!" he exclaimed, "is it not superb!"

Hofer continued his tour. He propped up two Boucher nudes that had once adorned Madame Pompadour's bedroom. "Very—what do you say?—hot." Here was a folio of drawings by Dürer, and here were five Rembrandts. Here was a Van Dyck. "Exquisite, no? Ah, what magic in that brush." Hofer rattled on contentedly, full of gossip and good cheer. "Goering knew nothing about art when he started. He just wanted to do the right thing and have a collection like other important men. . . . Goering had really got quite good at it in the end. He developed an almost unerring sense for what was important in art."

Hofer's wife was there, too. "His faded, colorless wife was an expert restorer," wrote Osmar White, "and while I was talking to her, she went imperturbably on with the work of removing a mildew mark from the surface of Vermeer's *Christ with the Woman Taken in Adultery.*"

It was the middle of May, in 1945. It would be two weeks before Han van Meegeren opened his front door to two men who wanted to ask him a few questions. At this point, as far as Maj. Harry Anderson or Walter Hofer or Hofer's wife or Hermann Goering or anyone else knew, *Christ with the Woman Taken in Adultery* was one of Vermeer's greatest achievements.

54

TRAPPED!

After the excitement of the art recoveries came the cleanup, the gigantic task of sorting out what belonged where. The first step involved gathering the loot from enormous recoveries like Goering's and Alt Aussee and countless smaller ones and collecting it at temporary depots. Perhaps never before, reported a stunned visitor to one such improvised warehouse, in Frankfurt, "had such a collection of what men call wealth been under one roof." The haul included billions of dollars in gold bullion, most of Hungary's silver reserves, and an entire room piled to the ceiling with canvas bags crammed with paper money. "There were hogsheads full of precious stones. There were barrels of silver and gold watches, jewelry of every kind, and long 'sausages' of threaded wedding rings stripped from the hands of women in concentration camps."

Goering's paintings and sculptures were transferred to the Central Collecting Point in Munich. *Christ with the Woman Taken in Adultery* was tagged as item number 5295 and readied for its return to Holland. But before the picture ever left Germany, Joop Piller had already come knocking on Van Meegeren's door, asking why his name had turned up in Goering's paperwork.

In the spring of 1945, Piller, the resistance fighter turned detective, had nearly complete authority to do as he wished. Liberation had come to Holland on May 5, 1945—almost five years to the day from the Nazi invasion—but several months would pass before the Dutch government began to run along its customary tracks. In the meantime, a decisive and impulsive man like Piller could impose order according to his own lights.

After years of suffering and bitterness, peace came to Holland amid rumors of "hatchet day," when Dutch patriots would take vengeance on those

countrymen who had collaborated with the Germans. The forecasts proved too dire—in Holland, retaliation more often took the form of shaved heads and beatings than lynchings or shootings—but collaboration remained a huge, angry issue. A generation later, Germans would ask, "What did you do in the war, Daddy?" In Holland, everyone asked the question immediately. Before a Dutch policeman could return to work, for instance, he had to demonstrate to an official tribunal that his wartime record was clean. In the meantime, the provisional government had charged the so-called Militair Gezag, the military authority, with keeping the peace. Piller was a captain in the Field Security unit. Essentially on his own say-so, he took on the task of investigating collaborators and looted property.

Some 120,000 Dutch collaborators would eventually be tried and imprisoned. Piller stood in the front hall of Han van Meegeren's mansion only three weeks after VE-Day. While many of his countrymen had starved, Van Meegeren had managed to thrive. Moreover, he had somehow gotten mixed up in Hermann Goering's affairs. In May 1945, in Holland, that was more than enough to bring a policeman calling.

But if not for a bad break, Piller might never have heard of Van Meegeren. After Van Meegeren's greatest coup, the sale of *Christ at Emmaus* in 1937, he had sold seven more forgeries. In each case, he had stayed safely out of sight while a middleman did the actual work of showing and selling his "De Hoochs" and "Vermeers." The first middleman, the ex-politician named G. A. Boon, had brought *Emmaus* to Bredius. Boon played a similar role with one more forgery, this one a "De Hooch," and then moved out of Van Meegeren's life. Next came several acquaintances of Van Meegeren's notable only for their ignorance of art and their willingness to take on a high-paying job without asking any questions.

Boon's first successor was a real estate agent named Rens Strijbis. Together he and Van Meegeren sold four forgeries, a De Hooch and three Vermeers, in 1941 and 1942. Then, for his next Vermeer, *Christ with the Woman Taken in Adultery*, Van Meegeren turned to a new go-between. He never explained his reasoning. Perhaps he simply felt that four sales in little more than a year, all supposedly from the same hoard of paintings, was too much. In any event, Van Meegeren settled on a disreputable Amsterdam businessman and sometime art dealer named P. J. Rienstra van Stuyvesande. The decision would ruin him.

Van Meegeren and Rienstra were friends of a sort—Van Meegeren had

bought his grand Amsterdam house through Rienstra—but they were not close. Among Rienstra's many acquaintances was the shady but well-connected art dealer Alois Miedl. A character out of *Casablanca*, Miedl was the friend of Goering's who had a Jewish wife. Miedl claimed later that he had secretly supported the Resistance throughout the war. In occupied Holland little was black or white, but in the gray area between trading with the Nazis out of necessity on the one hand and collaborating with them out of sheer greed on the other, Miedl occupied a place in the dark gray range of the spectrum. In 1940, as discussed earlier, one of Amsterdam's most prominent art dealers, Jacques Goudstikker, had fled Holland ahead of the Nazis only to die in an accident at sea. At the end of a tangled and dubious negotiation, Miedl ended up as the owner of the Goudstikker dealership and its hugely valuable collection.

In 1943, Van Meegeren told Rienstra about an extraordinary painting he'd come across, a Vermeer called *Christ with the Woman Taken in Adultery*, and he spun his usual story about how his involvement had to be kept secret. Rienstra brought the painting to Miedl, and Miedl whisked it off to show Goering. The Reich Marshal couldn't make up his mind. He coveted the painting (and kept it on display at Carin Hall for months) but balked at the $10-million asking price. While Goering procrastinated, Rienstra asked around in the art world about his new partner, Van Meegeren. What had people heard?

Nothing good, as it turned out. Rienstra was "stunned" to hear that Van Meegeren tumbled from one drinking bout to the next, with fits of delirium in between. A painter named Max Rauta passed along rumors that in the twenties Van Meegeren had been mixed up in a scandal to do with Frans Hals forgeries. Rienstra told Van Meegeren he was done with him.

That left Van Meegeren in a fix. If Rienstra had still been in possession of *Adultery*, Van Meegeren could simply have taken the picture back and looked for another middleman. But with the painting in Goering's hands, and with millions at stake, Van Meegeren had no choice but to deal with Miedl directly. To get his money he would have to step out of the shadows.

When Goering and Miedl finally hatched a deal for *Adultery*—Goering traded 137 paintings from his collection for this lone masterpiece—Van Meegeren's name was on the paperwork. Most forgers are finally caught, one scholar has written, because they fool one person too few. Van Meegeren's misfortune was that he fooled one person too many.

55

"I PAINTED
IT MYSELF!"

Joop Piller had settled on the most fitting quarters imaginable for an investigation squad specializing in looted property. Piller had moved into the sumptuous art dealership at 458 Herengracht, the building that had belonged to Goudstikker and then, after the Jewish dealer fled Holland, to Miedl. Goudstikker's building had managed to retain its grandeur through the occupation years. The marble staircase was undamaged, as were the carpets and the antique furniture and the satin wall linings. Many of the prize paintings had vanished, but the walls in every room still boasted gilt frames and venerable works of art. The best room, with a bay window overlooking a garden, had served in its day as an office for Jacques Goudstikker and then Alois Miedl. Now Piller took it over.

Piller was on Van Meegeren's trail in no time. It was almost inevitable: Piller had set to work in premises once run by Miedl; Van Meegeren and Miedl had been in cahoots; Miedl had kept impeccable records. (Piller could not interview Miedl, who had vanished as soon as the war ended.) Piller and Van Meegeren, unknown to each other, were practically neighbors. From Piller's office to Van Meegeren's home was a walk of less than half a mile along some of the handsomest canals in Amsterdam.

From the start, Piller's interest in Van Meegeren had more to do with collaboration than with art. Van Meegeren lived in style, and he had no obvious means of support. How had he managed it? Operating with virtual carte blanche, Piller set off to find out. Van Meegeren didn't help his cause by sticking to his usual vague story about where his Vermeer had come

from. A well-off family fallen on hard times had enlisted his help. The family's name, please? Their connection with you? Your connection with Goering?

To his infinite regret, Van Meegeren said, he was unable to provide more help. He had promised confidentiality to the family that owned the painting, and a promise was a promise. He had nothing to do with Germany or Goering. How the painting had ended up in Goering's hands he had no idea. Piller suggested that Van Meegeren think harder.

Piller returned a few days later to ask the same questions more urgently, and Van Meegeren delivered the same non-answers. On his own say-so, Piller arrested Van Meegeren and tossed him in a prison cell in the hope of jogging his memory. Convinced that Van Meegeren had been up to something ugly and illegal during the war years—perhaps dealing in property stolen from Jewish families—Piller and his men searched Van Meegeren's house. Nothing at first, and then someone thought to pry up the floorboards. They quickly found hoards of jewelry and great bundles of cash. Where had all this come from? Van Meegeren refused to say.

But Piller held all the cards. Snatched without warning from a mansion and flung into a jail cell, deprived of the cigarettes and sleeping pills and morphine he had come to rely on, and dependent on the whim of a cop with a free hand, Van Meegeren was in real trouble. If he had indeed gotten hold of a treasure that belonged to the Dutch people and sold it, in wartime, to a mortal enemy of the state—and Hermann Goering was the man who had rained bombs down on Rotterdam—then he was guilty of treason. The penalty for treason was death.

Piller, who was both a Jew and a resistance fighter, had every reason to despise Van Meegeren. Remarkably, though, the two men struck up a kind of friendship. Van Meegeren was a good talker, and Piller had endless questions about his wartime activities. Policeman and prisoner spent hours together in a way that would have been impossible in ordinary times. Piller would fetch Van Meegeren from his jail cell and the two men would walk the city streets, or Piller would bring Van Meegeren with him to his weekend cottage on a lake near Amsterdam. Piller's aim was partly to break Van Meegeren and find out what he was concealing, but he genuinely found Van Meegeren intriguing, too. Who was this complicated man?

In the course of these long conversations, Piller returned again and again to the question of finances. Van Meegeren was clearly that rare thing, an artist

with no financial worries. Where had the money come from? Piller would re-
call, years later, that Van Meegeren told him he had spent the better part of
1944 in nightclubs. "But what sort of nightclubs were open in Amsterdam in
1944?" Piller would ask. "Nightclubs frequented by the Germans, by the army
or the SS, not by ordinary Dutch citizens. In the first place, ordinary Dutch
citizens didn't have any money to spend. The only Dutch citizens who were
there were automatically suspect. But *he* was there every day and every
night!"

Piller had unimpeachable testimony that Van Meegeren not only had
Dutch Nazi friends but had himself been in and out of the main office of the
SS in the heart of Amsterdam. For six weeks, Piller pressed Van Meegeren for
an explanation, without result. But every lead bolstered the investigator's sus-
picions. He found that Van Meegeren had published a lavish book of draw-
ings, in 1942, with oversize pages as thick as bath towels. At the time paper
was in such short supply that even Dutch newspapers had been forced to grow
ever thinner and to shrink their pages. (Few people in 1942 had time for art
books. If they had, they would have seen immediately that the sad, heavy-
lidded figures in Van Meegeren's drawings looked identical to the Christ in
"Vermeer's" *Emmaus*.)

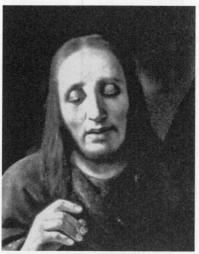

Museum Boymans–van Beuningen, Rotterdam Teekeningen I, 1942

Left, Van Meegeren's *Christ at Emmaus,* detail; *right,* Van Meegeren's *Mother and Children,*
detail

Who produced luxury goods in a time of nearly universal misery? And what of the book itself? Its cover was black and red—the Nazi colors—and Van Meegeren's drawings were accompanied by the poems of a notorious Dutch Nazi named Martien Beversluis.

On July 11, 1945, a Dutch reporter in bombed-out Berlin added a curious sidebar to his story. He had wandered into Hitler's private library in the once-grand Reich Chancellery, the seat of government. There he happened to see Van Meegeren's book. Inside was a handwritten dedication: "To the beloved Fuehrer in grateful tribute." Below the dedication Han van Meegeren had signed his name.

The next day, in the midst of yet another cat-and-mouse interrogation, Van Meegeren cracked. After one question too many from Piller and two colleagues, he burst out with an indignant cry. "Idiots!" he yelled. "You think I sold a Vermeer to that fat Goering. But it's not a Vermeer. I painted it myself!"

Piller rejected the ludicrous claim at once. Treason meant death. Forgery meant a fine or a brief jail sentence. A desperate man would say anything.

The timing of this astonishing confession was not coincidence, for Van Meegeren had no choice. Even the suspicion of a link to Goering was bad; the revelation of a link to *Hitler* was disastrous. Across Holland low-level collaborationists and Nazi sympathizers had been beaten by mobs and pummeled with rocks and thrown into prison. What would be the fate of someone in a position to send inscribed gifts to the Fuehrer? Only by detonating a bombshell could Van Meegeren shift attention away from his Nazi sympathies.

Van Meegeren talked vehemently and, it seemed, indignantly. For weeks he had responded to every question about Goering with vagueness and double talk. Now, for the first time, he spoke in specifics. *Of course* he could prove what he was saying. He'd painted the Goering picture on top of an old painting that he hadn't even bothered to scrape off. He took a piece of paper and sketched a battle scene with soldiers and horses. All Piller's crew had to do was X-ray Goering's "Vermeer"—Van Meegeren indicated a position next to Christ's raised hand—and they'd see the battlefield beneath it.

Piller gawked. Wound up now, Van Meegeren plunged on. "I painted other Vermeers, too, and a couple of De Hoochs. And Vermeer's *Emmaus* in the Boymans—it's mine, too!" By the time he was done, Van Meegeren claimed to have sold *eight* old master forgeries to Holland's best museums and wealthiest collectors. He rattled off names—the Boymans, the Rijksmuseum, Ver-

meer, De Hooch. All this was completely out of the blue. None of his questioners had ever mentioned a word about any picture except *Adultery*. As far as Piller knew, no one had ever said anything about any of the eight paintings being fakes. All were multimillion-dollar trophies, and *Emmaus* was a world-renowned masterpiece.

Piller had learned from informants that Van Meegeren had been mixed up in the sales of hugely expensive old masters, but Piller's focus had been on where the paintings had come from, not on whether they were genuine. Van Meegeren's bizarre claims made him less believable, not more, as if a man brought in for picking pockets had confessed to robbing Fort Knox.

Piller and his two partners staggered back from Van Meegeren's jail cell to their office. Sixty years later, a woman who worked as a secretary in Piller's office still recalled the bewilderment of the three men as they tried to sort out what they had heard. They debated among themselves for hours. Was Van Meegeren's story a confession? A joke? A desperate lie? *Could* it be true?

PILLER MADE A characteristically bold decision. He ordered Van Meegeren moved out of his jail cell and into Goudstikker's building, with him. Piller and his men would gather up as many of the supposed forgeries as they could put their hands on and go over them with Van Meegeren, inch by inch if necessary, and get to the bottom of this forgery business. Piller set aside a room in the top floor of the art dealership for Van Meegeren. Someone fetched a few of Van Meegeren's favorite pictures from his home—the most striking was a portrait of his wife in a long blue dress—and hung them on the walls. Piller had a bed for Van Meegeren put in a corner of the room.

House arrest in such plush conditions was a vast improvement over a prison cell, and soon everyone had grown accustomed to the sight of the small, worn man padding around in his slippers, a cigarette perpetually tucked in his mouth. The secretaries liked Van Meegeren for his good manners and his friendly little jokes, but in the first days after his confession his most important colleagues were a pair of outsiders. These were two highly regarded scientists—a Dutch chemist named Froentjes and a Belgian chemist named Coremans. With the aid of a small X-ray machine of the sort a dentist might use, they looked beneath the surface of several of the old masters that Van Meegeren claimed were really his work. Van Meegeren, whose memory had been so shaky in the weeks after his arrest, now proved the most willing

of guides. The three men huddled close together, cops and crook working as partners. Van Meegeren made sketches of the pictures he had painted over, to show the scientists how to prove his guilt.

The show-and-tell continued. Piller sent for Van Meegeren's paints and brushes, and Van Meegeren told the scientists his secrets. He explained how he ground his pigments, how he baked the pictures in an oven, how he formulated his Bakelite paints. Outside the confines of the art dealership at 458 Herengracht, the world had no idea of any of this. Van Meegeren had been arrested weeks before, but the police had not been involved, nor had anyone in the Department of Justice. Nor had Piller chosen, in the intervening weeks, to give any law official or anyone in the art world even a hint of where his investigation was heading.

In his own way Piller was as much a showman as Van Meegeren. He had come to know a handful of reporters in Amsterdam. Within days of Van Meegeren's confession he handed them an amazing story. This was as far as could be from the formal press conferences we know today, with a bouquet of microphones at a lectern and stacks of carefully edited press releases. Instead, Piller assembled a small group of journalists, including one who worked for the Dutch news agency ANP, and told them he had found something newsworthy. They might be interested to know that he had uncovered the greatest art hoax of modern times.

Piller appeared by himself, without Van Meegeren, but the forger had prepared a careful statement. As brilliantly manipulative as ever, he had devised a story tailored for his audience. Years before, he had seduced Boon, a liberal politician, with a tale about helping a family escape from fascism. Now, with Holland furious at its collaborationists, he chose not to defend his pro-German record but to skip over it altogether. Not a word about Nazis, then, but instead a simple story of a little man who had been done wrong. Van Meegeren was an underdog, he claimed, and he'd never wanted anything but the respect and recognition that had always eluded him. "One unlucky day," his statement read, "driven half mad by frustration, I determined to avenge myself on the critics by proving that they had underestimated me."

"*Emmaus* in Boymans a Forgery," screamed the headline in *Het Parool* on July 17, and a subheadline added the stunning information that "Several Vermeers Are Fakes." ANP's coverage spread the word everywhere, and newspapers and magazines around the world picked up the story and added their own shocking details. "One Vermeer After Another," announced *De Nieuwe Dag*. "A

Forger of Genius." Nearly every story found room to mention that, by Van Meegeren's reckoning, his forgeries had earned him 8 million guilders, about $30 million in today's dollars.

The news was sensational, but reporters treated the affair as a mystery that had yet to be resolved. They larded their stories with doubts about Van Meegeren's claims. *Time*'s coverage was typical. *Christ at Emmaus* was an "exquisite" painting that had been "authenticated by impeccable Dutch art experts." Van Meegeren, on the other hand, had no one to vouch for him. "One official of the Rotterdam Museum has a theory of his own," *Time* noted, and the magazine seemed inclined to agree with its unnamed source (who was almost certainly Hannema). "Van Meegeren may be a muddy-minded fantasist with a grudge against museums."

For years, Van Meegeren had lied to the world, and it had fallen for every lie. Now he had told the truth, and no one believed a word of it.

COMMAND PERFORMANCE

Piller harbored doubts, too, despite what he had told the reporters. Van Meegeren had every incentive to make up a story to save his hide. Forgery, after all . . . what prosecutor could be bothered? But treason!

Piller agreed that *someone* had forged the disputed Vermeers, he told friends years later, but how did he know that Van Meegeren was the forger? He was hardly a sterling character, after all. Maybe Van Meegeren could talk so convincingly about forgeries because he moved in the same circles as a forger or two. And why was it, Piller wanted to know, that *Emmaus* was so much better a painting than the five forged Vermeers that followed it? Van Meegeren claimed he had painted them all. But how could the same person have painted a masterpiece like *Emmaus* and then a series of awful, awkward follow-ups?

The easiest answer was that, after *Emmaus*'s stunning success, Van Meegeren had coasted on his reputation. Piller didn't quite buy it. But the most conspicuous hole in Van Meegeren's story, in Piller's view, was that no one had ever *seen* him at work. That seemed awfully convenient. How did anyone know Van Meegeren was a forger? Because he said so. Piller had Van Meegeren's word to go by and the opinions of some scientists, but nothing he could put his hands on.

Piller decided to put Van Meegeren to the test. If he had painted Vermeers before, he could do so again. While Van Meegeren rounded up a blank canvas and his paints and brushes, Piller occupied himself with logistics. This time there would be witnesses. Van Meegeren would paint while guards watched over his shoulders. By now, journalists were everywhere, and both the press

and the public thrilled to the idea that the collaboration charge could be re-
solved so dramatically. "He Paints For His Life," one newspaper headline
proclaimed.

IT WAS NOT an idea anyone in the art world would have come up with. Ev-
eryone agreed, after all, that Van Meegeren was a competent painter who
knew perfectly well what the disputed paintings looked like. In every art mu-
seum, painters set up their easels in front of their favorite pictures and try to
copy them. What would it prove if Van Meegeren did something similar?

But this was Piller's call. He knew that, in the end, proof would come
down to complicated technical questions that had to do with such things as
the chemical analysis of paint samples, but to settle his own mind he wanted
something more concrete. He wanted to see whether Van Meegeren could cre-
ate, from scratch, a painting like those that had bewitched the aesthetes of the
art world and the brute who headed the Luftwaffe.

In his attic studio at Goudstikker's, Van Meegeren happily set to work on
yet another biblical scene. He painted "under the constant supervision of six
silent men," one newspaper reporter declared, but that was an exaggeration.
Usually two guards stood watching, and the mood was not austere. Van
Meegeren had always had a performer's love of the spotlight. That had been a
hardship in a profession that demanded secrecy, but now he had a chance to
show off on a world stage.

At first Piller tried to keep visitors away, but it soon became clear that there
was no need for rigorous security. The point was to see what kind of painting
Van Meegeren could produce; there was no reason to make his working con-
ditions unpleasant. In any case, the end of occupation had lifted everyone's
spirits, and the mood inside 458 Herengracht was informal and cheery. When
Van Meegeren needed to get the folds of a cloak right, one of the secretaries
gladly posed for him.

Once they talked their way inside, journalists and photographers and the
merely curious wandered upstairs to see the little man who had created all the
fuss. He seemed small and tired, but he retained the good manners that had
drawn clients to him in his days as a society painter. One particularly enter-
prising reporter even managed to wangle an off-the-premises interview, in a
café.

"He is a simple, rather small man with gray hair and sharply cut features,
always ready for a drink and a chat," the writer noted with relief. "So much so

that when chatting and drinking with him, one wonders which of the two he likes best." Van Meegeren had nothing in common with "one of these important-looking bragging artists... who make everybody who isn't an insider feel like a blundering yokel."

The reporter asked admiringly about rumors that an American millionaire had offered to buy *all* the forgeries for eight million dollars (about $80 million today). The tone of the interview, which came three months after the story broke, reflected an important shift in the public mood. Many of the first news stories had spilled over with rage. Van Meegeren's painting career hadn't won him much attention, but during the occupation he'd made friends in all the wrong places, and the Dutch *had* noticed that. "Forgery of Paintings Discovered," read the July 17, 1945, headline in *De Waarheid*. "Han van Meegeren, Swindler and Nazi."

But by the time the café interview appeared, much of the anger seemed to have drained away. (Van Meegeren had managed to create enough confusion about the Hitler dedication to dampen down that controversy. His story was that he had signed many copies of his book; someone else, perhaps a "German officer," must have added a dedication and given Hitler the book.) In more recent news stories Van Meegeren came across as a rogue, not a villain, an ordinary man who had punctured the pomposity of the big shots. If he had sold a forgery to Goering, it was hardly a crime to have outwitted the biggest stuffed shirt of them all. "Well, I have seen the paintings and I have had a drink or two with the painter—and I like him," wrote the reporter who had met Van Meegeren at a café. "And I wonder if eight million dollars—if he would really get them—could possibly make a more charming man of him than he is now."

FOR HIS LAST "Vermeer," Van Meegeren chose a religious subject, *Jesus Teaching in the Temple*. Like several of its predecessors, the painting was on a grand scale, roughly five feet by six feet. This time Van Meegeren painted Jesus as young and rosy-cheeked, with a kind of overdone earnestness that calls to mind a middle-school valedictorian. Jesus is bathed in light and clothed in a blue robe just like the one in Goering's picture. He holds a Bible open in front of him—this was a little joke on Van Meegeren's part—while six robed figures, three on each side, look on.

The painting took two months to complete, and most of Van Meegeren's visitors seemed quite taken with it. "Experts have hailed the picture as mag-

nificent in parts," *The Illustrated London News* reported, "not only as giving the colour scheme of *Christ at Emmaus*, but as containing something of the serenity of Vermeer's works. . . . The face of Jesus—portrayed from memory of a woman's face—has a certain serenity, found also in Van Meegeren's other works." The inclusion of the Bible, the *News* wrote, would "prevent the picture being taken for a Vermeer in the future."

More important, *Jesus Teaching in the Temple* certainly looked like a Van Meegeren. The resemblance to Goering's *Christ with the Woman Taken in Adultery* was especially strong. In the topsy-turvy world in which Van Meegeren found himself—where the only way he could convince the authorities he was telling the truth was to demonstrate that he was a liar and a cheat—this was all to the good. Suddenly the similarity among all the suspect Vermeers told a new story. When everyone had thought that *Emmaus* was by Vermeer, people had looked at the rest of the new "Vermeers" and compared them with *Emmaus*, the first in line. If Vermeer had painted the first, and if all the others looked like that one, it stood to reason that Vermeer had painted them all.

But now, because of Piller's experiment, people looked at the string of "Vermeers" and concentrated not on the first picture in line, *Emmaus*, but on the last, *Jesus Teaching in the Temple*. Since Van Meegeren had indisputably painted it, and since all the others looked like that one, it stood to reason Van Meegeren had painted them all.

This was not proof, but it was a psychological turning point. Proof would come quickly enough. Van Meegeren made it easy. This was a chase where the fugitive wanted to be caught. With the completion of *Jesus Teaching in the Temple*, around September 1945, Piller had done his part. Now he handed the case over to a team of official investigators working for the Dutch Ministry of Justice.

THE EVIDENCE
PILES UP

Van Meegeren had nothing but disdain for the art connoisseurs and critics he had led astray. But he seemed fascinated by the scientists now on his trail and dazzled by the technological arsenal they could draw on. As a young boy growing up in a small town, he had once created a ruckus by locking the door to the police station (from the outside) and throwing away the key, or so he claimed. Then he had looked on with glee while the policemen rattled the door in frustration and finally resorted to climbing out the windows. Now, in similar fashion, Van Meegeren delighted at the trouble he had stirred up. Here were the scientists with their microscopes and magnifying glasses, their X-ray and ultraviolet and infrared photographs, their talk of spectographic analysis and partial solubility, the whole circus set in motion by his own mischievous enterprise.

The team investigating Van Meegeren numbered seven in all, five scientists and two art historians. The chairman was P. B. Coremans, director of the Central Laboratory of Belgian Museums. Coremans had met Van Meegeren already, at Goudstikker's, where he had studied his forgeries with a dentist's X-ray machine. That had been an informal probe, at Piller's request. This was an official inquest, charged with answering two questions: did the Vermeers and De Hoochs that Van Meegeren claimed to have painted date from the twentieth century or the seventeenth? If the paintings were modern, was it Van Meegeren who had painted them?

Coremans's team was sworn in on June 11, 1946. One group in The Hague and a second in Brussels settled down to a series of painstaking chemical in-

vestigations. First they looked into Van Meegeren's Bakelite story. Knowing what they were looking for, the chemists soon confirmed that Van Meegeren had been telling the truth. The tests were technically difficult, and since no forger before Van Meegeren had ever thought of this particular trick, investigators on their own might have been slow to find him out. But the results were definitive.

The analysis was worth all the trouble, because the ingredients that make up Bakelite could not possibly belong in a genuine seventeenth-century painting. Further tests would merely confirm what the presence of Bakelite had already proved. And so they did. Van Meegeren had bragged to the investigators about how he had used India ink to simulate grime in his pictures' craquelure, for instance, and the scientists soon verified his account.

Occasionally, they found signs of fraud even without Van Meegeren's help. In Goering's forgery, for instance, the blue in Jesus's robe proved to be cobalt blue, which was first used in the nineteenth century. Vermeer would have used ultramarine, as Van Meegeren had in *Emmaus*. In this late forgery, he had taken the easier, cheaper route, though no one noticed this until after his confession. Tellingly, too, the cobalt blue turned up in the original layer of paint rather than in a surface layer. That ruled out the usual forger's alibi, which is to blame a restorer for the presence of modern paint in an ancient painting.

Detective work of a more conventional sort provided still further proof of Van Meegeren's guilt. On a trip to Van Meegeren's long abandoned villa in Nice, in 1945, a Justice Department inspector named Wooning found all the signs of what had plainly been a forger's workshop. Inspector Wooning found the four "test" forgeries—two Vermeers, a Hals, and a Ter Borch—that Van Meegeren had completed but never tried to sell. He found seventeenth-century drinking glasses, plates, and a pitcher, as well as an ancient map hanging on a wall, all of which Van Meegeren had depicted in his forgeries. He found the makings for a new batch of Bakelite paint. He found one of the pieces of wood that Van Meegeren had cut down to make a new stretcher for *Emmaus*.

This ordinary-looking scrap of wood was especially significant because it tied Van Meegeren, as opposed to some other forger, to *Emmaus*, the one fake that towered above the others. As we have seen, Van Meegeren had painted *Emmaus* on the canvas from a larger picture called *The Raising of Lazarus*. He had taken the wooden stretcher from *Lazarus*, cut it down to the right size for *Emmaus*, and tossed aside the leftover bit of wood. By happenstance the restorers

at the Boymans had not replaced Van Meegeren's stretcher with a new one. That made it easy to see if the wooden stretcher from *Emmaus* matched the sawed-off length of wood Inspector Wooning had found in Nice.

The lines that formed the grain of one piece of wood exactly matched the grain of the other piece. As a bonus, it turned out that in shortening the *Lazarus* stretcher, Van Meegeren happened to saw through a wormhole in the wood. Back in Holland, the investigators looked at *Emmaus*'s stretcher and Inspector Wooning's piece of wood. At the end of each piece of wood was a wormhole sawed in half. The two halves matched exactly.

Why hadn't Van Meegeren thrown away so incriminating a piece of evidence? He had kept it, he said, precisely so that he could prove beyond question that *Emmaus* was his work. And perhaps that had once been his intent. But if Van Meegeren had truly wanted to tell the world that he had painted *Emmaus*, he had missed chance after chance. Why wouldn't he have announced his role in 1938, for instance, when the painting was the unrivaled star of the Boymans exhibition and the toast of the art world? (For that matter, why would he have chosen to prove himself with something as mundane as a piece of wood? It would have been perfectly easy to rig a camera to snap a picture of himself painting *Emmaus*.)

Van Meegeren had always had a choice—he could step out from the wings and onto center stage and win fame, or he could stay out of sight but rich. He had made his choice.

In that case, why had he kept the telltale piece of wood in his studio? The painter and Van Meegeren scholar Diederik Kraaijpoel suggests a simple answer: "I think it was just slovenliness," he says. "In every painter's studio, including mine, you find amazing amounts of rubbish lying around: ancient newspapers, pieces of cardboard, dried-out tubes of paint, ends of tape, half-empty pots of glue, stiffened rags, you name it. We don't throw it away because we think that maybe someday we'll find a use for it. But we never do. As far as I know, Van Meegeren never mentioned this beautiful proof of his genius. I think he just forgot about it."

In the case of one forgery, *The Last Supper*, the scientists' findings and the conventional police-style investigation converged. This was the enormous canvas—at roughly six feet by eight feet, the biggest Van Meegeren ever painted—for which Van Beuningen paid $8.6 million in today's dollars. When scientists X-rayed the picture, they found another picture beneath the biblical scene. In some places the newly discovered painting was remarkably

clear. In the foreground, for instance, a dog sniffed inquisitively at a game bird lying on the ground, where a hunter had presumably dropped it. The scene exactly matched one from a painting by the seventeenth-century Dutch painter Abraham Hondius. Van Meegeren claimed to have bought that very painting from Douwes Brothers, an art gallery in Amsterdam, and a quick search of the sales records at the gallery confirmed his story.

Jan J. van Waning, Rotterdam
Hondius, *Hunting Scene*

Vermeer and Hondius were contemporaries, so in theory Vermeer might have painted a picture on top of a Hondius. But certainly he had not painted over *this* Hondius, because the gallery's records (complete with a photograph of the painting) proved that Van Meegeren had purchased it on May 29, 1940.

By March 1947, the Coremans commission had proved beyond any doubt that Van Meegeren's tale was true. He had indeed forged the "Vermeer" he sold Goering, and all the others. He could not be accused of selling off Holland's heritage since he had not enriched Goering but had cheated him out of millions. The collaboration charge was dropped. Van Meegeren would go to trial, but only for fraud.

58

<center>———◆———</center>

THE TRIAL

In many ways Han van Meegeren's day in court was the greatest of his life. He had been praised in public before, as a young man just finishing college when he won a gold medal for a drawing of a church interior, and far more dramatically when the Boymans unveiled *Emmaus*. But the gold medal prize had been a local affair, and in 1938 Van Meegeren never had the chance to step forward and bow to all those applauding *Emmaus*.

The trial date was October 29, 1947, and a crowd had gathered outside the Palace of Justice long before the doors opened at 9:45. The day before, a van under close police guard had pulled up to the courthouse late in the afternoon. Then a team of armed uniformed men had unloaded Van Meegeren's forgeries as if they were delivering a fortune in cash from an armored car. Over the course of ninety minutes, while the Rijksmuseum's chief curator supervised, the paintings were hung in place. Finally, with the courtroom transformed, forty guards settled in for the night.

On the morning of the twenty-ninth, Van Meegeren walked to court, the better to prolong his time in the spotlight. A gaggle of eager reporters scribbled down the forger's bon mots. Photographers snapped off picture after picture, and a newsreel cameraman recorded the stroll for posterity.

The press had been admitted to the courtroom an hour early and had spent much of that time gazing at the forgeries and staking out their territory. Photographers shoved against one another, fighting for a clear shot when Van Meegeren finally arrived. The judge had decided to permit newsreel filming inside the courtroom, too, which made for more cameramen and more jockeying. The world's press had turned up, and the locals gawked at the international stars. Over there, in the fur collar and green glasses, that's Charles

Wertenbaker. *Time*'s star had come up from Paris. When Wertenbaker whispered to a neighbor that the trial was "big stuff," Dutch reporters beamed and jotted the words down in their notebooks. (Wertenbaker's presence was itself a sign of Van Meegeren's celebrity. Wertenbaker had covered the previous year's most notorious trial, the case of a French serial killer named Marcel Petiot, who had thrived during the war. Petiot had promised desperate men and women that he could smuggle them out of France to safety and then killed them, some twenty-six in all.)

At five minutes after ten, Van Meegeren entered the courtroom. The sound of scores of cameras in near unison, one reporter wrote, called to mind machine gun fire. Van Meegeren wore a dark blue suit and black glasses that seemed more prop than necessity. He had taken considerable care with his appearance, but his friends noted that he seemed even thinner than usual, almost frail. He was fifty-eight but looked older.

The forger scanned the room with his glasses on, while the cameras whirred and clicked, and then with his glasses off, as if at a fashion shoot. Then another survey with glasses on, and another with glasses off. He took a long moment to remove a piece of lint from his suit, as if this operation required all his concentration, and then turned his attention back to the overflowing courtroom. Finally he took his seat, flanked by two large policemen.

The judge and lawyers wore imposing black robes, but the dark paneled courtroom itself had little of its usual solemnity. Extra chairs had been added, and every seat was taken. The balcony was filled. A tall blank screen and a projector stood conspicuously in the center of the room, to help Coremans explain his scientific findings. A portrait of the queen occupied its customary place on the wall behind the judge, but today that small picture seemed pale and dreary in comparison with its two huge and gleaming neighbors, *Christ at Emmaus* and *The Last Supper*.

A *New York Times* reporter noted that the paintings on display "would have been the delight of any museum a few years ago," and Van Meegeren no doubt exulted in the same thought. But of course no museum had ever put together an exhibit like this one in the courthouse on Prinsengracht, and Van Meegeren took the time to savor it.

Eight of his paintings lined the room. Two were "De Hooch" interiors, the other six "Vermeer" biblical scenes. Here was *Christ with the Woman Taken in Adultery*, which had snookered Goering, and *Isaac Blessing Jacob* and the other masterpieces that Van Beuningen and Van der Vorm had paid millions for,

and *The Washing of Christ's Feet*, purchased by the Dutch state for the Rijks-museum, also for millions. The only picture that had not cost someone a fortune was the newest of all, *Jesus Teaching in the Temple*, painted under Piller's supervision. "As the cameras clicked and the flashbulbs popped, the painter admired his own paintings," one reporter wrote. "Never before had anyone here attracted so much publicity."

WHEN THE COMMOTION finally died down, the judge declared court in session. The prosecutor read the charges against Van Meegeren. He had obtained money by fraud, and he had signed paintings "Vermeer" and "De Hooch" in order to defraud buyers. (To copy a painting is no crime; the students in art museums are perfectly within their rights even if they go so far as to copy the artist's signature. The trouble comes at the moment of *selling* the picture by misrepresenting it as an original.)

The judge turned to Van Meegeren. "Do you admit the charges?"

"I do."

He not only admitted the charges but wallowed in them. For Van Meegeren and the two hundred spectators squeezed into courtroom 4, no prospect could be more inviting than a close-up look at just which experts had showered praise on which forgeries and which millionaires had dipped deep into their pockets.

For everyone else, the only goal was to wrap things up as quickly as possible. Van Meegeren had already admitted his guilt, so the prosecution had no reason to belabor its case. Van Meegeren's own lawyer wanted to keep the trial focused as narrowly as possible, for fear of exposing his client to dangerous questions about collaboration. Van Meegeren's many victims—museum directors, art dealers, critics, scholars, and collectors—cringed at the thought of rehashing their gullibility in public. The Dutch state, though it was prosecuting the case, was one of those mortified buyers. An examination of *that* purchase promised to be humiliating. So the order of the day was to proceed in a businesslike fashion and, as quickly as was decently possible, wrap up the whole fiasco.

The trial began with a scientific presentation by Coremans, featuring a slide show. The room was darkened. Dust danced in the projector's beam. Coremans took a seat near the screen. "Welcome to Cinema Prinsengracht," one reporter whispered.

Coremans laid out the whole story—craquelure, Bakelite, X-rays, Inspector

Wooning and the wormhole. Van Meegeren sat enthralled. It took half an hour. The judge asked Van Meegeren if he agreed with Coremans's conclusions. "Outstanding work, your honor, very well done. I find this research extraordinarily clever. Almost more clever than the painting of *Emmaus* itself."

Next came a string of witnesses to testify to Van Meegeren's sales technique. First was Piller, who testified about his long interviews during the weeks he had held Van Meegeren under house arrest. The court had a question. Why had Captain Piller kept Van Meegeren as a kind of private prisoner when he could immediately have turned him over to the Department of Justice? "Because it took me quite a while to find out who at Justice had been correct or incorrect in the years past," Piller said, in a deliberately unsubtle allusion to Holland's many collaborators and German sympathizers. "Your Honor, I can assure you, that was not an easy task." *No further questions.*

Strijbis, the real estate agent who had followed Boon as Van Meegeren's middleman, took the stand next. He knew nothing about art, he testified, and he told the court that when Van Meegeren had first recruited him, he had confessed his ignorance. "'Don't worry,'" Van Meegeren had assured him, "'the people you'll be dealing with don't know anything, either.'"

When the laughter died down, Strijbis testified that at least he knew what he liked. He "would not allow into his house" the pictures Van Meegeren had asked him to sell. With the prosecutor's prodding, Strijbis launched into a remarkable tale. It began in a familiar way. Van Meegeren claimed that he'd obtained a valuable collection of old masters from a Dutch family who needed to raise money but wanted, above all, to avoid publicity. Unfortunately, Van Meegeren had told Strijbis, he'd had run-ins with many powerful figures in the art world. But the paintings were *extremely* valuable, and if Strijbis were willing to help sell them, in return for one sixth of the sales price, everyone would come out ahead.

Almost at once, Strijbis testified, he had called on the Amsterdam art dealer D. A. Hoogendijk, one of Van Meegeren's fake De Hoochs in hand. This was 1941. Hoogendijk was a natural choice not only because of his prominence in Amsterdam but because he had been the dealer who had brokered the *Emmaus* sale in 1937. Hoogendijk took the picture and quickly sold it to Van der Vorm, the Rotterdam shipping tycoon, for the equivalent of $1.3 million today.

That same year, Strijbis turned up at Hoogendijk's again, this time with a Vermeer. (Van Meegeren, growing ever more brazen, had painted a *Head of*

Christ that looked almost identical to the Christ in *Emmaus*.) Van Meegeren had told Strijbis that the new picture, which he said came from the same family collection as the others, seemed to be a study for a painting now unfortunately lost. Hoogendijk took one look, Strijbis testified, and said that he "at once thought of the *Emmaus*." Hoogendijk bought the picture and immediately sold it to Van der Vorm's rival Van Beuningen, for the equivalent of $2.5 million today.

Two months later, Strijbis was back at Hoogendijk's, bringing miraculous news. What painting had turned up but the very one for which Vermeer had painted his *Head of Christ* as a study! Hoogendijk, nearly bursting with excitement, raced to tell Van Beuningen. The picture was an enormous *Last Supper*, and Christ was unmistakably based on the *Head of Christ* that Van Beuningen had just bought. Now, for the equivalent of $8.6 million today, he bought the *Last Supper*, too.

Strijbis and Hoogendijk sold one more forgery, a Vermeer called *Isaac Blessing Jacob*. Van der Vorm was the buyer this time. Strijbis had no idea the paintings weren't authentic, he told the court. It had never occurred to him to wonder. Van Meegeren had said they were, and Hoogendijk hadn't raised any questions. Strijbis didn't know how much he'd made on the various deals. He hadn't kept records.

After all this, Hoogendijk reluctantly took his turn in the witness box. A distinguished and accomplished man, he sat forlornly while the prosecutor asked him to take a moment to consider the paintings on display in the courtroom. In particular, the painting known as *Isaac Blessing Jacob*.

"It's difficult to explain," Hoogendijk admitted. "It's unbelievable that it fooled me. But we all slid downwards—from *Emmaus* to the *Last Supper*, from the *Last Supper* to *Isaac Blessing Jacob*. When I look at them now, I do not understand how it could possibly have happened."

For Hoogendijk and the other witnesses, this was painful, but the spectators had no qualms about enjoying themselves. When another middleman, Van Meegeren's school chum Jan Kok, took the stand and said he had never heard of Vermeer, onlookers whooped and giggled. (Kok had been involved in the sale of the last of Van Meegeren's forgeries, the hideous *Washing of Christ's Feet*. This was the painting that the Netherlands had purchased for the Rijksmuseum for $5.9 million in today's dollars.)

Incredulous, the judge interrupted Kok's testimony. "The name Vermeer didn't ring any bells with you?"

Van Meegeren spoke up on his friend's behalf. "He was completely honest and the noblest person in this whole affair."

More laughter. A cameraman climbed up on his chair in the hope of a better shot of the room. The judge gaveled him back into his seat and ordered a stop to all filming.

Hannema suffered through a recap of his role in the affair, and Van Beuningen and Van der Vorm, the Rotterdam tycoons, endured brief examinations, too. Finally, after all the seduced experts and suckered millionaires, Van Meegeren himself took the stand.

"You admit that you painted these fakes?" the judge asked.

"Yes, your honor."

"And that you sold them, at high prices?"

"I had no choice. If I had sold them at a low price, no one would have believed they were authentic."

Snickering in the court. "Why did you continue with your forgeries after your success with *Emmaus*?"

"I could not stop, your honor. It became an addiction. I wanted to prove myself over and over again."

"That's all well and good, but you did quite nicely for yourself."

More laughter. "It's true, your honor, but I didn't do it for the money. I already had more money than I could ever spend. I didn't know what to do with it."

"So your motive was *not* financial gain?"

"I wanted to strike at the art world for always belittling me. That was all."

"It seems you succeeded."

Applause in the courtroom, gaveled down by the judge.

It was only midday, but with Van Meegeren not contesting the charges against him, the trial was hurtling along. All that remained were summary speeches by the prosecution and the defense. The prosecutor spoke first.

"Honorable gentlemen," he began. "Today our courtroom, which is usually so sober, has a very different look." He gestured at the paintings on the walls. "Millions were paid for these old masters, which until very recently experts attributed to Johannes Vermeer and Pieter de Hooch. Now, however, we judge these paintings in a totally different way, now that we know that ten years ago even the oldest of them had yet to be painted.

"The defendant is charged with making these paintings, with signing them falsely, and with having these false paintings sold as real Vermeers and Pieter de Hoochs. The defendant admits the truth of these charges but says in his defense that he resented the critics' neglect and wanted to show the world that he is a true artist.

"The defendant failed in that ambition. Today his status as an artist is more in question than it ever was." Van Meegeren, listening intently, buried his face in both hands.

"In one respect, however, he did succeed," the prosecutor went on. "He sent the art world into raptures. Art experts and collectors were utterly convinced that these were genuine Vermeers and De Hoochs. But in so doing—and this undermines all his success—he made himself a criminal and showed himself to be an immoral human being. The defendant did his utmost to tarnish the essence of art. He did this not to show the world that he was a great painter but with the purposeful, premeditated intention of enriching himself in a criminal way."

Van Meegeren leaped to his feet. "That is a lie!" The judge hammered for silence. The photographers clicked off more pictures. Unperturbed, the prosecutor ran through the highlights of Van Meegeren's criminal résumé. The recitation inspired not anger or dismay from the spectators but applause, laughter, and appreciative whistles. The judge could scarcely set down his gavel before he had to take it up again.

"Now the defendant began to produce his 'Vermeers' on an assembly line. The *Head of Christ* sold for 475,000 guilders. The *Last Supper* sold for 1,600,000 guilders. *The Washing of Christ's Feet* sold for 1,300,000 guilders, *Isaac Blessing Jacob* sold for 1,270,000 guilders, *Christ with the Woman Taken in Adultery* sold for 1,650,000 guilders."

Even the judge shook his head and smiled in disbelief at the string of colossal sums. Then, more grudgingly than before, he took up his gavel again.

"*Emmaus* was called 'a masterpiece,'" the prosecutor went on, "'more beautiful than any other work by Vermeer,' 'a pure expression of a deeply religious emotion with no equal in Dutch art.'"

More laughter. The judge threatened to clear the courtroom.

"Hopefully this history will teach the experts modesty."

Applause in the courtroom. Gaveling. "The courtroom is *not* a theater," the judge insisted.

"Now," said the prosecutor, "we arrive at the question, What is the appro-

priate punishment for the defendant? In my opinion, the seriousness of the crimes he committed leaves us no other choice than imprisonment. I ask the court to sentence the defendant to a term of two years in prison."

The court adjourned for lunch. Van Meegeren and two friends went to a small restaurant. Van Meegeren drank a good deal.

VAN MEEGEREN'S LAWYER spoke next. He read approvingly from a court-ordered psychiatric report. The psychiatrists had found that Van Meegeren had an "amiable" and "kind-hearted" side, but also a "special vulnerability" to criticism and "an abnormal need to avenge himself" on his enemies.

Then the defense lawyer read aloud passages in which the critics heaped praise on "Vermeer" but condemned Van Meegeren's work in his own name as "kitsch." The spectators, who had apparently forgotten that they were not in a theater, cheered so vigorously that the lawyer had to raise his voice to be heard as he read out particularly ripe passages about "miracles" of art and "heights that only the greatest of artists can scale."

If there was blame to be assigned, Van Meegeren's lawyer went on, it attached less to his client, who had done his best to create beauty, than to those buyers who had let themselves be taken in by a name. Still, he conceded, "the law protects those who are willing to pay a hundred times more for a painting when it has the name Vermeer on it than when it has the name Van Meegeren."

But for so minor a misdeed, what punishment was appropriate? The prosecutor had asked for a two-year sentence. "Allow me to ask you to give my client a more lenient, more humane punishment. You can be certain that the deeds he is charged with today are ones he will never repeat. Any incentive to do so has long since vanished, and my client is now an obsolete man, a man with no proper place of his own on this earth. On his behalf, we plead for mercy."

The judge asked Van Meegeren if he had any last words. He stood up, thanked the judge, and said he had nothing more to say. The judge told the courtroom that he would announce his ruling in two weeks.

THE PLAYERS MAKE THEIR EXITS

On November 12, 1947, the judge sentenced Van Meegeren to one year in prison. The maximum allowable sentence was four years, and the prosecution had asked for two, but many observers had predicted little more than a scolding. Van Meegeren showed no emotion. "I think I must take it as a good sport," he told reporters afterward.

No doubt Van Meegeren knew that by this time anything a judge might say was beside the point. He was only fifty-eight, but he looked and felt years older. In the summer before the trial he had been diagnosed with heart disease and hospitalized for a month. On November 26, just before his prison term was to begin, he was admitted to the hospital once again. On December 29 he suffered a heart attack. On December 30, never having served a day of his sentence, he died.

He died a hero. Over the course of the year that passed between his confession and his trial, public opinion in Holland had swung completely in Van Meegeren's favor. Once damned as a traitor, he became, in the words of the American journalist Irving Wallace, "the man who swindled Goering." In one poll where the Dutch were asked to rank the popularity of public figures, the prime minister finished first and Van Meegeren placed second. A small group of writers and painters took up his cause. "I am for Han van Meegeren and I say so without shame," declared the novelist Simon Vestdijk. "What did Van Meegeren do? He painted a picture.... Would Vermeer condemn him for that? I hardly think so. Many a person would have been spiritually deprived

had he not witnessed this crowning achievement of the genius of Johannes Vermeer with his own eyes."

For a time a movement to put up a statue to Van Meegeren won considerable support, at least in the form of enthusiastic talk. But no one in Holland in 1947 had money to spare, and the plans soon fizzled.

ON OCTOBER 1, 1946, the judges at Nuremberg had found Hermann Goering guilty of war crimes and sentenced him to death by hanging. Goering poisoned himself and was found dead in his prison cell hours before his scheduled execution. Still, he had lived long enough to learn the truth about his "Vermeer."

Stewart Leonard, a Monuments Man, delivered the news a few weeks before Goering's death. Leonard was in charge of the Munich Central Collecting Point, one of the round-up centers for looted art. In the course of an interrogation, Goering boasted to Leonard that among the thousands of paintings in his collection, there were no fakes.

"Oh, yes, there are," Leonard said, and he laid out the whole Van Meegeren saga.

"No! No! No!" Goering shouted. He jumped up, indignant and disbelieving. It couldn't be true. Soldiers standing guard rushed up to subdue the prisoner, hands on their weapons. There was no need. Goering's anger quickly turned to anguish. "But it's impossible! That picture was old, so old I had to have it restored!" Anguish in turn gave way to incredulity. How could the picture be fake? "It would be a colossal fraud, because I paid the most of all for that one."

NO ONE KNOWS if Abraham Bredius ever learned the truth about his beloved *Emmaus* or Van Meegeren's other forgeries. Bredius died on April 13, 1946, well after Van Meegeren's confession but early enough to spare Bredius the ordeal of the trial. At his death, Bredius was within a few days of his ninety-first birthday. It would have been a small mercy if the last act of the Van Meegeren story passed him by.

Some of Van Meegeren's victims never gave in. Hannema lived until 1984 and believed to the end that *Emmaus* was Vermeer's greatest masterpiece. In his old age, Hannema retreated to his castle and his art. There visitors could examine his large collection of paintings, many of them first-rate. In Hannema's

eyes, the prizes of his collection were the Vermeers—seven of them alto-
gether, in comparison with a mere four at the Rijksmuseum—though not a
single one of the seven was truly by Vermeer.

The two most devout believers in Van Meegeren went even further. Both
were prominent, well-regarded figures. The more outspoken was Jean Decoen,
a Belgian art critic and painter who insisted that *Emmaus* and *The Last Supper*
were genuine Vermeers. Not merely genuine, in fact, but "the most impor-
tant" Vermeers of all. Van Meegeren's confession was a "hoax." In an expen-
sive campaign that culminated in the publication of an impressive-looking
book called *Back to the Truth,* Decoen fought not merely to correct the historical
record but to win a lawsuit against the scientists who had manipulated and
misrepresented the technical evidence. Van Beuningen, the owner of the *Last
Supper* (and of a Van Meegeren "De Hooch"), financed the project.

Decoen argued that Van Meegeren had somehow discovered two authentic
Vermeers and then concocted his forgery story in order to place himself on a
par with Vermeer and to guarantee himself a place in the spotlight. Decoen
agreed that Van Meegeren *had* faked the other disputed paintings but claimed
that *Emmaus* and the *Last Supper* were achievements far beyond his reach. The
critic's admiration for the *Last Supper* especially was almost unbounded. "The
whole picture reveals such knowledge and skill," he wrote, "that it seems to
me that it is difficult to go further in transmitting human sentiments by
means of paint and brush."

Decoen's book-long argument was impassioned but unconvincing, a grassy
knoll conspiracy theory that required, among other things, the rejection of all
the scientific data. Still, its twist-in-the-tale complexity stirred confusion for
decades. Decoen himself never suffered any doubts, even after a face-to-face
confrontation with Van Meegeren. "Listen, Monsieur Van Meegeren," Decoen
told the forger, "you will probably fool many people, but you can't fool me!"

EPILOGUE

Underlying all the specific questions about who painted what, a deeper question lurks. Van Meegeren posed it in its starkest form: "Yesterday this picture was worth millions of guilders, and experts and art lovers would come from all over the world and pay money to see it," he declared at his trial. "Today, it is worth nothing, and nobody would cross the street to see it for free. But the picture has not changed. What has?"

Van Meegeren presumably had an unflattering answer in mind. The picture had not changed, but it had lost its glamour. Why? Because the "experts and art lovers" were as fake as it was. The world was full of people who thought of themselves as art lovers but were in fact merely snobs.

Perhaps there is more to say in our defense. In his contribution to a brilliant collection of essays on forgery and art, the philosopher Alfred Lessing contends that Vermeer was great not only because he painted beautiful pictures. "He is great for that reason plus something else. And that something else is precisely the fact of his originality, i.e., the fact that he painted certain pictures in a certain manner *at a certain time in the history and development of art*." To create something new is an achievement. Einstein was the first to see that $e = mc^2$. Afterward any actor could don a fuzzy wig and scribble the identical formula on a blackboard. That wouldn't make him Einstein.

The critic and philosopher Denis Dutton makes a related argument. When we praise a work of art, we have in mind not only the finished product but the way that product was made. Dutton asks us to imagine listening to a recording of a pianist and admiring her dexterity. If we learned later that an engineer had sped up the tape (while adjusting the pitch), we would feel cheated. In a similar way, a forger's achievement is less than it seems, regardless of its beauty, because the forger has the unfair advantage of working from someone else's model.

* * *

THE HAN VAN Meegeren story was the sort of disaster that engineers call a "normal accident." It is a far different thing from a perfect storm, in which two or three calamities hit at once and each is big enough to be overwhelming on its own. A normal accident is made up of a string of small mishaps, and each on its own seems innocuous. The trouble comes if those miscues happen to interact in just the wrong way. A driver's sunglasses slide off the seat, he leans forward to retrieve them and takes his eyes off the road; a car coming the opposite way slows for a puddle; an eighteen-wheeler tailgating the slowing car suddenly has to switch lanes . . .

One other difference is crucial. Unlike a perfect storm, a normal accident need not pan out. With a tiny change at any step along the way—if the driver picks up his sunglasses at once, without fumbling around—the accident might never come to be. At a dozen places, Van Meegeren's scheme might have unraveled harmlessly. Bredius might have glanced at *Emmaus* and scoffed, as Duveen had. Hannema might not have found a donor willing to hand him a fortune. Luitwieler, the restorer, might have spotted the signs of self-inflicted damage.

But it did happen, one minor misstep at a time. Almost inevitably, similar things will happen again. In September 2003, a museum in Bolton, England, paid $935,000 for an ancient Egyptian statue. The statue is gorgeous. Carved in alabaster, it stands about twenty inches tall and depicts the torso of a barely cloaked princess, the daughter of the pharaoh Akhenaten and his queen, Nefertiti. The British Museum authenticated the 3,300-year-old statue. The experts at Christie's enthusiastically agreed, and *The Burlington Magazine* wrote an article hailing its importance.

Three years later, in 2006, British police raided a workshop filled with "equipment for making statues and the like" and arrested two men on suspicion of forgery. The Amarna princess, as the statue was known, had been carved not in 1350 BC but sometime in the twenty-first century, by a self-taught English forger using a hammer and chisel from his local hardware store.

The forgers had sung straight from Van Meegeren's hymnbook. To begin with, their statue had a hazy and almost uncheckable provenance. Nor did it look like a run-of-the-mill fake (who would forge a torso without a head?), and, in fact, it had hardly any counterparts even among *genuine* Egyptian statues. Moreover, the princess had a strikingly modern look, a sexiness that appealed to museum directors and museumgoers alike. Finally, because the

statue was unpainted stone, no scientific tests could be performed to evaluate it. Everything rested on the judgment of connoisseurs.

"This was," one of the purchasers declared, "a once-in-a-lifetime opportunity."

NOTES

Sources for quotations and for assertions that might prove elusive can be found below. To keep these notes in bounds, I have not documented facts that can be readily checked in standard sources.

CHAPTER ONE: A KNOCK ON THE DOOR

3 *The grandeur of 321 Keizersgracht* . . . Fredrik Kreuger, *De Arrestatie van een meestervervalser*, pp. 96–97. (The title means *The Arrest of a Master Forger.*)

3 *The front hall was* . . . The bicycle story featured regularly in news stories about Van Meegeren. See, for instance, "One Vermeer After Another: A Forger of Genius," *De Nieuwe Dag*, July 18, 1945, or "Master Hoaxer," *Newsweek*, Sept. 10, 1945. Van Meegeren's home is today the headquarters of the Association of Dutch Architects, which takes a natural interest in the building's past uses; the building's office manager debunked the bicycling story and confirmed the skating one.

4 *Joop Piller* . . . My description of Piller is based on Harry van Wijnen's account in his *Han van Meegeren en Zijn Meesterwerk van Vermeer* (with co-author Diederik Kraaijpoel) and on my interviews with Van Wijnen. For many years a personal friend of Piller, Van Wijnen is a contributing editor at *NRC Handelsblad* and a professor at Erasmus University in Rotterdam. He is also the author of a biography of D. G. van Beuningen, a major player in the Van Meegeren saga. See Harry van Wijnen, *Grootvorst aan de Maas: D. G. van Beuningen.* (The title means *Monarch on the* [*river*] *Maas*).

4 *He had brought his guitar* . . . "One Vermeer After Another."

CHAPTER TWO: LOOTED ART

6 "roof rabbit" . . . Walter B. Maass, *The Netherlands at War: 1940–1945*, p. 210.

7 "I love art" . . . Leon Goldensohn, *The Nuremberg Interviews*, p. 129.

7 "I intend to plunder" . . . Robert M. Edsel, *Rescuing da Vinci*, p. 105.

7 "At the current moment" . . . Hector Feliciano, *The Lost Museum*, p. 38.

7 *This was the most valuable* . . . David Irving, *Göring*, p. 305. Irving is an unpleasant character and a bigot who contends that Auschwitz was merely "a labor camp with an unfortunately high death rate." Nonetheless, such eminent historians as John Keegan and Gordon Craig call Irving's work "indispensable." Irving is both a propagandist for ugly views and a formidable researcher. The quotations I have drawn from his biography are not controversial and are well documented in his notes. For more on the debate over Irving's scholarship, see D. D. Guttenplan's "Taking a Holocaust Skeptic

Seriously," *New York Times*, June 26, 1999. Deborah Lipstadt's *History on Trial* tells of her courtroom victory over Irving. She called him a Holocaust denier; he sued for libel and lost. Gordon Craig reviewed *Göring* and several other books on the Nazis in *The New York Review of Books*, February 2, 1989.

7 *In the "hunger winter"* . . . Louis de Jong, *The Netherlands and Nazi Germany*, p. 47.

CHAPTER THREE: THE OUTBREAK OF WAR

9 *On the evening of May 9* . . . "Low Countries Attacked," *New York Times*, May 12, 1940.

9 *Elsewhere in Berlin* . . . This account is based on Maass, pp. 28–29, Werner Warmbrunn, *The Dutch Under German Occupation*, pp. 6–7, and Peter Voute, *Only a Free Man*, pp. 21–22.

9 *It was not to be* . . . Maass, pp. 28–29, and Voute, p. 22.

10 *In the months before* . . . Voute, p. 21.

11 *"They hoped," in the words* . . . Maass, p. 16.

11 *"The planes are searching"* . . . Ibid., p. 39.

11 *"Let my air force darken"* . . . David Irving, p. 289.

11 *"Curator of the Reich"* . . . Ibid., p. 300.

11 *"Behind us," Churchill told* . . . Martin Gilbert, *Winston S. Churchill: Finest Hour, 1939 to 1941* (Boston: Houghton Mifflin, 1983) p. 365.

12 *"English fathers, sailing to rescue"* . . . William Manchester, *The Last Lion: Winston Spencer Churchill, Visions of Glory* (Boston: Little, Brown, 1983), p. 3.

12 *"List of Pictures Delivered"* . . . David Irving, p. 291.

12 *This time the lure* . . . Lynn Nicholas tells Goudstikker's story in her superlative *The Rape of Europa*. See pp. 83–85. For specifics on Goudstikker's notebook, see Alan Riding's "Dutch to Return Art Seized by Nazis," in *New York Times*, Feb. 7, 2006, and his "Goering, Rembrandt, and the Little Black Book," in *New York Times*, March 26, 2006.

13 *Exactly what deals* . . . Nicholas, p. 106.

13 *"A few months after Goudstikker's death"* . . . Jacob Presser, *Ashes in the Wind*, p. 9.

CHAPTER FOUR: QUASIMODO

14 *One of Van Meegeren's paintings* . . . Marijke van den Brandhof, *Een vroege Vermeer uit 1937*, p. 155. (The title means *An Early Vermeer from 1937*.) This admirable book, which was a doctoral thesis published in 1979, broke considerable new ground, especially on Van Meegeren's own artistic career and on his Nazi sympathies.

15 *"Here and there one finds"* . . . Van den Brandhof.

15 *"a unique, fluent way of painting"* . . . Ibid.

15 *"art Bolsheviks"* . . . Jonathan Lopez, "De Meestervervalser en de fascistische droom," *De Groene Amsterdammer*, Sept. 29, 2006. (The title means "The Master Forger and the Fascist Dream.")

15 *"Revenge keeps its colour"* . . . John Russell, "Revenge Keeps Its Colour," *Sunday Times [of London]*, Oct. 23, 1955.

16 *"heavy-lidded eyes"* . . . M. Kirby Talley, Jr., "Van Meegeren's Fake 'Vermeers,'" in Mark Jones, ed., *Fake? The Art of Deception*, p. 240.

16 *Van Meegeren was a genius* . . . Endless examples could be supplied. P. B. Coremans, the scientist who led the government team appointed to investigate Van Meegeren's forgeries, wrote that "Van Meegeren was indisputably the greatest forger of all times." See *Van Meegeren's Faked Vermeers and De Hooghs*, p. 26. The title of Kilbracken's biography was *Van*

Meegeren: Master Forger, that of Frederik Kreuger's biography the virtually identical *Han van Meegeren: Meestervervalser*.

16 *"especially beautiful"* . . . M. M. van Dantzig, *Vermeer: De Emmausgangers en de critici* (*Vermeer: "Christ at Emmaus," and the Critics*).

16 *"serene"* . . . Sandra Weerdenburg, *De Emmausgangers: een omslag in waardering*, Utrecht, 1988. (The title means *Christ at Emmaus: A Reversal in Appreciation*.) Chapter 2 of this exemplary Ph.D. thesis contains dozens of similar hymns of praise to *Christ at Emmaus*.

16 *"exalted"* . . . Abraham Bredius, "Nog een word over Vermeer's Emmausgangers," *Oud Holland* 55, 1938. (The title means "Another Word About Vermeer's *Christ at Emmaus*.")

16 *"Why was there never again"* . . . Ibid.

16 *"After Van Meegeren's exposure"* . . . Jones, p. 15

CHAPTER FIVE: THE END OF FORGERY?

19 *"If you gave one of them"* . . . David Maurer, *The Big Con*, p. 258.

19 *"With old master paintings"* . . . Milton Esterow, "Fakes, Frauds, and Fake Fakers," *Art News*, June 2005, p. 100.

19 *"Nobody bothers to take"* . . . Thomas Hoving, author interview, Nov. 16, 2005.

19 *We turn to science* . . . The same is true in many fields besides art. The journalist Malcolm Gladwell cites mammograms as a notable example. We employ state-of-the-art X-ray technology in the hope of certainty only to find that the hunt for breast tumors demands one educated guess after another. See Malcolm Gladwell, "The Picture Problem," *The New Yorker*, Dec. 13, 2004.

19 *On the basis of stylistic* . . . Anthony Bailey, *Responses to Rembrandt*, p. 40.

20 *Unless you find something* . . . Hoving interview. All the quotations from Hoving in the rest of this chapter are from this interview.

20 *Anthony Bailey tells the story* . . . Bailey, *Responses to Rembrandt*, p. 39.

CHAPTER SIX: FORGERY 101

22 *Christopher Wright, a distinguished* . . . Author interview, Nov. 8, 2005.

23 *"Let the paper choose"* . . . Eric Hebborn, *The Art Forger's Handbook*, p. 39.

23 *Tom Keating, a sloppy* . . . Frank Geraldine and Norman Norman, *The Fake's Progress*, p. 241.

23 *Elmyr de Hory* . . . Clifford Irving, *Fake!* p. 72.

23 *He claimed he once* . . . Ibid., p. 62.

23 *Thomas Hoving says* . . . Hoving made his comment in a review of Hebborn's *Art Forger's Handbook*. See "Sleight of a Master's Hand," *The Times [of London]*, Jan. 23, 1997.

23 *Could it really be true* . . . Eric Hebborn, *Drawn to Trouble*, p. 73.

23 *He had sold upward* . . . Hebborn refers to "500 pictures" on p. 364 of *Drawn to Trouble*, and to the Met and the National Gallery on p. 362 of the same book.

24 *"frightening talent"* . . . Hoving, "Sleight."

24 *Hebborn's solution* . . . Hebborn, *Art Forger's Handbook*, p. 15.

24 *"When the ink was dry"* . . . Norman and Norman, p. 84.

24 *"He also copied drawings"* . . . Quoted in Hebborn, *Art Forger's Handbook*, p. 49. The passage is near the beginning of Vasari's chapter on Michelangelo.

24 *The forger David Stein* . . . Anne-Marie Stein, *Three Picassos Before Breakfast*, p. 122.

24 *To produce a drawing* . . . Hebborn, *Art Forger's Handbook*, p. 49.

25 *Add a few flakes* . . . Hebborn, *Drawn to Trouble*, p. 295.

25 *"It is rather like frying"* . . . Hebborn, *Art Forger's Handbook*, p. 51.

25 *"The likelihood of catching"* . . . Stein, p. 46.

25 *"accessible artists"* . . . Hebborn, *Art Forger's Handbook*, p. 46.

CHAPTER SEVEN: OCCUPIED HOLLAND

26 *"The man on the street"* . . . Maass, p. 43.

27 *"The Dutchman's character"* . . . Louis Lochner, ed., *The Goebbels Diaries*, p. 110.

27 *"As everybody knows"* . . . Ibid., p. 494.

27 *IQ tests at Nuremberg* . . . Leonard Mosley, *The Reich Marshal*, p. 399.

27 *"as far as possible"* . . . Maass, p. 48.

27 *"gingerbread with whippings"* . . . Lochner, ed., p. 485.

27 *"If you tried to escape"* . . . De Jong, *Netherlands and Nazi Germany*, p. 19.

28 *Only two hundred Dutchmen* . . . Maass, p. 69.

28 *"Probably no other country"* . . . Ibid., p. 68.

28 *"Every tradition of conspiracy"* . . . Ibid., p. 70.

29 *No one had thought* . . . Ibid., p. 71.

29 *"They had spent their whole lives"* . . . Bob Moore, *Victims and Survivors: The Nazi Persecution of the Jews in the Netherlands, 1940–1945*, p. 195.

29 *Failure to produce* . . . Maass, p. 71.

29 *This was no mere* . . . Presser, p. 39.

29 *"Although undoubtedly pro-German"* . . . Moore, p. 198.

CHAPTER EIGHT: THE WAR AGAINST THE JEWS

30 *"a little prayerful"* . . . Quoted in Moore, p. 44.

30 *Before the war* . . . De Jong, *Netherlands and Nazi Germany*, p. 20.

30 *The comparable figure* . . . Moore, p. 2.

30 *"I have now been here four"* . . . Ibid., p. 16.

31 *"Tens of thousands"* . . . Ibid., p. 17.

31 *The blows directed* . . . The dates in this paragraph come from Presser, pp. 31, 65, 68, 77, 83, 115, 120, 131. The dates in the following paragraph come from Presser, pp. 129, 130.

31 *"countless friends and acquaintances"* . . . Anne Frank, *The Diary of a Young Girl*, p. 69.

31 *By the end of September* . . . Presser, pp. 184–89, 214.

32 *After two days, the SS* . . . Maass, p. 65.

32 *"This strike," Louis de Jong* . . . De Jong, *Netherlands and Nazi Germany*, p. 8.

32 *"One felt sorry"* . . . Quoted in Presser, p. 325.

CHAPTER NINE: THE FORGER'S CHALLENGE

34 *The acclaimed Elmyr de Hory* . . . Clifford Irving, *Fake!*, p. 90.

34 *In 1931, according to* . . . Russell, "Revenge Keeps Its Colour."

34 *Solving it took him almost* . . . Hope Werness, "Han van Meegeren *fecit*," p. 23. In Denis Dutton, ed., *The Forger's Art*. Werness's essay is one of the essential documents on Van Meegeren in English.

34 *Dishonest apothecaries* . . . Philip Ball, *Bright Earth: Art and the Invention of Color*, p. 77.

34 *Some forgers have been* . . . Esterow, "Fakes, Frauds."

35 *It takes somewhere between* . . . Leo Stevenson, personal communication, Nov. 8, 2005.

35 *an English painter named Leo Stevenson* . . . Author interview, Nov. 7, 2005.

36 *The particles in hand-ground* . . . Richard Harris, "The Forgery of Art," *The New Yorker*, Sept. 16, 1961, p. 140.

36 *Until the advent* . . . Ball, p. 180.

36 *"a stone table"* . . . P.T.A. Swillens, *Johannes Vermeer*, p. 129.

36 *In Vermeer's day* . . . Ibid., p. 126.

36 *lapis lazuli* . . . Ball, pp. 92, 236.

36 *Next came the grinding* . . . Swillens, p. 122, and Ball, p. 237.

36 *In addition to freeing* . . . Ibid., p. 180.

37 *"More than with any other"* . . . Jan Veth, quoted in "Girl with a Pearl Earring," in Arthur Wheelock, ed., *Johannes Vermeer*, p. 168.

37 *Every color called* . . . Swillens, p. 127.

37 *Van Meegeren labored away* . . . Van den Brandhof, p. 94.

37 *"I saw a splendid"* . . . Marie Doudart de la Grée, *Geen standbeeld voor Han van Meegeren*, p. 30. (The title means *No Statue for Van Meegeren*.)

37 *"Never believe Van Meegeren!"* . . . Kraaijpoel, personal communication, April 2, 2006.

38 *He may have left* . . . See Koos Levy-Van Halm, "Where Did Vermeer Buy His Painting Materials? Theory and Practice," in Ivan Gaskell and Michiel Jonker, eds., *Vermeer Studies*, p. 141.

38 *"He was the Edison"* . . . Quoted in Harris, "The Forgery of Art," p. 141.

38 *Before Edison came up* . . . Francis Arthur Jones, *Thomas Alva Edison: Sixty Years of an Inventor's Life*, Boston: Thomas Y. Crowell, 1908, p. 252.

39 *To make a pound* . . . "Leo Baekeland and Wallace Carothers: Maestros of Molecules," *US News and World Report*, Aug. 17, 1998.

39 *"from the time that a man"* . . . *Time*, Sept. 22, 1924.

CHAPTER TEN: BARGAINING WITH VULTURES

40 *On October 1, 1944* . . . The Dutch Resistance Museum, p. 115.

40 *So many moving vans* . . . Presser, pp. 364, 369.

40 *Prices on the black market* . . . Warmbrunn, p. 80.

40 *When night fell* . . . Henri van der Zee, *The Hunger Winter: Occupied Holland*, p. 153, and Maass, p. 209.

40 *To rig a battery* . . . De Jong, "Life in Occupied Holland," p. 29.

41 *"Dutch girls," historian Walter Maass records* . . . Maass, pp. 208–10.

41 *"Beautiful old houses"* . . . De Jong, "Life in Occupied Holland," p. 29.

41 *"Along the roads"* . . . Ibid.

41 *"endless road behind Hoorn"* . . . Maass, p. 212.

41 *"there was no reason to forgo"* . . . Nicholas, p. 101.

42 *"Art soon became"* . . . Ibid., p. 103.

42 *In his role as middleman* . . . Janet Flanner, *Men and Monuments*, p. 230.

CHAPTER ELEVEN: VAN MEEGEREN'S TEARS

44 *Two painters made especially* . . . This account is based on a superb essay by Arthur Wheelock, a Vermeer scholar at the National Gallery in Washington, D.C. See "The Story of Two Vermeer Forgeries," in *Shop Talk: Studies in Honor of Seymour Slive*.

45 *Perhaps it was Wright* . . . Arthur Wheelock says this was the suggestion of the late Vermeer scholar A. B. de Vries. Wheelock, "Two Vermeer Forgeries," p. 274.

45 *"a little zero"* . . . Van den Brandhof.

45 *Rol had the talent* . . . Author interview, Dec. 19, 2005.

46 *Even today, in an upstairs room* . . . Frederik Kreuger, *Han van Meegeren: Meestervervalser*, p. 73.

46 *"by chance, in an old book"* . . . Oct. 22, 1945, *Het Binnenhof.*

46 *Van Meegeren may have reasoned* . . . Leo Stevenson, personal communication, June 26, 2006.

46 *"On my way home"* . . . Doudart de la Grée, p. 56.

46 *The oils have a heavy* . . . Doudart de la Grée, p. 48.

47 *"Bakelite is a solid"* . . . Diederik Kraaijpoel and Harry van Wijnen, *Han van Meegeren en Zijn Meesterwerk van Vermeer*, p. 40.

CHAPTER TWELVE: HERMANN GOERING

51 *"By the liberation of Paris"* . . . Hector Feliciano, *The Lost Museum*, p. 4.

51 *Over the course of the war's five years* . . . Ibid., p. 16.

51 *"This is for me alone"* . . . Albert Speer, *Inside the Third Reich*, p. 214.

52 *"at least a yard across"* . . . David Irving, p. 161.

52 *"In his personal appearance"* . . . Schacht, Testimony at Nuremberg War Crimes Trial, May 3, 1946 (online at www.nizkor.org/hweb/imt/tgmwc/tgmwc-13/)

52 *He favored uniforms* . . . Nicholas, p. 35, and Joachim Fest, *The Face of the Third Reich*, p. 78.

52 *He wore so many medals* . . . Rudolph Herzog includes this joke in *Heil Hitler, Das Schwein ist Tot: Lachen unter Hitler—Komik und Humor im Dritten Reich.* (The book is a study of humor in the Third Reich. The title means *Heil Hitler, The Pig is Dead!*, which was the punch line of a joke.)

52 *"animated flea"* . . . David Irving, p. 172.

52 *Goering liked jewelry* . . . Fest, p. 328.

52 *Germanic Robin Hood* . . . Ibid., p. 78.

53 *"He obviously would have loved"* . . . Rudolf Diels, quoted in ibid., p. 329.

53 *"My flyers are no projectionists"* . . . Ibid.

53 *"I felt," Wagener wrote* . . . Henry A. Turner, Jr., ed., *Hitler: Memoirs of a Confidant*, pp. 117–19.

53 *Of his eight houses* . . . Nicholas, p. 36.

53 *"carved French cupids"* . . . Flanner, p. 245.

54 *Every design decision* . . . David Irving, p. 136.

54 *Under a soaring dome* . . . Kenneth Alford, *Great Treasure Stories of World War II*, p. 26 (Mason City, Iowa: Savas, 2000).

54 *model railroad* . . . David Irving, p. 217.

54 *"After all, I am a Renaissance man"* . . . Fest, p. 71, and David Irving, p. 324.

54 *"Goering is by no means"* . . . Mosley, p. 390.

CHAPTER THIRTEEN: ADOLF HITLER

55 *Whenever someone on Hitler's staff* . . . Fest, p. 75.

55 *"Adolf Hitler is my conscience"* . . . Ibid.

55 *"How shall I say, my Fuehrer"* . . . G. M. Gilbert, "Hermann Goering: Amiable Psychopath," *Journal of Abnormal and Social Psychology* 43, no. 2 (April 1948), p. 221.

55 *"the picture war"* . . . Speer, p. 213.

56 *"a man of many parts"* . . . Goldensohn, p. 106.

56 *Hitler, on the other hand* . . . Frederic Spotts, *Hitler and the Power of Esthetics*, pp. 7–8.

56 *Twice he applied* . . . Ibid. pp. 123–25.

56 *In Vienna shortly before* . . . Ibid., pp. 127–28.

56 *"After being appointed chancellor"* . . . Ibid., p. xi.

56 *The day after* . . . Ibid., p. 385.

56 *Long after his world.* . . . Ibid., p. xi. This anecdote, with a photograph of Hitler raptly
 contemplating his model, serves as the opening of Spotts's compelling book.

CHAPTER FOURTEEN: CHASING VERMEER

57 *"an opportunity never before offered"* . . . Spotts, p. 191.

57 *"only the best"* . . . Ibid., p. 187.

58 *"not up to the level"* . . . Feliciano, p. 22.

58 *He died without a penny* . . . Albert Blankert, *Vermeer of Delft*, p. 163, and Anthony Bailey,
 Vermeer: A View of Delft, p. 134.

58 *Vermeer "may have given himself"* . . . Kenneth Clark, *Looking at Pictures*, p. 104.

58 *The art historian Willem van de Watering* . . . Blankert, *Vermeer of Delft*, p. 163.

59 *"the heavy oak table"* . . . Norbert Schneider, *Vermeer: The Complete Paintings*, p. 82.

59 *"doubt or disbelief"* . . . Ivan Gaskell, *Vermeer's Wager*, p. 40.

59 *Vermeer's own wife* . . . Blankert, *Vermeer of Delft*, p. 163.

59 *"No other work so flawlessly"* . . . Ibid., p. 49.

60 *At that time and for decades* . . . Ibid., p. 163.

60 *Duveen and the American tycoon Andrew Mellon* . . . Nicholas, p. 47.

60 *Reemtsa contributed hundreds of thousands* . . . Ibid., p. 37.

61 *In today's dollars, the final price* . . . Reemtsa had offered 1.8 million marks; Hitler's price was
 1.625 million marks. See Spotts, p. 198.

61 *Count Jaromir Czernin wrote* . . . Nicholas, p. 40.

61 *One color illustration after another* . . . Spotts, pp. 193–94.

61 Hendrickje Stoffels *has since been* . . . Ibid., p. 199.

CHAPTER FIFTEEN: GOERING'S ART COLLECTION

62 *"Rommel has completely lost"* . . . David Irving, p. 372.

62 *Rommel returned to Africa furious* . . . Mosely, p. 355.

63 *He visited twenty times* . . . Feliciano, p. 36.

63 *"The following items were loaded"* . . . David Irving, p. 371.

63 *"the armistice with the French"* . . . Feliciano, p. 40.

63 *When war broke out* . . . Ibid., pp. 45–46.

63 *"As far as the confiscated"* . . . David Irving, p. 302.

63 *With art as with mass* . . . Flanner, p. 229.

64 *One admiring biographer* . . . Ibid., p. 300.

64 *In all, the Germans confiscated* . . . Feliciano, pp. 44–45.

64 *Those crates marked H1* . . . Ibid., p. 47.

64 *The astronomer may actually be* . . . Schneider, p. 77.

64 *The Vermeer scholar Arthur Wheelock* . . . "The Geographer," Wheelock, ed., *Johannes Vermeer*,
 p. 172.

65 *Unusually, The Astronomer* . . . Blankert, *Vermeer of Delft*, p. 13.

CHAPTER SIXTEEN: INSIGHTS FROM A FORGER

66 *"There are only three"* ... Author interview, Nov. 4, 2005. Unless otherwise noted, all quotations from Myatt in this chapter are from this interview.

66 *But as ancient as forgery* ... See the fascinating two-part article by Robert Hughes, "Art and Money," *New Art Examiner*, October 1984, and November 1984.

66 *"inch for inch"* ... Flanner, p. xxi.

66 *Thomas Hoving is fond* ... Hoving chose Horace's remark as the epigraph for *False Impressions: The Hunt for Big-time Art Fakes*. Joseph Alsop cited Phaedrus's warning in his essay "The Faker's Art," in *New York Review of Books*, Oct. 23, 1986.

68 *The challenge for a forger* ... E. H. Gombrich, *Art and Illusion*, p. 309. Gombrich made the Van Gogh–Millet comparison and illustrated it with Van Gogh's *Cornfield* and Millet's *Cornfield*.

72 *While Myatt did his best* ... The information in this paragraph and the next comes from Peter Landesman, "A 20th-Century Master Scam," *New York Times Magazine*, July 18, 1999.

73 *At one point he hired* ... Bartos told his story in a documentary called *The Puppet Master*, shown on British television in 2003.

CHAPTER SEVENTEEN: THE AMIABLE PSYCHOPATH

77 *He clapped along merrily* ... Mosley, p. 390.

77 *"I saw on the platform"* ... Ibid., p. 10.

78 *"The director did object"* ... David Irving, p. 155.

78 *Goering used another painting* ... Nicholas, p. 35.

78 *"Goering was never unpleasant"* ... Ibid., p. 109.

78 *"Bachstitz is to be left alone"* ... David Irving, p. 437.

78 *One colleague, writing* ... Quoted in Fest, p. 78.

78 *Hofer made the rounds* ... Nicholas, p. 36.

78 *Goering ignored UFA's invoice* ... David Irving, p. 280.

79 *In April 1935, when Goering married* ... This description of Goering's wedding festivities and the quote from Emmy Goering come from David Irving, pp. 157–58.

79 *The gifts were lavish* ... Fest, p. 31, and David Irving, p. 374.

80 *"I was the last court"* ... David Irving, p. 299.

80 *"Heil der Dicke!"* ... Mosley, p. 211.

80 *"The people want to love"* ... Fest, p. 72.

80 *One nightclub comic* ... Mosley, p. 9.

80 *"He can turn on a smile"* ... Goldensohn, p. 101.

80 *"When you use a plane"* ... Mosley, p. 204.

80 *"Certainly as second man"* ... Goldensohn, p. 131.

80 *"I seem to come alive"* ... Mosley, p. 34.

80 *"there will be statues"* ... Fest, p. 82.

81 *"what made those Nazis tick"* ... Goldensohn, p xx.

81 *"half militarist and half gangster"* ... Mosley, p. 416.

81 *"For these crimes"* ... Quoted by Gary J. Bass in a *New York Times* op-ed entitled "Try and Try Again," Sept. 26, 2006. Bass is the author of *Stay the Hand of Vengeance: The Politics of War Crimes Tribunals*.

81 *It was in a conversation* ... G. M. Gilbert, *Nuremberg Diary*, p. 278.

CHAPTER EIGHTEEN: GOERING'S PRIZE

83 *Vermeer's procuress has a cagey*...Diederik Kraaijpoel, personal communication, June 7, 2006.

83 *That suddenly precious painting*...Blankert, *Vermeer of Delft*, p. 155.

84 *Miedl knew Goering well*...Nicholas, p. 105.

84 *2 million Dutch guilders*...Ibid., p. 110.

84 *Goering handed Miedl 137 paintings*...There is dispute over this number. Nicholas cites a figure of 150. See pp. 109–10. Kilbracken puts the number at "some two hundred"; see p. 2. The 137 figure comes from Thomas Carr Howe, *Salt Mines and Castles: The Discovery and Restitution of Looted European Art*, p. 193. I have gone with 137 both because it is the most conservative figure and because Howe, a Monuments Man, wrote a firsthand account of seeing Goering's stolen "Vermeer" in Berchtesgaden.

CHAPTER NINETEEN: VERMEER

85 *"It now seems uncontentious"*...Gaskell, p. 39.

85 *"perhaps the loveliest objects"*...John Updike, *Just Looking*, p. 22.

86 *Vermeer "stayed with me"*...Swillens, p. 13. Werness cites this passage in "Han van Meegeren *fecit*"; see p. 51.

86 *plague swept through Amsterdam*...Anthony Bailey, *Responses to Rembrandt*, p. 105.

86 *in 1654, an explosion*...The first chapter of Anthony Bailey's *Vermeer* is a tour de force description of the explosion. See also Hans Koningsberger, *The World of Vermeer*, pp. 60–61.

86 *"Everyone must be made to live"*...Simon Schama, *Rembrandt's Eyes*, p. 57.

86 *"If there are vices"*...E. H. Carr, *What Is History?* p. 77.

86 *One victim of the blast*...Koningsberger, p. 60.

87 *The war was "still going"*...Koningsberger, p. 29.

87 *"to spend a little time with the Vermeers"*...Lawrence Weschler, *Vermeer in Bosnia*, p. 14.

CHAPTER TWENTY: JOHANNES VERMEER, SUPERSTAR

88 *The painting had suffered*...Blankert, personal communication, May 20, 2006. Blankert, who studied the prices in nineteenth-century travelers' guides to Holland, estimates that 2.3 florins was roughly the price of a night in a first-class hotel and a light meal.

88 *From the start, rapturous crowds*...Quentin Buvelot, "On Des Tombe, Donor of Vermeer's *Girl with a Pearl Earring*," *Mauritshuis in Focus*, Jan. 2004.

89 *The frenzy was dubbed*...Arthur Wheelock and Marguerite Glass, "The Appreciation of Vermeer in Twentieth-Century America," in *The Cambridge Companion to Vermeer*, ed. Wayne Franits, p. 163.

89 *Duveen had "noticed that Europe"*...S. N. Behrman, *Duveen*, p. 3.

89 *J.P. Morgan acquired*...Philipp Blom discusses Morgan's Bibles and Hearst's warehouses in *To Have and to Hold*; see pp. 127 and 134.

89 *She had been so worried*...Peter Watson, *From Manet to Manhattan*, p. 127.

90 *"It is important for both"*...Colin Simpson, *Artful Partners: Bernard Berenson and Joseph Duveen*, p. 87.

90 *"He did not object to my mentioning"*...Jean Strouse, *Morgan*, p. 562.

90 *"This bronze bust is in"*...Blom, p. 126.

90 *Morgan had evidently paid*...Ben Broos, "Un celebre Peijntre nommé Vermeer," in Wheelock, ed. *Johannes Vermeer*, pp. 159–61.

91 *"The rare and incomparable"*... Wheelock and Glass, "Appreciation," p. 167.

91 *Vermeer was "the greatest"*... Ibid., p. 170. The other superlatives can be found in Philip Hale, *Jan Vermeer of Delft* (Boston: Small, Maynard, 1913).

91 *Ladies' Home Journal*... Wheelock and Glass, "Appreciation," p. 169.

91 *The debate centered on*... "The Milkmaid," in Wheelock, ed., *Johannes Vermeer*, p. 112.

91 *J. P. Morgan owned three*... Strouse, p. 611.

92 *All six of the Vermeers*... Wheelock and Glass, "Appreciation," p. 168.

92 *"Railroads," Frick declared*... Matthew Josephson, *The Robber Barons* (New York: Harcourt, Brace, 1934), p. 344.

CHAPTER TWENTY-ONE: A GHOST'S FINGERPRINTS

93 *We have seventy-odd Rembrandt*... Albert Blankert puts the Rembrandt tally at roughly forty painted self-portraits and thirty etched self-portraits. Personal communication, June 4, 2006.

93 *"Rembrandt, the painter of mystery"*... Wheelock and Glass, "Appreciation," p. 171.

93 *Historians can name fifty*... Bailey, *Responses to Rembrandt*, p. 41.

94 *"Not only are the paintings"*... Blankert, *Vermeer of Delft*, p. 17.

94 *"full of warmth"*... Schneider, p. 79.

94 *"almost inhuman coolness"*... Updike, p. 26.

95 *That house still stands*... Philip Steadman, *Vermeer's Camera*, pp. 59—62.

95 *The buildings that Vermeer*... Author interview with Frederik Kreuger, Aug. 23, 2005. Kreuger, a resident of Delft, graciously conducted me on a tour of the city he knows so well, with special attention paid to locations relevant to Vermeer and Van Meegeren. A tireless investigator of all things related to Van Meegeren, Kreuger taught engineering at Van Meegeren's old school, the Delft Institute of Technology. He is the author of a biography called *Han van Meegeren: Meestervervalser,* which is notable for thoroughness and more than a hundred reproductions of Van Meegeren's paintings, and an account of Van Meegeren's arrest called *De Arrestatie van een Meestervervalser.* Kreuger also wrote a novel based on the case, available in English, called *The Deception.*

95 *Even Vermeer's mortal remains*... Kreuger, Aug. 23, 2005.

95 *Ordinarily they moved often*... I owe this information on Van Meegeren's student days, and in particular the speculation about a liberal landlady, to Kreuger.

95 *"generally ignored or completely forgotten"*... J. H. Huizinga, *Dutch Civilization in the Seventeenth Century and Other Essays*, p. 44.

96 *At age twenty-one*... The source of these sentences on "master painters" is Bailey, *Vermeer,* pp. 56 and 89.

96 *Certainly no one spoke*... Arthur Wheelock, *Vermeer: The Complete Works*, p. 6.

96 *But his work commanded*... Blankert, *Vermeer of Delft*, p. 60.

96 *At an Amsterdam auction*... Bailey, *Vermeer*, p. 212.

96 *Two hundred guilders was*... Ibid., p. 99.

96 *One Dutch scholar has made*... Bailey, *Responses to Rembrandt*, p. 67, citing the work of A. D. van der Woude.

97 *that second job may have brought in*... Bailey, *Vermeer*, p. 99.

97 *"decay and decadence"*... Ibid., p. 204.

97 *"The greatest mystery"*... Paul Johnson, *Art: A New History*, p. 379.

97 *Vermeer's paintings "passed"*... Updike, p. 24.

97 *In July 2004* . . . See Carol Vogel, "Long Suspect, A Vermeer Is Vindicated by $30-Million Sale," *New York Times*, July 8, 2004; Martin Bailey, "Rediscovery: A 36th Vermeer?" www.theartnewspaper.com, March 2001; Martin Bailey, "Oh Yes It Is! Oh No It's Not!" www.theartnewspaper.com, July/August 2001.

98 *"An eighteenth-century owner"* . . . Koningsberger, p. 169.

98 *"Historical accuracy was not"* . . . Blankert, *Vermeer of Delft*, p. 62.

98 *Worse still, a long list* . . . Bailey, *Vermeer*, pp. 215–16.

98 *The word* Bürger . . . Blankert, p. 68.

98 *The long-neglected Vermeer* . . . Bailey, *Vermeer*, p. 220.

99 *In 1816, the authors* . . . Blankert, *Vermeer of Delft*, pp. 64–65.

99 *In Amsterdam he found* . . . Bailey, *Vermeer*, p. 215.

99 *In Dresden he discovered* . . . Blankert, *Vermeer of Delft*, p. 156.

99 *In Brunswick he turned up* . . . Ibid., p. 159.

99 *"nowadays Mr. Bürger sees"* . . . Ben Broos, "Vermeer: Malice and Misconception," in Gaskell and Jonker, eds., *Vermeer Studies*, p. 22.

99 *Thoré-Bürger wrote enthusiastically* . . . Broos, "Malice," p. 23.

99 *"This devil of an artist"* . . . "Woman in Blue Reading a Letter," Wheelock, ed., *Johannes Vermeer*, p. 138.

100 *"Hardly a Dutch name"* . . . Broos, "Malice," p. 24.

100 *In his three essays* . . . Ibid., p. 23.

100 *"I hope that researchers"* . . . Théophile Thoré-Bürger, "Van der Meer de Delft (Suite)," *Gazette des Beaux Arts*, 1866, p. 470. This was the second of Thoré-Bürger's three Vermeer essays.

CHAPTER TWENTY-TWO: TWO FORGED VERMEERS

105 *"It is a frightful"* . . . René Gimpel, *Diary of an Art Dealer, 1918–1939*, p. 230.

106 *"an oracle of art-historical"* . . . Albert Blankert, " 'Dame Winter' by Caesar van Everdingen," in his *Selected Writings on Dutch Painting*, p. 209.

106 *"WE MUST SAY," they added* . . . These excerpts from Duveen's correspondence can be found at the Getty Research Institute, which houses the entire Duveen archives, or on microfilm in the Watson Library of the Metropolitan Museum of Art, where I consulted them. See Box 300, reel 155, folder 9 of the microfilms.

106 *Each time a new Vermeer appeared* . . . Arthur Wheelock's brilliant essay "The Story of Two Vermeer Forgeries" is by far the best account of this Vermeer fever and the follies it inspired. Much of my discussion in this chapter and the next follows Wheelock's essay.

106 *"It was not without emotion"* . . . This is Wheelock's translation in his "Two Forgeries" essay, p. 273. The original passage is in Seymour de Ricci, "Le quarante-et-unième Vermeer," *Gazette des Beaux-Arts* 16 (1927): 305–10. The quoted passage begins on p. 306. (The title means "The Forty-first Vermeer.")

107 *Mellon had purchased* . . . "The Girl with the Red Hat," in Wheelock, ed. *Johannes Vermeer*, p. 165.

107 *"a double-entry bookkeeper"* . . . Behrman, pp. 254–55.

107 *Mellon had not revealed* . . . David Cannadine, *Mellon*, pp. 130–31.

108 *"Duveen," one biographer tells us* . . . Meryle Secrest, *Duveen*, p. 303.

108 *By the time Mellon had walked* . . . Ibid.

108 *In 1936, when Mellon* ... Wheelock, "Two Forgeries," p. 275.

108 *In recent years* ... Wheelock, "Two Forgeries," p. 275.

108 *"It's just impossible"* ... Author interview, Dec. 19, 2005.

108 *That forger, he argues* ... Wheelock writes on p. 271 of "Two Forgeries" that "circumstan-
 tial evidence convinces me that all four of these paintings [Mellon's two Vermeers and
 De Groot's two Halses] originated in the workshop of Theodorus van Wijngaarden."
 On p. 426 he labels reproductions of *A Boy Smoking* and the *Smiling Girl* as "probably
 Theodorus van Wijngaarden," and on p. 427 he makes the same attribution for *The
 Lacemaker*. As noted in chapter 24, Hope Werness follows Marijke van den Brandhof in
 attributing the two "Halses" to Van Meegeren.

CHAPTER TWENTY-THREE: THE EXPERT'S EYE

109 *"To hear almost every year"* ... W. R. Valentiner, "A Newly Discovered Vermeer," *Art in
 America*, April 1928, p. 107.

110 *Arthur Wheelock points out* ... Wheelock, "Two Forgeries," p. 273.

111 *In a discussion of the* Smiling ... Broos, "Un celebre Peijntre," p. 65.

112 *"genuine and extraordinarily beautiful"* ... *Echt of Onecht? Oog of Chemie?* (The title means *True or
 False? Eye or Chemistry?*). My quotation follows the translation of Harry van de Waal,
 "Forgery as a Stylistic Problem," in *Aspects of Art Forgery*, p. 9. Van de Waal's essay, especially
 the sections on how hard it is for artists and forgers to escape their own era, is dazzling.

112 *"magnificent in the contrast of colors"* ... Cornelis Hofstede de Groot, "Some Recently Dis-
 covered Works by Frans Hals," *The Burlington Magazine* 45 (1924) 87.

112 *"This little gem"* ... De Groot, "Recently Discovered," p. 87.

112 *If he was wrong, he roared* ... Van de Waal, p. 10, quoting *Echt of Onecht?*

113 *"I should have to admit"* ... Ibid.

113 *An array of scientific tests* ... Otto Kurz, *Fakes*, p. 60.

113 *A modern restorer might* ... De Groot, *Echt of Onecht?*

113 *Knowing that the standard* ... Wheelock, "Two Forgeries," p. 272.

113 *"As I am firmly convinced"* ... Kurz, p. 61.

113 *"the inexpertness of the experts"* ... This remark and the one about the Dreyfus case are
 from Van de Waal, p. 10.

114 *Seeing where things* ... Kurz, p. 60.

114 *"probably painted about 1625–30"* ... De Groot, "Recently Discovered," p. 87.

114 *"from a dealer"* ... Ibid.

114 *"In the art of painting"* ... De Groot, *Echt of Onecht?*

CHAPTER TWENTY-FOUR: A FORGER'S LESSONS

115 *Hope Werness declares outright* ... Werness, "Han van Meegeren *fecit*," p. 18. Werness cites
 Van den Brandhof, pp. 67–77.

115 *Küffner sawed the panel* ... Sepp Schüller tells this story in *Forgers, Dealers, Experts*; see pp. 18–
 21. For a more recent, skeptical take, see Daniel Hess, "Dürer als Nürnberger Markenar-
 tikel," in *Quasi Centrum Europae Europa kauft in Nürnberg 1400–1800*, ed. Hermann Maué et
 al., 2002.

116 *"he had had the good fortune"* ... De Groot, *Echt of Onecht?*

118 *Hals's painting at the Schwerin museum* ... Van den Brandhof makes this point, p. 70.

118 "evidently the same boy"... This remark (and De Groot's exclamations of delight) are in De Groot, "Recently Discovered," p. 87.

118 "In no other field"... Van de Waal, p. 13.

118 The English painter Leo Stevenson... Leo Stevenson, "A Genuine Copy?," available online at www.leostevenson.com.

119 a "characteristic fairly early work"... Wheelock, "Two Forgeries," p. 273.

119 "one which, up to the present"... Ibid., p. 274.

119 The esteemed Vermeer scholar... Ibid.

119 Berenson's dismissal... Simpson, Artful Partners, p. 67.

120 "highly imaginative"... Jorgen Wadum, "Contours of Vermeer," Vermeer Studies, p. 223.

120 "Gratuitous nastiness is part"... Author interview, Nov. 8, 2005.

CHAPTER TWENTY-FIVE: BREDIUS

121 The best brief essay on Bredius's life is "Abraham Bredius, a Biography," by Louise Barnouw-de Ranitz, the source of many of the facts in this chapter. It is available online at the Bredius Museum website, http://www.museumbredius.nl/biography.htm.

121 he had been the first to praise... "Vermeer slays them all," Bredius wrote. "The head of a girl, which would almost have one forget that one is looking at a canvas, and the unique glow of light, take sole hold of your attention." See "Girl with a Pearl Earring," Wheelock, ed., Johannes Vermeer, p. 168.

122 His colleague's book was "horrible"... Catherine Scallen, Rembrandt, Reputation, and the Practice of Conoisseurship, p. 118.

122 he lent the museum twenty-five... Marjolein de Boer and Josephine Leistra, Bredius, Rembrandt en het Mauritshuis!!!

122 "Jumpy, agitated, nervous"... Barnouw-de Ranitz.

123 "murder of the century"... Theo van der Meer and Paul Snijders, "Ernstige moraliteits— toestanden in de residentie. Een 'whodunnit' over het Haagse zedenschandaal van 1920," Pro Memorie 4, no. 2 (2002): 373–408. (The title means "Moral Crisis in the Capital. A Whodunit About the Scandal of 1920.")

123 "consumed by jealousy"... Barnouw-de Ranitz.

124 "What a heresy, is it not"... Abraham Bredius, "Ein Pseudo-Vermeer in der Berliner Galerie," Kunst-Chronik 18 (1883): 67–71. (The title means "A Pseudo-Vermeer in the Berlin Gallery.") Ben Broos discusses Bredius's essay in "Vermeer: Malice and Misconception." See Gaskell and Jonker, eds., Vermeer Studies, p. 23.

124 "Rembrandt becomes closer and more precious"... Barnouw-de Ranitz.

125 "A short time ago"... Bredius, "An Unknown Rembrandt Portrait," The Burlington Magazine 48, 1926, p. 205.

125 "His door was always"... Marjolein de Boer, "Bredius Museum Reborn." This essay is available online at http://www.art.nl/journal/article.aspx?ID=8.

126 "Let us not forget"... Barnouw-de Ranitz.

CHAPTER TWENTY-SIX: "WITHOUT ANY DOUBT!"

127 "With this acquisition of the new"... "Allegory of Faith," Wheelock, ed. Johannes Vermeer, p. 194.

127 Bredius picked up the picture... "Allegory of Faith," Wheelock, ed., Johannes Vermeer, pp. 194–95, and Bailey, Vermeer p. 226.

127 *Nor do many other* . . . "Allegory of Faith," Ibid., p. 195, 20n.

129 *And the Utrecht Vermeer* . . . "Christ in the House of Mary and Martha," Wheelock, ed.,
 Johannes Vermeer, pp. 94–95.

129 *There an art dealer threw it in* . . . Ibid., pp. 90, 94.

129 *"I told him it was a Vermeer"* . . . *[London] Morning Post*, Jan. 14, 1927, p. 9.

129 *"Exactly as the M[aurits] huis Diana"* . . . "Diana and Her Companions," Wheelock, ed.,
 Johannes Vermeer, p. 100.

130 *"Diana never can have been his"* . . . P.T.A. Swillens, *Johannes Vermeer*. See "Works Wrongly
 Attributed to Vermeer," pp. 157–64. The *Diana* quote is from p. 159, the *Christ in the
 House* quote from p. 162.

131 *In 1989 the great scholar J. M. Montias* . . . "Young Girl with a Flute," Wheelock, ed. *Johannes
 Vermeer*, p. 207.

CHAPTER TWENTY-SEVEN: THE UNCANNY VALLEY

133 *Under the headline "Art as Dung"* . . . Gerritsen's article appeared in the *NRC Handelsblad* on
 Feb. 19, 1996. The letter to the editor from the director of the Kunsthal, Wim van
 Krimpen, ran on Feb. 21, 1996.

134 *Samuel Taylor Coleridge once saw* . . . Richard Holmes, "The Passionate Partnership," *New
 York Review of Books*, April 12, 2007, p. 44.

134 *Albert Blankert thinks it means* . . . Blankert, *Vermeer of Delft*, p. 73, and author interview with
 Wheelock, Dec. 19, 2005.

135 *The writer Clive Thompson spelled out* . . . Thompson's article appeared online at www.slate
 .com on June 9, 2004.

136 *A painstaking, seemingly perfect depiction* . . . Gombrich explored this topic in great depth, es-
 pecially in *Art and Illusion*. The chapter of that book called "The Beholder's Share" is a
 marvelous essay, stuffed with examples, on precisely this question.

136 *"an old shoe is easier"* . . . Franzen, "Growing Up with Charlie Brown," *The New Yorker*,
 Oct. 29, 2004. In a similar vein, the film critic A. O. Scott once wrote a meditation
 on "why certain faces haunt and move us as they do." The face he had in mind was
 not that of Mona Lisa or the girl with a pearl earring but Gromit, a cartoon dog who
 "has no mouth, and yet his face is one of the most expressive ever committed to the
 screen." See "A New Challenge for an Englishman and His Dog," *New York Times*,
 Oct. 5, 2005.

CHAPTER TWENTY-EIGHT: BETTING THE FARM

137 *"Vermeer was the painter Van Meegeren"* . . . Doudart de la Grée, p. 14.

137 *"a blessed terrain lay fallow"* . . . Ibid.

138 *"But with Rembrandt, everything"* . . . Author interview, Aug. 22, 2005.

CHAPTER TWENTY-NINE: *LADY AND GENTLEMAN AT THE HARPSICHORD*

139 *"one of the finest gems"* . . . Bredius, "An Unpublished Vermeer," *The Burlington Magazine*, Oct.
 1932, p. 145.

139 *The Hague had an active* . . . The source for this paragraph and the next is Werness, p. 17,
 quoting Van den Brandhof.

140 *could strut standing still* . . . Charlie Dressen, one-time manager of the Brooklyn Dodgers,
 supposedly used the phrase to describe the flamboyant star Big Ed Walsh.

140 *"No more intense detective work"*... This quotation, and all the others in this section of this chapter, are from Bredius's "An Unpublished Vermeer."

141 *almost certainly Van Meegeren's work*... Many writers simply assert as a matter of fact that it is Van Meegeren's. See, for example, Van den Brandhof, p. 93, or M. Kirby Talley, Jr., in Jones, p. 240. Albert Blankert notes that Duveen's Edward Fowles disagreed. See Blankert, "The Case of Han van Meegeren's Fake Vermeer *Supper at Emmaus* Reconsidered," p. 52, in *In His Milieu*, ed. A. Golahny et al. As discussed in chapter 37, Fowles's judgments on Van Meegeren warrant respect. Blankert's essay is the best and most thoughtful look at Van Meegeren and the art connoisseurs he befuddled.

141 *De Groot had treated Bredius*... Blankert, *Rembrandt: A Genius and His Impact*, p. 184.

142 *"Stripped of his cloak"*... Talley, in Jones, p. 240.

142 *"it is common talk"*... Blankert, "The Case of Van Meegeren," p. 52.

142 *The eminent Parisian dealer*... The comment on Wildenstein and Loebl comes from a letter written on October 19, 1932, by Edward Fowles, in the Paris office of Duveen Brothers, to Joseph Duveen in New York. The letter is in Duveen Brothers Records, Box 315, Folder 1, Special Collections, Archive Division, J. Paul Getty Trust.

143 *Each looked closely*... The books in question were Eduard Plietzsch, *Vermeer van Delft*, and Arie B. de Vries, *Jan Vermeer van Delft*.

143 *This was no oversight*... Blankert, "The Case of Van Meegeren," p. 52.

143 *Mannheimer was a man of colossal*... "Post-war Story," *Time*, Aug. 21, 1939.

143 *one-time protégé*... The reference to Schmidt-Degener as Bredius's protégé is from an essay by Wilhelm Martin, deputy director of the Mauritshuis under Bredius and later director in his own right. See http://www.maatschappijdernederlandseletterkunde.nl/mnl/levens/46–47/bredius.htm.

143 *"The Vermeer at Mannheimer"*... The art historian Jim van der Meer Mohr has dug deeper into the archives in quest of Bredius than any other researcher and has graciously shared many of his findings with me. The comment on Mannheimer appeared in a letter Bredius wrote to Hannema on Nov. 12, 1937. It can be found in a detailed chronology of the events of 1937 compiled by Van der Meer Mohr and based on his archival research. The chronology, "Bredius en zijn 'Emmausgangers van Vermeer.' Een nieuwe reconstructie aan de hand van de correspondentie van Dr. A. Bredius met Mr. G. A. Boon, Dr. D. Hannema, de Vereniging Rembrandt en anderen," can be found online at http://www.vandermeermohr.nl/AbrahamBredius/tabid/930/Default.aspx. (The title means "Bredius and *Christ at Emmaus*: A New Reconstruction Based on Dr. Bredius' Correspondence with Boon, Hannema, the Rembrandt Society, and Others.")

 Van der Meer Mohr has written several essays that highlight his findings. See "Eerherstel voor Abraham Bredius?" *Tableau* 18, no. 5 (April 1996): 39–45. (The title means "Rehabilitation for Abraham Bredius?" The article includes a summary in English.) See also Van der Meer Mohr's two-part article "Bredius en zijn '*Emmausgängers van Vermeer*': Een Nieuwe Reconstructie," *Origine* nos. 5 and 6 (2006).

143 *Bredius "knew himself"*... Lord Kilbracken, *Van Meegeren: Master Forger*, p. 101. Thomas Hoving writes in the same vein in *False Impressions*, p. 171. "Van Meegeren had learned that to foist a forgery on the world one had only to fool a single expert. Once he had been taken in, the mark would do all the work to convince the rest of the world that an unknown masterwork had been found."

143 *"Bredius' authority on Vermeer matters"*... Blankert, "The Case of Van Meegeren," p. 48.

144 *Bredius's assistant, Hans Schneider* . . . Ibid., p. 51.

144 *"I meant to have my picture hang"* . . . Sepp Schüller, *Forgers, Dealers, Experts: Strange Chapters in the History of Art*, p 97. Schüller does not give a source, and I have not been able to find the remark elsewhere.

CHAPTER THIRTY: DIRK HANNEMA

145 *Tall, handsome, aristocratic* . . . The summary of Hannema's career in this chapter is based on Max Pam's essay "De tragiek van het onfeilbare oog. Over Dirk Hannema," in his *De Armen van de inktvis.* (The title means "The Tragedy of an Infallible Eye.")

147 *"Never throw anything away"* . . . Pam, "Het onfeilbare oog"

147 *Van Beuningen refused* . . . Pierre Cabanne, *The Great Collectors*, p. 140. Van Beuningen's painting, sometimes called the *Little 'Tower of Babel,'* is now in Rotterdam's Boymans Museum; Brueghel's more famous *Tower of Babel* hangs in Vienna's Kunsthistorisches Museum.

148 *"a building with serenity"* . . . Ibid.

148 *"what to many had long seemed"* . . . Broos, "Un celebre Peijntre," p. 61.

148 *"Never in living memory* . . . Ibid.

148 *One hundred thousand enthralled* . . . Pam, "Het onfeilbare oog."

148 *"Next to Rembrandt," museumgoers read* . . . Broos, "Un celebre Peijntre," p. 61.

148 *"Each creation [of Vermeer's]"* . . . D. Hannema and A. van Schendel, Jr., *Noord- en Zuid-Nederlandsche Schilderkunst der XVIIe eeuw*, pp. 14–16.

148 *A Dutch art historian argued* . . . W. R. Juynboll assigned the *Magdalene Under the Cross* (which Hannema had assigned to Vermeer) to Tournier. Juynboll's observation appeared not in an article about the Hannema exhibition but in a review of a book by Alfred Leroy, *Histoire de la peinture francaise au XVIIe siècle (1600–1700).* See *Nieuwe Rotterdamsche Courant*, March 10, 1936.

149 *In their Vermeer books* . . . Blankert, "The Case of Van Meegeren," p. 53.

CHAPTER THIRTY-ONE: THE CHOICE

150 *"It is unique in the history"* . . . Russell, *Sunday Times [of London]*, Oct. 23, 1955.

151 *"How long would it take you"* . . . Ronald D. Spencer, ed., *The Expert versus the Object*, p. 205.

152 *"On one hand there are the rare"* . . . Hannema and van Schendel, Jr., pp. 14–16.

152 *"It is," the art historian Christopher Wright* . . . Wright, *Vermeer*, p. 20.

152 *there was no agreement in the 1930s* . . . Blankert, personal communication, Dec. 12, 2005.

152 *Piltdown Man* . . . For the best short account of the Piltdown affair, see Stephen Jay Gould's essay "Piltdown Revisited" in *The Panda's Thumb* (New York: Norton, 1982).

153 *"Man at first . . . was merely an Ape"* . . . Ibid., p. 117.

CHAPTER THIRTY-TWO: THE CARAVAGGIO CONNECTION

163 *Caravaggio was a brilliant, mischievous choice* . . . See, for example, the suggestion of the Belgian sculptor and critic Jean Decoen (who was destined to play a farcical role in the Van Meegeren saga) in *The Burlington Magazine*. Decoen proposed that "at the age of 13 or 14, Vermeer was learning the rudiments of his art at Delft. He then left for Italy, where he remained two or three years (1648–1650), returned to Holland, stopped at Utrecht where he stayed during the following two years, and afterwards made his way to Delft, where from 1653 he installed himself finally." Jean Decoen, "Shorter Notices:

The New Museum at Rotterdam," *The Burlington Magazine* 67, July/December 1935, pp. 131–32.

164 *Vermeer indisputably knew* . . . His mother-in-law owned Baburen's *Procuress*, for example, and Vermeer painted it into the background of both *The Concert* and *Lady Seated at a Virginal.* See Blankert, *Vermeer* of Delft, p. 170, and Wheelock, ed., *Johannes Vermeer*, p. 16–17.

164 *"They are related to early"* . . . D. Hannema, *Vermeer: Oorsprong en Invloed.* (The title means "Origins and Influences.")

164 *"Perhaps tomorrow we will discover"* . . . Pieter Koomen, *Maandblad voor Beeldende Kunsten*, December, 1935. See "Vermeer en zijn verwanten" (The title means "Vermeer and Related Artists.")

CHAPTER THIRTY-THREE: IN THE FORGER'S STUDIO

167 *He began with a trip* . . . Doudart de la Grée, p. 82.

168 *The Raising of Lazarus* . . . P. B. Coremans, *Van Meegeren's Faked Vermeers and De Hooghs*, p. 9. Coremans was the scientist who proved that Van Meegeren's "Vermeers" were indeed forgeries. His account of his findings is one of the essential Van Meegeren texts.

168 *One modern-day expert estimates* . . . Leo Stevenson, personal communication, Nov. 3, 2006.

169 *The famously bare white wall* . . . "The Milkmaid," Wheelock, ed., *Johannes Vermeer*, p. 108. X-rays show that in *Girl Asleep at a Table* Vermeer painted over a dog in the doorway and a man in the next room. See Norbert Schneider, *Vermeer*, p. 27.

169 *The canvas in front of him measured* . . . Leo Stevenson, an English painter and art historian who has carried out experiments on scraping paint off old canvases, described the process to me. Personal communication, July 4, 2006.

169 *The Girl with a Red Hat* . . . "The Girl with the Red Hat," Wheelock, ed., *Johannes Vermeer*, p. 162.

CHAPTER THIRTY-FOUR: *CHRIST AT EMMAUS*

170 *The actual painting took* . . . Coremans, p. 32.

171 *"He did not copy Caravaggio's"* . . . Kraaijpoel, personal communication, Jan. 2, 2006.

171 *They marveled at the painting's "serenity"* . . . C. Veth, "Meesterwerken uit vier eeuwen," *Maandblad voor Beeldende Kunsten* 15, July 1938. (The title means "Masterpieces of Four Centuries.")

171 *Others were allusions to* . . . Theodore Rousseau pointed out the allusions to *Christ in the House of Mary and Martha, The Procuress, The Astronomer*, and several more. See "The Stylistic Detection of Forgeries," *Bulletin of the Metropolitan Museum of Art* 26 (1967–68), 248.

171 *The signature, a neat "I V Meer"* . . . Albert Blankert, personal communication, Aug. 25, 2005.

171 *"Do you know how long"* . . . Doudart de la Grée, p. 91.

CHAPTER THIRTY-FIVE: UNDERGROUND TREMORS

173 *That meant sliding* . . . Coremans, p. 20.

175 *In a typical seventeenth-century oil* . . . Leo Stevenson spoke to me in great detail about how and why cracks form in oil paintings. Stevenson, who has carried out many experiments of his own, emphatically rejects Van Meegeren's account.

175 *"Nowadays you just use"* . . . Kraaijpoel, personal communication, June 29, 2006.

176 *"Like miniature tectonic plates"* . . . Stevenson, personal communication, July 4, 2006.

176 *Then, pushing gently but firmly* . . . Doudart de la Grée.

176 *Van Meegeren would later claim* . . . Lord Kilbracken, *Van Meegeren: Master Forger*, p. 42.

178 *The back of Jesus' right hand* . . . Ibid., p. 55.

CHAPTER THIRTY-SIX: THE SUMMER OF 1937

179 *"Germany has to realize"*... Lopez, Sept. 29, 2006.

180 *"They were confirmed anti-Fascists"*... Ibid.

180 *The collection numbered 162*... Coremans, p. 30.

181 *At the end of June 1937*... As the rest of this chapter makes clear, this date is disputed. Kronig's letter on July 1, 1937, quoted on page 182, refers to Boon's recent visit to Bredius and to *Emmaus*. On August 30, 1937, Boon wrote to Bredius as if the two men had never met. In his letter to the NRC on March 2, 1938, Boon describes his first meeting with Bredius but does not mention a date.

181 *Bredius warned Boon*... See Boon's letter to the *Nieuwe Rotterdamsche Courant*, March 2, 1938.

181 *"delicious Vermeer"*... The phrase occurs in a letter from Bredius to Hannema written on Sept. 13, 1937. Van der Meer Mohr, "Reconstructie."

181 *"wonderful moment"*... Bredius, "A New Vermeer," p. 210.

181 *"in an almost overwrought state"*... Bredius letter to Hannema written on Sept. 9, 1937. Van der Meer Mohr, "Reconstructie."

181 *"As requested by Dr. A. Bredius"*... Van der Meer Mohr, "Reconstructie."

182 *"Dear sir," Boon wrote*... Ibid.

183 *Boon and Bredius kept diaries*... Ibid.

183 *Perhaps the simplest scenario*... Van der Meer Mohr suspects that Bredius genuinely was unavailable at the time of Kronig's first visit. He believes that Bredius was in Holland at the time. Van der Meer Mohr has managed to track some of Bredius's comings and goings in that summer, but documentation for the crucial dates remains elusive.

183 *But Albert Blankert, the Dutch art historian believes*... Blankert and I debated the events of this mysterious summer endlessly, in dozens of exchanges throughout 2005–2007. He included some of his thoughts on this question in Blankert, "The Case of Van Meegeren."

184 *"it belongs in your archives"*... Bredius letter to Hannema written on Feb. 10, 1938, Van der Meer Mohr, "Reconstructie."

185 *"I am in a state of anxiety"*... Van der Meer Mohr, "Reconstructie."

185 *"This gorgeous work by Vermeer"*... Ibid.

CHAPTER THIRTY-SEVEN: THE LAMB AT THE BANK

186 *"a charming man"*... Bredius letter to Hannema written on Sept. 13, 1937, Van der Meer Mohr, "Reconstructie."

186 *He wrote to the Rembrandt*... Bredius letter written on Dec. 2, 1937, Van der Meer Mohr, "Reconstructie."

187 *He wrote to the minister*... Bredius letter written on Sept. 15, 1937, Van der Meer Mohr, "Reconstructie."

187 *"When an archer is shooting"*... Thomas Merton, *The Way of Chuang Tzu* (New York: New Directions, 1969) p. 158.

187 *"In raptures about discovery"*... Van der Meer Mohr, "Reconstructie."

188 *"These bargains were for somebody else"*... *Het Museum-Boijmans te Rotterdam door P. Haverkorn van Rijsewijk, Oud-Director van het Museum*, Amsterdam, pp. 215–33.

188 *"If only those in power"*... *Nieuwe Rotterdamsche Courant*, Aug. 24, 1935.

188 *Rotterdam had "lost"*... *Nieuwe Rotterdamsche Courant*, Oct. 30, 1932, "Johannes Vermeer van Delft, 31 October 1632–13 December 1675."

188 *"Mr. Boon informed me"*... Van der Meer Mohr, "Reconstructie."

188 *Duveen had been the one to plant*... Behrman, *Duveen*, p. 260.

188 *"If Duveen offered me two"*... Ibid., p. 139.

189 *"Lord Duveen will immediately sell"*... Bredius letter to Hannema written on Sept. 13, 1937, Van der Meer Mohr, "Reconstructie."

189 *"an almost infallible eye"*... Secrest, *Duveen*, p. 180.

189 *"The moment we looked"*... Letter written by Fowles on May 1, 1952, in Duveen Archives, Watson Library, Metropolitan Museum of Art, Box 300, reel 155, folder 9 of the microfilms.

189 *"a poor piece of painted up linoleum"*... Blankert, "The Case of Van Meegeren," p. 50.

189 *"The thing I can never understand"*... Letter written by Fowles on Sept. 15, 1951, Duveen Archives, Watson Library, Metropolitan Museum of Art, Box 300, reel 155, folder 9 of the microfilms.

190 *Had Duveen's men truly hated*... Boon letter to Bredius written on March 3, 1938. See the last paragraph of the letter, which begins, "One thing I hope to find out some day: was it ignorance or cunning on Duveen's part?" Van der Meer Mohr, "Reconstructie."

190 *"Fortunately you have seen"*... Bredius letter to Hannema written on Nov. 12, 1937. Van der Meer Mohr, "Reconstructie."

191 *"the old man, past his prime"*... Bredius letter to Rembrandt Society written on Dec. 2, 1937, and Bredius letter to Martin written on Dec. 3, 1937. Van der Meer Mohr, "Reconstructie."

CHAPTER THIRTY-EIGHT: "EVERY INCH A VERMEER"

192 *"It is a wonderful moment"*... Bredius, "A New Vermeer," p. 210.

193 *"Go and see the painting"*... Bredius letter to Hannema written on Nov. 19, 1937, Van der Meer Mohr, "Reconstructie."

193 *Titian, one story has it*... Quoting Seymour Keck, the renowned conservator, in Harris, *The New Yorker*, Sept. 16, 1961.

193 *its account was "in total disagreement"*... Boon's letter appeared in the *Nieuwe Rotterdamsche Courant* on March 2, 1938.

194 *"every inch a Vermeer"*... Bredius, "A New Vermeer," p. 210.

194 *This painting was different*... Weerdenburg makes this argument in her doctoral thesis. See full citation in chapter 46.

194 *"conscious and deliberate decision"*... Kilbracken, p. 40.

195 *"I notice that you do not say anything"*... Jim van der Meer Mohr kindly provided me a copy of this letter, which Read sent to Bredius on Sept. 22, 1937.

196 *the great majority of connoisseurs attributed*... Weerdenburg, pp. 49 and 80.

196 *"Emmaus is from the painter's late"*... Veth, "Meesterwerken uit vier eeuwen."

196 *One notable exception was*... J. H. Huizinga, *Dutch Civilization*, p. 84.

197 *Bredius mentioned three surprises*... Bredius, "The New 'Delft' (!) Vermeer in London," *Nieuwe Rotterdamsche Courant*, March 27, 1901.

CHAPTER THIRTY-NINE: TWO WEEKS AND COUNTING

198 *"There are only 40"*... Bredius letter to Hannema written on Dec. 7, 1937, Van der Meer Mohr, "Reconstructie."

198 *"I had assembled a considerable sum"*... Hannema letter to Bredius written on Dec. 8, 1937, Van der Meer Mohr, "Reconstructie."

198 *"authentic as gold"* . . . Bredius letter to Van Hasselt written on Dec. 9, 1937, Van der Meer
 Mohr, "Reconstructie."

198 *"there* has *to be a rich man"* . . . Bredius letter to Van Hasselt, president of the Rembrandt
 Society, written on Dec. 11, 1937, Van der Meer Mohr, "Reconstructie."

198 *if only* he *could afford* . . . See, for example, Bredius letters of Dec. 8, 1937, and Dec. 11, 1937,
 Van der Meer Mohr, "Reconstructie."

198 *"Everything possible must be done"* . . . Dec. 13, 1937 meeting of the Rembrandt Society, Van
 der Meer Mohr, "Reconstructie."

199 *Two days later, Boon wrote* . . . Boon letter to Bredius, Dec. 15, 1937, Van der Meer Mohr,
 "Reconstructie."

199 *Bredius immediately wrote* . . . Letter written Dec. 15, 1937, Van der Meer Mohr, "Recon-
 structie."

200 *"Do I need to tell you"* . . . Bredius letter to Van Hasselt written Dec. 26, 1937. Van der
 Meer Mohr, "Reconstructie."

200 *"People will talk for a long time"* . . . Bredius letter to Hannema written on or near Dec. 26,
 1937, Van der Meer Mohr, "Reconstructie."

CHAPTER FORTY: TOO LATE!

201 *"Duveen's little man-servant"* . . . Bredius letter to Hannema written on Nov. 12, 1937, Van
 der Meer Mohr, "Reconstructie."

201 *"A connoisseur's eye is like a musical ear"* . . . Schmidt-Degener's remark was cited in his obitu-
 ary in the *New York Times* on Nov. 22, 1941.

202 *Hannema listened politely* . . . Hannema tells the story of this meeting in his autobiography,
 Flitsen uit mijn Leven, p. 106 (Rotterdam: Ad Donker, 1973). (The title means *Glimpses of
 My Life*.) If we had only his account, we might suspect that he had invented or embel-
 lished the tale to save face—if Schmidt-Degener and the Rijksmuseum had proposed
 to trade one of their own Vermeers (and more) for *Emmaus*, then surely no one could
 blame Hannema for what turned out to be a colossal misjudgment. But we have a sec-
 ond, independent source that confirms Schmidt-Degener's eagerness for *Emmaus*. This
 was an account of Schmidt-Degener's tenure as director of the Rijksmuseum, written
 on the occasion of the museum's 175th anniversary. See G. Luijten, " 'De Veelheid en de
 eelheid': een Rijksmuseum Schmidt-Degener" in *Nederlands Kunsthistorisch Jaarboek* 1984
 (1935), pp. 387–88.

CHAPTER FORTY-ONE: THE LAST HURDLE

203 *"What a difference,"* Bredius exclaimed . . . Bredius, "Nog een word over Vermeer's *Emmaus-
 gangers*," *Oud Holland* 55 (1938): pp. 97–99. Unless otherwise attributed, all quotations
 from Bredius in this section are from this article.

204 *"If only it doesn't get"* . . . Bredius letter to Rembrandt Society written on Dec. 2, 1937, Van
 der Meer Mohr, "Reconstructie."

204 *"Do you know what I'm scared"* . . . Bredius letter to Hannema written very near Jan. 4, 1938,
 Van der Meer Mohr, "Reconstructie."

206 *"ripe for the restorer"* . . . Author interview, Jan. 17, 2006.

206 *Neither Luitwieler nor anyone else* . . . Coremans, p. 35.

206 *When it came to the technical side* . . . Author interview, Jan. 17, 2006. That judgment echoes the
 verdict of P. B. Coremans, the Belgian scientist who headed the official investigation

of Van Meegeren's fakes. In his article on forgery, the journalist Richard Harris quoted Sheldon Keck, a renowned American authority on the scientific study of paintings: "Van Meegeren was close to being a genius." See *The New Yorker*, Sept. 16, 1961, p. 139.

206 *On July 18, 1945* . . . "Cheating the Dutch," *Newsweek*, July 20, 1945.

CHAPTER FORTY-TWO: THE UNVEILING

207 *"I can still see the painting"* . . . Pam, "Het onfeilbare oog."
208 Time *magazine's art critic* . . . "From a Linen Closet," *Time*, Sept. 19, 1938.
208 *Van Meegeren liked to tell* . . . Kilbracken, p. 184.
209 *"The discovery of* Emmaus" . . . F. van Thienen, *Vermeer*, quoted in Weerdenburg.

CHAPTER FORTY-THREE: SCANDAL IN THE ARCHIVES

213 *"It's awful that it's one of our most"* . . . Author interview, Aug. 25, 2005.
214 *"They sold just the same"* . . . Coremans, p. 33.
215 *"Each new biblical 'Vermeer'"* . . . Van Beuningen, the Rotterdam collector, said that he expected more Vermeers to turn up after *Emmaus* and *Head of Christ*, "because I was convinced that such creations could not stand by themselves." See Kraaijpoel and Van Wijnen, p. 75.
215 *"What appeared impossible"* . . . Bredius, "Een Prachtige Pieter de Hoogh," *Oud Holland*, 56 (1939), 126—27.
216 *"women by the dozen"* . . . Joop Piller and Van Meegeren would become friends of a sort, and Van Meegeren regaled Piller with endless tales of debauchery. Author interview with Harry Van Wijnen, Aug. 25, 2005.
216 *In 1942, when the government issued* . . . Kraaijpoel and Van Wijnen, p. 70.
217 *"It looks disturbingly as though"* . . . Werness, p. 41.
217 *"I do not understand"* . . . Kilbracken, p. 180.

CHAPTER FORTY-FOUR: ALL IN THE TIMING

218 *men spent more on a single bulb* . . . Anna Pavord, *The Tulip* (New York: Bloomsbury, 1999), p. 133.
218 *"a nobler creation has, perhaps, never"* . . . Dirk Hannema, "*Annual Report of the Rembrandt Society, 1937*," quoted in Van Dantzig, *Vermeer, De Emmausgangers en de critici*, p. 73.
218 *"After a comparison of both works"* . . . Dr. J.L.A.A.M. Van Rijckevorsel, *Historia Boymansnummer: Vermeer en Caravaggio*," . . . July 1938, quoted in Van Dantzig, *Vermeer*, pp. 83—84.
218 *"Amidst the anxious and seemingly hopeless"* . . . Blankert, *Vermeer of Delft*, p. 73.
219 *But when the same sentiment was sanctified* . . . My remark is a paraphrase of Blankert's observation in *Vermeer of Delft*, p. 73.
219 *"Because Holland was so sturdy"* . . . Anne O'Hare McCormick, "Jewels of Holland's Art Illumine a Cave," *New York Times*, December 4, 1944.
219 *Daniel Mendelsohn has looked* . . . Daniel Mendelsohn, "Novel of the Year," *New York Review of Books*, Jan. 16, 2003.
220 *If he had lived half a century earlier* . . . Kraaijpoel and Van Wijnen, p. 44.
220 *"With the old masters"* . . . Ibid., p. 43.
221 *"Death seems truly conquered here"* . . . G. Knuttel, *De Nederlandsche schilderkunst van van Eyck tot van Gogh*, p. 308, quoted in Weerdenburg.
221 *"Forgery is a kind of short-cut"* . . . Kurz, p. 320.

221 *When the critic Kenneth Clark* . . . Jones, ed., pp. 34–35.

222 *"Forgeries must be served hot"* . . . Max Friedländer, "On Forgeries," in Ronald D. Spencer, ed., *The Expert versus The Object*, p. 41. (This essay is a chapter from Friedländer's *On Art and Connoisseurship*.)

222 *It is a rule with* . . . Rousseau, "Stylistic Detection," p. 247.

CHAPTER FORTY-FIVE: BELIEVING IS SEEING

223 *"We have a saying"* . . . Author interview, Aug. 22, 2005.

224 *"The main reason why a scholar"* . . . David Hirshleifer, "The Blind Leading the Blind: Social Influence, Fads, and Informational Cascades," UCLA, Anderson Graduate School of Management, Paper 1156, 1993.

224 *"One of our most prominent scholars"* . . . Rousseau, "Stylistic Detection," p. 252.

224 *"Before the second world war"* . . . Author interview, Aug. 23, 2005.

224 *In 1977 a prankster* . . . "Polish Joke," *Time*, Feb. 19, 1979.

224 *To cry "fake!"* . . . Thomas Hoving remarks that "the worst thing you can do is to stamp a genuine piece with the mark of falsehood," and he quotes Max Friedländer's observation that "It is indeed an error to collect a forgery, but it is a sin to stamp a genuine piece with the seal of forgery." See Hoving, "The Game of Duplicity," *Bulletin of the Metropolitan Museum of Art* 26 (1967–68), pp. 241, 246.

225 *Connoisseurs, wrote Van de Waal* . . . Van de Waal, "Forgery as a Stylistic Problem."

226 *the number on our bathroom scale* . . . Daniel Gilbert provided the bathroom scale example in an op-ed entitled "I'm Ok, You're Biased," in *New York Times*, on April 17, 2006. He explored self-deception and related topics at greater length in his intriguing book *Stumbling on Happiness*.

226 *Half the babies were* . . . Spelke told this story in a debate with Steven Pinker at Harvard on May 16, 2005. The debate was called "The Science of Gender and Science." A transcript can be found at http://www.edge.org/3rd_culture/debate05/debate05_index.html.

226 *He clung to the paintings* . . . Wheelock, "Two Forgeries," p. 271.

226 *"A man with a conviction"* . . . Festinger had been studying a group of religious believers who had declared that the world would end on a particular day. His classic account, *When Prophecy Failed*, described their response when the world went on as usual. In short, the believers clung to their faith and decided that somehow their calculations had gone awry.

226 *"Even before the war"* . . . Joachim C. Fest, *The Face of the Third Reich*, p. 59.

CHAPTER FORTY-SIX: THE MEN WHO KNEW TOO MUCH

227 *"When you're certain you cannot"* . . . Teller, "The Grift of the Magi," *New York Times Book Review*, Feb. 13, 2005. Teller, the silent half of Penn and Teller, was reviewing Peter Lamont's *Rise of the Indian Rope Trick: How a Spectacular Hoax Became History*.

227 *"There are some mistakes"* . . . The remark may be apocryphal. The political scientist Francis Fukuyama attributed it to Moynihan in a television interview. I have not been able to track it to the source. Perhaps Fukuyama had in mind Orwell's comment, in "Notes on Nationalism," that "one has to belong to the intelligentsia to believe things like that: no ordinary man could be such a fool."

227 *Bredius himself compared* . . . In his essay "A New Vermeer," quoted earlier.

227 *The eminent astronomer Percival Lowell* . . . Lowell, *Mars*, chap. 4 (Boston: Houghton, Mifflin, 1895).

228 *"It's not as simple"* . . . Jim Steinmeyer, "The Simple Art of Deception," *Montreal Gazette*, April 16, 2004. Steinmeyer discusses this question at greater length in his fine book *Hiding the Elephant.*

228 *In one classic study* . . . Fischoff, Slovic, and Lichtenstein, "Knowing with Certainty: The Appropriateness of Extreme Confidence," *Journal of Experimental Psychology* 3 (1977): 552–64. My description follows the account in Massimo Piattelli-Palmarini, *Inevitable Illusions*, pp. 116–20.

229 *"It is therefore most important"* . . . Piattelli-Palmarini, p. 120.

229 *"You know what forgers do"* . . . John McPhee, *A Roomful of Hovings*, p. 23.

229 *Sir George Hill* . . . Jones, ed., p. 172.

229 *The wine connoisseur immediately recognizes* . . . Max Friedländer, "Artistic Quality: Original and Copy," *The Burlington Magazine*, May 1941. (This essay is a chapter from Friedländer's *On Art and Connoisseurship.*)

230 *Frédéric Brochet gave fifty-four experts* . . . "Cheeky little test exposes wine experts as weak and flat," *The Times [of London]*, Jan. 14, 2002.

231 *"When I studied art history"* . . . Author interview, Aug. 26, 2005.

231 *Arabs see a furry* . . . N. R. Hanson gives this example in *Patterns of Discovery*, p. 19.

231 *Before Van Meegeren was unmasked* . . . Sandra Weerdenburg, *De Emmausgangers: een omslag in waardering*, Utrecht, 1988.

233 *"Who would have believed"* . . . Quoted in Clara Pinto-Correia, *The Ovary of Eve* (Chicago: University of Chicago Press, 1997), p. 231. This charming history argues that the conventional story of "the little man in the sperm cell" may misrepresent the true, and tangled, story.

CHAPTER FORTY-SEVEN: BLUE MONDAY

236 *The artist's right hand looks swollen* . . . Diederik Kraaijpoel calls attention to this oddly painted hand in Kraaijpoel and Van Wijnen, p. 32.

237 *The curious result is that* . . . See the discussion in Bailey, *Responses to Rembrandt*, pp. 73–74.

237 Bathsheba, *"the most beautiful nude"* . . . Simon Schama, *Rembrandt's Eyes*, p. 551.

237 *"It is a question of not just how well"* . . . Bailey, *Responses to Rembrandt*, p. 73.

238 *Kraaijpoel cites specific weaknesses* . . . Kraaijpoel and Van Wijnen, pp. 31–34, and personal communication, Dec. 11, 2005.

238 *The police would later find* . . . Coremans includes a photo of several such objects. See his plate 45. The glasses and pitcher in Coremans' photo look slightly different from those in *Emmaus*. Kilbracken suggests that at the time Van Meegeren painted *Emmaus* he owned the white jug but not the other artifacts. See Kilbracken, p. 46.

238 *"If you have painted two or three thousand"* . . . David Anderson, "Old Masters to Order: Forgery as a Fine Art," *New York Times Magazine*, Dec. 23, 1945.

CHAPTER FORTY-EIGHT: HE WHO HESITATES

239 *"Sometimes it is a question of lovely equipoise"* . . . Max Friedländer, "Artistic Quality: Original and Copy," *The Burlington Magazine* 78, May 1941, p. 143.

240 *"You figure it out, I know it."* . . . Tom Mueller, "Your Move," *The New Yorker*, Dec. 12, 2005.

240 *"He was as good at recognizing"* . . . Blankert, personal communication, Dec. 2, 2006.

240 *Malcolm Gladwell began his book* . . . Gladwell's book is eye-opening and provocative. He tells the Hoving story on pp. 3–8.

241 *Did it take him two seconds* . . . Sue Halpern makes this point in a fine essay reviewing *Blink* and a second book. See Sue Halpern, "The Moment of Truth?" *New York Review of Books,* April 28, 2005.

241 *"I always swoon when I see"* . . . Christopher Reed, "Wrong!" *Harvard Magazine,* Sept.–Oct., 2004.

241 *"picking out, in seconds, the fuzzy"* . . . Thomas Hoving, *Master Pieces,* pp. 6–7.

241 *The pianist Lorin Hollander* . . . Marie Winn, *New York Times Magazine,* Dec. 23, 1979.

242 *"Provenance is a laugh"* . . . Author interview, Nov. 16, 2005.

242 *"That's the trouble with an 'eye'"* . . . Author interview, Aug. 26, 2005.

CHAPTER FORTY-NINE: THE GREAT CHANGEOVER

243 *"sometimes so thorough"* . . . J. C. Masterman, *The Double-Cross System,* p. 18.

243 *"It appeared that the only quality"* . . . Ibid., p. 30.

244 *"Look at it from Bredius's"* . . . Author interview, Nov. 16, 2005.

244 *"They'll help us all the way"* . . . Clifford Irving tells his story in *The Hoax.* This quote is from p. 69.

245 *His publishers swallowed* . . . Ibid., pp. 169–70, 209.

245 *"It's got to occur to them"* . . . Ibid., p. 269.

CHAPTER FIFTY: THE SECRET IN THE SALT MINE

249 *"In the last weeks of the war"* . . . Osmar White, *Conqueror's Road,* p. 65.

249 *"At the height of its war effort"* . . . Flanner, p. 266. For a history of the Monuments Men (and hundreds of photographs), see Robert M. Edsel, *Rescuing da Vinci.*

250 *a peak of perhaps 80* . . . Flanner, p. 269.

250 *art at fifty-three different locations* . . . White, p. 65.

250 *a private named Mootz* . . . This account is taken from White, p. 68, and Flanner, p. 276.

251 *On both sides of the tracks* . . . Greg Bradsher, "Nazi Gold: The Merkers Mine Treasure," *Prologue: Quarterly of the National Archives and Records Administration* 31, no. 1 (Spring 1999).

251 *"With weary courtesy"* . . . White, p. 70.

CHAPTER FIFTY-ONE: THE DENTIST'S TALE

252 *The private's job was* . . . Lincoln Kirstein, *Rhymes of a PFC.* See "Arts and Monuments," pp. 200–205.

253 *Bunjes, one historian would later write* . . . Flanner, p. 252.

253 *"Information tumbled out"* . . . Lincoln Kirstein, "The Quest of the Golden Lamb," *Town and Country,* Sept. 1945.

253 *Platoons of workmen had built* . . . The details in this paragraph are from Nicholas, p. 314 (temperature and humidity); Howe, p. 150 (four tiers); Milton Esterow, *The Art Stealers,* p. 90 (Nazi orders); Hugh McLeave, *Rogues in the Gallery,* p. 227 (urgent pleas) (Boston: David Godine, 1981).

253 *No help was forthcoming* . . . Nicholas, p. 332, and Kirstein, "Arts and Monuments," p. 204.

254 *worked since 1310* . . . Kirstein, "Golden Lamb."

254 *There they beheld* . . . Ibid.

254 *The altarpiece included twelve* . . . Esterow, *The Art Stealers,* p. 86.

255 *Here were painting upon painting* . . . Howe, pp. 151–53.

255 *"6577 paintings, 2300 drawings"* . . . Nicholas, p. 348.

CHAPTER FIFTY-TWO: GOERING ON THE RUN

256 *Goering had begun shipping* . . . Nicholas, p. 318.

256 *Goering sent the soldiers* . . . Kenneth D. Alford, *Great Treasure Stories of World War II*, p. 30.

256 *"From one private house"* . . . David Irving, p. 451.

256 *The prizes of Goering's collection* . . . Nicholas, p. 318.

256 *Goering shot four bison* . . . Mosley, p. 374.

257 *the engineers set off their dynamite* . . . Ibid.

257 *crazy or close to it* . . . See, for instance, Fest, p. 60.

257 *"I as your deputy"* Mosley, p. 378.

257 *"YOU WILL BE RESPONSIBLE"* . . . Ibid., p. 381.

257 *three trains had left* . . . Nicholas, p. 319.

257 *"The German army was retreating"* . . . Alford, p. 31.

258 *an American soldier named Jerome Shapiro* . . . "GI Recalls the Capture of Holocaust Architect," *Los Angeles Daily News*, May 4, 2005; "Jerome Shapiro, Caught Goering," *New York Times*, April 10, 1968; author interview with Stephanie Mellen, Shapiro's daughter, Jan. 25, 2007.

258 *Operating under the delusion* . . . Mosley, pp. 386–87.

258 *the Americans ordered Goering* . . . Ibid., p. 388.

258 *deep within an air raid bunker* . . . Nicholas, p. 320.

258 *"The whole population seemed to be"* . . . Ibid.

259 *Grabbing anything they could carry* . . . Ibid., and Howe, p. 190.

259 *a Monuments Man named James Rorimer* . . . James Rorimer, *Survival: The Salvage and Protection of Art in War*, p. 199.

259 *The Germans had flung tapestries* . . . Nicholas, p. 320, and David Irving, p. 470.

259 *The American soldiers collected* . . . Nicholas, p. 320, and Alford, p. 37.

CHAPTER FIFTY-THREE: THE NEST EGG

260 *Maj. Harry Anderson* . . . Howe, p. 191, and "Goering Gave Nurse a $1,000,000 Vermeer," *New York Times*, May 22, 1945.

261 *"A large bedroom was almost filled"* . . . White, pp. 72–74.

CHAPTER FIFTY-FOUR: TRAPPED!

262 *"such a collection of what men call wealth"* . . . White, p. 65.

262 *tagged as item 5295* . . . Nancy Yeide, personal communication, Oct. 3, 2005. Yeide is head of the Department of Curatorial Records at the National Gallery of Art in Washington, D.C. She is completing a catalog of Goering's entire painting collection.

262 *rumors of "hatchet day"* . . . Maass, p. 245.

263 *Before a Dutch policeman* . . . Harry van Wijnen, personal communication, May 12, 2006.

263 *Some 120,000 Dutch collaborators* . . . *The Dutch Resistance Museum*, p. 117.

263 *a middleman did the actual work* . . . Kraaijpoel and Van Wijnen.

264 *secretly supported the Resistance* . . . Theodore Rousseau reported Miedl's claim. See "Stylistic Detection," p. 252.

264 *in the gray area between* . . . Lynn Nicholas, personal communication, May 4, 2006.

264 *At the end of a tangled and dubious* . . . Nicholas, p. 106.

264 *Rienstra told Van Meegeren he was done* . . . Kraaijpoel and Van Wijnen.

264 *To get his money he would have to* . . . Van Meegeren would later claim that he had never meant for *Adultery* to leave Holland and had certainly not wanted it to fall into German hands. He told his version of the story, in which it was Rienstra who took all the initiative, to a reporter from the *Amersfoortse Courant*, on July 19, 1946: "The painting *Christ with the Woman Taken in Adultery* was hanging in my house when on a certain day Mr. Rienstra van Stuyvesande paid me a visit and showed great interest in a genuine Frans Hals that I owned. I didn't want to sell that painting, but I showed him my 'Vermeer' instead. My visitor seemed interested and thought he could sell the painting for 2-million guilders. I emphasized that he should be careful not to sell the 'Vermeer' to Germany, but when he returned six weeks later I was startled to hear that the painting had been sold for 1,650,000 guilders to a certain Miedl, well known as a buyer for Goering. Since it would have been foolish to leave the proceeds to the middleman, I accepted, after some hesitation, a sum of 1,500,000 guilders for the painting."

 This was a lie. The reason Van Meegeren enlisted Rienstra in the first place was because of his ties to Miedl. And to deal with Miedl *meant* to deal with Goering.

264 *Most forgers are finally caught* . . . Jones, p. 15.

CHAPTER FIFTY-FIVE: "I PAINTED IT MYSELF!"

265 *Now Piller took it over* . . . The description of Goudstikker's dealership is from Frederik Kreuger, *De Arrestatie van een Meestervervalser*, p. 25. (The title means *The Arrest of a Master Forger*.)

266 *They quickly found hoards* . . . Harry van Wijnen, personal communication, May 28, 2006.

266 *The penalty for treason* . . . Author interview with Van Wijnen, Aug. 25, 2005.

267 *"But what sort of nightclubs?"* . . . Ibid.

267 *Piller had unimpeachable testimony* . . . Ibid.

267 *paper was in such short supply* . . . Maass, p. 208.

268 *notorious Dutch Nazi named Martien Beversluis* . . . Lopez, Sept. 29, 2006.

268 *X-ray Goering's "Vermeer"* . . . Kreuger, *De Arrestatie*, p. 21, and Coremans, plate 55.

268 *"I painted other Vermeers"* . . . Kreuger, *De Arrestatie*, p. 21.

269 *Sixty years later, a woman who worked* . . . Frederik Kreuger interviewed Mrs. Pieternella van Waning-Heemskerk for *De Arrestatie*.

269 *House arrest in such plush* . . . This account, including the description of Van Meegeren working with Coremans and Froentjes, is based on Kreuger, *De Arrestatie*, p. 26.

270 *"One unlucky day"* . . . Schüller, p. 97.

271 *"Nearly every story"* . . . See, for instance, "Masterpieces Only," *Time*, July 30, 1945, and "Dutch Cast Doubt on New Vermeers," *New York Times*, July 24, 1945.

CHAPTER FIFTY-SIX: COMMAND PERFORMANCE

272 *Piller agreed that someone* . . . Harry van Wijnen, author interview, Aug. 25, 2005.

273 *"He Paints For His Life"* . . . Kilbracken cites this headline (see p. 158), as does David Anderson in "Old Masters to Order: Forgery as a Fine Art," *New York Times Magazine*, Dec. 23, 1945. Neither author mentions a newspaper, and I have been unable to find the headline myself.

273 *"under the constant supervision of six"* . . . "Han van Meegeren Vertelt," *Het Binnenhof*, October 22, 1945.

273　*one of the secretaries gladly* . . . Kreuger, *De Arrestatie*, p. 27.

273　*"He is a simple, rather small"* . . . "Han van Meegeren," *The Liberator*, Oct. 31, 1945.

274　*"Forgery of Paintings Discovered"* . . . It was *De Waarheid* that had broken the news, a week before, that Van Meegeren had given Hitler a book of drawings with a handwritten inscription.

274　*perhaps a "German officer"* . . . The American scholar Jonathan Lopez recently proved that Van Meegeren wrote both the inscription and the signature. Lopez, *De Groene Amsterdammer*, Sept. 29, 2006.

274　*"Experts have hailed the picture"* . . . "The Greatest Art Sensation of the Decade," *Illustrated London News*, Nov. 3, 1945.

CHAPTER FIFTY-SEVEN: THE EVIDENCE PILES UP

276　*As a young boy growing up* . . . Kilbracken, p. 81.

276　*Coremans's team was sworn in* . . . Coremans's book detailing his findings is the best source of technical information on Van Meegeren's forgeries.

277　*he had used India ink* . . . Ibid., p. 23.

277　*cobalt blue turned up* . . . Ibid., p. 12.

277　*Wooning found all the signs* . . . Ibid., p. 5 and plate 45.

278　*"I think it was just slovenliness"* . . . Kraaijpoel, personal communication, March 15, 2006.

279　*a painting by the seventeenth-century Dutch painter Abraham Hondius* . . . Coremans, p. 39. This evidence came to light after Van Meegeren's trial.

CHAPTER FIFTY-EIGHT: THE TRIAL

280　*The trial date was October 29, 1947* . . . The trial lasted only a single day. The details in this chapter come from coverage of the case in Dutch newspapers, from Doudart de la Grée's eyewitness account in *Geen Standbeeld voor Han van Meegeren*, and from a brief Dutch newsreel entitled *Proces van Meegeren*, available from the Nederlands Instituut voor Beeld en Geluid.

280　*Over the course of ninety minutes* . . . "Paintings as Silent Witnesses," *Volkskrant*, Oct. 29, 1947.

280　*in the fur collar and green glasses* . . . "Van Meegeren Lawsuit," *Elseviers Weekblad*, date unknown.

281　*"big stuff"* . . . "Van Meegeren Before the Judge," *Het Parool*, Oct. 29, 1947.

281　*called to mind machine gun fire* . . . *Algemeen Handelsblad*, Oct. 29, 1947

281　*thinner than usual, almost frail* . . . Doudart de la Grée.

281　*He took a long moment* . . . "Han van Meegeren on Trial," *De Tijd*, Oct. 29, 1947.

281　*its two huge and gleaming* . . . "Van Meegeren Before the Judge," *Het Parool*, Oct. 29, 1947.

281　*"would have been the delight"* . . . David Anderson, "Forging of Masters Admitted by Artist," *New York Times*, Oct. 30, 1947.

282　*"As the cameras clicked"* . . . "Van Meegeren in Courtroom Full of Paintings," *Trouw*, Oct. 29, 1947.

282　*"Welcome to Cinema Prinsengracht"* . . . Unidentified newspaper, "Magic Lantern and 'Vermeers' as Court-room Décor," Oct. 29, 1947. (Several newspaper clippings in the Dutch archives, the RKD, are incomplete.)

283　*Why had Captain Piller kept* . . . Kraaijpoel and Van Wijnen.

284　*he bought the* Last Supper, *too* . . . van Beuningen offset part of the purchase price by turning over to Hoogendijk several pictures from his collection, including the *Head of Christ*.

Hoogendijk still owned that picture at the time of Van Meegeren's trial, which presumably shows he did not suspect it was fake.

284 *"It's difficult to explain"*... Kilbracken, p. 180.

286 *buried his face in both hands*... "The Van Meegeren Trial," *Rotterdams Nieuwsblad*, Oct. 30, 1947.

287 *Van Meegeren and two friends*... Doudart de la Grée, *Geen Stanbeeld*. De la Grée was one of Van Meegeren's lunch companions.

CHAPTER FIFTY-NINE: THE PLAYERS MAKE THEIR EXITS

288 *"I think I must take it"*... "Calm at Sentencing," *New York Times*, Nov. 13, 1947.

288 *"the man who swindled Goering"*... Irving Wallace, *Saturday Evening Post*, Jan. 11, 1947.

288 *"I am for Han van Meegeren"*... Vestdijk's essay appeared in *De Baanbreker*, Jan. 1947. Van Wijnen quotes the passage cited here in Kraaijpoel and Van Wijnen.

289 *"But it's impossible!"*... Helen Boswell, "Berlin Newsletter," *Art Digest*, Jan. 1, 1948, and Feb. 15, 1948.

289 *"It would be a colossal fraud"*... David Irving, p. 305.

289 *believed to the end that* Emmaus... Albert Blankert personal communication, Feb. 15, 2007.

290 *Jean Decoen, a Belgian art critic*... Jean Decoen, *Back to the Truth: Two Genuine Vermeers*, p. 7.

290 *"The whole picture reveals"*... Ibid., p. 42.

290 *"Listen, Monsieur Van Meegeren"*... Ibid., p. 11.

EPILOGUE

291 *"Yesterday this picture was worth millions"*... Or so he supposedly said. I have not found Van Meegeren's remark in any contemporary account of the trial, though perhaps he made his observation to a reporter or during a break rather than in a formal setting. The question, which is a good one, is often cited in discussions of forgery. See, for instance, Peter Landesman, "A Twentieth-Century Master Scam," *New York Times Magazine*, July 18, 1999. Robertson Davies may offer a clue. In his essay "Painting, Fiction, and Faking" (included in the book *The Merry Heart*), Davies writes that Van Meegeren "asked a question which nobody attempted to answer; later, a play was written about him in which his question took this form." Davies then gives the quote in its customary form. See *The Merry Heart*, p. 87.

291 *were in fact merely snobs*... Arthur Koestler put the snobbism case forcefully in "The Anatomy of Snobbery," *Anchor Review* 1 (1955).

291 *a brilliant collection of essays*... The essay collection is Dutton, ed., *The Forger's Art: Forgery and the Philosophy of Art*.

291 *"He is great for that reason"*... Italics in original. Alfred Lessing, "What Is Wrong with a Forger?" pp. 73–74, included in Dutton.

291 *Dutton asks us to imagine*... Years after Dutton's thought experiment, the real-life case of the pianist Joyce Hatto turned on precisely such manipulations in the engineering studio.

292 *the sort of disaster that engineers call*... See Charles Perrow, *Normal Accidents: Living with High-Risk Technologies* (New York: Basic Books, 1984).

292 *At a dozen places, Van Meegeren's scheme*... In a passage on normal accidents and airplane crashes, the writer and pilot William Langewiesche remarks, "As Charles Perrow mentioned to me, Murphy's Law is wrong—what *can* go wrong usually goes *right*. But then

one day, a few of the bad little choices combine, and circumstances take an airplane down." See Langewiesche, *Inside the Sky* (New York: Vintage, 1998), p. 196.

292 *In September 2003, a museum in Bolton* . . . "Museum Secures Rare Egyptian Sculpture," BBC News, Sept. 30, 2003, and Martin Bailey, "How the Entire British Art World Was Duped by a Fake Egyptian Statue," *The Art Newspaper*, May 2006.

292 *by a self-taught English forger* . . . "Fake It Till You Make It," *Newsweek*, Dec. 24, 2007.

BIBLIOGRAPHY

Alsop, Joseph. "The Faker's Art." *New York Review of Books*, Oct. 23, 1986.

Anderson, David. "Old Masters to Order: Forgery as a Fine Art." *New York Times Magazine*, Dec. 23, 1945.

Arnau, Frank. *The Art of the Faker*. Boston: Little, Brown, 1959.

Bailey, Anthony. *Responses to Rembrandt*. New York: Timken, 1994.

————. *Vermeer: A View of Delft*. New York: Henry Holt, 2001.

Ball, Philip. *Bright Earth: Art and the Invention of Color*. New York: Farrar, Straus and Giroux, 2001.

Barnouw-de Ranitz, Louise. "Abraham Bredius, a Biography" (online at http://www .museumbredius.nl/biography.htm).

Behrman, S. N. *Duveen*. New York: Random House, 1951.

Blankert, Albert. "The Case of Han van Meegeren's Fake Vermeer *Supper at Emmaus* Reconsidered." In *In His Milieu: Essays on Netherlandish Art in Memory of John Michael Montias*, ed. A. Golahny et al., Amsterdam: Amsterdam University Press, 2006.

————. *Rembrandt: A Genius and His Impact*. National Gallery of Victoria, Melbourne, Australia, 1997.

————. *Selected Writings on Dutch Painting*. Zwolle, Holland: Waanders, 2004.

————. *Vermeer of Delft*. New York: Dutton, 1978.

Blom, Philipp. *To Have and to Hold: An Intimate History of Collectors and Collecting*. Woodstock, N.Y.: Overlook Press, 2003.

Boswell, Helen. "Berlin Newsletter." *Art Digest*, Jan. 1, 1948, and Feb. 15, 1948.

Bredius, Abraham. "A New Vermeer." *The Burlington Magazine* 71, Nov. 1937, pp. 210–11.

————. "Een Prachtige Pieter de Hoogh." *Oud Holland* 56 (1939): 126–27.

————. "Ein Pseudo-Vermeer in der Berliner Galerie." *Kunst-Chronik* 18 (1883), pp. 67–71.

————. "An Unknown Rembrandt Portrait." *The Burlington Magazine* 48, 1926, p. 205.

————. "An Unpublished Vermeer." *The Burlington Magazine*, Oct. 1932, p. 145.

Broos, Ben. "Un celebre Peijntre nommé Vermeer." In *Johannes Vermeer*, ed. Arthur Wheelock, National Gallery of Art, 1995.

————. "Vermeer: Malice and Misconception." In *Vermeer Studies*, ed. Ivan Gaskell and Michiel Jonker, National Gallery, 1998.

Browning, Christopher R. *The Origins of the Final Solution.* Lincoln: University of Ne-
 braska Press, 2004.
Bullock, Alan. *Hitler: A Study in Tyranny.* New York: Harper, 1964.
Buvelot, Quentin. "On Des Tombe, Donor of Vermeer's *Girl with a Pearl Earring.*" *Mau-
 ritshuis in Focus,* Jan. 2004.
Cabanne, Pierre. *The Great Collectors.* New York: Farrar, Straus, 1961.
Cannadine, David. *Mellon.* New York: Knopf, 2006.
Carr, E. H. *What Is History?* New York: Penguin, 1964.
Clark, Kenneth. *Looking at Pictures.* London: John Murray, 1960.
Coremans, P. B., *Van Meegeren's Faked Vermeers and De Hooghs.* Amsterdam: Meulenhoff, 1949.
De Boer, Marjolein. "Bredius Museum Reborn" (online at http://www.art.nl/
 journal/article.aspx?ID=8).
Decoen, Jean. *Back to the Truth: Two Genuine Vermeers.* Rotterdam: Donker, 1951.
————. "Shorter Notices: The New Museum at Rotterdam." *The Burlington Magazine*
 67, July/December 1935, pp. 131–32.
De Jong, Louis. "Life in Occupied Holland." *Proceedings of the Anglo-Netherlands Society
 1944–45,* pp. 27–31.
————. *The Netherlands and Nazi Germany.* Cambridge, Mass.: Harvard University
 Press, 1990.
De Ricci, Seymour. "Le quarante-et-unième Vermeer." *Gazette des Beaux-Arts* 16, 1927,
 pp. 305–10.
Doudart de la Grée, Marie. *Geen standbeeld voor Han van Meegeren.* Amsterdam: Neder-
 landsche Keurboekerij, 1966.
Dutton, Denis, ed. *The Forger's Art: Forgery and the Philosophy of Art.* Berkeley: University of
 California Press, 1983.
Duveen Archives (on microfilm in the Watson Library of the Metropolitan Museum
 of Art).
Edsel, Robert M. *Rescuing da Vinci.* Dallas: Laurel Publishing, 2006.
Esterow, Milton. *The Art Stealers.* New York: Macmillan, 1966.
————. "Fakes, Frauds, and Fake Fakers." *Art News,* June 2005, p. 100.
Feliciano, Hector. *The Lost Museum.* New York: Basic Books, 1997.
Fest, Joachim. *The Face of the Third Reich.* New York: Da Capo, 1999.
Flanner, Janet. *Men and Monuments.* New York: Harper, 1957.
Frank, Anne. *The Diary of a Young Girl.* New York: Doubleday, 2001.
Friedländer, Max, "Artistic Quality: Original and Copy." *The Burlington Magazine* 78,
 May 1941.
————. "On Forgeries." In *The Expert versus The Object.* ed. Ronald D. Spencer, New
 York: Oxford University Press.
Gaskell, Ivan. *Vermeer's Wager.* London: Reaktion Books, 2000.
Gaskell, Ivan, and Jonker Michiel, eds. *Vermeer Studies.* Washington, D.C.: National
 Gallery, 1998.
Gilbert, Daniel. *Stumbling on Happiness.* New York: Knopf, 2006.

Gilbert, G. M. "Hermann Goering: Amiable Psychopath." *Journal of Abnormal and Social Psychology* 43, no. 2 (April 1948): 221.

———. *Nuremberg Diary.* New York: Farrar, Straus, 1947.

Gimpel, René. *Diary of an Art Dealer, 1918–1939.* New York: Universe Books, 1963.

Gladwell, Malcolm. *Blink.* New York: Little, Brown, 2005.

———. "The Picture Problem." *The New Yorker,* Dec. 13, 2004.

Goldensohn, Leon. *The Nuremberg Interviews.* New York: Knopf, 2004.

Gombrich, E. H. *Art and Illusion.* London: Phaidon Press, 1960.

———. *Meditations on a Hobby Horse.* London: Phaidon Press, 1963.

———. *The Story of Art.* London: Phaidon Press, 1972.

Grafton, Anthony. *Forgers and Critics.* Princeton, N.J.: Princeton University Press, 1990.

Halpern, Sue. "The Moment of Truth?" *New York Review of Books,* April 28, 2005.

Hanson, N. R. *Patterns of Discovery.* New York: Cambridge University Press, 1965.

Harr, Jonathan. *The Lost Painting.* New York: Random House, 2005.

Harris, Richard. "The Forgery of Art," *The New Yorker,* Sept. 16, 1961.

Harris, Robert. *Selling Hitler.* New York: Pantheon, 1986.

Hebborn, Eric. *The Art Forger's Handbook.* Woodstock, N.Y.: Overlook Press, 2004.

———. *Drawn to Trouble.* New York: Random House, 1991.

Hofstede de Groot, Cornelis. *Echt of Onecht? Oog of Chemie?* The Hague: Nijhoff, 1925.

———. "Some Recently Discovered Works by Frans Hals." *The Burlington Magazine* 45, 1924.

Hoving, Thomas. *False Impressions.* New York: Simon and Schuster, 1996.

———. "The Game of Duplicity." *Bulletin of the Metropolitan Museum of Art.* 26, 1967–68.

———. *Making the Mummies Dance.* New York: Simon and Schuster, 1993.

———. *Master Pieces.* New York: Norton, 2006.

Howard, Michael. *Strategic Deception in the Second World War.* New York: Norton, 1995.

Howe, Thomas Carr. *Salt Mines and Castles: The Discovery and Restitution of Looted European Art.* New York: Bobbs-Merrill, 1946.

Hughes, Robert. "Art and Money," *New Art Examiner,* October 1984 and November 1984.

Huizinga, J. H., *Dutch Civilization in the Seventeenth Century and Other Essays.* New York: Harper, 1968.

Irving, Clifford. *Fake!* New York: McGraw-Hill, 1969.

———. *The Hoax.* Sagaponack, N.Y.: Permanent Press, 1981.

Irving, David. *Göring.* New York: Avon, 1989.

Johnson, Paul. *Art: A New History.* New York: HarperCollins, 2003.

Jones, Mark, ed. *Fake? The Art of Deception.* Berkeley: University of California Press, 1990.

Kershaw, Ian. *Hitler, 1889–1936: Hubris.* New York: Norton, 2000.

Kilbracken, Lord (John Godley). *Van Meegeren: Master Forger.* New York: Scribner's, 1967.

Kirstein, Lincoln. *Rhymes of a PFC*. Boston: David Godine, 1981.

Koestler, Arthur. "The Anatomy of Snobbery." *Anchor Review* 1 (1955).

Koningsberger, Hans. *The World of Vermeer*. New York: Time-Life, 1967.

Kraaijpoel, Diederik, and Harry van Wijnen. *Han van Meegeren en Zijn Meesterwerk van Vermeer*. Zwolle, Holland: Waanders, 1996. (Kraaijpoel wrote pp. 23–64, Van Wijnen pp. 65–89.)

Kreuger, Frederik. *De Arrestatie van een Meestervervalser*. Diemen, Holland: Veen, 2006.

——. *Han van Meegeren: Meestervervalser*. Diemen, Holland: Veen, 2004.

Kurz, Otto. *Fakes*. New York: Dover, 1967.

Lamont, Peter. *The Rise of the Indian Rope Trick: How a Spectacular Hoax Became History*. New York: Thunder's Mouth Press, 2004.

Landesman, Peter. "A 20th-Century Master Scam." *New York Times Magazine*, July 18, 1999.

Lessing, Alfred. "What Is Wrong with a Forgery?" pp. 73–74. In Denis Dutton, ed., *The Forger's Art; Forgery and the Philosophy of Art*. Berkeley: University of California Press, 1983.

Lochner, Louis, ed. *The Goebbels Diaries*. New York: Doubleday, 1948.

Lopez, Jonathan. "De Meestervervalser en de fascistische droom." *De Groene Amsterdammer*, Sept. 29, 2006.

Maass, Walter B. *The Netherlands at War: 1940–1945*. London: Abelard, Schumann 1970.

Masterman, J. C. *The Double-Cross System*. New York: Lyons Press, 2000.

Maurer, David. *The Big Con*. New York: Anchor Books, 1940.

McPhee, John. *A Roomful of Hovings*. New York: Farrar, Straus and Giroux, 1966.

Moore, Bob. *Victims and Survivors: The Nazi Persecution of the Jews in the Netherlands 1940–1945*. New York: St. Martin's, 1997.

Mosley, Leonard. *The Reich Marshal*. New York: Dell, 1974.

Nicholas, Lynn. *The Rape of Europa*. New York: Vintage, 1995.

Norman, Geraldine, and Frank Norman. *The Fake's Progress*. London: Hutchinson, 1977.

Pam, Max. "De tragiek van het onfeilbare oog: Over Dirk Hannema." In his *De Armen van de inktvis* (Amsterdam: Prometheus, 2005).

Petropoulos, Jonathan. *Art as Politics in the Third Reich*. Chapel Hill, N.C.: University of North Carolina Press, 1996.

Piattelli-Palmarini, Massimo. *Inevitable Illusions*. New York: Wiley, 1994.

Plietzsch, Eduard. *Vermeer van Delft*. Munich: Bruckmann, 1939.

Presser, Jacob. *Ashes in the Wind: The Destruction of Dutch Jewry*. Detroit, Mich.: Wayne State University Press, 1965.

Reed, Christopher. "Wrong!" *Harvard Magazine*, Sept.–Oct. 2004.

Rorimer, James. *Survival: The Salvage and Protection of Art in War*. New York: Abelard Press, 1950.

Rousseau, Theodore. "The Stylistic Detection of Forgeries." *Bulletin of the Metropolitan Museum of Art* 26 (1967–68): 248.

Russell, John. "Revenge Keeps Its Colour." *Sunday Times [of London]*, Oct. 23, 1955.

Scallen, Catherine. *Rembrandt, Reputation, and the Practice of Connoisseurship*. Amsterdam: Amsterdam University Press, 2003.

Schama, Simon. *The Embarrassment of Riches*. New York: Knopf, 1987.

————. *Rembrandt's Eyes*. New York: Knopf, 1999.

Schneider, Norbert. *Vermeer: The Complete Paintings*. Cologne, Germany: Taschen, 2000.

Schüller, Sepp. *Forgers, Dealers, Experts*. New York: Putnam, 1960.

Schwartz, Gary. "Connoisseurship: The Penalty of Ahistoricism." *The International Journal of Museum Management and Curatorship* 7 (1988): 261–68.

Secrest, Meryle. *Duveen*. Chicago: University of Chicago Press, 2004.

Simpson, Colin. *Artful Partners: Bernard Berenson and Joseph Duveen*. New York: Macmillan, 1986.

Snow, Edward. *A Study of Vermeer*. Berkeley: University of California Press, 1994.

Sox, David. *Unmasking the Forger: The Dossena Deception*. New York: Universe Books, 1987.

Speer, Albert. *Inside the Third Reich*. New York: Macmillan, 1970.

Spencer, Ronald D., ed., *The Expert versus The Object*. New York: Oxford University Press, 2004.

Spotts, Frederic. *Hitler and the Power of Esthetics*. Woodstock, N.Y.: Overland Press, 2004.

Steadman, Philip. *Vermeer's Camera*. New York: Oxford University Press, 2001.

Stein, Anne-Marie. *Three Picassos Before Breakfast*. New York: Hawthorn Books, 1973.

Steinmeyer, Jim. *Hiding the Elephant*. New York: Carroll and Graf, 2003.

Strouse, Jean. *Morgan*. New York: Random House, 1999.

Surowiecki, James. *The Wisdom of Crowds*. New York: Doubleday, 2004.

Swillens, P.T.A. *Johannes Vermeer*. Utrecht, Holland: Spectrum, 1950.

Thompson, Clive. "Why Realistic Graphics Make Humans Look Creepy." June 9, 2004, online at www.slate.com.

Thoré-Bürger, Théophile. Three essays on "Van der Meer de Delft." *Gazette des Beaux-Arts* 21 (1866): 297–330, 458–70, and 542–75.

Turner, Henry A., ed. *Hitler: Memoirs of a Confidant*. New Haven, Conn.: Yale University Press, 1985.

Updike, John. *Just Looking*. New York: Knopf, 1989.

Valentiner, W. R., "A Newly Discovered Vermeer." *Art in America* (April 1928): 107.

Van Dantzig, M. M. *Vermeer: De Emmausgangers en de critici*. Leiden: Sijthof, 1947.

Van den Brandhof, Marijke. *Een vroege Vermeer uit 1937*. Utrecht: Spectrum, 1979.

Van der Meer, Theo, and Paul Snijders, "Ernstige moraliteits—toestanden in de residentie. Een 'whodunnit' over het Haagse zedenschandaal van 1920." *Pro Memorie* 4, no. 2 (2002): 373–408.

Van der Meer Mohr, Jim. "Bredius en zijn 'Emmausgangers van Vermeer.' Een nieuwe reconstructie aan de hand van de correspondentie van Dr. A. Bredius met Mr. G. A. Boon, Dr. D. Hannema, de Vereniging Rembrandt en anderen" *Origine*, no. 5 and 6, 2006 (online at http://www.vandermeermohr.nl/AbrahamBredius/tabid/930/Default.aspx).

————. "Eerherstel voor Abraham Bredius?" *Tableau* 18, no. 5, (April 1996).

Van der Zee, Henri. *The Hunger Winter: Occupied Holland.* Lincoln: University of Nebraska Press, 1998.

Van de Waal, Harry. "Forgery as a Stylistic Problem." In *Aspects of Art Forgery.* The Hague: Nijhoff, 1962.

Voute, Peter. *Only a Free Man.* Santa Fe, N.M.: Lightning Tree, 1982.

Wallace, Irving. "The Man Who Swindled Goering." *Saturday Evening Post*, Jan. 11, 1947.

Warmbrunn, Werner. *The Dutch Under German Occupation, 1940–1945.* Stanford, Calif.: Stanford University Press, 1963.

Watson, Peter. *From Manet to Manhattan.* New York: Random House, 1992.

Weerdenburg, Sandra. *De Emmausgangers: een omslag in waardering,* Utrecht, 1988. Weerdenburg's essay was her doctoral thesis at Utrecht University.

Werness, Hope. "Han van Meegeren *fecit.*" In Denis Dutton, ed., *The Forger's Art: Forgery and the Philosophy of Art.* Berkeley: University of California Press, 1983.

Weschler, Lawrence. *Vermeer in Bosnia.* New York: Pantheon, 2004.

Wheelock, Arthur, ed., *Johannes Vermeer.* Washington, D.C.: National Gallery of Art, 1995.

————. "The Story of Two Vermeer Forgeries." In *Shop Talk: Studies in Honor of Seymour Slive,* Cambridge, Mass.: Harvard University Art Museums, 1995.

————. *Vermeer: The Complete Works.* New York: Harry Abrams, 1996.

Wheelock, Arthur, and Marguerite Glass. "The Appreciation of Vermeer in Twentieth-Century America." In *The Cambridge Companion to Vermeer,* ed. Wayne Franits. New York: Cambridge University Press, 2001.

White, Osmar. *Conqueror's Road.* New York: Cambridge University Press, 1996.

Wright, Christopher. *The Art of the Forger.* New York: Dodd, Mead, 1985.

————. *Vermeer.* London: Chaucer, 2005.

ACKNOWLEDGMENTS

I've spent the last five years prowling the back alleys of the art world, in the company of crooks and con artists and the detectives and sleuths who try to unmask them. Without guides to the underworld, I never would have made my way.

Four people especially, three of them Dutch and one English, helped me stumble toward an understanding of how Han van Meegeren fooled the art experts of his day. Albert Blankert is a renowned art historian who reluctantly opened his door to me one summer afternoon and went on, over the following year and a half, to spend hundreds of hours answering questions and debating Van Meegeren theories with me. He is a model of an open-minded and insightful (and stubborn) intellectual, and an authority on art history, forgery, and connoisseurship. His essay on Van Meegeren (see Bibliography) is groundbreaking. Jim van der Meer Mohr is an art historian and a brilliant researcher, who generously shared his archival treasures with me. Diederik Kraaijpoel, a painter and an art historian both, led me by the hand in a brilliant tutorial. And Leo Stevenson, an English painter and an authority on forgery (but not a forger himself), took me inch by inch through the process of creating a new "old master." Stevenson notes that he has painted "more Vermeers than Vermeer." His copies are purchased by such institutions as the British Foreign Office, so that various dignitaries can enjoy a Rembrandt, say, while the genuine article sits safely in a vault. Stevenson's extraordinary work can be seen at www.leostevenson.com.

Marleen Blokhuis, an art historian and researcher who is a find in her own right, unearthed countless deep-buried gems. Michele Missner and Kate Headline cajoled lost articles and pictures from libraries in half a dozen countries. Katerina Barry, artist and computer savant, dazzled digitally. Cornelis Glaudemans took on what was intended to be a small translation project and ended up with what was nearly an extra job. I'm delighted to say that this work relationship grew into a fast friendship.

Jenna Dolan copyedited thoughtfully and meticulously. Rafe Sagalyn is my agent and my friend. Hugh Van Dusen is the editor every writer hopes for. It's been my good fortune to have found him.

My two sons, writers both, read every draft and weighed in on every editorial decision. No writer could imagine better allies.

Lynn deserves more thanks than I know how to put in words.

INDEX

Page numbers of photographs appear in italics.

A

Aarts, Marina, 231, 242
"Abraham Bredius, a Biography" (Barnouw-
 de Ranitz), 307n
Academy of Fine Arts, Vienna, 56
Adoration of the Lamb (Eyck), 254, 254n
Agnew art dealers, 89
Alberto and Annette Giacometti Founda-
 tion, 75n
Allegory of Faith (Vermeer), 127, 127n, 131,
 139, 142
Alsop, Joseph, 302n
Alt Aussee (salt mine at), Austria, 253–55,
 254n, 262
Altena, J. Q., 217
Amstel Hotel, Amsterdam, 12
Amsterdam
 Anne Frank's house, 32
 anti-pogrom strike in, 31–32
 Goering buying of jewelry and art in, 12
 Van Meegeren's house in, 3–4, 32, 263,
 295n
 Vermeer era, 86
Anderson, Maj. Harry, 260–61
Arendt, Hannah, 81
Art and Illusion (Gombrich), 302n, 308n
"Art as Dung" (Gerritsen), 133, 308n
art experts, 19, 20, 23–24, 45n, 64n, 66n,
 89, 108, 149. See also Bredius, Abraham;
 Hannema, Dirk
 charges of fakery made by, 224–25,
 224n, 316n
 Christ at Emmaus forgery, other forged

Vermeers, and, 188–90, 190, 191, 192,
 195–97, 196n, 201–2, 205–6, 206n,
 209, 213–14, 217, 218–22, 223,
 231–33, 238, 242, 276, 285, 286,
 297n
 confirmation bias, 225–26
 feuds and rivalries, 119–20
 fooling the experts, 227–33, 232, 242,
 243–45, 285, 286, 290, 291–93, 293
 hesitation as sign of uncertainty,
 239–42
 opinion of and faith in the "eye" of, 20,
 109–14, 121–31, 201–2, 223–26,
 239–42, 239n, 242n, 291–93, 293
 peer pressure and, 223–26, 231
 rejection of science by, 114, 117
 support of forged works, importance,
 117–20, 145–49
 the Uncanny Valley and, 132–36, 144,
 150
 Vermeer scholars, 22, 45n, 58, 58n, 59,
 92, 95, 97n, 106, 108, 109–11, 119,
 120, 121–31, 134n, 137, 140–41,
 142–44, 145, 152, 164, 299n
Art Forger's Handbook (Hebborn), 23
Art in America, 109
Art of Painting, The (Vermeer), 58–61, 58n,
 82, 83, 93n, 142, 236, 236, 317n
 Hitler's obtaining of, 59–61, 301n
 recovery of, 255
Astronomer, The (Vermeer), 64–65, 64n, 94,
 171, 234, 235
 obtained by Hitler, 64

Auschwitz, 30–31, 295n
Austria
 art treasures obtained by Nazis, 60–61
 art treasures recovered in Alt Aussee salt
 mine, 253–55, 254n, 262
 Germany annexation of, 60
 Goering's wife in, 260
 Hitler's art museum for Linz, 51, 56,
 57–58, 60, 61

B
Bachstitz, Kurt, 78
Back to the Truth (Decoen), 290
Baekeland, Leo H., 38–39
Bailey, Anthony, 96, 125n, 303n
Bakelite, 39, 45–47, 74, 167, 173, 173n, 176,
 177, 214, 270, 277
Balanchine, George, 252
Barnouw-de Ranitz, Louise, 307n
Bartos, Armand, 73, 73n
Bathsheba (Rembrandt), 237, 237
Battle of Arnhem, 4
Battle of Stalingrad, 62–63
Belgium
 art treasures taken by the Nazis, 7
 escape from occupied, 28
 percentage of Jews killed in, 30n
 World War I and, 10
 World War II and, 11
Berchtesgaden, Germany, 63, 257
 Goering's train and art, 259, 303n
Berenson, Bernard, 119n
Beversluis, Martien, 268
Blankert, Albert, 59, 97n., 98, 134n, 143,
 218–19, 224–25, 240, 242n, 303n,
 304n, 309n, 312n
Blind Leading the Blind (Brueghel), 255
Blink (Gladwell), 240, 318n
Bode, Wilhelm von, 118–19, 118n, 140,
 140n
Bolton, England, hoax, 292–93, 293
Boon, Gerard A., 179–84, 180, 186–89,
 193, 198–200, 263, 270, 283, 312n
Bormann, Martin, 257
Botticelli, Sandro, 221

Boucher, François, 261
Bourdichon, Jean, 105
Boymans Museum, 127, 144–49, 156,
 310n
 Christ at Emmaus forgery and, 185, 186,
 188–91, 198–202, 203–10, 213–14,
 268, 271, 280
 restorer for, 203–6, 206n
 storage of paintings in 1939, 209–10
 Van Meegeren story of show at, 208–9
 Vermeer show with fakes, 1935, 148–49,
 164, 203, 207–10
Boy Smoking, A (Van Wijngaarden fake Hals),
 114, 118, 306n
Braque, Georges, 75
 Myatt's fakes, 67, 70
Braun, Eva, 57
Bredius, Abraham, 92, 121–31, 141n, 156,
 227, 307n, 309n
 Christ at Emmaus forgery and, vii,
 139–44, 149, 156, 179, 181–85,
 186–91, 192–97, 198–200, 201,
 203–5, 209, 221, 226, 240, 244,
 263, 289, 312n
 death of, 289
 De Hooch forgeries and, 215, 263
 as expert on Vermeer, 99, 120, 140–41,
 226, 228, 240, 307n
 homosexuality and, 122–23
 Lady and Gentleman at the Harpsichord and,
 139–44, 149, 179, 184, 186, 187, 190
 Rembrandts discovered by, 121
 signature of, 124, 124
 Vermeer paintings discovered by, 127–31,
 194, 203, 307n
 Villa Evelyne, Monaco, 121, 181, 182,
 183
Bredius Museum, 307n
British Museum, 229
Brochet, Fréderic, 230
Brooklyn Museum, 250
Broos, Ben, 111n, 148
Brueghel, Pieter, 25, 147n, 310n
 paintings owned by Goering, 12, 255
 paintings owned by Hitler, 61
Brunswick, Duke of, 98

Brunswick, Germany, 99
Brussels, Belgium, 276
Buckingham Palace, 216
Bunjes, Hermann, 252–53, 253n
Burlington Magazine, The, 139, 192–93, 195, 224, 292, 310n

C
Capablanca, José Raúl, 240
Caravaggio, 163–66, 167, 171, 195, 197, 310n
 models used by, 170–71
 versions of Christ at Emmaus, 165–66, 170
Catalogue Raisonné of the Works of the Most Eminent Dutch, Flemish, and French Painters, A (Smith), 22
Central Laboratory, Belgian Museums, 276
Cézanne, Paul, 75
 Myatt's forgery of, 67
Chagall, Marc
 forgeries of, 24, 25
 Myatt's fakes, 67, 70
Christ and the Adulteress (van Meegeren forgery), 214
Christ at Emmaus (van Meegeren), 14, 84, 150, 153, 156, 267, 267, 271, 272, 275
 attempts to argue for authenticity of, 290
 as benchmark for other "new" Vermeers, 214–17, 275
 Boon as middleman for sale of, 179–84, 180, 186–89, 193, 198–200, 263, 270, 283, 312n
 Boymans Museum and, 185, 186, 188–91, 198–210, 268
 Bredius and, vii, 139–44, 149, 156, 179, 181–85, 186–91, 192–97, 198–200, 201, 203–5, 209, 221, 226, 240, 244, 263, 289, 312n
 canvas (from *The Raising of Lazarus*) and stretcher used for, 168–69, 168n, 277–78, 311n
 Caravaggio connection, 163–66, 167, 195, 197

craquelure created on, 173–78, 174, 204, 277
critical evaluation of, 171, 213–14, 218, 220–22, 223–24, 238, 239, 239n, 297n
display of, current, 213–14
evaluated as fake by Duveen, 188–90, 190, 191, 192, 195, 199–200, 209, 230, 292
fooling the experts, 195–97, 196n, 201–2, 205–6, 206n, 209, 230–33, 239n, 242, 243–45, 285, 286
forgery techniques used in, 167–69, 205, 277–78, 317n
Hannema and, 185, 186, 187, 188–91, 198–205, 207–10, 218, 243, 271, 285, 289, 292, 314n
mistakes and clumsy execution in, 234–35, 235
as "normal accident," 292, 322n
put in storage, 1939, 209–10, 222
sale of, 198–200
sale price, 181n, 199–200
random damage to, 178, 204
relining of by Luitwieler, 204–5
restorer's examination of, 203–6, 206n
signature, 171–72, 192–93, 195
success of, 170–72, 239n
unveiling of, 207–10
Van Meegeren's trial and, 281, 283–84, 285, 286
Christie's Auction House, 292
Christ in the House of Mary and Martha (Vermeer), 83–84, 129–31, 131n, 152, 194, 195, 196, 197, 203
Christ with the Woman Taken in Adultery (Van Meegeren forgery), 7, 8, 21, 214, 261, 263, 269, 275, 278, 281, 286, 320n
 Goering and, 84–85, 209, 250, 260–61, 262, 263–64, 268, 275, 281, 303n, 320n
Chuang Tzu, 187
Churchill, Winston, 11–12
Clark, Kenneth, 58, 221
Coleridge, Samuel Taylor, 134

Colnaghi art dealer, 89, 90
Cologne, Germany, bombing of, 56
Concert, The (Vermeer), 90, 100n, 311n
 theft of, 90n
Constable, John, 251
Coremans, P. B., 269–70, 276, 278, 281,
 282–83, 296n, 311n, 314–15n, 317n,
 321n
Cornfield (Millet), 302n
Cornfield (Van Gogh), 302n
Craig, Gordon, 295n, 296n
Czechoslovakia, resistance in occupied, 28
Czernin, Eugen and Jaromir, 59–61, 301n

D
Dachau, 258
Danaë (Titian), 255
David (Michelangelo), 242
Davies, Robertson, 322n
Decoen, Jean, 290, 310n
De Groene Amsterdammer magazine, 15
de Groot, Cornelis Hostede, 111–14, 111n,
 116, 117, 118, 122, 123, 128, 130,
 140, 141, 141n, 226, 306n
de Hooch, Pieter, 90, 98, 202, 215–16,
 215n, 263, 281, 283
de Hory, Elmyr, 23, 34, 68, 244
de Jong, Louis, 27, 31, 32
Delft, Holland
 explosion of 1654, 86, 86n, 303n
 Van Meegeren in, 4, 5, 304n
 Vermeer in, 4, 64n, 86, 94–95, 125,
 303n, 304n
De Nieuwe Dag, 270
Denmark, World War II and, 11
de Ricci, Seymour, 106–7
*Descriptive and Critical Catalogue of the Works of the
 Most Outstanding Dutch Painters of the
 Seventeenth Century* (De Groot), 111–12
Des Tombe, A. A., 88
de Vries, Arie B., 143, 149, 209, 299n
De Waarheid, 274, 321n
Diana and Her Companions (Vermeer), 83, 87,
 128–30, 131n, 152, 197
Diana at the Stag Hunt (Rubens), 78

Diana with Nymphs (Vermeer forgery), 219
Dickens, Charles, 110
Douglas, Michael, 75
Dresden, Germany, 99
Dresden Gallery museum, 57
Dressen, Charlie, 308n
Drewe, John, 70, 71–72, 73, 74, 115
Duchamp, Marcel, 144
Dufy, Raoul, 69
 Myatt's fakes, 69
Dunkirk, 12
Dürer, Albrecht, 115–16, *116*, 147, 163, 251,
 261, 306n
Dutton, Denis, 291, 322n
Duveen, Joseph (Duveen Brothers Gallery),
 60, 89, 105, 119, 142, 309n
 Andrew Mellon and, 108, 119, 188
 Christ at Emmaus evaluated as fake by,
 188–90, *190*, 191, 192, 195, 199–200,
 209, 230, 292
 newfound "Vermeers" and, 105–6, 108,
 305n

E
Early Netherlandish Painting (Friedländer), 119
Edison, Thomas A., 38
Een vroege Vermeer (van den Brandhof), 296n,
 306n, 309n
Eisenhower, Dwight D., 258
El Greco. *See* Greco, El
Emmaus (Caravaggio), 165–66, 170, 171, 218
England
 Amarna princess hoax, 292–93, *293*
 Nazi threat to, 10
Eyck, Jan van
 Rothschild collection of, 64
 Adoration of the Lamb, 254, 254n

F
Fabritius, Carel, 86n, 169n
False Impressions: The Hunt for Big-Time Art Fakes
 (Hoving), 302n, 309n
Feliciano, Hector, 51
Festinger, Leon, 226, 316n

First Steps (Millet, Van Gogh), 68, *68*

Flanner, Janet, 53, 66, 249

Fogg Art Museum, 250

Forbes, Norman (Forbes and Peterson Gallery), 129

forgery
 "accessible artists" as likely targets for, 25
 antiquity of, 66, 66n
 approach of the forger, 21
 art prices and, 66
 basics of, 22–25
 Bolton, England, Amarna princess hoax, 292–93, *293*
 canvas, dating of, 168
 canvas stretchers, 168–69, 168n
 catching of forgers, 264
 charges of, experts' reluctance to make, 224–25, 224n, 316n
 Christ at Emmaus, crafting of, 167–69, 173–78
 craft of, 19–21
 craquelure, creating, 173–78, *174*, 277
 current, 19
 difficulty of, 25
 expert support of, importance, 117–20, 145–49, 195–97
 fooling the experts, 227–33, *232*, 240–41, 242, 243–45, 285, 286, 291–93, *293*
 fox marks, 24
 Getty Museum kouros buy, 240–41, 244
 ink, 24–25
 Irving hoax, 244–45
 lifespan of forgeries, 221–22, 222n
 as male profession, 21n
 "missing link" approach, 151–53, 151n, 164
 motives for, 66
 Myatt's observations on, 66–76
 myth about forgers, 18
 oil paintings, 25, 33–39, 45–47, 113, 117, 277 (*see also* paint, oil)
 old masters forged, 35, 221–22
 Piltdown Man hoax, 152–53, 310n
 problem of escaping their own era in style, 111, 112, 306n
 provenance and, 25, 71–72, 75n, 115–17, 242, 292, 306n
 random damage to forgeries, techniques of, 178
 scientific detection of, 19–20, 113, 117, 269–70, 276–79
 signatures, faking of, 67, 100, 124, 151, 171–72, 192–93, 195
 simulating age, 22–25, 33–39, 45–47, 74–75, 173–78, 173n, 277
 techniques to "prove" authenticity, 34n, 73
 test of an old master, 35
 the Uncanny Valley and, 132–36, 144, 150
 undetected, 222n
 Van Meegeren's strategy, 136, 137–38, 151, 164–66, 194–95, 215–16
 Van Wijngaarden's strategy, 109–14
 wormhole problem, 23–24

Fowles, Edward, 142, 189, *190*, 309n

France
 art treasures taken by the Nazis, 7
 escape from occupied, 28
 Jews of, confiscation of property by Nazis, 63–64, 64n
 Nazi invasion of, 9, 11
 percentage of French Jews killed, 30n
 resistance in occupied, 28

France, Anatole, vii

Frank, Anne, 30, 31, 32

Frankfort, Germany, 262

Franzen, Jonathan, 136, 308n

Frick, Henry, 90, 125n

Frick Collection (Museum), 90, 125, 242

Friedländer, Max, 119, 316n

Fukuyama, Francis, 316n

G

Gardner, Isabella Stewart, 89–90, 100n

Gaskell, Ivan, 59

Geographer, The (Vermeer), 64, 64n, 83, 94

George III, King of England, 98

Germany, Nazi-controlled
 Afrika Corps, 62

Germany (*continued*)
 art agents for, 42
 art hidden in, 249–61, 262
 art mania of, 92
 art treasures taken by, 6–8, 11, 13,
 42–43, 51, 60–61, 63, 63n, *160,* 251,
 253, 255
 atrocities, 26
 Berlin Olympics, 167
 collapse of Nazi regime, 249, 257
 England as target of, 10
 fate of collaborators, 253, 253n, 262–63
 invasion of Holland, 9–13
 Luftwaffe, 10, 11, 52–53, 255
 miscalculation about the Dutch, 26–27
 recovery of art looted by, 209, 249–62
 Rothschild masterpieces taken by, 63–64
 Russian front, 40, 62–63
 spies and, 243
 Vermeer popular in, 85
 war against the Jews, 30–32
Gerritsen, Jan, 133, 308n
Getty Museum, 240–41, 244
Getty Research Institute, 305n
Ghiselin, Michael, 224
Giacometti, Alberto, 75
 Myatt's forgeries of, 67, 69, 73, 73n, 75n
Gilbert, Daniel, 226, 316n
Gilbert, G. M., 80–81, 81n
Gilot, Françoise, 67
Giltaij, Jeroen, 213–14
Gimpel, René, 105
Giorgione, 119n
Girl Asleep at a Table (Vermeer), 134, 171,
 311n
Girl Interrupted at her Music (Vermeer), 90
Girl Reading a Letter at an Open Window
 (Vermeer), 134
Girl with a Pearl Earring (Vermeer), 17, 33, 37,
 83, 87, 88, 88n, 96, 121, 140n, *174,*
 209, 231
 Rols' copy, 45n
Girl with a Red Hat (Vermeer), 107, 134,
 134n, 169n
Gladwell, Malcolm, 240, 297n, 318n
Glass of Wine, The (Vermeer) 134, 171

Goebbels, Joseph, 27
Goering, Emmy Sonneman, 79, 158, 260
Goering, Hermann, 51–54, *157, 158, 159*
 addiction to morphine, 259
 amount spent on art, 13
 appearance, 52, 52n
 arrested by Americans, 258
 arrested by SS, 257
 as art connoisseur and collector, 6–7, 10,
 13, 42, 43, 51, 56, 78, 79, 253, 255,
 256–57, 261, 295n, 319n
 art hidden by, 249, 255, 256–59,
 260–61, 262, 303n
 art scouts and experts for, 11, 43, 78, 82,
 84, 253, 260–61
 art stolen from Naples museum, 255
 art treasures plundered by, 7, 11, 12–13,
 62–65, *160*
 Battle of Stalingrad and, 62–63
 Berchtesgaden retreat, 63, 257, 303n
 Carin Hall, country estate, 7, 12, 51, 52,
 53–54, 78–79, 84, 254, 256–57, 258,
 264
 chief of Germany's Four-Year Plan, 79
 clothes, uniforms, costumes, 9, 52–53,
 80, *159,* 258, 300n
 death of, 288
 duping, ease of, 227
 escape attempt, 256–59
 famous observation on mass psychology,
 81n
 first wife of, 53
 funds at hand, 79–80
 Gestapo head, 78, 79
 gifts to, 79
 Hitler's art rivalry with, 55–56, 147, 157
 invasion of Holland and, 10, 11–12
 Jews and, 80
 Luftwaffe commander in chief, 10, 11,
 52–53, 79, 255
 Nuremberg imprisonment and trial, 7,
 13, 54, 80, 81, 288
 personality and temperament, 9, 27, 52,
 53–54, 62, 77–81, 158
 psychosis or mania of, 53, 62, 77–81, 81n
 rank of, 7

Rommel and, 62
Rothschild art collection and, 64
Van Meegeren and, 26, 157, 263, 268, 273, 274, 320n
Vermeer fake *Christ with the Woman Taken in Adultery* and, 82–84, 209, 250, 260–61, 262, 263–64, 268, 273, 275, 278, 281, 289, 303n, 320n
Vermeer paintings and, 85, 147
Vermeer's *Art of Painting* and, 60–61, 82, 301n
Vermeer's *The Astronomer* and, 64–65
wife, Emmy Sonneman, 79, 258, 260
Gombrich, E. H., 68, 136, 302n, 308n
"Gorgeous Pieter de Hoogh, A" (Bredius), 215–16
Gormanns, Christa, 260
Goudstikker, Jacques, 12–13, 255, 264, 265, 296n
art dealership of, 265, 269, 270, 273, 276
Gowing, Lawrence, 97n
Goya y Lucientes, Francisco, 144
Rothschild collection of, 64
Greco, El, 147
Groningen Museum, 226
Guitar Player, The (Vermeer), 97n
Gutenberg Bibles, 89, 303n
Guttenplan, D. D., 295n

H
Haak, Bob, 237
Hague, The
Art Circle, 139–40
art establishment in, 1920s, 44
Bredius in, 122
Dutch government in, 9–10
Girl with a Pearl Earring in, 45n, 140n, 209
investigation of van Meegeren, 276
Van Meegeren in, 5, 15, 44, 179
Van Wijngaarden in, 112, 114
Vermeers in, 87
Yugoslav War Crimes Tribunal, 87
Hale, Philip, 91, 93
Hals, Frans, 137, 147
forgeries of, 45, 111–14, 115, 116–17,

118, 132, 137, 138, 226, 264, 277, 306n
Metropolitan collection, 91
Morgan collection, 90
Hannema, Dirk, 144–49, 152, *156*, 164, 217, 242n, 309n
art collection of, 289–90
Christ at Emmaus forgery and, 185, 186, 187, 188–91, 198–205, 207–10, 218, 243, 271, 285, 289, 292, 314n
Harris, Richard, 315n
Harrison, Evelyn, 240
Hartley, L. P., 221
Harvard University, 252
Hatto, Joyce, 322n
Hay Harvest (Brueghel), 61
Haystack (Myatt's forgeries of Monet), 67–68
Head of Christ (Van Meegeren forgery), 214, 283–84, 286, 321n
Hearst, William Randolph, 89, 303n
Hebborn, Eric, 23–25, 68
Heil Hitler, Das Schwein ist Tot (Herzog), 300n
Hellman, G. S., 90–91
Hendrickje Stoffels (Rembrandt), 61, 61n
Hendrik, Prince consort, 123, 123n
"Hermann Goering, Amiable Psychopath" (Gilbert), 81
Herzberg, A. J., 30
Herzog, Rudolph, 300n
Het Parool newspaper, 206n, 270
Het Vaderland magazine, 15
Hill, Sir George, 229
History on Trial (Lipstadt), 296n
Hitler, Adolf, 55–56, *157*, 300n
amount spent on art, 63n
architecture and, 56
art advisors, 57–58, 61, 253
art connoisseur and collector, 6–7, 43, 51, 56, 61, 253, 301n
art museum in Linz conceived by, 51, 56, 57–58, 60, 61
Berlin Olympics, 167
criticism or negative evaluations forbidden by, 226n
final days and suicide, 257
Goering art rivalry with, 55–56, 147, 157

Hitler, Adolf (*continued*)
 invasion of Holland and, 10
 Rothschild art collection and, 64
 Van Meegeren and, 268, 274, 32In
 Vermeer paintings and, 58–61, 147
 Vermeer's *Art of Painting* and, 60–61, 255,
 30In
 Vermeer's *The Astronomer* and, 64–65
Hitler Nobody Knows, The (Hoffman), 57
Hofer, Walter, 11, 78, 82, 84, *160*, 260–61
Hoffman, Heinrich, 57, 61
Holbein, Hans, 25
Holland (Netherlands)
 anti-pogrom strike in, 31–32
 arrest and imprisonment of van Meegeren
 in, 3–5, 206, 263, 265–73
 black market in Occupied, 40, 42
 devastation of land during war, 219
 Dutch army, 11
 Dutch bureaucracy under the Nazis, 29
 Dutch Nazi Party, 6
 Dutch resistance, 4, 28, 40
 escape from Nazis, problems of, 27–28
 fate of Nazi collaborators in, 262–63,
 270, 283
 hiding of art masterpieces and attempts
 to keep from Nazis, 42–43, 219
 history of art in, 95–96
 Holland mania (desire for things Dutch),
 89, 218
 hunger winter (1944–1945), 7–9, 40–41
 hunt for stolen art, post-war, 6–8,
 262–63
 invasion of (1940), 9–13
 Jews in, 4, 28, 29, 30–32, 40
 language, use of *ij*, 44n
 Lentz's registration system, 29
 liberation, 262–63
 Nazi collection of art treasures in,
 41–43, 51
 Nazi confiscation of bicycles, 40, 40n
 Nazi Reich Commissar for, 27
 Nazi reprisals, 40
 Occupied, 6, 26–29, 40–43, 85–86
 post-war provisional government, 6, 263
 public opinion of van Meegeren, 288–89
 seventeenth century (time of Vermeer),
 86–87
 Spanish occupation of, 86–87
 timing of Van Meegeren's forgeries and,
 218–22
 trial of Van Meegeren, *161, 162*, 280–87,
 32In
 Vermeer popularity in, 85–86, 91–92
Hollander, Lorin, 24In
Hondius, Abraham, 278, *278*
Hoogendijk, D. A., 198, 199, 200, 217,
 283–84, 32In
Horace, 66n, 302n
Hoving, Thomas, 19, 20, 23–24, 66n, 229,
 241, 302n, 309n, 316n, 318n
 "fakebusting" by, 242
 spots fake kouros, 240–41, 244
Howe, Thomas Carr, 303n
Hughes, Howard, 244–45
Huizinga, J. H., 95, 196n
Hunting Scene (Hondius), 278, *278*
Huntington, Collis P., 90
Huntington, H. E., 188–89

I
I.G. Farben, 79
Illustrated London News, The, 275
"I'm OK, You're Biased" (Gilbert), 316n
Impressionism, 36n
Ingres, Jean Auguste, Rothschild collection
 of, 64
Institute of Contemporary Arts, London, 72
Irving, Clifford, 244–45
Irving, David, 295n
Isaac Blessing Jacob (van Meegeren forgery),
 161, 214, 217, 281, 284
Italy, art treasures taken by the Nazis, 7, 51,
 255

J
Jan Vermeer of Delft (de Vries), 209
Jesus Teaching in the Temple (van Meegeren), *161*,
 272–75
Jeu de Paume, 63

Jews
 art collection of Goudstikker, confisca-
 tion by Nazis, 12–13
 art treasures of, confiscated, 61, 63
 Dachau and Holocaust, 258, 295n
 Dutch, fate in Occupied Holland, 4, 28,
 30–32, 40
 Dutch, highest proportion killed in
 Europe, 30
 Dutch, Lentz's registration system and, 29
 Joop Piller as, 4, 266
 satiric comment on "master race" by, 52n
Johnson, Paul, 97
Juynboll, W. R., 310n

K
Kaiser Friedrich Museum, Berlin, 78, 118,
 119
Keating, Tom, 23, 24
Keck, Sheldon, 38, 315n
Keegen, John, 295n
Kilbracken, Lord (John Godley), 194–95,
 296n
Kirstein, Lincoln, 252, 253–54
Klaes, Pieter, 137
Kleinberger gallery, Paris, 142, 309n
Knoedler art dealers, 89
Koestler, Arthur, 322n
Kok, Jan, 284–85
Koomen, Pieter, 164, 165
Kosinski, Jerzy, 224n
Kraaijpoel, Diederik, 37, 47, 171, 175, 220,
 238, 278, 295n, 317n
Kreuger, Frederik, 297n, 304n
Kronig, Joseph, 123, 181–82, 183–84, 312n
Küffner, Abraham, 115–16, 116n, 306n
Kunst dem Volk magazine, 61
Kunsthal, Rotterdam, 223
Kunsthistorisches Museum, Vienna, 60, 310n
Kurz, Otto, 221

L
Lacemaker (van Wijngaarden fake), 105–8,
 109–11, 110n, 111n, 118, 119, 306n

Lacemaker, The (Vermeer), 83, 96, 97n, 106n,
 168
 bought by the Louvre, 187–88
Ladies Home Journal, 91
Lady and Gentleman at the Harpsichord (Van
 Meegeren fake Vermeer), 139–44, 149,
 150, 179, 184, 186, 187, 190, 309n
Lady Professor of Bologna, A (attributed to
 Giorgione), 119n
Lady Seated at a Virginal (Vermeer), 171, 311n
Lady Writing (Vermeer), 90–91
Lady Writing a Letter with Her Maid, A
 (Vermeer), 97n, 134
Last Supper (Van Meegeren forgery), 214,
 216, 281, 284, 286, 321n
 attempts to argue for authenticity of, 290
La Tour, Georges de , 145
Leda (Leonardo da Vinci), 61
Lentz, Jacob, 29
Leonard, Stewart, 289
Leonardo da Vinci, 61, 136, 251
Lessing, Alfred, 291
Life magazine, 244–45
Linz, Austria, 51, 56, 57–58, 60, 61
Lipstadt, Deborah, 296n
"Literature and Art" (Bredius), 197
Little Street, The (Vermeer), 95, 99
Lives of the Artists (Vasari), 24
Loebl, Allen, 142, 309n
Lopez, Jonathan, 321n
Louvre
 Rothschild collection, 63
 Vermeers in, 97n, 106n, 148, 187–88
Love Letter (Vermeer), 202
Lovely Bones, The (Mendelsohn), 219–20
Lowell, Percival, 227n
Lufthansa, 79
Luitwieler, H. G., 156, 204–6, 206n, 292

M
Maandblad voor Beeldende Kunsten, 164
Maass, Walter, 11, 26, 28, 41
Maastricht, Holland, 219
Madame Charpentier and Her Children (Renoir),
 242

Madonna and Child (Michelangelo), 254

Madonna of Divine Love (Raphael), 255

Maes, Nicholaes, 128

Manchester, William, 12

Manet, Édouard, 251

Mannheimer, Fritz, 143, 150, 309n

Marquand, Henry, 90

Martin, Willem, 118, 130, 198, 309n

Mary Magdalene Under the Cross (fake Vermeer, attributed to Tournier), 148–49, 310n

Masterman, Sir John, 243

Master Pieces (Hoving), 241–42

Matisse, Henri
 forged works, 34
 Myatt's fakes, 67, 70

Mauritshuis Museum, The Hague, 92, 118, 127, 128, 198, 309n
 Vermeer paintings in, 87, 88, 88n, 129
 Vermeer show (1996), 45n, 133

McCormick, Anne O'Hare, 219

McGraw-Hill publishers, 244–45

Mellon, Andrew, 45, 60
 Duveen Brothers gallery and, 108, 119, 188
 National Gallery of Art founded by, 107–8, 188
 "Vermeers" bought by, 107, 109–11, 118, 119, 140n, 306n

Mendelsohn, Daniel, 219–20

Menzel-Joseph, James, 251

Merkers, Germany, 250
 salt mine and Nazi's hidden art, 250–51

Merry Cavalier (Hals), 112

Merry Cavalier (van Wijngaarden fake Hals), 112–14, 116–17, 306n

Metropolitan Museum of Art, New York, 19, 20, 23, 148, 222n, 224, 242, 259
 Allegory of Faith in, 127
 Dutch masterpieces show, 91
 first American Vermeer, *Woman with a Water Jug*, 90, 110n
 Monuments Men from, 250
 Vermeers acquired for, 90
 Watson Library, 305n

Metsu, Jacques, 98

Michelangelo, 146, 193, 242, 254

copies by, 24

Morgan collection, 90

Vermeer evaluation of, 94

Miedl, Alois, 84, 264, 265, 303n, 320n

Militair Gezag (provisional government), Holland, 6, 263

Milkmaid, The (Vermeer), 17, 64, 83, 88n, 91–92, 96, 99, 152, 169, 171, 187, 209

Millet, Jean François, 68
 Cornfield, 302n
 First Steps, 68

Miró, Joán: Myatt's fakes, 74

Modigliani, Amedeo
 forgeries of, 23
 Myatt's forgery of, 67

Monaco, 121, 139, 181, 182, 183

Mondrian, Piet, 14
 Myatt's forgery of, 67

Monet, Claude, 74
 Myatt's forgeries of, 67–68, 74

Montgomery, Bernard Law, 1st Viscount, 62

Montias, J. M., 95, 131

Monuments Men, 249–55, 259, 289, 303n

Moore, Bob, 29

Morgan, J. P., 89, 92
 art collection, 90–91, 303n

Mori, Masahiro, 135

Mosley, Leonard, 77, 80

Motley, John Lothrop, 86

Moynihan, Daniel, 227, 316n

Mühlmann, Kajetan, 42

Munich, Germany, 116

Museum of Fine Arts, Boston, 83n

Music Lesson, The (Vermeer), 171

Mussolini, Benito, 52

Myatt, John, 66–76

N

National Art Library, Victoria and Albert Museum, 72–73

National Gallery, London, 35, 148, 216

National Gallery, Washington DC, 23, 131, 188, 299n, 319n
 forgeries in, 45, 108, 111, 140n

Mellon's collection and, 107–8
Monuments Men from, 250
Netherlands Institute for Art History, 122
Netscher, Caspar, 127
Newkirk, Raymond, 259
"Newly Discovered Vermeer, A" (Valentiner), 109
"New Vermeer, A" (Bredius), 192–93
New York City Ballet, 252
New York Times, 219, 260, 281, 316n
Nice, France, Van Meegeren's studio in, 5, 277–78
Nicholas, Lynn, 41–42, 58, 60, 78, 296n, 303n
Night Watch, The (Rembrandt), 170, 198, 219
"normal accident," 292, 322n
Norway
 escape from occupied, 28
 resistance in occupied, 28
"Notes on Nationalism" (Orwell), 316n
NRC Handelsblad, 133, 295n, 308n, 312n
Nuremberg, Germany, 115–16
 trials, Goering and, 7, 13, 65, 80, 81, 289

O
On Art and Connoisseurship (Friedländer), 119
On Fat Oils: Substitutes for Linseed Oil and
 Oil-based Pigments, 37
Orwell, George, 316n
Oster, Hans, 9, 9n
Oud Holland art magazine, 203, 215
Ovary of Eve, The (Pinto-Correia), 317n
Owens, Jesse, 167

P
paint, oil
 black, pigments for, 36
 canvas and, 175–76, 177
 cobalt blue, 277
 craquelure, 173–78, 174, 204, 277, 311n
 creating color, 175
 difficulty of preparation, 37
 drying, 33–36, 169
 forgeries detected by age of, 113

hardness of dried, 169
metal tubes of, use of, 36, 36n
oils used for, 36–37, 46, 46n
red, 34
removing from old canvas, 169
seventeenth century techniques, 175
testing age of, 35, 113
traditional method of making, 34–35, 36
ultramarine blue, 34, 36, 113, 277
zinc white, 113
Palmer, Mary-Lisa, 75n
Patton, Gen. George, 249, 250, 252
Perrow, Charles, 322n
Petiot, Marcel, 281
Phaedrus, 66n, 302n
Philip II, King of Spain, 86
Picasso, Pablo, 144
 Demoiselles d'Avignon, 14]
 forgeries of, 24
 Myatt's fakes, 67, 70
Pijbes, Wim, 138, 223
Pilgrims at Emmaus (Vermeer forgery), 219
Piller, Joop, 295n
 Goudstikker's art gallery as headquarters,
 265, 269, 270, 273, 276
 hunt for stolen art in Holland, 6–8,
 262–63
 new painting by Van Meegeren as proof,
 272–75
 suffering of, 7–8, 266
 Van Meegeren and, 4, 265–73, 283,
 315n
Piltdown Man, 152–53, 310n
Pinker, Steven, 316n
Pinto-Correia, Clara, 317n
Plietzsch, Eduard, 119, 143, 149
Poland
 art treasures taken by the Nazis, 7
 Nazi invasion and occupation of, 9, 27
 resistance in occupied, 28
Polish Rider (Rembrandt), 121, 125, 125n,
 126
Pollack, Jackson, 151
Porter, Kingsley, 252
Portrait of Dr. Gachet (Van Gogh), 71
Portrait of an Elderly Man (Rembrandt), 141n

Posey, Capt. Robert, 252–55, 254n
Posse, Hans, 57–58
Praxiteles, 66n
Presser, Jacob, 13
Private Eye magazine, 70
Procuress, The (van Baburen), 82–83, 83n,
 311n
Procuress, The (Vermeer), 58, 82–83, 83n,
 93n, 94, 99, 130
"Pseudo-Vermeer in the Berlin Gallery, A"
 (Bredius), 123

R
Raising of Lazarus, The (canvas and stretcher
 used for *Christ at Emmaus* forgery),
 168–69, 168n, 277–78, 311n
Rape of Europa, The (Nicholas), 60, 296n
Raphael, Raffaello Santi, 193, 251, 255
 paintings in Goudstikker collection, 12
 Rothschild collection of, 64
 Vermeer evaluation of, 94
Rauta, Max, 264
Rave, Paul, 251
Read, Herbert, 195
Reemtsa, Philip, 60, 61, 301n
Rembrandt: The Complete Edition of His Paintings
 (Bredius), 144
Rembrandt Research Project, 19–20, 125n,
 237
Rembrandt Society, 186–87, 198, 201
Rembrandt van Rijn, 85, 96–97, 98, 124,
 137, 141n, 144, 146, 163, 170
 authenticity of paintings by, 19–20, 20n,
 61n, 112
 Bredius discovers paintings by, 121
 forgeries of, 25, 122, 138
 Metropolitan collection, 91
 mistakes and clumsy executions in, 237,
 237
 Morgan collection, 90
 paintings hidden during Nazi occupation,
 219, 255, 261
 paintings in Goudstikker collection, 12
 paintings owned by Goering, 12, 261
 paintings owned by Hitler, 61

Rothschild collection of, 64
 self-portraits, 93, 304n
Renoir, Auguste, 36n, 242
 Myatt's forgery of, 67
Responses to Rembrandt (Bailey), 125
Riefenstahl, Leni, 167
Rienstra van Stuyvesande, P. J., 263–64, 320n
Rijksmuseum, Amsterdam, 88n, 92, 133,
 187, 190, 206, 268, 280, 290
 attempt to buy *Christ at Emmaus* forgery,
 201–2, 314n
 purchase of forged Vermeer, 217, 284
Rol, Henricus, 44–45, 45n
Rommel, Erwin, 62
Roosevelt, Franklin D., 52, 107
Roquebrune, France, 5, 46, 139, 167, 186
Rorimer, James, 259
Rothschild family
 art collection recovered, 255
 art collection stolen, 63–64
Rotterdam, Holland, 146
 art rivals in, 146–48, *147*, 216, 284
 bombing of, 11, 12
 forgery show in, 133, 138
 new Boymans Musuem in, 148
Rousseau, Theodore, 222n, 224
Rubens, Peter Paul, 163, 255
 paintings in Goudstikker collection, 12
 paintings owned by Goering, 12, 13, 78
 Rothschild collection of, 64
Russia
 Battle of Stalingrad, 62–63
 Nazi attack on, 40
Rustic Cottage (erroneously attributed to
 Vermeer), 99, 123–24

S
Saint Praxedis (attributed to Vermeer), 142
*Salt Mines and Castles: The Discovery and
 Restitution of Looted European Art* (Howe),
 303n
Sas, Maj. G. J., 9–10, 9n
Schacht, Hjalmar, 52
Schmidt-Degener, 106, 143, 190, 201–2,
 309n, 314n

Schneider, Hans, 144
Schneider, Norbert, 58–59
Schulz, Charles, 136, 308n
Schwerin museum, 118
Scott, A. O., 308n
Seyss-Inquart, Arthur, 27
Shapiro, Jerome, 258
Smiling Girl (van Wijngaarden fake Vermeer),
 107, 108, 109–11, 111n, 118, 119,
 140n, 306n
Smith, John, 22
"Some Recently Discovered Paintings by
 Frans Hals" (De Groot), 112
Sotheby's sale of Vermeer, 97n
Spain, 28
 Inquisition, 86
 occupation of Netherlands, 86–87
Speer, Albert, 51, 55
Spelke, Elizabeth, 226, 316n
Spotts, Frederic, 56, 57, 301n
SS Bodengraven, 12
Staatliche Kunstsammlungen, Dresden, 83n
Staatliche Museum, Berlin, 100
State Theater, Berlin, 9
Stein, David, 24, 25
Steinmeyer, Jim, 228, 317n
Steps (Kosinski), 224n
Stevenson, Leo, 35–36, 118n, 176, 177,
 307n, 311n
Stout, George, 255
Street in Delft, A (Vermeer), 64
Strijbis, Rens, 263, 283, 284
Stumbling on Happiness (Gilbert), 316n
Sunflowers (Van Gogh), 35
 copy of, 35–36
Supper at Emmaus (Caravaggio), 165
Swillens, P.T.A., 85–86, 130, 131n

T
"Taking a Holocaust Skeptic Seriously"
 (Guttenplan), 295n
Tate Gallery, 72
Teller, (Raymond Joseph), 227, 316n
ter Borch, Gerard, 132, 137, 277
Thompson, Clive, 135, 308n

Thoré-Bürger, Theophile, 98–101, 100n,
 123, 130, 305n
Thurber, James, 113
"Tichborne claimant," 151n
Time magazine, 208, 271, 280–81
Tintoretto, Jacopo, 255
 paintings in Goudstikker collection, 12,
 255
Titian, Tiziano Vecellio, 251, 255
 paintings in Goudstikker collection, 12
 Rothschild collection of, 64
 Vermeer evaluation of, 94
Tournier, Nicolas, 148, 310n
Tower of Babel and Little Tower of Babel
 (Brueghel), 147n, 310n
Trier, Germany, 252
True or False? Eye or Chemistry? (De Groot),
 114

U
UFA studio, 78–79
Uncanny Valley, 132–36, 144, 150
United States
 art collectors, robber barons as, 89
 Duveen Brothers influence in, 188–89
 European art sold in, 89
 Holland mania, 89
 Monuments Men, 249–55, 259, 289,
 303n
 101st Airborne, 259, 260
 recovery of art stolen by Nazis, 249–62
 sale of fake Vermeer to buyer in
 proposed, 187, 188
 Seventh Army, 258
 size of army in European Theater of
 Operations (ETO), 249
 Third Army, 249, 250, 252
 Vermeer acquisition in, 89–92
 Vermeer popularity in, 91
"Unknown Rembrandt Portrait, An"
 (Bredius), 125
"Unpublished Vermeer, An" (Bredius), 139
Updike, John, 85, 94, 97–98
Utrecht, Holland
 Caravaggisti in, 163–64

Utrecht, Holland (*continued*)
 Nazi threat to, 11
 painter Van Der Meer or Vermeer from, 98, 99, 129, 130

V
Valentiner, Wilhelm, 109–11, 118n
van Baburen, Dirck, 82–83, 311n
van Belyswijck, Dirck, 94
van Beuningen, D. G., 146–48, *147*, 147n, 216, 278, 281, 284, 285, 290, 295n, 310n, 315n, 321n
van de Laar, Michel, 206
van den Brandhof, Marijke, 296n, 306n, 309n
van der Haagen, J. K., 201
van der Laan, Derk, 123–24
van der Meer Mohr, Jim, 309n, 312n
van der Neer, Eglon, 127
van der Vorm, W., 146–48, *147*, 199, 202, 216, 217, 281, 283, 284, 285
van de Waal, Harry, 118, 225, 306n
van de Watering, Willem, 58n
van Dyck, Sir Anthony, 144, 251, 255
 owned by Goering, 79, 261
 Morgan collection, 90
van Eyck, Jan. *See* Eyck, Jan van
van Gogh, Vincent, 35, 144, 147
 Myatt's forgery, 67
 paintings copied from Millet, 68, *68*, 302n
 prices paid for paintings of, 71
 self-portraits, 93
Van Hasselt, 201
van Leeuwenhoek, Anthonie, 64n
van Meegeren, Han, 14–17, *155*, *161*, *162*, 263
 amount made from forgery, 3, 42–43, 161, 181n, 199–200, 215, 216–17, 271, 278, 283, 284, 286, 301n, 320n
 appearance, 3, 162, 269, 273–74, 281
 arrest and imprisonment, 3–5, 206, 263, 265–73
 art, style, and talent of, 4, 14, 15, 267, *267*, 296n

 background of, 4–5, 14, 44
 birthplace, 4
 charged with collaboration, 8, 265–66, 278
 charged with fraud, 278
 Christ at Emmaus (1922), 14, 153
 confession of, 268–71
 death of, 162, 288
 in Delft, 4, 5, 95, 304n
 Goering and, 26, 157, 263, 268, 273, 274, 320n
 in The Hague, 5, 15, 44, 179
 Hitler and, 268, 274, 321n
 home at 321 Keizersgracht, Amsterdam, 3–4, 32, 263, 295n
 investigation of forgeries by, 276–79, *279*, 314–15n
 lies and tall tales, 37
 life style, 3–4, 8, 216–17, 263, 267, 295n, 315n
 marriage to Jo de Boer, 44, 45
 Nazi friends and collaboration, 267–68, 296n, 320n
 Nice residence, 5, 277–78
 note on revenge, 15
 notoriety of, 15–16
 occupied Holland as setting for scams, 26, 42–43
 personality and temperament, 15, 38, 68
 Piller and, 4, 265–73
 public opinion of, 288–89
 in Roquebrune, France, 5, 46, 139, 167, 186
 sentence imposed on, 288
 trial, *161*, *162*, 280–87, 321n
 FORGERY CAREER AND PAINTINGS BY
 booklet on oils used by, 37, 46
 Boon as middleman for, 179–85, 186–89, 193, 198–200, 283, 312n
 Boymans show anecdote, 208–9
 Bredius as dupe for, 139–44, 149, 179, 181–85, 186–91, 192–97, 198–200, 201, 203–5, 209, 215, 221, 226, 240, 244, 289
 Christ at Emmaus, 14, 84, 150, 153, *156*, 163–66, 167–69, 170–72, 173–78,

179–85, 181n, 186–210, 213–14, 218,
220–22, 231–32, 238, 239, 239n,
240, 242, 267, *267*, 268, 271, 272,
275, 277, 281, 283–84, 285, 286, 290,
292, 317n
Christ with the Woman Taken in Adultery, 7, 8,
21, 84–85, 214, 209, 250, 260–61,
262, 263–64, 268, 269, 275, 278, 281,
286, 289, 303n, 320n
De Hooch forgeries, 215, 263, 268, 276,
281, 283, 290
fate of paintings, after discovery,
16–17
first and unsold forgeries, 15, 132–33,
277
forgery techniques, 33–39, 45–47, 46n,
74, 111, 117, 167–69, 205
Hals forged by, 45, 111, 115, 132, 137,
138, 264, 277, 306n
Head of Christ, 214, 283–84, 286, 321n
Isaac Blessing Jacob, *161*, 214, 217, 281, 284
Jesus Teaching in the Temple (new painting cre-
ated as proof of forgery skill), *161*,
272–75, 282–83
Lady and Gentleman at the Harpsichord,
139–44, 149, 150, 179, 184, 186, 187,
190, 309n
Last Supper, 214, 216, 281, 284, 286, 290,
321n
partners in forgery scams, 44–45, 111,
115, 138, 263–64
quality of forgeries by, 16–17, 117, 206,
206n
savvy of marketing, 16, 21, 66
show of forgeries by, 133, 138
skill of, 109, 134, *161*, 206, 218–19, 224,
229, 238, 270–71, 296n, 314–15n,
317n
strategy of, 136, 137–38, 151, 164–66,
194–95, 215–16
timing forgeries and conditions in
Holland, 218–22
use of Bakelite, 38–39, 45–47, 74, 167,
173, 173n, 176, 177, 214, 270, 277
Vermeer as choice of, 25, 93, 101,
137–38, 150–53

Vermeer forgeries following success of
Christ at Emmaus, 214–17
Vermeers studied by, 65
The Washing of Christ's Feet, 214, 217, 282,
284, 286
van Meegeren, Jo de Boer, 44, 45, 46n, 139,
140
van Mieris, Frans, 137
van Rijckevorsel, J. L., 218
van Wijnen, Harry, 295n, 317n
van Wijngaarden, Theo, 44–45, 108,
109–14, 115, 116–17, 138, 306n
Vasari, Giorgio, 24
Vasters, Reinhold, 222n
Velasquez, Diego de Silva y, 163, 241
Vermeer (Bailey), 303n
Vermeer, Johannes, 85–87
American collectors of, 89–92
art of desired by the Nazis, 7, 58–61,
85
Baburen's *Procuress* and, 311n
biographical information, 95–97, 97n
birth, 95
Bredius and unknown paintings by
discovered, 127–31, 139–44, 194
Caravaggio connection, 163–66, 167,
170, 195, 197, 310n
colors typical of, 34, 36, 82
current prices paid for, 88, 97n
dating of paintings, 94, 152, 194
death of, 47, 97, 204
in Delft, 4, 86, 94–95, 125, 303n, 304n
demand for works by, 105, 305n
document containing words of, 94
Goering's desire for, 60–61, 82–84, 85
Hitler's acquisition, 58–61
Holland of his time, 86–87
life of, gaps in, 93–94
"missing link" in development of, 153
mistakes and clumsy execution in
paintings of, 234–36, *235, 236*, 238,
317n
models for, 64n
naming of his paintings, 33n
"newfound" and not authentic, 105–8,
305n

Vermeer, Johannes, (*continued*)
 number of known paintings by, 7, 97, 98,
 106
 obscurity of, 97–98
 painters with similar names, 98
 paintings by attributed to other artists, 98
 paints and materials used by, 33, 36, 169n
 popularity of, 85, 87, 88–92, 88n, 91,
 105, 137, 305n
 reused canvases, 169, 169n
 revival of, 85, 88–92. 98–101
 Rothschild collection of, 64
 sales during his lifetime, 96–97, 97n
 scholars and experts on, 22, 45n, 58, 58n,
 59, 92, 95, 97n, 106, 108, 109–11,
 119, 120, 121–31, 134n, 137, 140–41,
 142–44, 145, 152, 164, 195–97,
 230–33, 242, 299n
 self-portraits absent, 93, 93n
 serenity of works, 59, 87, 218
 signature, 100, 124, 128, 128n, 151,
 171–72, 192–93, 195
 size of paintings, 64, 82, 83, 168
 style and stylistic devices, 82, 83, 87, 99,
 171
 subjects of paintings by, 83
 Van Meegeren's choice of, 25, 93, 101,
 137–38, 150–53
 Van Meegeren's forged paintings
 attributed to, 7, 8, 14, 16, 45, 84,
 139–44, 150, 153, 156, 163–85,
 181n, 186–210, 213–17 (*see also*
 Christ at Emmaus *and other forged
 Vermeers*)
 widow's inventory of possessions, 35
 widow's payment of debt with paintings,
 97n
 PAINTINGS BY
 Allegory of Faith, 127, 127n, 131, 139, 142
 The Art of Painting, 58–61, 58n, 82, 83,
 93n, 142, 236, 236, 255, 301n, 317n
 The Astronomer, 64–65, 64n, 94, 171, 234,
 235
 Christ in the House of Mary and Martha,
 83–84, 129–31, 131n, 152, 194, 195,
 196, 197, 203

The Concert, 90, 100n, 311n
Diana and Her Companions, 83, 87, 128–30,
 131n, 152, 197
The Geographer, 64, 64n, 83, 94
Girl Asleep at a Table, 134, 171, 311n
Girl Interrupted at the Music, 90
*Girl Reading a Letter a Letter at an Open
 Window*, 134
Girl with a Pearl Earring, 17, 33, 37, 64, 83,
 87, 88, 88n, 96, 121, 140n, 174
Girl with a Red Hat, 107, 134, 134n, 169n
The Glass of Wine, 134, 171
The Guitar Player, The, 97n
The Lacemaker, 83, 96, 97n, 106n, 168,
 187–88
Lady Seated at a Virginal, 171, 311n
A Lady Writing, 90–91
A Lady Writing a Letter with Her Maid, 97n, 134
The Little Street, 95, 99
Love Letter, 202
The Milkmaid, 17, 64, 83, 88n, 91–92, 96,
 99, 152, 169, 171, 187, 209
The Music Lesson, 171
The Procuress, 58, 82–83, 83n, 93n, 94, 99,
 130
Saint Praxedis (attributed), 142
Street in Delft, A, 64
View of Delft, 58n, 83, 87, 96, 99, 129
Woman and Two Men, 99, 110, 235–26, 236
Woman Holding a Balance, 91
Woman in Blue Reading a Letter, 99, 132, 134,
 152
Woman Playing a Lute, 90
Woman Pouring Milk,, 58n
Woman Weighing Gold, 152
Woman with a Pearl Necklace, 100, 152
Woman with a Water Jug, 90, 134
Young Girl with a Flute (attributed), 130–31,
 131n, 142, 169n
Young Woman at a Virginal (attributed), 97n
Vermeer of Utrecht, 98, 99, 129, 130
Vestdijk, Simon, 288–89
Veth, Cornelis, 196
View of Delft (Vermeer), 58n, 83, 87, 96, 99,
 129
Vrel, Jacobus, 100

W

Wagner, Otto, 53
Wallace, Irving, 288
Walsh, Big Ed, 308n
Washing of Christ's Feet, The (Van Meegeren forgery), 214, 217, 282, 284, 286
Weerdenburg, Sandra, 231, 297n, 313n
Wertenbaker, Charles, 280–81
Weschler, Lawrence, 87
Wheelock, Arthur, 45n, 64n, 89, 108, 110n, 127n, 134n, 137, 169n, 299n, 305n, 306n
When Prophecy Failed (Festinger), 316n
Whistler, James, 241, 242
White, Osmar, 250–51, 260–61
"Why Realistic Graphics Make Humans Look Creepy" (Thompson), 135, 308n
Wijsman, Jacques, 123
Wildenstein, Nathan, 142, 309n
Wilhelmina, Queen of the Netherlands, 123, 123n, 148, 203
Winsor and Newton paints, 34
Woman and Two Men (Vermeer), 99, 110, 235–36, 236
Woman Holding a Balance (Vermeer), 91
Woman in Blue Reading a Letter (Vermeer), 99, 132, 134, 152

Woman Playing a Lute (Vermeer), 90
Woman Pouring Milk (Vermeer), 58n
Woman Reading a Letter (Van Meegeren fake Vermeer), 132–33
Woman Weighing Gold (Vermeer), 152
Woman with a Child in a Pantry (De Hooch), 202
Woman with a Pearl Necklace, 100, 152
Woman with a Water Jug (Vermeer), 90, 110n, 134
Wooning, Inspector, 277, 282–83
Wordsworth, William, 134
Wright, Christopher, 22, 120, 152
Wright, Harold, 45

Y

Yeide, Nancy, 319n
Young Girl with a Flute (attributed to Vermeer), 130–31, 131n, 142, 169n
Young Woman at a Virginal (attributed to Vermeer), 97n

Z

Zell [am See], Austria, 260
Zeri, Federico, 240